1840

Patroclus } April 19
Cloisters }

Abbey. S. front
 Church
tall jar. 2 Candles
Woodyard. Cart & faggots } April 20
 Venus

Abbey. S. & W. fronts, arch, H. Chesnut, &c }
 Venus } April 24
 Eve
Table, decanters, cups &c.

Boxwood, entrance front
Boxwood, side view } April 25
Temple }

Cart, in orchard } April 26
Barrow, d° }

Urn, S.J.E.'s garden
South front Abbey } April 27
Apple branch
Antique Vase & Shakspeare }

 Eve
Correggio
Horse } April 28
Patroclus
Coach Houses, 2 Coaches
Abbey W. front, from near
 entrance }
 Eve
Table with Lamp & Candles } April 29
Tower from Urn
Malpese Vase & Boy reading }

Chintz } April 30
Sabines }
 d° }

The Photographic Art of

WILLIAM HENRY FOX TALBOT

Latticed Window
(with the Camera Obscura)
August 1835

When first made, the squares
of glass about 200 in number
could be counted, with help
of a lens.

The Photographic Art of
WILLIAM HENRY FOX TALBOT

Larry J. Schaaf

PRINCETON UNIVERSITY PRESS

PRINCETON AND OXFORD

*This book is dedicated to the two women who had the most influence on
the legacy of William Henry Fox Talbot. His mother, Lady Elisabeth Feilding,
encouraged him to press his art well beyond the limits he might have set for himself. She played
a crucial role in shaping his education and brought him into full contact with society. A
century later, his granddaughter, Miss Matilda Talbot (originally Gilchrist-Clark),
worked tirelessly to preserve his archives and to make his work better known.
Between them, they ensured that his story is the rich one
that Henry Talbot deserved.*

Publication of this book was made possible through the generous support of
The Hite Foundation, the Research Corporation, and an anonymous contributor

Published by Princeton University Press,
41 William Street, Princeton, New Jersey 08540
In the United Kingdom: Princeton University Press,
3 Market Place, Woodstock, Oxfordshire OX20 1SY
www.pup.princeton.edu

Permission to reproduce illustrations is provided by courtesy of the owners as listed in the captions. Additional photography credits are as follows: H. Chr. Adam (plate 21); Copyright © 2000 The American Photography Museum, Inc. (plate 33); Bayerische Akademie der Wissenschaften, München. Fotomuseum im Münchner Stadtmuseum (plate 53); Digital Image © 2000 The Museum of Modern Art, New York (plate 87); © The Manfred Heiting Collection, Amsterdam (plates 91, 95); Photograph © 1987 (plate 13), © 1997 (plate 88), © 1998 (plates 1, 100B), The Metropolitan Museum of Art, New York; Museum Ludwig/Agfa Foto-Historama, Köln; photo Rheinisches Bildarchiv, Köln (plate 67); © Museum of the History of Science, Oxford (p. 23, plate 8); National Museum of Photography, Film, and Television, Bradford/Science & Society Picture Library, London (p. 27, plates 10, 15, 20, 28, 29, 36, 39, 42, 44, 45, 47, 51, 54, 55, 57, 63, 68, 69, 71, 72, 73, 77, 78, 82, 84, 86, 90, 94); Miki Slingsby (plate 61)

Endpapers: For the brief period of 12 November 1839 through 25 October 1840, Talbot maintained a manuscript list of most of his negatives. The majority of the photographs listed on the six-page manuscript have been identified. Front endpapers (*left*) 1 March–18 April 1840; (*right*) 19–30 April 1840; rear endpapers (*left*) 1 May–15 July 1840; (*right*) 12 November 1839–29 February 1840. The Fox Talbot Museum, Lacock

Frontispiece: "*Latticed Window (with the Camera Obscura) August 1835.*" Photogenic drawing negative, 3.6 x 2.8 cm image mounted on blackened paper, on a 6.9 x 14.9 cm paper mount. National Museum of Photography, Film & Television, Bradford (1937-361), *Schaaf 2242*. This is the oldest positively dated Talbot photograph surviving. The label was likely created for exhibition at the beginning of 1839, when photography was announced to the public.

Color separations and printing by Stamperia Valdonega, Verona
Printed on specially made 160 gsm Pordenone uncoated paper
Printed and bound in Italy
10 9 8 7 6 5 4 3 2 1

Library of Congress Cataloging-in-Publication Data

Schaaf, Larry J. (Larry John), 1947–
The photographic art of William Henry Fox Talbot / Larry J. Schaaf.
p. cm.
Includes bibliographical references and index.
ISBN 0-691-05000-7
1. Photography, Artistic. 2. Talbot, William Henry Fox, 1800–1877.
I. Talbot, William Henry Fox, 1800–1877. II. Title.
TR651 .S33 2000
770'.92—dc21
00-32618

Contents

Preface

I remember distinctly the electrifying comment made in the course of discussion at a conference. Pressed on a position, Mike Weaver led himself into the spontaneous conclusion that William Henry Fox Talbot had grown into being "a little artist." The year was 1988, on the eve of the sesquicentennial celebrations for the year photography was announced to the public. The venue was Cerisy-la-Salle.[1] At some point everyone there realized that even though the conference was being held in France, not a single one of the invited speakers had chosen to talk about Talbot's contemporary, the brilliant Louis Jacques Mandé Daguerre. Perhaps a good part of the reason is that in contrast to the paucity of information available on the French inventor, we are blessed with great riches when it comes to studying Talbot. Henry Talbot accomplished prodigious amounts of work and surprisingly much of it has survived to this day. The present book is a celebration of this richness, as well as an indication of what is to be found as the *Catalogue Raisonné of Talbot and His Circle* is further developed.

"A little artist." I liked that thought immediately and the concept has worn well over time. Talbot started as a scientist with a problem. When he found he could not draw by conventional means, it was natural for him to turn to science for help. The result was the invention of photography, an art/science that has had a tremendous and continuing impact on society. It was one that enriched Talbot's own life as well. It brought out a creative side to him that previously had been evidenced mostly through eclectic exploration of subjects ranging from serious mathematical studies to retelling of legendary tales. The new art that Talbot invented taught him how to see, and from that new vision emerged the first signs of a camera vision—a photographic vision—that has continued to grow in the hands of others to this day. Talbot was the first artist taught by photography, and it is hoped that the present book represents a fair portfolio. It is at once romantic and surprisingly modern. And it is beautiful.

My first thanks must go to Talbot's descendants at Lacock Abbey. They have been consistently generous and helpful over the years and have always made my frequent visits to the abbey seem magical. Anthony Burnett-Brown (Talbot's great-great-grandson), his sister Janet, and his wife Petronella have faced many questions and have shared in many a quest for Talbot arcana. If the pleasure is in the details, they are to be given much of the credit.

In this emerging digital age, it is a great satisfaction to think that a book of this scope and physical quality can still be produced today. It would not have been feasible without the generous support of Sybil and Larry Hite at The Hite Foundation. The Hite Foundation's contribution made it possible to include a much wider range of Talbot's originals and to reproduce them well. In recognition of Talbot's diverse scientific attainment, generous support was supplied by John P. Schaefer and the Research Corporation.

This book could not have been produced without the encouragement and support of Hans P. Kraus, Jr. I have learned a great deal from him in many years of working closely together. His persistent and penetrating questions have led to a much greater sense of precision on my part. At the same time, he has never lost the real pleasure of looking at early photographic material, and it is that pleasure of the image that drew us both into this field. His introductions to private collectors enriched this book, and he has freely given permission to use many of the points originally raised in my essays for his *Sun Pictures Catalogues*. In Mr. Kraus's office, Shelley Dowell, Russell Isaacs, and Jennifer Parkinson have never found any request to be too much.

Mark Haworth-Booth of the Victoria & Albert Museum first suggested Princeton University Press as a publisher for this book. Maria Morris Hambourg of the Metropolitan Museum of Art provided an enthusiastic second. Both of these curators have had more influence on my work than they probably realize. At Princeton University Press, Patricia Fidler provided a firm editorial control and her assistant, Kate Zanzucchi, kept everything moving efficiently. Curtis Scott guided the manuscript through production, and Ken Wong and Sarah Henry ensured that the very difficult Talbot originals were sensitively reproduced. My copyeditor, Sharon Herson, had a reassuringly light touch but still managed to rescue me from my own linguistic tangles. Lisa de Alwis provided valuable assistance with the index. Peter Andersen, with whom I have happily worked before, crafted a fine layout from the mass of materials presented to him. Martino Mardersteig and the Stamperia Valdonega insured that our ideas were faithfully transferred to paper. This is my third book printed with them. It is particularly satisfying that their press in Verona, Italy, is less than one hundred miles from Bellagio, the village where Talbot was first inspired with the concept of photography.

Roger Taylor has very generously taken time out from his own writing schedule to comment on my manuscripts. His combination of photographic experience and a freely shared library has been immensely helpful.

My wife, Elizabeth, a professional archivist, has lived with Talbot-mania for many years now. Her professional advice and her personal support have been invaluable.

The identification of botanical specimens proved to be particularly difficult. Gavin Bridson, Yvonne Chamberlain, Jim Dickson, Gina Douglas, Robert Peck, Monica Thorp, and Roy Vickery were of particular help.

Over the years, in the course of reassembling Talbot's story, a great many people have given generously of their time and their thoughts. They cannot all be included here, but thanks to: Hans Christian Adam; David Allison; Pierre Apraxine; H. J. P. Arnold; Saskia Asser; Sylvie Aubenas; Anna Auer; Gordon Baldwin; Geoffrey Batchen; William Becker; Terry Binns; Werner Bokelberg; James Borcoman; Gavin Bridson; David Bruce; Bill and Alison Buchanan; Gail Buckland; Henry Buhl; Nicoletta Cassieri; David Coleman; Mariana Cook; Julian Cox; Malcolm Daniel; Christopher Date; Michelle Anne Delaney; Robert Drapkin; Lee Fontanella; Peter Galassi; Philippe Garner; Arthur Gill; Michael Gray; Sarah Greenough; André Gunthert; Anthony Hamber; Violet Hamilton; Colin Harding; Michael Hargreaves; Margaret Harker; Colin Harris; Virginia Heckert; Manfred Heiting; Cathy Henderson; Heinz and Bridget Henisch; John Herschel-Shorland; William Hillman; Tom Hinson; Steven Hobbs; Judith Hochberg; William Hodges; Harrison and Jean Horblit; Ralph Hyde; Charles Isaacs; Kira Ivanova; Frank James; André Jammes; Reese Jenkins; Stephen Joseph; Nancy Keeler; Martin Kemp; Walter Knysz; Gerardo Kurtz; Bob Lassam; Jim and Julie Lawson; Brian Liddy; Ezra Mack; Hazel Mackenzie; Lee Marks; Michael Mattis; Jay McDonald; Bernard McTigue; Richard Menschel; Steve Moriarty; Richard Morris; Alison Morrison-Low; Weston Naef; Amanda Nevill; Doug Nickel; Richard Pearce-Moses; Michael Pearman; Maria Antonella Pelizzari; Sylvie Penichon; Shannon Thomas Perich; Sandra Phillips; Ulrich Pohlmann; Françoise Reynaud; Howard Ricketts; Pamela Roberts; Russell Roberts; Grant Romer; William Rubel; Paul Sack; Thom Sempere; Maurice Sendak; Tony Simcock; Graham Smith; Joel Snyder; Vladimir Sobolev; Fred Spira; Michael Stanley; Phoebe Stanton; Howard Stein; Sara Stevenson; John Szarkowski; Ann Thomas; Julia Thompson; Monica Thorp; Nigel Thorp; Steven Tomlinson; David Travis; Julia Van Haaften; Bodo Von Dewitz; Clive Wainwright; Thomas Walther; John Ward; Mike Ware; Brian Warner; Mike Weaver; David Weston; Michael Wilson; R. Derek Wood; David Wooters; Helena Wright; and Phillipa Wright.

Many institutions have kindly shared their collections and information with me: Académie des Beaux-Arts, Paris; Africana Museum, Johannesburg; Agfa Foto-Historama, Cologne; Amsterdam Rijksmuseum; Art Institute of Chicago; Ashmolean Museum, Oxford; Auckland Museum; Biblioteca Estense di Modena; Bibliothèque Nationale, Paris; Birr Scientific Heritage Foundation; Bodleian Library, Oxford; Bristol University Library; British Library; British Museum; Cambridge University Library; Canadian Centre for Architecture; Devonshire Collections, Chatsworth House, Bakewell, England; Cleveland Museum of Art; Deutches Museum Bibliothek; Edinburgh Central Library, Scotland; Eisenhower Library, Johns Hopkins University, Baltimore; Firestone Library, Princeton University; Fox Talbot Museum, Lacock; George Eastman House, Rochester, New York; George Peabody Library, Baltimore; J. Paul Getty Museum, Santa Monica, California; Gilman Paper Company; Glasgow University Library; Göttingen University; Guildhall Library, London; Haverford College, Pennsylvania; Hohere Graphische, Vienna; Houghton Library, Cambridge, Massachusetts; Huntington Library, San Marino, California; Institut de France, Paris; Kings College Library, London; LaSalle Bank, Chicago; Library of Congress; Linnean Society, London; London Library; Manchester Central Library; McGill University Library; Metropolitan Museum of Art, New York; John Murray, publisher, London; Museum of the History of Science, Oxford; Museum of Modern Art, New York; National Gallery of Art, Washington, D.C.; National Gallery of Canada, Ottawa; National Library of Scotland, Edinburgh; National Library of Wales, Aberystwyth, Dyfed; National Maritime Museum, London; National Museum of American History, Smithsonian Institution, Washington, D.C.; National Museum of Photography, Film & Television, Bradford, England; National Museum of Scotland; National Museum of Wales, Cardiff; Natural History Museum, London; New York Public Library, New York; Newcastle University Library; Reading Central Library, England; Reading Museum and Art Gallery, England; Reading University Library, England; Royal Archives, Windsor; Royal Botanic Garden, Edinburgh; Royal Botanic Gardens, Kew; Royal Institution of Great Britain, London; Royal Museum of Scotland, Edinburgh; Royal Photographic Society, Bath; Royal Society of Arts, London; Royal Society of London; Russian Academy of Science, St. Petersburg; San Francisco Museum of Modern Art; St. Bride Printing Library, London; Science Museum Library, London; Scottish National Portrait Gallery, Edinburgh; Seaver Center for Western History Research, Los Angeles, California; Smithsonian Institution, Washington, D.C.; Snite Museum of Art, Notre Dame, Indiana; Société Française de Photographie, Paris; Spencer Research Library, University of Kansas at Lawrence; Stanford University Art Museum; Tokyo Fuji Art Museum; Tokyo Metropolitan Museum of Photography; Toledo Art Museum; University of Michigan Art Gallery; Victoria & Albert Museum, London; Wellcome Foundation Library, London; Welsh Industrial and Maritime Museum, Cardiff; Wiltshire County Archives.

Larry J. Schaaf
Rock House
Baltimore, Maryland

We have a rather remarkable young man here, a Mr. Talbot, a Wiltshire gentleman of independent fortune. He was high in the list . . . at Cambridge . . . he is rather <u>unlicked</u>, but that don't signify. We have fine gentlemen enough. He is very laborious, not so much I think out of vanity or even ambition as from the mere love of what he is acquiring. He has an innate love of knowledge, and rushes towards it as an otter does to a pond. He bids fair to be a distinguished man. MR. WARD, AT NICE, 1821[1]

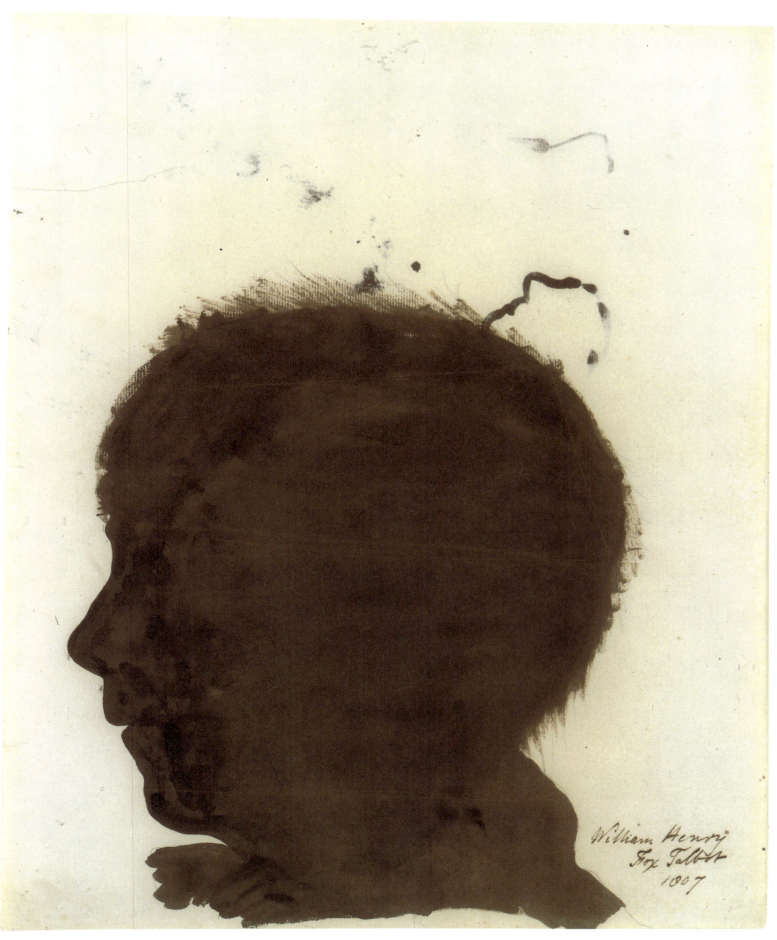

Anonymous, *Silhouette Portrait of William Henry Fox Talbot at the Age of Seven*.
Ink on paper, 38.0 x 20.6 cm. Mariana Cook and Hans P. Kraus, Jr.[2]

"Miscellanea Photogenica." Ink inscription (enlarged), in Talbot's hand, on a paper folder originally containing photographs. Photographic History Collection, National Museum of American History, Smithsonian Institution, Washington, D.C. (1995. 0206.667)

"A Little Bit of Magic Realised"[3]

What defines a great and original mind? What is creativity? Why does one man see what others have missed? How does an innate talent grow into mastery? One confronts all these questions and more when considering William Henry Fox Talbot, a sometimes flawed but highly creative man whose shortcomings yielded to insight and led to the invention of the art of photography.

By the time Talbot announced his invention of photography to the public in 1839, he had already amassed a substantial reputation. He had been successful at guiding the estate of Lacock through the violent political turmoil of the 1830s and had served as a Member of the Reform Parliament. In 1822, Talbot was elected to memberships in the Astronomical Society (later the Royal Astronomical Society) and the experimentally oriented Royal Institution of Great Britain. In 1831, he became a Fellow of Britain's premier scientific body, the Royal Society of London. His first published papers were in mathematics, in the 1820s.[4] Talbot's first scientific paper based on experiment rather than abstract reasoning examined colored flames and was published in 1826. It was communicated by John (later Sir John) Herschel to Sir David Brewster's influential *Edinburgh Journal of Science*. Both of these giants of the scientific world would later have a profound influence on photography's acceptance.[5] By the end of the year 1839, Henry Talbot had published four books and twenty-seven scientific papers. His original research work on crystals had led to the prestigious Bakerian Lecture before the Royal Society in 1836; in 1838, he received the society's Royal Medal for his work in mathematics. Talbot revealed his art of photography from a position of considerable strength and accomplishment. And yet this art seems a complete anomaly in his life's work, a vividly expressive dream played out brilliantly, but for a preciously short period of time.

There are two excellent and complementary biographies of Henry Talbot that together outline his development.[6] He was born on 11 February 1800 at Melbury, Dorset, the only child of William Davenport Talbot of Lacock Abbey, Wiltshire, and Elisabeth Theresa, daughter of the earl of Ilchester. Davenport Talbot died when his son was five months old, leaving an estate in ruinous condition and forcing the boy and his mother to live in a succession of family homes. That family was extensive and influential and saw to it that Henry Talbot never lacked for opportunity. Although painfully shy and reclusive by nature, Talbot was an earnest student who made the most of these opportunities. Following initial tutoring at home and in Sussex, Talbot was accepted at Harrow School in 1811. He entered Trinity College, Cambridge, in 1817, becoming a Scholar in 1819. In 1820 he won the Porson University Prize in Greek verse. In 1821, he became twelfth Wrangler and won the second Chancellor's Classical Medal before securing his B.A. in 1825, Talbot was granted his M.A.[7] Lady Elisabeth remarried in 1804 to Captain (later Rear Admiral) Charles Feilding, who became a real father to the boy. Two half-sisters, Caroline Augusta Feilding (later Lady Mt. Edgcumbe) and Henrietta Horatia Maria Feilding (later Mrs. Thomas Gaisford) entered Henry Talbot's world; they grew close and both exerted artistic influence on their brother. Talbot's extensive family connections provided him access to elite circles in science and politics, and Caroline's later position in the Queen's household strengthened his royal contacts. By the time he attained his majority, his mother had deftly turned the financial ruins into which he had been born into a proper inheritance, and Talbot was able to reoccupy their Wiltshire home of Lacock Abbey. Although never wealthy, particularly by the standards of his peers, he was able to live the life of an amateur scholar—amateur in its proper sense, as one who labored at his subjects out of pure love of knowledge.

Lady Elisabeth Feilding (see pl. 55) was almost certainly the most important person in Henry Talbot's personal and professional life, and on the occasion of his twenty-first birthday, she made it clear that the close bonds they had developed were not about to be severed: "You cannot judge of the rapture with which I first beheld you," she confessed, and then forthrightly reserved "for myself . . . the right *which Nature gives me*, of suggesting any thing which from your youth & inexperience may

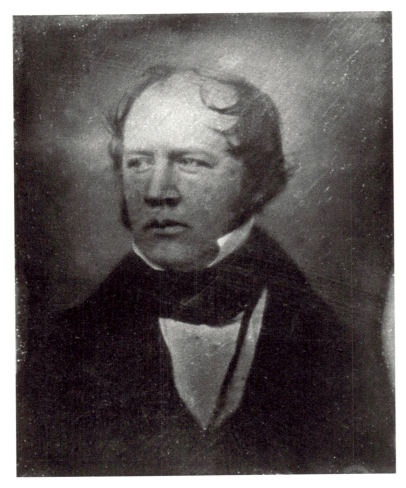

William Henry Fox Talbot, c. 1842. Daguerreotype portrait by the studio of Richard Beard, on the roof of the Royal Polytechnic Institution in London. Fox Talbot Museum, Lacock. Curiously, the best existing portraits of Talbot were taken by his rival Daguerre's process.

not occur to you."[8] Lady Elisabeth set very high standards for herself and demanded nothing less of her son. As might be expected from her background, her social skills were highly honed, and she moved easily through circles that Henry Talbot might have preferred to avoid. Her facility with foreign languages was reflected in Talbot's later philological and translation work, and the family's extensive travel abroad diversified his education and contacts. Many of her family were gardeners and botanists, and this fueled Talbot's own life-long involvement in botany. Lady Elisabeth's talents in sketching, watercoloring, and lithography were well above the usual parlor level expected in her own day, and this strong visual influence cannot be ignored when considering Talbot's achievements in photography. She had an unwavering confidence in her son's abilities and constantly attempted to fire a sense of ambition that seemed otherwise lacking in his character. About the only thing Lady Elisabeth might have failed in was her hope that he would use the family name of "Fox" more often. Henry Talbot himself nearly always signed things as H. F. Talbot or Henry F. Talbot. Some of his peers called him Fox Talbot and this melodious compounded name is practically universal today—he would have strongly preferred otherwise.[9]

Elsewhere within his family's circle, Talbot met with many influences. His uncle, William Thomas Horner Fox Strangways, was nearly as sharp a critic of his work as his mother was. Strangways traveled widely in his career as a diplomat, bringing outside influences to bear on his nephew, and affording him many contacts and opportunities on the Continent. Uncle William was a keen botanist—the bulk of the correspondence between the two men is about this science—but also an avid collector of art. He tried, unsuccessfully, to get Henry Talbot to collect art for a gallery proposed at Lacock Abbey. Their letters during the 1820s on art collecting are quite illuminating of the influences on Talbot (today, Strangways's collection forms an important core of the art collections of Christ Church and the Ashmolean Museum in Oxford).[10] Lady Elisabeth brought a diverse society of friends into contact with her son, including Sir Humphry Davy's widow and the eccentric scientist Charles Babbage. A particularly close family friend was the Reverend George Montgomerie, a highly accomplished artist who frequently accompanied the family on trips abroad.[11] Undoubtedly young Talbot observed him sketching many times during their journeys, and Montgomerie took an active interest in Talbot's photography when it was made public. A nearby neighbor and close friend of the family who introduced Talbot into literary and publishing circles was the wildly popular Irish poet Thomas Moore.[12]

In the scientific world, Talbot's work was highly respected and he came to know many scientists, both in Britain and on the Continent. Two of these stand out in the introduction of photography. Talbot first met John Herschel by chance in Munich in 1824. By then, Talbot had already published six papers in mathematics and was well positioned to benefit from contact with Britain's most famous scientific family. This meeting likely influenced Talbot's turn toward research into light and optical phenomena, and established a friendship and a scientific collaboration crucial to Talbot's later success.[13] In 1826, Herschel introduced him to Dr. David Brewster, the important Scottish scientist and encyclopedist.[14] Both Talbot and Brewster could be awkward socially, but they got along famously with each other and developed a true friendship. Brewster's and Talbot's individual researches on light frequently overlapped, and Brewster began publishing Talbot's scientific articles in his journal. Later, Brewster would be the stimulus for photography

in Scotland, bringing Talbot's work to the interested circle there, particularly to the intriguing partnership of Robert Adamson and David Octavius Hill.[15]

On 20 December 1832, Henry Talbot married Constance Mundy of Markeaton in Derbyshire. He had just been elected to Parliament as the reform candidate for Chippenham, and together the couple seemed destined for life on a country estate. The following summer, during a parliamentary recess, he and his new wife departed for Italy. From this journey to the time-honored haunts of artistic inspiration, quite unexpectedly, the new art of photography was to be born!

And the numerous researches which were afterwards made—whatever success may be thought to have attended them—cannot, I think, admit of a comparison with the value of the first and original idea.

HENRY TALBOT[16]

The first and original idea! By October 1833, Henry Talbot's meandering Italian journey had brought him to the shores of Lake Como, to the picturesque little village of Bellagio (once a favorite stop of Lord Byron's). He and his young wife had met up with his sisters and other family members. One of their favorite activities—one in which everyone in the party save Henry was adept—was sketching the landscape around them. For all the influences that had been brought to bear on him and for all the various attainments that he had achieved, Talbot had a very serious shortcoming. In an age in which the visual sketch with a pencil was almost as important as the verbal sketch with the pen, he simply could not draw. Although his eyesight was a problem, his hands were accustomed to fine work, and through botany especially his mind was attuned to a high degree of visual acuity. However, he lacked the skill of the draftsman to examine the complex and ever-changing three-dimensional colorful world of nature, reduce it to line and shading and form, and render it on a two-dimensional sheet of paper.

Surrounded by loved ones who were happily sketching away, mired in his dilemma, Talbot turned to the familiar realm of science. For at least the last decade he had carried around a *camera lucida*, a tiny drawing instrument invented by William Hyde Wollaston.[17] The term "camera" might be misleading here, for Wollaston's instrument was nothing more than a tiny prism mounted on a stem. The artist would look through the edge of the prism and when all was aligned just right, he thought he saw the image of nature imposed on the sheet of drawing paper

in front of him. It was all a neat visual trick; there was no projected image and the fusion of nature and the paper took place in the artist's brain. In the hands of an artist, this was a great aid to accurately and quickly sketching a scene of nature. In the hands of Henry Talbot, it was absolutely useless. As he later recalled, "When the eye was removed from the prism—in which all had looked beautiful—I found that the faithless pencil had only left traces on the paper melancholy to behold."[18] He still could not draw.

A decade before, also in Italy, Talbot had tried to sketch using another common artist's tool, the *camera obscura*, but with no better success. The camera obscura Talbot had toyed with intermittently since the 1820s and the photographic camera that would evolve were virtually identical. A hefty lens was mounted at the end of a wooden box (the size of a shoebox or perhaps a little larger). Inside, a mirror mounted at a 45-degree angle bounced the image up to a ground glass screen mounted on top of the box. An artist would fasten a sheet of thin paper over this glass and then trace the image that was projected onto it. Unable to take advantage of the view of nature presented by the camera lucida, Talbot was recalling the camera obscura when he was prompted to "reflect on the inimitable beauty of the pictures of nature's painting which the glass lens of the Camera throws upon the paper in its focus—fairy pictures, creations of a moment, and destined as rapidly to fade away . . . the idea occurred to me . . . how charming it would be if it were possible to cause these natural images to imprint themselves durably, and remain fixed upon the paper."[19]

Look abroad through nature's range
Nature's mighty law is change
ROBERT BURNS[20]

Talbot reasoned that the picture in the camera obscura, "divested of the ideas which accompany it, and considered only in its ultimate nature, is but a succession or variety of stronger lights thrown upon one part of the paper, and of deeper shadows on another. Now Light, where it exists, can exert an action, and, in certain circumstances, does exert one sufficient to cause changes in material bodies."[21] Talbot was unable to execute any experiments whilst travelling, and when he returned to England by the end of 1833, he was immediately plunged back into parliamentary duties. We don't know exactly when, but sometime later in the spring of 1834, he began in his efforts to turn his dream into reality. His research notes for this period

South Front of Lacock Abbey in Wiltshire, c. 1842–43. Salt print from a calotype negative, 10.7 x 21.1 cm image on 18.3 x 22.3 cm paper, watermarked "J Whatman Turkey Mill 1842." Photographic History Collection, National Museum of American History, Smithsonian Institution, Washington, D.C. (3864.e), *Schaaf 1262.* The circumstance of residing in a place like Lacock Abbey had a noticeable influence on Talbot's work in photography. The abbey's library underpinned his research; its kitchen provided him with ingredients and implements; and its staff was available to assist in his activities. In addition, its eclectic architecture and the varied botanical life on its grounds provided ready subject matter.

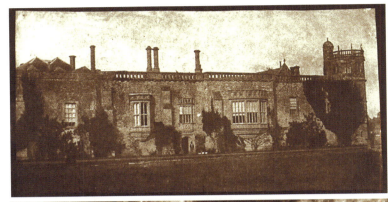

Detail. While Talbot was producing his photographs at Lacock Abbey, he had a much higher degree of control over the results. In this greatly enlarged section of the above image of Lacock, an unidentified top-hatted gentleman (possibly Henry Talbot himself) supervises the printing of three negatives in wooden frames placed to receive the daylight. In tightly controlled and supervised situations like this, the pieces of paper could be carefully selected and handled, ample water was available for washing the prints, and there was no real pressure to produce prints if the sunlight was less than adequate at a given time. After late 1843, when prints from Talbot's negatives were more likely to be made at Nicolaas Henneman's calotype works in Reading, England, the situation changed. Water was in short supply, and the pressures of commercial production sometimes meant that inexperienced help was pressed into service. If the sun happened to be weak on a day when prints were required, they had to be made anyway, even if the results were less than optimal.

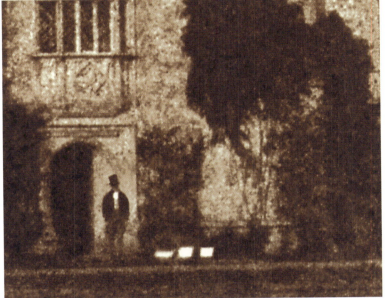

are scanty; Talbot was a highly imaginative person, and it is likely that he worked as much from inspiration as from method. The library at Lacock would have yielded the knowledge that the various salts of silver were peculiarly sensitive to the effects of light. Coating these on paper, it would not have been long before Talbot began to observe the effects of the sun. Although self-confessed as "not much of a Chemist,"[22] his powers of observation had been finely honed by botany. Seeing that the light in the camera obscura was too weak for experimental purposes, he turned to simple shadows of objects placed on light-sensitive papers. These papers would darken in sunlight (in much the same way as our skin acquires a tan). By coating ordinary writing paper with light-sensitive silver chloride, and placing this in the sun under an object such as a leaf, within the space of perhaps a quarter hour he would obtain a rudimentary image. Where the light had reached the paper, it darkened it, but where the leaf blocked the light, the paper remained white. In his notebook of the period, he called these images *scia-*

graphs—the depictions of shadows. His images were negative impressions—light represented by dark—and he had yet to find a way to make them permanent. The light-sensitive silver salts remained in the paper and could not be washed out. These first crude pictures had to be viewed under candlelight, but perhaps that made them all the more magical to Talbot.

Henry Talbot did not set out to invent the negative. In seeking to find a way to have nature do his drawing for him, Talbot logically would have been expecting an impression where the lights and shades were in their natural order. Had his first experiments emphasized images taken within a camera, it is possible that he would have suffered the same disillusionment that other inventors had when they found that light produced dark. It is perhaps fortunate, then, that in an effort to use light more efficiently, Talbot turned to contact images of botanical specimens and lace. The shadowgrams he first produced of these suffered not at all by being negatives (a fine example is the *Band of Lace* in pl. 15); what intrigued Talbot most was the

ability to render the fine detail. For the first year or two of photography, the negative would be seen as being an unfortunate and cumbersome intermediate step toward making a print. Even Talbot was slow to truly appreciate the inherent advantage of this, the negative's ability to be the master of multiple prints. Faced with these negative images, why was Talbot the one who was able to make the imaginative leap from seeking a literal work of art to accepting the way that nature chose to draw herself? Was it that most would-be inventors of photography were artists who were seeking another way to produce the art with which they were already familiar? One of these was Samuel F. B. Morse, best known for his invention of the telegraph, but generally a portrait painter. In his student days at Yale, he had set out to invent photography, but "finding that light produced dark and dark light, I presumed the production of a true image to be impracticable, and gave up the attempt."[23] Talbot was not shackled by a past body of artistic endeavors and was able to accept immediately a whole new type of visual representation. For Talbot himself, the precise rendering of the form was as intelligible in a negative image as it would have been in the positive.

In any case, Talbot understood immediately how to correct this problem. In the autumn of 1834, he employed what we would now call a *cliché verre* negative to make positive prints; his term for this was *photogenic etching* (see *"Villaggio,"* pl. 2). In his research notebook early in 1835, Talbot recorded the thought that "in the Photogenic or Sciagraphic process, if the paper is transparent, the first drawing may serve as an object, to produce a second drawing, in which the lights and shadows would be reversed."[24]

Talbot was later genuinely uncertain why the muse had tapped him at Lake Como. He felt that the foundations of his idea were likely more complex than even he realized, admitting freely that "whether it had ever occurred to me before amid floating philosophic visions, I know not, though I rather think it must have done so, because on this occasion it struck me so forcibly."[25] What were Talbot's "floating philosophic visions?" One possibility was provided by his friend, John Herschel, who in 1831 entertained the guests at a scientific breakfast by making simple images with light in a solution of platinum salts; along with Sir David Brewster and Charles Babbage, Talbot was one of the witnesses to this.[26] In conducting this demonstration, Herschel had no intention of inventing photography—unlike Talbot, he was a highly accomplished draftsman already—but merely wanted to study the physical effects of light. And although Talbot said that he was unaware of the previous work

of others (and there is no basis for doubting this), he had in fact gone over ground already covered.[27] In his first work, Talbot closely duplicated what Thomas Wedgwood had accomplished forty years before. The potter's son had succeeded in making images on silver-coated white leather but had found no way to make them permanent.[28] Talbot later said that he would have been discouraged if he had known of the earlier efforts. Wedgwood's friend, the eminent chemist Humphry (later Sir Humphry) Davy, had lamented that "nothing but a method of preventing the unshaded parts of the delineation from being coloured by exposure to the day is wanting, to render the process as useful as it is elegant."[29] Wedgwood never got past the stage where his images could be viewed only under candlelight.

It was in Geneva in the autumn of 1834 that Talbot put into place the second and indisputably the most original part of his invention. After trials with many substances, he found that he could stabilize his images against the further action of light by a simple wash of potassium iodide (an example, possibly dating from 1834, is plate 7). This converted the remaining light-sensitive salts into an insensitive form. Around the same time, he discovered that he could accomplish the same goal with a strong solution of common table salt. The essential elements of photography had been invented!

No human hand has hitherto traced such lines as these drawings display; and what man may hereafter do, now that Dame Nature has become his drawing mistress, it is impossible to predict.
MICHAEL FARADAY, 1839[30]

In the "brilliant summer" of 1835, Talbot worked at increasing the sensitivity of his coatings to the point where camera negatives would be practical. Using smaller cameras and multiple washes of his coatings, Talbot finally succeeded in getting nature to draw her own image. He immediately grasped the idea that his negatives could themselves be printed on sensitive paper, reversing the tones back to normal, and allowing the production of multiple prints from one negative. While his cameras at this stage were small crude wooden boxes that required long exposures (see pls. 1, 3, and 4), the fundamental concepts of permanent negative-positive photography had all been achieved by Talbot eighteen months after his bout of frustration at Lake Como.

Although he had achieved a high degree of success, Talbot desired to improve matters further before publication, and the

knowledge of his discovery remained within his family. During the following three years, Talbot was intensively engaged in other optical studies and in refining his mathematical works. One of his most productive periods was in the late 1830s, but this left little room to further improve his photography. It was not until November 1838 that Henry Talbot returned to his photographic experiments with a mind toward drawing up a paper for presentation to the Royal Society. His timing was awful. In a brutal shock just weeks later, word came from Paris in early January 1839 that the artist Louis Jacques Mandé

Daguerre had frozen the images of the camera obscura. With no details disclosed, Talbot was placed in the dilemma of the loss of his discovery if Daguerre's method proved identical to his. In the gloomy light of an English winter, Talbot could not demonstrate his own process, but on 25 January Michael Faraday displayed some of Talbot's still-preserved 1835 examples at the Royal Institution in London.[31] On 31 January, he read his years-delayed paper before the Royal Society of London and before the end of February 1839 he disclosed the working details of his process.[32]

Some Tools for Understanding Talbot's Photographs

With the disclosure of photography to the public in 1839, Talbot was encouraged to consider his invention in a much more formal way. No longer did the art exist solely in his own mind; terminology had to be established and his working processes expressed in a manner that could be followed by others. In order to comprehend the physical rudiments of Talbot's work, we must separate the actual photographic object in front of us, first from the mechanism by which it was produced, and second from the more powerful chains of what we perceive its function to be. Too often the chemistry and the camera and the concept of a print are stirred together into a confusing linguistic stew.

Of the myriad photographic processes that Talbot conceived, only two need command our attention in order to comprehend the main body of his work: *photogenic drawing* and the *calotype*. Both of these were produced on a paper base and both took advantage of the light sensitivity of salts of silver. Each formed an image of finely divided particles of metallic silver. Beyond that, they worked in a fundamentally different way: the first was a *print-out* process, the second a *developed-out* process. The process of converting the light-sensitive photographic paper into something that is relatively permanent is generally called *fixing*. It took many different forms, some more successful than others.

The terms of the *negative* and the *positive* (more commonly, the *print*) are best reserved as descriptors of our own perception of what function we assign to a photographic object. There is no real physical distinction between these. Also, although our hearts may respond more warmly to images produced in a camera than to those done under a leaf or ones that replicate another work of art, the photographic process itself is largely indifferent to these distinctions.

The two processes of photogenic drawing and calotype can each be employed either in a camera or by contact with another object. The results of either of these processes can serve the function of a negative or a positive. However, all of these had typical applications and served well-defined roles in Talbot's photographic productions.

PHOTOGENIC DRAWING

This was Talbot's first photographic process, and it can fairly be said that it was one that he set out to *invent*, rather than one that he *discovered*. In his private notes in 1835 he called it *Sciagraphy*—the art of depicting objects through their shadows—but this is not a term he used publicly. Talbot also privately used the term *photogenic drawing* as early as 1834 and this was the label he would apply in 1839.[33] It is not clear what Michael Faraday called these when he exhibited Talbot's work at the Royal Institution on 25 January 1839. However, *photogenic drawing* was part of Talbot's title in his first paper on photography read at the Royal Society a few days later, on 31 January. The general public first learned of it in the pages of the *Literary Gazette* two days later. Charles Wheatstone and Sir John Herschel objected almost immediately to this term, the latter making a persuasive case for the use of the more flexible root word of *photography*, but Talbot continued to use his own label of *photogenic drawing* for some years.[34]

In the period between Talbot's first inspiration on the shores of Lake Como in October 1833 and when he started his actual experiments at Lacock Abbey sometime in the late spring of 1834, he had time to consider how to approach the problem. He knew from his readings that the salts of silver were peculiarly sensitive to light and logically he started with them. He found that of all the compounds of silver, that of silver chloride was the most sensitive to light. Silver chloride, however, had the drawback that it was not readily soluble in water and therefore was impossible to coat directly onto the paper. Talbot sidestepped this by starting with some table salt from Lacock's kitchen. A sheet of plain writing paper could either be dipped or soaked in a mild brine solution or else brushed over with the salt solution. Once dried, it was "salted paper" (a term of convenience used by later writers, not by Talbot): simply put, the paper fibers were coated with common salt. The next step was initially done in ordinary room light, anything short of bright sunlight. Using a brush or a ball of cotton wool, Talbot applied

silver nitrate to one side of the paper. Silver nitrate was greatly convenient for this step, as it was freely soluble in water but only minimally sensitive to light. When the silver nitrate solution reached the common salt trapped in the paper fibers, a chemical reaction occurred immediately, precipitating minute flakes of silver chloride. Since they were not soluble in water, they resisted being washed out and instead were trapped within the matrix of the paper fibers, coating these fibers with a light-sensitive compound. This paper was dried and was ready for use. It was at its best when freshly prepared and rarely kept for more than a day or two.

Photogenic drawing paper was a print-out paper. If an area of it was exposed to sunlight, the silver chloride in that area was reduced to fine particles of metallic silver. These appeared to be various colors, depending on how finely divided they were, but generally were in the range of lavender to purple-black. Where light struck, darkness was produced, hence the negative impression. The important factor here was that a print-out paper maintained a direct link to the sun, relying totally on the energy of the solar light to create the silver image. The paper darkened in light and the image became visible during the course of exposure. There was no subsequent development of the image (although additional steps had to be taken to insure its longevity).

Talbot initially exposed his photogenic drawing paper under objects such as botanical specimens. The flattened plant was arranged on the surface of the sensitive paper, the two were pressed together under glass (usually in a wooden frame) and placed out in the sunlight. Where the light was not blocked by the object, its full solar force hit the paper and those areas darkened rapidly and fully. Where the object was semitransparent—perhaps the petal of a flower—varying amounts of light filtered through and some silver was deposited in that area of the paper, forming a range of middle tones. Where the original object was relatively opaque, such as the stem, the sensitive paper was effectively defended from the light and remained its natural white color. After an appropriate period of exposure, perhaps in the range of ten to thirty minutes, the paper was extracted from the sandwich. The result was an immediately visible negative image. As long as this was viewed under reduced light levels (candlelight was ideal), the image would remain visible for some time. However, the unused silver chloride was still trapped in the paper and was still sensitive to light. Any strong light would cause it to darken all over.

The same paper could be used in a camera and worked in exactly the same way. Talbot initially tried using a camera obscura of sufficient size to accept a full sheet of writing paper but found that not enough light made it through to create the reaction. He then dropped to a much smaller camera size—a cube about the size of an apple—holding a tiny scrap of sensitized paper, often no larger than a business card. This allowed much more concentrated light to reach the paper. Refinements in his coatings, including coating twice to precipitate more silver chloride, increased the sensitivity of photogenic drawing paper to the point where the light in the tiny camera could have an effect. The photogenic drawing paper was still totally dependent on solar energy to produce a visible image, and exposure times were long, even in these small cameras. A range of tens of minutes or even past an hour was necessary. The image would become visible in the camera as metallic silver was deposited in the pattern of the lights and shades of the original. The result was a negative image: where light had fallen, dark was produced.

As physical objects, a photogenic drawing negative made by contact and a photogenic drawing negative made in a camera are identical. As he came under increasing pressure to make camera images after photography was made public, Talbot evolved more sophisticated ways of producing his paper. A major step was the substitution of silver bromide for his original silver chloride.[35] Although he never used the name publicly, he called this his *Waterloo* paper.[36] While unstable and more difficult to prepare, it could be up to ten times as sensitive as his ordinary paper. It was still a print-out paper, a refined photogenic drawing process, and Talbot did not record when he used it in preference to silver chloride. His contemporary, Robert Hunt, said that Talbot "certainly prefers the bromide for all purposes requiring highly sensitive papers."[37] Whether employed in a camera or placed under a leaf, the photogenic drawing negatives were a little bit of magic. There was an immediacy to the images produced by the process—images that literally grew in the sun—that had a compelling effect on Henry Talbot. Nature drew her pictures for him and then she "fixed them durably on the paper." Long before he discovered the calotype, photogenic drawing had taught Talbot how to see. Had he progressed no further than this, he would have already achieved his original goal. The first twenty-eight plates in this book, along with some later ones, either are themselves or were printed from photogenic drawing negatives.[38]

NEGATIVES VERSUS POSITIVES

An important point that must be kept in mind is that from a physical-chemical point of view, there is no essential difference between a negative and a positive in Talbot's work; the latter is merely a negative of a negative. At least by February 1835, he had grasped this idea and knew how to make it work for him.[39] Talbot was little tempted at first by the thought of making prints; in the summer of 1839, he wrote to Herschel that "in the little packet of photogenic drawings which I send today by the Railway, there is a re-transfer of a fern leaf; these are easily made but in the estimation of most people are less pretty than the first or white images."[40] Even as late as *The Pencil of Nature* in December 1845, Talbot still raised the argument that "in copying such things as lace or leaves of plants, a negative image is perfectly allowable, black lace being as familiar to the eye as white lace, and the object being only to exhibit the pattern with accuracy."[41] It is possible that Talbot did not print any of his *camera* negatives until April 1839 (the first known example is his *Middle Window*, pl. 9). He wrote at that time to Herschel to say, "I have found that the Camera pictures transfer very well, & the resulting effect is altogether Rembrandtish."[42]

A little etymological diversion is in order here. The terms *negative* and *positive* we use so freely today were brought onto the scene rather late by Sir John Herschel; Talbot really didn't have standardized terminology for these. In his first public paper on photography, read on 31 January 1839, he barely touched on the distinction, noting merely that the images he had formed were white on a colored ground. Only when discussing copies of engravings did he refer to a "second process" of making the original (what we would call the negative) the subject for a second photograph (a negative of a negative, making a positive).[43] In his exhibition of photographs in August 1839, Talbot had a class of prints he called "Reversed images, requiring the action of light to be TWICE employed."[44] Herschel stumbled for a while with this. In his first paper on photography, given to the Royal Society on 14 March 1839, he used the term *first transfers* for the negative stage and *second transfers* for the prints.[45] In his research notebook in April 1839 he dreamed up the still-cumbersome terms *transitional photograph* for the negative and *copies* for the prints; fortunately, these never made it into the general language.[46] Herschel finally drew on an analogy with electrical terms. In his magisterial February 1840 paper on photography, he decided "to avoid much circumlocution" by employing "the terms positive and negative, to express respectively, pictures in which the lights and shades are as in nature, or as in the original model, and in which they are the opposite, i.e. light representing shade, and shade light. The terms direct and reversed will also be used to express pictures in which objects appear (as regards right and left) as they do in nature, or in the original, and the contrary."[47]

FIXING THE IMAGES

Had Talbot gone no further than his first experiments in 1834, he would have accomplished nothing more than what Thomas Wedgwood had done at the end of the eighteenth century. Producing images by taking advantage of the light sensitivity of the salts of silver was relatively easy. All that was required was rudimentary chemical knowledge, and even more importantly, the inspiration and desire to do so. These images, however, were not permanent. The light-sensitive silver chloride remained suffused throughout the paper. As long as the new image was looked at in dim candlelight, it would remain visible, but as soon as the paper was brought into ordinary light the remaining silver started to deposit, soon obscuring the image in an overall darkness. Something was needed to *fix* the image—to make it resist the further action of light.

Although he was working from memory rather than notes, Talbot recalled that the first successful method he employed for *fixing* his photographs in 1834 was to brush them over with a solution of potassium iodide. This converted the remaining silver salts to silver iodide, an insoluble but also insensitive compound that stained the paper a lemon yellow. A more interesting and more common approach stemmed from Talbot's first observations when he was creating his first papers with silver nitrate and common salt. He observed that, contrary to expectations, while the salt was absolutely essential to the process, a lesser quantity of salt produced a more sensitive paper. Talbot probably came to this conclusion because of the casual way in which his first papers were produced. He swabbed on the solution of silver nitrate, inevitably leading to an uneven coating near the edges. Some of these edges proved more sensitive to light, and he soon deduced that these were areas where the concentration of silver nitrate was relatively higher. When he reduced the overall amount of table salt in his paper, the sensitivity increased overall. From that, it was a short step of reasoning to conclude that if less salt produced more sensitivity, then more salt would reduce the sensitivity. After exposure, he flooded the paper with a strong salt solution, which did not affect the silver image, but rather converted the

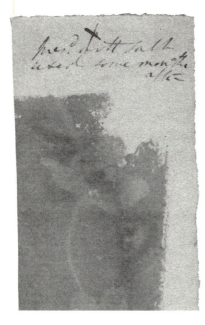

Experimental notations on photographs, in Talbot's hand. Photographic History Collection, National Museum of American History, Smithsonian Institution, Washington, D.C. *Left:* 9.5 x 4.0 cm (1995.0206.547), *Schaaf 3995. Right:* 5.9 x 3.8 cm (1995.0206.181), *Schaaf 2546.* Talbot sometimes recorded experimental data directly on his photographs. On the left, a photogenic drawing negative of leaves and a small flower almost certainly dates from 1839 or earlier. Talbot sometimes deferred fixing his negatives until a more convenient period—the ink inscription says "pres[erve]d with salt used some months after." As is characteristic with salt fixing, the image color is a soft lavender. No image is visible any longer on the negative on the right, but the paper retains a yellow stain, betraying the use of an iodine compound. The inscription, combined with Talbot's record in his research notebook *Q,* establishes this as one of his first experiments in sensitizing a calotype paper. It apparently retained its sensitivity for three months before use.

remaining salts into a relatively insensitive form of silver chloride. These images, on the whole, were lavender in color.

A third approach Talbot used was similar to the above methods except that he used potassium bromide. This produced unhappily cold-toned prints but was fine for fixing later photogenic drawing and calotype negatives.

All of Talbot's approaches to fixing involved taking the unused silver salts remaining in the paper after exposure and converting them into relatively insensitive compounds. These were largely insoluble and remained in the paper, doing their job temporarily but raising the specter of complications in the future. In fact, in his first paper on photography to the Royal Society, Talbot referred to this quite honestly as the *preserving process.*[48] It was up to Talbot's friend Sir John Herschel to suggest an entirely different approach. Long before the public introduction of photography, as part of his general researches, Herschel had explored the chemical properties of the hyposulphites (today more commonly known as thiosulphates).[49]

These had the property of dissolving many salts of silver while leaving untouched the metallic silver. When he began experimenting in photography in 1839, Herschel applied these *hypo* solutions. They took a different path than Talbot's approach. Hypo (essentially the same as the fixer employed by photographers to this day) dissolved the unused silver salts. At first, Herschel let them leach out into the solution of hypo, or sponged the solution off, but he soon discovered that greater permanence resulted with a thorough washing with water after the application of hypo. Properly done, this thoroughly removed all the remaining salts and made for the most permanent prints and negatives. The prints normally acquired a deep brown color.

Talbot did not adopt his friend's process for some time. Part of the reason for this might have been a preference for the print colors obtained with his halide fixers. More had to do with the nature of hypo itself. It was tricky to prepare and consequently was a very expensive compound. The quality of that supplied by chemists varied enormously, with unpredictable results. Used too strong, it would destroy the more delicate tones of the print. Used contaminated or not fresh, hypo planted destructive chemical "seeds" in the photographs that damaged them, sometimes after only a few months had passed.

A second etymological diversion is necessary here. The two colleagues both maintained a careful distinction between Talbot's term of *fixing* and Herschel's of *washing out.* To "fix" something is to place it in a less vulnerable state; artists use a fixative, for example, to provide a protective coating over a delicate chalk drawing. Talbot's use of halides such as common salt and potassium iodide as fixers did, in fact, convert the remaining light-sensitive silver salts into relatively insensitive states. Herschel's washing out involved the ability of hypo to convert the silver salts into a form that could literally be washed out in water. At an early stage, both men considered Talbot's process to be more simple and desirable. This etymological distinction is all the more ironic when we consider that Herschel's hypo became commonly known as fixer, even though his original label of it as a washing-out agent more accurately describes its true function.

THE CALOTYPE

This process is one that Talbot *discovered* rather than one that he set out to *invent.* Comparing it to *photogenic drawing,* Talbot claimed that with his new process "certainly a much better pic-

ture can now be obtained in a *minute* than by the former process in an *hour*."[50] It is not clear when he first devised this term; the first time it appears in his research notebooks is on 30 January 1840, but this entry appears to be merely the recording of a name, not associated with any process.[51] When he first revealed the discovery of the process—not the working details—to the public in February 1841, Talbot gave this process the extended name of *Calotype (Photogenic) Drawing*. This cumbersome title was thankfully immediately abandoned in favor of the simple and more elegant *calotype* (from the Greek word for beautiful, *kalos*).[52] Indeed, it was not long before his loyal friends encouraged the use of the term *Talbotype*. One of the most vocal, if not the earliest, was Sir David Brewster, who wrote on 14 October 1841: "I was yesterday favoured with your most agreeable packet of *Talbo-types*, which my friends insist upon calling them, not only from a desire of doing honour to the Inventor, but from a like of symmetry, and also to avoid the trouble of explaining the meaning of καλος which some of them cannot do. It must be *Talbo-type* and Daguerreo-type whether you will or no; and you must put up with the affront the best way you can."[53] Talbot obtained a patent on this process[54] and first revealed the working details of it in June 1841.[55]

It was later in the month of September 1840, during the course of a series of experiments of uncertain direction, that Talbot observed some anomalous behavior in his prepared papers. At first he noticed that coating his photogenic drawing paper with a mixture of silver nitrate and gallic acid made it very sensitive, if rather unstable and unpredictable. It registered a distinct image during a five-minute camera exposure on a cloudy day. On 23 September, Talbot's observations led him to the great breakthrough. Up until this point, in all his sensitive papers, the solar energy made the image immediately visible. With his new approach, however, Talbot discovered that half a minute of exposure in the camera was sufficient to register an invisible image—a *latent image*—that established the groundwork for the photograph.[56] At first he found that simply leaving the paper to sit for several minutes in a darkened room after removing it from the camera allowed the invisible image to come out spontaneously. He also found that photographs that had faded months before could be revived by applying a wash of this same gallic acid solution. They had miraculously retained the image in their structure and it had simply become too faint to see; the gallic acid brought the image back to its original strength.

Some days passed before Talbot figured out what was really going on. Some of his results were confused by the practice of working under dim room light, no problem for his photogenic drawing paper, but too active for his newly discovered experimental paper.[57] Within that first week—before the end of September 1840—Talbot finally comprehended the essentials of what he had unearthed. The gallic acid solution was acting as a *developer*. The initial brief exposure to light in the camera created an invisible change in the structure of the coating. Essentially, a small amount of solar energy "tagged" the areas where light struck, marking them for future development but not reducing these areas to metallic silver. The developer then acted on these tags chemically, greatly amplifying the original effect and reducing the silver that would make a visible image. This is very similar to the way that modern photographic films and papers work.[58] Nothing is visible after the brief exposure and the image becomes apparent only after development. In contrast to photogenic drawing, which used a print-out paper, the calotype is a developed-out paper. In his first negatives done this way, the ones that darkened spontaneously after being removed from the camera, there was sufficient gallic acid solution left on the paper to effect the development. When he turned to using a wash of gallic acid solution, the effect was much more dramatic.

Although others were later to modify the process, the basic formula that Talbot published for the calotype was the core of them all.[59] After selecting a good and uniform sheet of paper, he brushed one side with a solution of silver nitrate and then dried the sheet. When damp or dry, it was placed in a solution of potassium iodide for two or three minutes, dipped in clean water, and again dried. Talbot called this *iodized paper*, and a stock of it could be kept in the dark for some months before final preparation. When a photograph was about to be made, two solutions were freshly mixed together: one was a silver nitrate solution (*solution A*) and one was a gallic acid solution (*solution B*). The combined solution of *A* and *B* spoiled quickly—Talbot called it the *gallo-nitrate of silver*. In candlelight, one side of a sheet of iodized paper was brushed over with this solution, allowed to sit for half a minute, and then dipped in water. The calotype paper just formed was pressed between blotting paper and could then be used in that state or fully dried. Sometimes it could be kept in this condition for some weeks, but this was never predictable, and ideally it would be exposed straight away. After the exposure, which had created little or no visible effect on the paper, a developer was used to bring out the latent image by depositing the metallic silver; conveniently, this developer was identical to the gallo-nitrate of silver solution used in the coating. Under candlelight, the pho-

tographer would brush this onto the exposed paper and observe the progress; development might take anywhere from a few seconds to a minute or two and was carried on to the point the photographer found satisfactory by inspection. Talbot presaged the feelings of subsequent generations of photographers working in a darkroom: "It is a highly curious and beautiful phenomenon to see the spontaneous commencement of the picture, first tracing out the stronger outlines, and then gradually filling up all the numerous and complicated details."[60] All that remained to be done was to rinse off the excess developer, fix the paper (usually with potassium bromide, later with hypo), and rinse and dry it.

Talbot immediately began taking camera photographs with his new paper (see pl. 29). Calotype paper was generally used to make negatives in the camera. It was at its most sensitive when freshly made and exposed while the paper was still moist, although it could be prepared some weeks in advance and used dry. Once developed, the calotype negative could be printed, but this was almost always done on a sheet of paper prepared according to the original photogenic drawing process. The calotype paper could be used to make prints (much like modern photographic developing papers are), but the process was complex and the image tone was considered unsatisfactory. Many of Talbot's contemporaries called the prints from these negatives "calotypes"; strictly speaking, only the developed negative is the calotype, and the print is a photogenic drawing. Again, Talbot really did not have a term for this application of his photogenic drawing paper, calling it merely his *ordinary* paper. The modern practice generally adopted for convenience is to call these *salt prints* or *salted paper prints*.

SOME THOUGHTS ON TALBOT'S NEGATIVES

In making negatives or prints, Talbot's usual paper of choice was Whatman's Turkey Mill. More reliable than many papers of the period, it still suffered from occasional irregularities and contaminants. For contact negatives that he did not plan to use in making prints, the uniformity of the paper was less important and the presence of a watermark was not a problem. If he was anticipating using a negative to make prints, Talbot took special care to select a piece of paper without a watermark and uniform in texture when held up to the light. An interesting variation on this potential problem is plate 23, a negative made directly by contact from one of Lord Byron's manuscripts. In this particular case, the "1811" is the watermark contained in

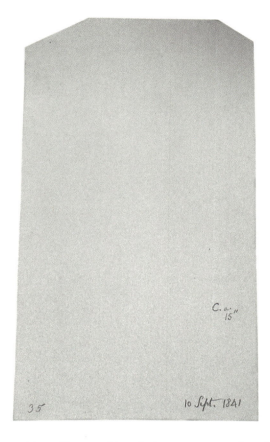

The photographic artifact as a historical map, 10 September 1841. Verso of a calotype negative of an oriel window over a doorway on the south front of Lacock Abbey, 17.3 x 10.3 cm (9.7 cm wide at top). Photographic History Collection, National Museum of American History, Smithsonian Institution, Washington, D.C. (1995.0206.068), *Schaaf 2621*. There were no standardized cameras when Talbot started his photography, and he trimmed his negative paper with a pair of shears to suit the particular image. This sometimes led to subtle but distinctive geometric shapes of the negative paper; the angle and size of the corner trimming add further clues. The coordinates of this distinctive "map" in a computer database promote the matching of scattered prints and negatives. So far, only one print from this negative has been located, in the Fox Talbot Museum, Lacock (LA937). The pencil annotations on the verso of this negative reveal what camera Talbot used and the 15-inch focal length of the lens. The number "35" probably refers to the exposure time in seconds. The precise date makes it possible to cross-reference the photograph with other manuscript material. Lady Elisabeth Feilding recorded in her diary (in the Wiltshire Record Office, Trowbridge) that this was a "very fine day." She had noted that Talbot's licensee Henry Collen had visited the previous day, but it is not yet known if he stayed to assist in the taking of this photograph.

the original manuscript, and it could be argued that this increases the verisimilitude of the resulting photographic copy. However, in general, it was a problem to be avoided.

When Talbot started, there were of course no standardized print frames or negative carriers. He cut his paper to a roughly convenient size for the particular camera. At first, he simply pasted the sensitized sheet by its corners inside the plain wooden back of the camera. After exposure, the paper would be

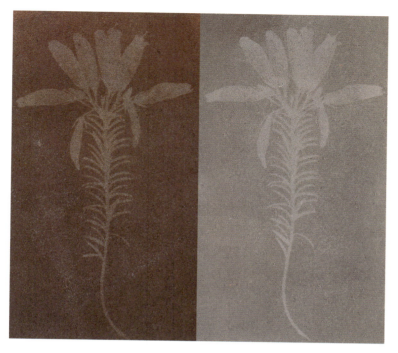

Two negatives of the same plant. *Left:* 12.3 x 11.3 cm, Museum of the History of Science, Oxford, *Schaaf 2291* (plate 8). *Right:* 14.0 x 6.9 cm, J. Paul Getty Museum, Los Angeles (85.XM.150.13), *Schaaf 2290.* Nature duplicates herself so consistently that very similar looking negatives of a plant usually turn out to have been made from different specimens. In this case, precisely the same specimen was used to make two negatives. The one on the right was not dated and was previously assumed to have been made around 1835; it is inscribed in ink on verso "fx" (indicating fixing) and in pencil on verso "7." However, when matched with the one on the left, its dating became clear. The left-hand specimen was given by Talbot to Sir John Herschel and is inscribed in ink on verso "H.F.T. March 1839 Erica Mutabilis." Being a fresh specimen of a flower, it must have served as the original for the one on the right just minutes later. The sequence is established by the fact that a small leaf has broken off the bottom between the making of the two negatives. The original plant was about 9 cm tall.

simply torn out or, in preference, its corners would be cut with a knife to release it—this is why most of Talbot's earlier negatives have irregular and missing corners. After exposure and processing, Talbot would typically trim the paper further (as will be seen, this has proven to be an essential tool in identifying his work). Later, Talbot devised several types of negative paper holders for the camera, including ones that used glass pressure plates. The corners of these later negatives were often neatly trimmed in order to forestall accidental damage in printing.

The "mapping" of Talbot's photographs in a computer database has also made it possible to retrieve some types of information that were previously thought to have been lost. Many of Talbot's earlier negatives that were fixed with potassium iodide (ones where the paper was stained a lemon yellow) lightened under the influence of ambient light, and today many of them

are blank sheets of yellow paper. Fortunately, they have been preserved, largely because they contain Talbot's handwriting, and their distinctive color and small size has led to them being christened Talbot's *Post-it*™ *Notes*![61] They survive by the hundreds and they have a particular value not immediately apparent. Because Talbot trimmed each of his negatives by hand, no matter how regularly this was accomplished there are distinctive physical characteristics to the edges of each negative. Sometimes it is the waver of the shears along one edge, sometimes it is a trapezoidal shape, sometimes it is the way the corners were trimmed. Each presents a unique outline. Unlike other photographers, Talbot was reluctant to trim the edges off his prints, and in many of them the outline of the negative is clearly shown.[62] The database can make sense of this jigsaw puzzle of thousands of forms. The distinctive outlines of both strong and faded negatives can be matched up with prints once made from them. The blank negative can provide a date (usually unknown from the print) and that date can then be used to derive information from manuscript sources. The print, in turn, usually retains the image now lost in the negative and permits its identification. The result is a more positive identification of Talbot's work than has ever been possible.

Prior to the public announcement of photography in 1839, there was no real reason for Talbot to inscribe his negatives with a date. In fact, there are only a few such examples (see pl. 6). In the very few instances where Talbot used the same specimen of a plant or a starched piece of lace to make more than one negative, it is sometimes possible to sequence the negatives by physical changes in the original object. In a few other cases, negatives taken in the same session can be sequenced by the evidence of the moving shadows of the sunlight. In the majority of cases, however, unless Talbot actually marked the date on a negative or a corresponding print, we are left in the world of speculation.

During 1839, it was not uncommon for Talbot to inscribe a dedication on negatives and prints that he distributed. These inscriptions were nearly always in ink, sometimes including a title, sometimes a date, and usually his initials or signature. This practice was clearly meant to permanently label presentation items. Since the negative was on plain writing paper, it was a simple matter to add notes to it, and there are numerous examples where Talbot recorded a date on the negative for his own purposes, probably to match up with records of his experiments. It appears that 12 November 1839 was the turning point in his thinking, for that is when he started writing dates on his negatives in a manner clearly meant to show through on the

prints.[63] Since the negatives would be turned face down to print, the date was written in pencil on the back of the negative (the plain paper side), usually in a corner. Fortunately, for nearly a year after this, Talbot kept a log of many of his negatives; an astonishing proportion of these have survived and more than two hundred fifty of them have been located thus far. After this, and particularly after the introduction of the calotype negative at the end of 1840, he dated his negatives only sporadically, in no discernable pattern.

Unlike Hill and Adamson, Henry Collen, and others of his contemporaries, Talbot rarely retouched his negatives. He was not above the practice, but for him the hand of nature was supreme. In his announcement for the forthcoming *Pencil of Nature* in 1844, Talbot commented on the figures frequently introduced into French engravings, claiming that "the plates of the present work will be executed with the greatest care, entirely by optical and chemical processes. It is not intended to have them altered in any way, and the scenes represented will contain nothing but the genuine touches of Nature's pencil."[64] Some pencil and occasional ink retouching can be found in his negatives, but there is every reason to assume that this was a practice generally done a few years later by those who printed from them.

Finally, after they were processed, the paper negatives could be waxed (or, less commonly, oiled) in order to increase their transparency in printing. This *post-waxing* was quite different in practice and effect from Gustave LeGray's 1848 *waxed-paper negatives*, a process with which it is often confused.[65] Waxing the paper to make it transparent was such an obvious approach that it must have occurred to Talbot (and others) almost immediately. The earliest known firmly dated negative that he waxed was on 16 August 1839.[66] About fourteen hundred of Talbot's negatives have been waxed, although it is likely that some of these were treated after they left his hands. The fact that the negatives printed more quickly was not necessarily a virtue, for this could alter the color of the prints. Waxing had the effect of increasing the contrast of the prints as well. The darkest areas of the negatives would block most of the light whether they were waxed or not, leaving a bright white highlight. However, the areas of the negative that received very little exposure— those that remained essentially white paper—would pass much more light when the sheet was waxed, converting the white paper to a semitransparent one. This increase of light caused the print paper to darken more than usual in these areas, leading to deeper shadow areas in the print. This could be a real disadvantage, particularly in subjects such as architecture

where fine details might be lost. Talbot's friend the Reverend Calvert R. Jones was particularly careful in noting which negatives he wanted waxed and which ones he wanted left plain after processing; it was a technical and aesthetic decision. Waxing posed one other problem in that it made the negative paper more fragile in handling. This can easily be demonstrated by taking a modern sheet of culinary waxed paper. Only a couple of flexes are necessary to put permanent creases into the waxed paper. The wax stiffens the fibers of the paper so much that they become more brittle.[67] Waxing was a useful tool for some circumstances, but a tool of particular utility, and one whose employment came at a price.

In spite of the fact that they were printed in sunlight, Talbot's negatives are often more stable than his prints, and many of them would yield perfect prints to this day (a fine example is plate 100). Sadly, many of his earlier negatives were fixed with potassium iodide. This simple process stained the paper a lemon yellow. Unfortunately, it left photochemically active silver iodide distributed through the negative; further exposure to light over time would fade this. Those of his early negatives fixed with common salt possessed a lavender color image. The silver chloride left in these also remained active, but usually these negatives darkened slightly to a pleasant lavender tone (where many of them remain today). That many of his photogenic drawing negatives from 1840 and particularly his calotype negatives from 1841 onward survive in fine shape is due to his practice of fixing them with potassium bromide. This yielded a cold gray image tone, not favored by Talbot for his prints, but relatively permanent in its action. Some of Talbot's negatives were fixed in hypo, and those that were adequately washed to begin with have proven to be fairly permanent as well.[68]

ON THE MAKING OF TALBOT'S PRINTS

Perhaps one of the most striking impressions that one receives when first seeing a selection of Talbot's prints is the enormous range of colors that they possess. Although they are generally monochromatic, their hues cover the gamut from reds to yellows to purples to various shades of brown to near black. Some of this is explainable and some of it is not. And not all of it was controllable. Talbot himself recognized this. In his introduction to *The Pencil of Nature*, he noted that in his prints "there is some variety in the tint which they present." After briefly explaining why, he made the important point that "these tints . . . might undoubtedly be brought nearer to uniformity, if any

great advantage appeared likely to result: but, several persons of taste having been consulted on the point, viz. which tint on the whole deserved a preference, it was found that their opinions offered nothing approaching to unanimity, and therefore, as the process presents us spontaneously with a variety of shades of colour, it was thought best to admit whichever appeared pleasing to the eye, without aiming at an uniformity which is hardly obtainable."

Modern photographic prints are almost always made on a developed-out paper, not unlike Talbot's calotype paper.[69] Talbot could use his calotype paper to make prints, but examples are extremely rare.[70] The paper was much more complex to prepare than his original photogenic drawing paper, it required more careful handling in respect to light, and in the end, the developed image tone would be gray or black. Talbot found this not to his taste.

Talbot made virtually all of his prints on his "ordinary" paper, virtually the same as the photogenic drawing paper he first invented. Many of his colors were rooted in the nature of this paper. It is important to remember that this was all accomplished before the uniformity of factory-made products. Each sheet of Talbot's negative paper and printing paper was sensitized by hand. There were enormous differences in various batches of paper to begin with (the rag trade did not supply a uniform raw material!). The chemicals Talbot had available were either homemade or purchased from various chemists who had no standardized practices. Even factors such as the humidity could make a difference. There was no emulsion to keep the light-sensitive compounds above the surface of the paper. They were actually created within the fibers of the paper, mostly near the surface of one side but extending below that surface. Not all of Talbot's papers were prepared by him personally. His main servant, Nicolaas Henneman, made many of them, and others in the household such as Charles Porter would be pressed into service. Infrequently, Constance Talbot tried her hand as well. In spite of who made it, if the paper were to be kept for a while before it was used, gradual changes could occur.

Once coated, however, the biggest variable facing the paper was the sun. The prints were all made by direct contact with the negative, pressed together in a frame and placed in the sunlight. Depending on the density of the particular negative, and even more on the fickle nature of the English sun, the exposure time for the print might vary from a few minutes up to many tens of minutes. This had profound effects, not only on productivity, but more importantly on the tonal range and color of the final print. In a print-out paper, such as Talbot's photogenic

A history of printing. Each image 19.6 x 16.7 cm. *Schaaf 1981. Left:* Private collection (plate 59). *Right:* Patrons' Permanent Fund, © 2000 Board of Trustees, National Gallery of Art, Washington, D.C. (1995.36.117). Rarely is it possible to establish precisely when a particular print was made. In this case, even the dating of this calotype negative of an *Oak Tree in Winter* is elusive; it is thought to date from 1842/43. In these greatly magnified details, the print on the left reveals that it was taken from the negative while it still retained a slight paper snag on the right side. The print on the right was made later, after this protuberance of paper had broken off.

drawing paper, the visible image started forming and darkening on the surface as soon as light began its action. That visible image was composed of minute clumps of particles of metallic silver. If the sunlight was weak (because of the season, or cloud cover, or the dense yellow coal smoke that plagued the cities), the exposure took a correspondingly longer time. Even with more exposure, this could lead to feeble prints, and it affected the final color they attained. The metallic silver image appears to be colored because of the way that the minute clumps reflect and refract the light. A longer exposure led to smaller clumps of metallic silver and these tended to appear to be much warmer in tone. All other factors being equal, strong daylight would produce a print with colder tones, toward deep purplish browns. Weak light and prolonged exposure would tend to make prints more approaching a tan color.

The intensity of exposure had implications for the longevity of the print as well. If a prolonged exposure under weaker light produced smaller clumps of silver, leading to a warmer image tone, these clumps were more vulnerable to contamination, particularly from airborne pollutants. Imagine a solid silver knife that acquires a layer of tarnish from sulphur in the air. This thin tarnish (a compound of silver sulphide) can be polished off with no detectable effect on the knife. But now imag-

ine a solid silver knife made for a dollhouse. It will acquire the same layer of tarnish, but there will be relatively much less solid silver left underneath if this is removed. The smaller the core of solid silver, the more surface area it presents to be damaged. In Talbot's prints, if prolonged exposure led to finely divided silver particles, these proved to be more easily damaged over time by pollutants. All other factors being equal (and they are numerous!), a print reddish or orange in tone as a result of feeble exposure in printing will suffer more visible fading over time than will a print deep purple brown in tone that was printed in more vigorous light.

Happily, there is a harmonizing effect of print-out papers that is most beneficial in making prints. As an area begins to darken, that very darkening begins to control the amount of light that can penetrate deeper into the paper. Thus, a deep shadow that might be in danger of darkening into obscurity becomes self-limiting, creating its own mask during the exposure. As the surface of the paper begins to darken in this area, that effect starts to block the area from further exposure to light. Highlight areas can then continue to receive more sunlight until they acquire detail.[71] However, the speed of the exposure can also have an effect here. A prolonged exposure in weak light would overemphasize this self-masking effect, and the range of tones finally produced would be very limited. On the other hand, too rapid an exposure would not give the mask time to form properly, and a print with too much contrast could result.

This world is all a fleeting show,
For man's illusion given

THOMAS MOORE[72]

The fixing process is the other major variable in print color. Talbot's procedures were complex, not always possible to identify, and many variables could enter in. With all those caveats, as a generalization, prints (and negatives) fixed in common salt tend toward lavender tones, those fixed in iodide have a characteristic yellow color, and those fixed with Herschel's hypo generally assumed a range of reddish to purplish browns. There were also occasional practices, tied to fixing, that could affect the tones. For certain images, Talbot found that if he overexposed the print, and then bleached it back, the contrast could be raised. This was sometimes done by "sunning" the prints—leaving them out in bright light—and sometimes by leaving them too long in a concentrated hypo fixer. A related

practice was the later discovery that the color of hypo-fixed prints could be improved by ironing them with a hot iron while they still contained a bit of hypo.[73] This produced a sulphur compound, pretty at the time, but which would prove disastrous to the longevity of the print. Not all long-term effects of variations in fixing are necessarily bad. The materials on which a print was mounted, as well as how it was stored and handled during its lifetime, can cause colors and tones to evolve in several directions.

Another major factor to consider in Talbot's prints is where they were made and by whom. In the prints that were made at Lacock Abbey, Talbot could exercise more control. Ample water was available for washing, and the cost of fuel for heating this water was not a difficulty. Who prepared the paper had an effect, for some servants were more diligent than others. In prints that still retain their original borders, the brushmarks can clearly betray the practice of coating by brush or cotton wool (plate 58 is a particularly fine example). Such coating is less common after about 1844 but was still employed when a single print was to be made.

It was near the end of 1843 that the largest change affecting the prints was put into place. Certainly from the start of 1839, if not earlier, Nicolaas Henneman (pl. 40), had served as Talbot's closest collaborator. He so believed in the future of photography that he made the highly unusual move of separating from Talbot's service in order to set up a business on his own. With financial backing from Talbot, Henneman moved to the bustling railway town of Reading (about halfway between Lacock and London) and set up the first photographic establishment devoted to the mass production of prints.[74] It was from here that most of the prints used in *The Pencil of Nature* were produced, and indeed, the majority of the "Talbot" prints that survive today emanated from Henneman's establishment. This change from prints made in limited quantities at a country house to large-scale production by a semi-industrial operation had many effects on the qualities of the prints from Talbot's negatives.[75] Henneman's business was not a financial success, and by late 1846 he effectively became an employee (not a servant) of Talbot's, managing the business under a contract. By the end of that year, Henneman relocated to London and Talbot loaned him many negatives from which to make prints for his stock.[76] Mounted and priced prints, particularly those with a "Patent Talbotype" stamp or label, would have at one time been in Henneman's or a printseller's stock.[77] While most of these prints may be assumed to have been made by Henneman and his assistants, either at Reading or London,

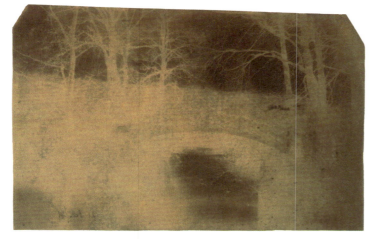

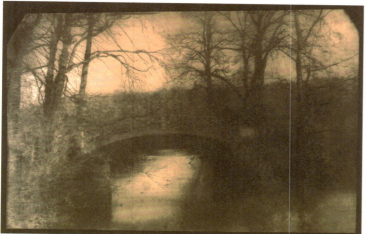

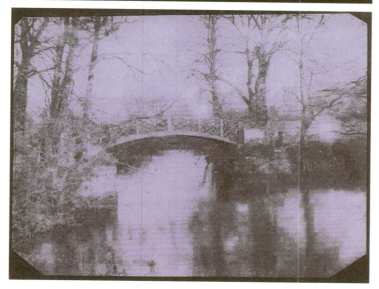

China Bridge at Lacock Abbey. National Museum of Photography, Film & Television, Bradford, *Schaaf 2553.* Because Talbot's negatives were on paper and were not standardized in size, they could be and frequently were trimmed to custom sizes. Sometimes this was done immediately for purposes of cropping, either for aesthetic considerations or because of defects in the coating of the negative material. In other cases, it was done at a later date, after some prints had been made, usually in response to damage the negative suffered in handling. Prints exist from this negative made at several progressive stages of trimming. *Top:* waxed calotype negative, 13.6 x 21.0 cm, 21 February 1841 (1937-1449). *Middle:* salt print from an intermediate state of this negative, 14.1 x 21.0 cm (1937-1549/2). *Bottom:* salt print from an earlier state of the negative, 16.1 x 21.6 cm image (1937-366/120 [plate 39]).

Applying this same interest to Talbot's prints, however, has little hope of gratification. Sometimes the relative sequence of production of certain prints can be established by physical changes in the negative, either through evidence of damage (fig. 8) or when Talbot chose to trim a negative further before making additional prints (fig. 9). Sometimes a print can be tied to a definite recipient and correspondence or another manuscript source will establish that the particular print was made before a certain date (plate 21 is an example); these are the exceptions. Avoiding their use for negatives, Talbot reserved the watermarked sections of paper for making prints, and these can provide an indication of how early a print might have been made. However, since Talbot scoured London for batches of older Whatman's paper—certain vintages were favored—an early watermark is no guarantee of an early print. Also, the odd sheet of an earlier lot of paper could lie in a drawer at Lacock Abbey for some time, only to be mixed into a later batch of paper and printed at a later date. Only rarely can a particular watermark even be loosely associated with a time period (see plate 70 for an unusual example). Talbot's prints were made within a relatively short span of time, the bulk of them within the 1840s, and there are presently no forensic tests that can meaningfully discriminate on such a fine scale. Nor is the present quality of a print of much value in dating it, for past exhibitions (formal or informal) and conditions of storage and handling can have had a great effect on what has survived to our day.

some of them might have been made at Lacock Abbey. Small-scale printing continued at Lacock throughout this period; a print that came from the abbey may, but does not necessarily, predate Henneman's commercial work.[78]

Establishing a precise date for when a particular print was made is a topic of some interest in the works of later photographers, especially as a guarantee against fraudulent practices.[79]

Epilogue

The future is composed merely of images of the past . . .
HUMPHRY DAVY, 1802[80]

The plates in this book represent the whole period of Talbot's activity as a photographer. That was little more than a decade, spanning the relatively short era from 1835 to early 1846. As a photographer, Talbot had several defined periods of real strength and growth. In the spring and summer of 1840, still working with his initial photogenic drawing process, he grew the most in his personal vision—the testimony of this is in plates 18 to 28. Talbot's discovery of the calotype process immediately expanded his range of subject matter, especially in relation to matters of time, and this early excitement is witnessed in plates 29 onward. By 1843 (plate 61 and passim) Henry Talbot had clearly demonstrated his mastery of his art, to others to be sure, but more importantly to himself. In preparation for his grand work, *The Pencil of Nature*, he began amassing more and more accomplished images. The first part of this book was issued in June 1844 and Talbot's plans were to include a wide range of photographic subjects. An indifferent public, combined with real production problems, began to hobble *The Pencil of Nature*, and its sixth and last published fascicle was issued in April 1846.[81]

On 12 March 1846, Talbot's mother, the Lady Elisabeth Feilding, died after a short illness. Her influences on her son had been numerous, but nowhere more evident than in encouraging him to place his work before the public. Devastated by the loss of this intellectual partner, Henry Talbot was already suffering from an extended period of ill health. Combined with the collapse of *The Pencil of Nature*, he slowly ceased to take photographs himself. As his health began to recover near the end of the 1840s, Talbot renewed his interest in photography and took on a research partner in the form of Thomas Malone, a young chemist who had worked with Nicolaas Henneman. It seemed for a while that they might make progress in overcoming the fading problems of photographic prints, but by the early 1850s Talbot came to accept that this was a hopeless quest.

Starting in the 1850s, Talbot concentrated his intellectual efforts on studies in Assyriology and other remote languages, publishing a number of important translations of cuneiform texts. In his lifetime, Talbot published seven books and nearly sixty scientific and mathematical articles. In a handwritten reminiscence of his father, Charles Henry Talbot concluded that his "mind was essentially original . . . he disliked laborious application in beaten paths." In 1863, Edinburgh University celebrated this intellectual diversity by awarding Talbot an honorary Doctor of Laws degree. In conferring the degree (in the same ceremony that honored Lord Palmerston, in whose Reform Parliament Talbot had served), Professor Muirhead said that it was in recognition not so much of Talbot's political contributions, but rather "his pre-eminence in literature and science, and the benefits his discoveries have conferred upon society."[82]

The photographic side of Talbot's story does not end when he ceased to be a photographer. From his earliest days in photography, Talbot had demonstrated a complete faith that the future of photography was inextricably linked to the printing press. Building on earlier experiments, by 1852 he patented the first of his photogravure processes, called *photographic engraving*. Although nature still drew her image on his plate, the final rendition of the photograph was done in stable printer's ink, rather than in silver. In this, Talbot was on absolutely the right track, for more photographs have been seen and preserved in printer's ink than were ever done in silver. In our modern society, the art that Talbot invented—the one that contributed so much to the growth of his own vision—has become so pervasive that its products are sometimes as invisible to us as were his original latent images. By 1858, he had made so many fundamental advances in photogravure that he took out a second patent, under the name of *photoglyphic engraving*. Many of the practices of modern photogravure are based directly on his work. He pursued this until the end of his life; when he died on 17 September 1877, Henry Talbot was in the process of completing a chapter on photogravure for Tissandier's *History of Photography*.[83]

We are particularly fortunate that both Henry Talbot's invention and his practice of the art of photography are so very rich in resources. It is unusual enough to have detailed records of a nineteenth-century scientist's working practices. It is even less common to have extensive amounts of correspondence preserved. And it is unprecedented to have both of these alongside the visual testimony of thousands of photographs, experimental as well as artistic. Those seeking to understand the roots of the parallel invention by Louis Jacques Mandé Daguerre, Talbot's contemporary and rival, have virtually no manuscript sources at their disposal, and precious few images taken by the inventor.[84] Talbot's case provides a very special opportunity.

One major reservoir of knowledge about Talbot's inventions and discoveries lies within the numerous notebooks and memoranda books that he kept.[85] The more formal ones cover various scientific researches, mathematics, etymology and philology, and other topics, sometimes intermixed on the same pages in a stimulating if frustrating display of the range of Talbot's creative thinking. Other Talbot memoranda and travel diaries contain exciting hints of ideas, working practices, and where and to whom Talbot distributed his photographs.[86] Two of his major research notebooks relative to photography have been published in facsimile and it is hoped others will follow.[87] In addition to these bound volumes, Talbot kept thousands of sheets of manuscript notes—the bulk of these deal with his later work on photogravure, but there are important earlier records contained in them as well.[88]

A vital resource of information about Talbot and his whole range of activities and contacts is contained within the voluminous correspondence that has been preserved. When he was just eight years old, a very precocious Henry Talbot commanded his stepfather to "keep my letters and not burn them."[89] By and large, this decree seems to have been adhered to, and nearly ten thousand letters to and from Talbot have been located worldwide thus far.[90]

Talbot's photographs—both his negatives and prints from them—survive in pleasingly large numbers. Some are testimony to his progress as a "little artist." Others are valued by us today more for their documentary value of the world around Talbot. Many betray the various technical hurdles that Talbot approached, and some of these testify to the intellectual breakthroughs that he achieved so often in developing his art. Talbot's visual legacy includes a considerable body of photographs that he distributed personally in the 1830s and the 1840s. These items, often inscribed by him, wound up in the personal collections of other people. After taking whatever path through

"The Barberini Ivory," July 1865. Experimental photoglyphic engraving, 16.6 x 12.7 cm image on 20.0 x 15.0 cm plate, printed on 26.0 x 17.6 cm paper. From the André Jammes Collection, now in the National Gallery of Canada, Ottawa (P72:170:4). In 1852, Talbot announced and patented his process of *photographic engraving,* a pioneering form of photogravure. This was greatly improved in his 1858 *photoglyphic engraving* process. Talbot, finally accepting that silver-based prints were too vulnerable over time to be included in books and journals, instead based his new processes on the time-proven printer's ink. In the same way that his original photographic processes employed nature to draw his pictures, he turned to nature to engrave printing plates from his photographs. In this, he was ahead of his day, but his foresight proved entirely correct. Although the procedures were perfected after his lifetime, most photographs are now seen reproduced in printer's ink. This copy of the sixth-century "Barberini Ivory," a famous and unique surviving part of a diptych, is now preserved in the Louvre. Talbot made his plate from a glass positive photograph of the ivory supplied by Alexander Nesbitt, who had hoped to publish this plate in *Archaeologia.*

history they were given, these have reached us today in scattered collections. In many cases, they pose fewer problems of identification and attribution than photographs that Talbot kept, for they are often supported by specific documentary information.[91]

The larger body of surviving Talbot photographs, however, is that associated with the collections at Lacock Abbey. This is a very complex grouping. It came from many sources and major sections of it have been widely distributed in the past. Much of it represents the personal work of Talbot and his family. Some of it was comprised of examples sent by other photographers to Talbot. We know of some examples of others' work that he collected and many more examples of others' negatives that he

purchased. Over time, all of these became mixed together. But the largest part of this collection actually resulted from Nicolaas Henneman's efforts to set up a calotype establishment at Reading.[92]

When he set up late in 1843, Henneman expected Talbot to be his first and major client. Talbot was entirely happy about this; while he did not want to take an active role in commerce himself, he was anxious that his invention of photography should have a wider impact. Talbot initially sent negatives to Henneman to be printed, some intended for inclusion in publications such as *The Pencil of Nature*, and others for general distribution. Henneman began producing his own negatives at Reading as well. As the calotype establishment began to seek a wider market for its output, Henneman borrowed additional negatives from Talbot to use in making up a stock of prints for sale. When it became apparent that Henneman's establishment needed a broader economic base, Talbot began purchasing negatives from other photographers for Henneman to print. We have good records on some of these, particularly those purchased from Calvert Jones, but for others the photographer is not known.[93] Henneman relocated to London at the end of 1846, actually becoming an employee of Talbot's once again, but encouraged by circumstances to photograph more independently of the master. Henneman continued to use the same photographic materials, and his aesthetic approach was conditioned by years of working closely under Talbot. Henneman borrowed additional negatives from Talbot even while continuing to make his own negatives. Presumably, he continued the practice of purchasing negatives from others as well. During the 1850s, it became apparent that Nicolaas Henneman was unable to adjust to the rapidly changing world of photography. The exact ending date is unclear, but by late 1858 or 1859 Henneman closed down his business.

As Talbot had been his major financial backer over the years, Henneman was heavily in debt to him, and the two men agreed that the stock of negatives and prints in London should be turned over to Talbot as partial discharge of this debt.[94] And that is where the real confusion began. Dozens of parcels of unsorted negatives and prints—the former by the hundreds and the latter by the thousands—were sent to Lacock Abbey sometime during the 1850s. It is likely that Henry Talbot never even saw the contents of some of these. They became intermixed with the photographs created at the abbey, and over the years successive generations of Henry Talbot's descendants distributed them from time to time to interested parties. Sometimes this took the form of individual "souvenir" prints to

The Evolution of an Image Idea. Of all the images associated with William Henry Fox Talbot, *The Open Door* is surely the most prominent. This April 1844 composition (plate 82 and detail H) has its roots in Dutch painting, but its simple structure belies a more complex history, as is evident from an extremely close variant image (A), taken at virtually the same time as the best-known image. Only the movement of the shadow (H and I) betrays the passage of time.

The Open Door is an image idea that evolved over some years in Talbot's hands. The first known attempt (B, plate 37), which Lady Feilding titled *"The Soliloquy of the Broom,"* was made on 21 January 1841. In many ways this is very similar to the final composition Talbot eventually settled on. Additional attempts were made two years later, the more successful of which (C) shows a sharply delineated broom but a loose composition. The other negative made that day had severe coating problems (D). A final attempt in this series was made two weeks later, on 1 March 1843 (E), but the more vertically positioned broom weakens the composition. A calotype negative taken on the same day (F) reveals an interesting link with the *Open Door* images: in the greatly enlarged detail in a modern print (G), Talbot's camera is visible set up in front of the broom in the doorway, a possibly unique record of the photographic process within Talbot's archive.

(A) Late April 1844. Salt print from a now-unknown calotype negative, 14.3 x 19.4 cm. Private collection, North America, *Schaaf 2821*
(B) 21 January 1841. Salt print from a calotype negative, 15.3 x 17.3 cm image. Private collection, North America, *Schaaf 2548*
(C) 13 February 1843. Salt print from a calotype negative, 16.7 x 19.0 cm image. Private collection, North America, *Schaaf 2709*
(D) 13 February 1843. Modern print from a calotype negative, 16.2 x 20.7 cm image, made from the negative in the National Museum of Photography, Film & Television, Bradford (1937-1572), *Schaaf 2708*
(E) 1 March 1843. Modern print from a calotype negative, 16.9 x 22.6 cm image, made from the negative in the National Museum of Photography, Film & Television, Bradford (1937-1272), *Schaaf 2712*
(F) 1 March 1843. Calotype negative, 16.1 x 19.7 cm. The National Museum of Photography, Film & Television, Bradford (1937-1532), *Schaaf 2711*
(G) Enlarged detail of (F), in a modern print
(H) Late April 1844. Salt print from a calotype negative (detail of plate 82). The National Museum of Photography, Film & Television, Bradford (1937-1249/6), *Schaaf 2772*
(I) Detail of (A)

interested parties and sometimes there was a more substantial gift. The largely unrecognized role of the material returned from Henneman's studio continued to exert an influence. At least one parcel from there was opened as late as the 1960s!

The largest distributions, however, were in the 1930s, when Miss Matilda Talbot began taking an active role in promoting her grandfather's contributions to the art.[95] She sent groups of prints to diverse institutions in places as far-flung as California, Canada, and New Zealand. Her largest donation, however, was

A

B

C

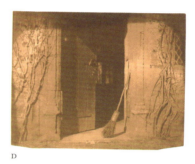

D

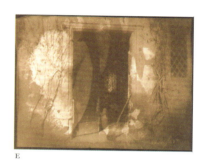

E

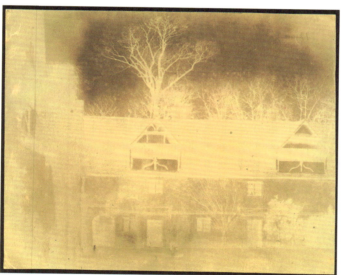

F

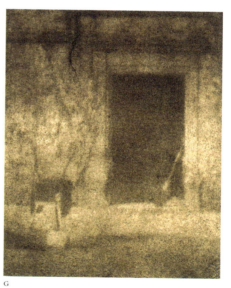

G

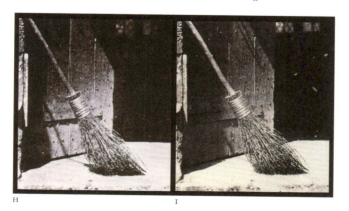

H I

in 1934, to the Science Museum in London. More than six thousand negatives and prints were removed from Lacock Abbey in a mass, and many of these items were drawn from the stocks returned from Henneman's London operation. As a consequence, this collection, the largest single Talbot collection in the world and now in the National Museum of Photography, Film & Television, is comprised of both Talbot originals and other photographers' works.[96] The greatest influence on the structure of the collections was Miss Talbot's meeting the photographer Harold White during World War II. Miss Talbot ("Maudie" to him and her other close friends) charmed him. After he evolved into a historian, White began trying to realize her dream of publishing a biography of her grandfather. In the 1940s and 1950s, he and his entire family were frequent visitors to Lacock. They and Miss Talbot put enormous energy into bringing together and sorting out the scattered groupings of material within Lacock Abbey. Sometime during the course of this, White became a collector, acquiring some examples from Miss Talbot and gathering together others from villagers in Lacock.[97] His biography was never completed, although the organizational work he achieved remained important, and his collection was eventually dispersed worldwide.

The best known of the efforts to catalogue Talbot's photographic output resulted from the 1965 and 1966 visits to Lacock Abbey by Eugene Ostroff, the curator of photography for the Smithsonian Institution. He initially traveled to England in order to better understand the Smithsonian's Talbot collection (built over a span of years by donations from Charles Henry Talbot and Miss Matilda Talbot). Seeing the potential in the massive collections still at Lacock Abbey, Ostroff recognized the need to further organize and catalogue them. At the same time, he was retained by the National Trust to help establish a museum on the grounds of Lacock Abbey (a hope realized a decade later with the start of the Fox Talbot Museum). Ostroff's wife, Caroline, worked with the family to distribute sets of what were considered to be duplicate prints from the abbey's collection to museums worldwide.[98] From April through July 1967, Eugene and Caroline Ostroff organized the remaining collections at the abbey.[99] Each print and negative was numbered in India ink—a time-honored if archaic museum practice—with "LA" numbers in preparation for photographic copying and microfilming. About half of Talbot's correspondence at the abbey was also numbered. What Ostroff did not realize at the time was that the letters he catalogued were limited to those Harold White had segregated for his own planned biography of Talbot. Ostroff never saw an equally extensive (and equally important) group of letters, those that White had considered of "doubtful use." These were finally reintegrated in the late 1970s but naturally lacked any numbering by Ostroff. The "LA" numbers on the letters and photographs are useful for internal identification, but they do not provide a basis for a universal cataloguing. They applied only to the collection then remaining at Lacock and could not be related to items in other collections. Prints from the same negative but in different parts of the Lacock collection (say, in albums) received different LA numbers. Sometimes similar prints from variant negatives were gathered together under one number.

Henry Talbot would have been fascinated with the emergence of powerful computer databases in the 1980s. These have finally made it practical to undertake the preparation of a proper *Catalogue Raisonné of the Photographs of Talbot and His Circle*. This is a work in progress, already comprising records on more than fifteen thousand negatives and prints worldwide. Important additions and refinements still need to be made, and some lacunae are inevitable, but the story of Talbot's visual productions is beginning to emerge with a degree of clarity and a level of detail unavailable for most photographers. Bearing as it does on the productions of the inventor and first practitioner of the art, it is especially important.

The Plates

It is the curator's dilemma that the process of making any selective choice of an artist's work is bound to be as much autobiographical as it is impartial to the originals. I hope that Henry Talbot would have approved of these choices. In selecting the one hundred plates that follow, both the full span of time and the full range of Talbot's subjects have been respected. Some of these images are very well known and some of them will be new to most readers. Many are reproduced here for the first time. Every photograph in this group is believed to have been taken by Talbot himself.

Each of the prints and negatives that follow represents a real and unique object, fairly reproduced in its present state. Negatives dominate the earlier section because that is what Talbot most commonly produced at first. They are included at intervals throughout the selection, partly as a reminder of the negative/positive nature of his invention, but more importantly because they are beautiful and significant objects in and of themselves. Several of the most widely admired images by Talbot were reluctantly left out because no adequate prints of them are known to have survived; they are known today through older or highly enhanced reproductions. I hope these lacunae will be partially filled by the inclusion of some lesser-known photographs that deserve at least equal attention. In trying to fairly represent Talbot's work, the critical months of the first half of 1840 presented the most painful difficulties.

This was the period of Talbot's greatest personal growth, but on the whole his techniques for fixing his prints were not yet fully refined. His image ideas during this time were so exciting that the few prints he made then were undoubtedly shown to many people. Many of them deservedly continued to be favorites down through the generations, and frequent handling and exhibition have taken their toll. To whatever extent they may be weakened in substance, they remain strong in spirit.

The arrangement of the plates is generally chronological, although this structure has been interpreted loosely near the beginning and end of the sequence. Those items that have defied precise dating have been placed where they seem most logically to belong.

The titles for the plates come from a mixture of sources. Those titles (or sections of titles) within quotation marks are taken from Talbot's writings or from contemporary sources and are referred to within the plate texts. Those titles (or sections) outside quotation marks have been editorially assigned.

Talbot's legacy is very rich and complex. In an effort to understand this and to promote future research, two organizational systems are reflected in the plate texts and their associated notes. Nearly fifteen thousand of the known surviving Talbot-associated prints and negatives worldwide have been recorded in the *Catalogue Raisonné of Talbot and His Circle*. Each unique image has been assigned a "Schaaf number," and this facilitates the association of negatives with their surviving prints.[2] Similarly, approximately ten thousand letters to and from Talbot have been located thus far. The entire body of this correspondence is now being edited, and each letter has been assigned a unique "Document number."[3]

PLATE 1

An Oriel Window at Lacock Abbey

Probably summer 1835. Photogenic drawing camera negative,
8.3 x 10.7 cm image on 8.3 x 11.6 cm paper
The Metropolitan Museum of Art, New York. The Rubel Collection, Purchase,
Ann Tenenbaum and Thomas H. Lee and Anonymous Gifts, 1997 (1997.382.1)
SCHAAF 1100

Just as one begins to waken, perhaps emerging from a dream, the eyes struggle to open and a tentatively defined world starts to take shape. Light separates into lines and forms even as memories start to be imposed. This moment of the genesis of sight is wonderfully represented here. An opening onto the world materializes—a window—but a fantastic window it is, inverting our experience and passing dark mystery instead of bright light. It is natural magic. Talbot presents us with a negative image of light, accumulated in a camera obscura by his original process of photogenic drawing. Nature literally drew the subject on the paper, and wherever light was present a deposit of purple-colored silver occurred. After a lengthy exposure—certainly many minutes and perhaps even exceeding an hour—the sheet of paper was withdrawn from the camera, and the image of the window was as visible as it would ever be.

As a subject for Talbot's early days of experimenting, the attractiveness of the oriel window at Lacock is understandable. More than two hundred diamond-shaped panes provided fine details, easy to focus on with the makeshift camera, and eminently satisfying when their complexity was drawn by the light. Safely inside the brilliantly lit south corridor of the abbey, defended from wind and showers, the camera was free to patiently accumulate as much light as was required by a primitive process. The three oriel windows in the south gallery of Lacock Abbey, related in style but distinct in their individual character, had another significance for Henry Talbot. When he was finally able to reoccupy the family home in 1827, he undertook a number of architectural changes to make the building more suited to his lifestyle. Chief among these was the creation of the south gallery, completed in 1831, shortly before this negative was made. Talbot might have been influenced by his uncle William's hope that there would be a gallery for paintings at Lacock (an ambition never realized).

It is surprising that any of Talbot's very earliest negatives survive, and for one to have been preserved in this condition is nearly miraculous. It was once owned by the historian-collector Harold White and almost certainly came from the Lacock Abbey collection in the 1940s or 1950s.[1] Several variants of this interior view of the window exist in institutional collections. The best-preserved ones are generally quite small—perhaps less than a fourth of the area of this negative—and represent Talbot's attempts later in the summer of 1835 to shorten exposure times by employing smaller cameras. The most famous of these is the postage-stamp-size negative dated by Talbot to August 1835 (see frontispiece), although there are others quite similar in character.[2] The example closest in size and framing to the one presented here is in the Royal Photographic Society. However, it is very pale, its coating method is quite different, and an inscription seems to date it to the summer of 1839.[3]

In spite of the vividness and strength of its visual testimony, this artifact remains mysterious through a paucity of physical clues as to its origins. There are no inscriptions or markings. It appears that the sensitizing solution was flowed (rather than brushed) onto the paper. Four small glue spots might indicate that it was removed from an album mount. Equally, they could be evidence that the sensitive paper was temporarily pasted inside the wooden back of the camera for exposure. Whether from 1835 or 1839, it is the finest preserved example of this important photographic subject, and an extraordinary image in itself.

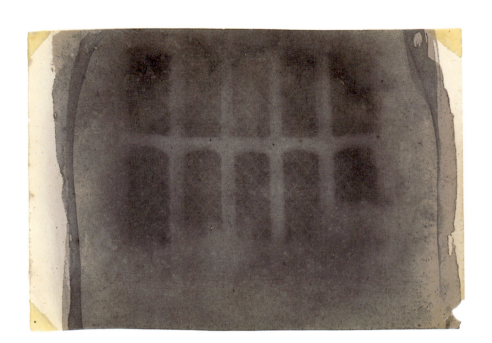

PLATE 2

"Villagio"—Print from a Cliché Verre Negative

Prior to June 1839, negative probably drawn autumn 1834.
Salt print from a glass negative, 14.0 x 10.2 cm image on 19.0 x 11.5 cm paper
Private collection, courtesy of Ezra Mack, New York
SCHAAF 1

While the *cliché verre* process is most frequently associated with the circle of the Barbizon artist Camille Corot, it was one of the first image-making approaches employed by Talbot, conceived well before the public announcement of photography. In March 1839, when he was approaching people whom he hoped might make practical use of photography, Talbot wrote to the botanist William Jackson Hooker: "Pray accept . . . the enclosed Photographic imitation of etching, an invention which I made in the autumn of 1834. The present specimen was however not made by myself, I cannot draw so well. Any body who can draw, may multiply their drawings in this manner, viz. by drawing them on varnished glass, & using photographic paper for the impressions . . . you who are a skilful draughtsman may very likely turn this branch of the art to good account."[1] This image is certainly the first intentional fusion of the traditional arts and the new medium of photography.

Just a few days before this letter, Talbot had sent the Royal Society some additional information on photography. In his haste to reply to the challenge of Daguerre, Talbot had omitted mention of the *cliché verre* process in his first paper on photography, read to the Royal Society on 31 January 1839. However, he included it as an addendum to his "Note Respecting a New Kind of Sensitive Paper." In this communication, Talbot revealed his "method of imitating *etchings on copperplate* . . . which, though not a real art of *photogenic engraving* (if I may assume such a process to exist) yet might easily be mistaken for it, if not explained. This was among the first applications which I made of my principle, nearly 5 years ago, & is performed in the following manner. Take a sheet of glass & smear it over with a solution of resin in turpentine. When half dry hold it over the smoke of a candle: the smoke will be absorbed by the resin, & altho' the glass will be darkened as usual there will be a sort of glaze over the smoke, which will prevent it from rubbing off. Of course if any opaque varnish should be at hand it will be simpler to use that. On this blackened surface, when not quite dry, let any design whatever be made with a needle's point, the lines of which will of course be transparent. When this is placed over a sheet of prepared paper, a very perfect copy is obtained every line which the needle has traced being represented by a *dark* line upon the paper. In the autumn of 1834, being then at Geneva, I tried several photogenic etchings in this way, which were executed for me by a friend, as I am not myself skilled at drawing." Recognizing that this might provide a way of producing limited editions of artists' and authors' works, Talbot pointed out that "the chief expense will be from the silver used, the quantity of which is however small: but no *press* being wanted it cannot fail to be, on the whole, a very economical process."[2]

The hand-etched glass plate has not yet been located but it may be hidden amongst the hundreds of experimental glass plates preserved from Talbot's later developmental work in photogravure. This image is the only Talbot *cliché verre* known to have survived, and there are only three other recognized copies of this print. One is in the album that once belonged to Talbot's friend, the Italian botanist Antonio Bertoloni; it is from his hand that the title "Villaggio" is taken.[3] A possibly earlier copy was extracted from an album owned by Charles Babbage, the active but controversial scientist who was a long-standing society friend of Talbot's mother.[4]

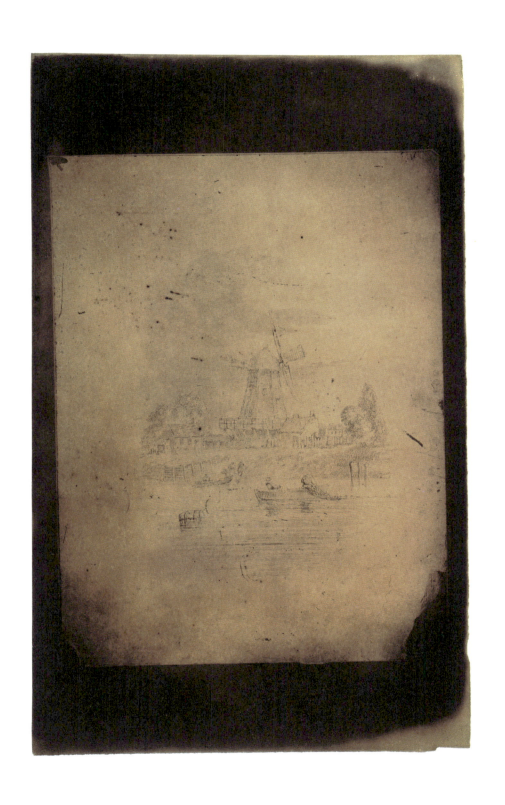

PLATE 3

A Grove of Trees at Lacock Abbey,
from the Point of View of a Mouse

Probably summer 1835. Photogenic drawing camera negative,
4.5 x 4.5 cm, bottom corners trimmed, top cut to rough arch
Collection of Dr. Walter Knysz, Jr.
SCHAAF 944

Upon seeing this extraordinary view, the feeling is created of having just poked one's head into the world. Peeping up over the grass, the trees bend in at a rakish angle, betraying a camera at ground level tilted up toward the sky. This image is one of the rare survivors to have emerged from Henry Talbot's "mouse trap" cameras.

Talbot's first efforts at photography were with homemade cameras of conventional size, devices that would hold an ordinary sheet of writing paper. Equipped with lenses designed for viewing with the eye, these proved inadequate in their light-gathering power for his early and not yet very sensitive photographic materials. Talbot later recalled that "a little experience in this branch of the art showed me that with smaller *cameræ obscuræ* the effect would be produced in a smaller time. Accordingly I had several small boxes made, in which I fixed lenses of shorter focus, and with these I obtained very perfect but extremely small pictures; such as without great stretch of the imagination might be supposed to be the work of some Lilliputian artist. They require indeed examination with a lens to discover all their minutiæ . . . the method of proceeding was this: having first adjusted the paper to the proper focus in each of these little *cameræ*, I then took a number of them with me out of doors and placed them in different situations around the building. After a lapse of half an hour I gathered them all up, and brought them within doors to open them. When opened, there was found in each a miniature picture of the objects before which it had been placed."[1] These crude wooden boxes would fit in the palm of the hand and were reportedly knocked together by the village carpenter.[2] In *The Pencil of Nature*, Talbot elaborated that "during the brilliant summer of 1835 in England I made new attempts to obtain pictures of buildings with the Camera Obscura; and having devised a process which gave additional sensibility to the paper, viz. by giving it repeated alternate washes of salt and silver, and using it in a moist state, I succeeded in reducing the time necessary for obtaining an image with the Camera Obscura on a bright day to

ten minutes. But these pictures, though very pretty, were very small, being quite miniatures."[3]

In 1835, while admiring a beautiful scene, Talbot's wife Constance asked, "Shall you take any of your mouse traps with you into Wales? It would be charming for you to bring home some views"[4] This playful description of her husband's cameras as "mouse traps" has found a permanent place within the literature of photography.[5] However, this is the only instance of the word in any of their correspondence, and Henry seems never to have employed it. One can only imagine what the villagers of Lacock thought as the master set these tiny wooden boxes about, trapping not mice but rather Lilliputian impressions of the marvels of the natural world.

The leafiness of the trees establishes this as a summer view, making it plausible that this negative was produced in the "brilliant summer" of 1835. After his initial success, Talbot mostly suspended his photographic activities until November 1838, a time when the leaves would have been less full. The summer of 1839, although a possible dating for this image, was miserably dark and largely unproductive for him. By the summer of 1840, Talbot had advanced considerably in his chemistry, and the need for such tiny cameras was lessened.

This is the first instance of a *camera vision* asserting itself in Talbot's work. Although we are quite conscious of the interpretation of nature the camera has introduced—the trees slope inward as they shoot up into the sky—it is unlikely that at this stage Talbot would have given this much advance thought. What did he think when he extracted this magic slice of nature from his mouse trap? Just why this negative was so carefully trimmed to such a strange, toothlike shape can only be the object of speculation. Were the sloping sides of the negative meant to follow the pyramidal shape of the grove of trees? Talbot did trim some of his negatives to match the shape of the object.[6] He also cut a number of his negatives to create an arched top or bottom, but this is the only one where he also trimmed the bottom corners.

PLATE 4

Looking Up to the Summit of Sharington's Tower at Lacock Abbey

Probably summer 1835, Photogenic drawing camera negative,
10.5 x 11.7 cm. Pencil "XX" on recto
The George Eastman House, Rochester, New York (74:047:32)
SCHAAF 1662

The octagonal sixteenth-century tower built by Sir William Sharington rises above the remaining medieval church of Lacock Abbey and dominates its skyline. The story is told that his niece Olive jumped from the parapet into the waiting arms of her lover, John Talbot of Worcestershire. One can almost imagine this image as being John Talbot's point of view on the day his intended came hurtling down. He was "felled to the earth by the blow, and for a time lay lifeless." It was not long after his recovery that her father relented and consented to their marriage, giving as a reason "the step which his daughter had taken."[1]

In his first paper on photography, Talbot recalled that "every one is acquainted with the beautiful effects which are produced by a camera obscura and has admired the vivid picture of external nature which it displays . . .not having with me in the country a *camera obscura* of any considerable size, I constructed one out of a large box, the image being thrown upon one end of it by a good object glass fixed in the opposite end. This apparatus being armed with a sensitive paper, was taken out in a summer afternoon and placed about one hundred yards from a building favourably illuminated by the sun. An hour or two afterwards I opened the box, and I found depicted upon the paper a very distinct representation of the building, with the exception of those parts of it which lay in the shade . . . in the summer of 1835 I made in this way a great number of representations of my house in the country, which is well suited for this purpose, from its ancient and remarkable architecture."[2]

However, in *The Pencil of Nature*, Talbot revealed that "some were obtained of a larger size, but they required much patience, nor did they seem so perfect as the smaller ones, for it was difficult to keep the instrument steady for a great length of time pointing at the same object, and the paper being used moist was often acted on irregularly."[3] The present photographic negative must have been one of those "of a larger size." It has sufficient sharpness in the center to capture Sharington's distinctive balustrade. The tower is rigidly suspended in the middle of the frame, undoubtedly the side effect of a crude camera focused directly on the center of the subject.[4]

As is typical of his early productions, there are no known prints from this negative. Talbot recognized and respected the intrinsic beauty of his primal negatives and often viewed them as final productions in their own right, a view he retained until forced by public comment into displaying more conventional positive prints. Since this negative carries no markings or inscriptions other than the "XX" (which indicated the sensitized side and probably that it was coated twice to increase its sensitivity), dating it with any precision is impossible. Talbot employed pieces of paper measuring roughly 11 x 19 cm early in his photographic work. It is likely that the present sheet was originally about the same size as that of plate 2 and plate 5. This sheet was cut off on the left side; the torn-off right corners may have resulted from the negative paper having been pasted onto the camera back for exposure. The known Talbot items using this unusual format are also thought to predate 1839.

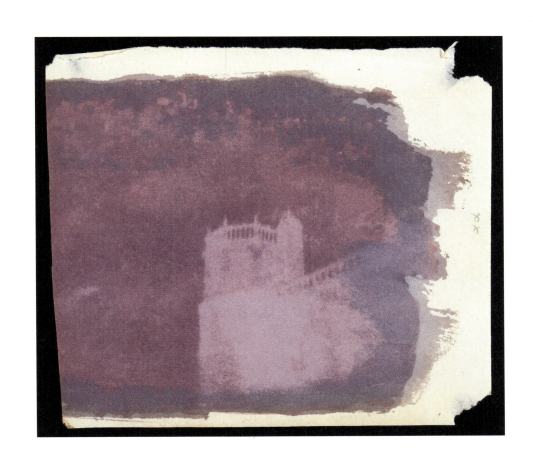

PLATE 5

The Ghost of a Plant

6 February, probably 1836. Photogenic drawing contact negative, 11.4 x 19.0 cm.
Pencil "X" on recto; inscribed in pencil on recto: "Feb. 6. not fixd."
The J. Paul Getty Museum, Los Angeles (84.XM.1002.27)
SCHAAF 112

In the silver moonlight growing
Thou wilt see a pale-eyed flower,
Shunning day, and only blowing
At the silent midnight hour.

HENRY TALBOT
The Presentiment, 1830[1]

Shadows and plants exist for the moment and here Talbot has worked his magic to preserve both of these transitory things. We are allowed to look at a specimen of *Leguminosæ papilionaceæ*, a pea bean named for its evocation of the butterfly, as it gracefully arches its leaves and flowers. Nature's composition is a moment frozen, a single frame extracted from a time-lapse recording of plant life. In normal circumstances, this particular specimen of a plant would have hardly outlived its own shadow. It must have especially delighted Henry Talbot to readily impress images of the botanical wonders he loved so dearly onto his photographic paper. "Botany is a science to which I am particularly attracted," he confessed to his friend Sir John Herschel.[2]

Indeed, like other experimenters before him, Talbot's very earliest images made by light must have been photograms of plants. The subjects, appealing and readily available, retained their form when flattened into contact with the sensitive paper. At just about the time Henry Talbot was born, Thomas Wedgwood, the complex son of the famous potter, conceived of using silver to record the shadows of plants. His images did not survive, for "nothing but a method of preventing the unshaded parts of the delineation from being coloured by exposure to the day is wanting, to render the process as useful as it is elegant."[3] There is no evidence that Talbot knew of Wedgwood's experiments when he started his own (indeed, he said he probably would have been discouraged from starting if he had), but within the year 1834 he had identified an approach that had eluded all previous researchers.[4] Talbot's first photographic materials were made by coating a sheet of writing paper with a solution of common table salt, drying this, and then coating it with a solution of silver nitrate. The light-sensitive silver chloride thus formed could then be used to make an image. In this, he had taken the same path as Wedgwood, and had advanced no further. However, with his powers of observation keenly honed by his botanical studies, Talbot soon noticed that the edges of his shadowgrams displayed varying densities after exposure, and he rapidly identified the source of this as being a different ratio of salt to silver. In coating by hand (which is so clearly evidenced in this image), the periphery of the sensitized area was uneven. Talbot determined that, contrary to reason, a lesser quantity of salt produced a more sensitive paper. From this, it was a logical step to finish the photograph afterward in a strong solution of salt, making it relatively insensitive to light—in other words, fixed![5]

In spite of the testimony of his inscription, did Talbot eventually "fix" this negative? However fragile it may be, it has resisted time so well that one thinks he must have done so eventually, perhaps well after it was made. Since common salt led to the lavender color that makes up the original image, its use as a fixer would give us no visual clue. Of the less than a handful of Talbot photographs positively dated to before 1839, one is a companion piece to this. Dated in Talbot's hand more fully than the present one, "Feb 6th 1836," it is also a negative of a botanical specimen, and it is similar in color and general feel.[6]

The present ephemeral image was formerly in the Arnold Crane Collection.

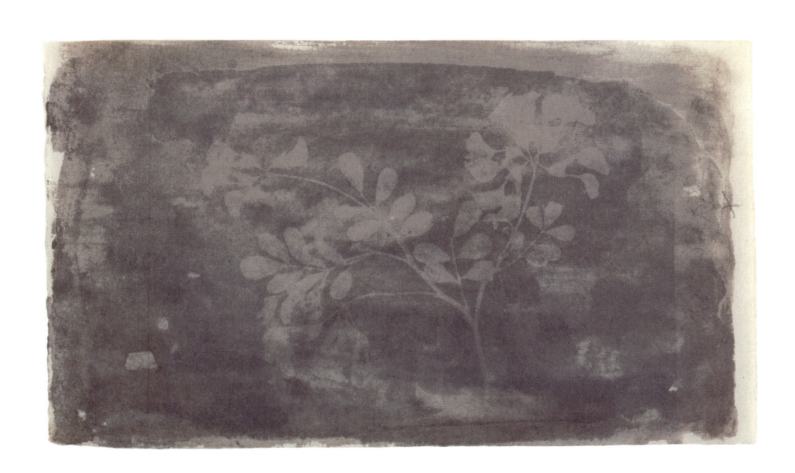

PLATE 6

Astrantia major—the "Melancholy Gentleman"

13 November 1838. Photogenic drawing contact negative,
17.3 x 9.5 cm, trimmed irregularly.
Inscribed in ink on verso: "fx" and "ab." and "Nov. 13/38"
The Royal Photographic Society, Bath (RPS025134)
SCHAAF 2244

Our imagination can readily transform this lively and striking arrangement of flowers, stems, and leaves into exuberant bursts of fireworks. With tense excitement encouraged by the asymmetrically balanced composition, the eye is drawn into tracing the arching path of the stem into the sky, branching out and bursting into flowers of light. There was good cause for fireworks. Within a fortnight of making this, Henry Talbot wrote to his wife after attending a meeting of the Royal Society in London. In a complete surprise, he was asked to sit in the front row, finding out that "the Council had awarded me the Medal for my Mathematical papers published in their Transactions . . . a medal was also awarded to Dr. Faraday for experiments on electricity."[1] The prestigious gold medal, recognizing the years of Talbot's groundbreaking work in mathematics, would easily have been cause for celebration (had the squire of Lacock been so inclined, which on the whole, he was not).

Although many others are suspected, there are only three negatives positively dated in Talbot's hand prior to 1839, and this is the strongest and easily the most beautiful of this select group. It is also one of the last photographs, if not the last, that Talbot made in the privacy of his own philosophical musings. Viewed in this light, perhaps the common name of this plant—the melancholy gentleman—was more appropriate to the situation that was just then looming. Less than two months after Talbot made this striking image, Louis Jacques Mandé Daguerre's art was forcefully brought before the public. Less than ten weeks after this image was made, Michael Faraday would present the first public exhibition of Talbot's photogenic drawings, in London (perhaps displaying this very image!).

Talbot had every reason to be a "melancholy gentleman." He publicly lamented that he could not "help thinking that a very singular chance (or mischance) has happened to myself, viz. that after having devoted much labour and attention to the perfecting of this invention, and having now brought it, as I think, to a point in which it deserves the notice of the scientific world,—that exactly at the moment when I was engaged in drawing up an account of it, to be presented to the Royal Society, the same invention should be announced in France." Had Talbot in fact been engaged in drawing up his memoir *before* Daguerre's announcement?[2] The present image is proof that he had again taken up his photographic work by the middle of November 1838. We know of at least one other image from this period. On 26 March 1839, Talbot wrote to the noted botanist William Jackson Hooker: "I beg your acceptance of the enclosed Photograph, representing Camp. hederacea from bog on the summit of a mountain, Llantrissent Glamorgan. It was done with a November Sun." That image is no longer with the letter—there is no record of it ever having been there—so perhaps Hooker took Talbot up on his suggestion to "try whether it is well *fixed*, by putting it in the sun."[3]

The inscriptions on this example are a bit puzzling. In early 1839 Talbot made a private list of "Marks on Shadow Pictures," where "ab" represented photographs that were "not preserved" (i.e., not fixed).[4] The "fx" almost certainly refers to fixing. Taken together, these likely mean that he kept the negative for a period in an unfixed state, fixing it later. Given the apparent freshness and delicacy of the original botanical specimen, perhaps the negative was made in the field where it grew, using the same sunshine that had fed the plant, and the exposed photograph was preserved for posterity once Talbot returned to Lacock Abbey.

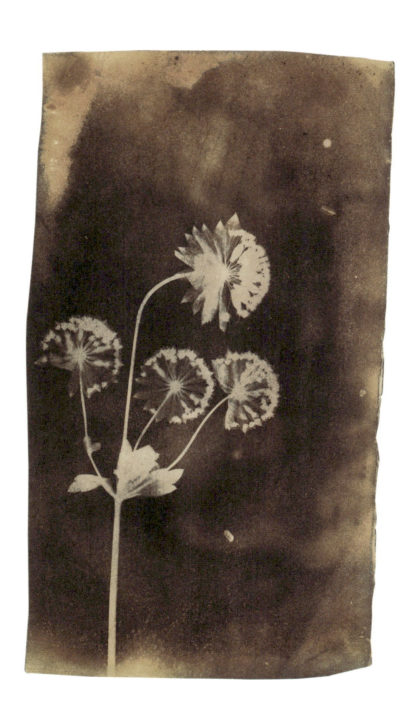

PLATE 7

An Image of Lace, Presented for an Exhibition

Probably exhibited 25 January 1839. Photogenic drawing contact negative,
8.9 x 6.2 cm image, mounted on 12.4 x 9.8 cm paper
Photographic History Collection, National Museum of American History,
Smithsonian Institution, Washington, D.C. (1995.0206.039)
SCHAAF 1501

Looking for all the world like a hieroglyphic tablet propped up in a museum display, this uniquely trimmed fragment of lace is as mysterious as it is striking. The fine detail and repetitive pattern of the lacemaker's skill is well demonstrated by Talbot's art, and surely this appealed to him. Even though this is a negative, it appears as white lace should, for the threads blocked the light from reaching those sections and allowed the white of the paper to show through. It is mounted on a hand-blackened shiny piece of paper, very similar to the carefully labeled view of the oriel window from August 1835 (frontispiece). Six other negatives are known that are still mounted on this hand-blackened paper.[1]

Daguerre's announcement had caught Talbot totally by surprise. Since the gloomy depths of an English winter prohibited him from making any new specimens, he had to rely on examples produced for his private portfolio during the years 1834–38. Very likely this piece of lace was one of the items exhibited by Talbot at the Royal Institution in January 1839. The earliest opportunity for a public showing to a scientific audience was on 25 January, when Michael Faraday addressed the more than three hundred people who had assembled at the Royal Institution for the popular Friday evening lecture. After discussing the parallel announcements of Talbot and Daguerre, Faraday invited the audience to inspect the customary library exhibits.

There, displayed amongst diverse curious objects such as papier-mâché ornaments, specimens of "artificial fuel," and a collection of sixteenth-century engravings, were shown examples of Henry Talbot's first photographs. Among these was a "pattern of lace."[2] One audience member recalled Faraday's statement that "no human hand has hitherto traced such lines as these drawings display; and what man may hereafter do, now that Dame Nature has become his drawing mistress, it is impossible to predict."[3]

Although it is undated, it is possible that this is one of the earliest surviving examples of Talbot's work. When he disclosed the working details of his photogenic drawing process to the Royal Society in February 1839, Talbot detailed his first method of fixing with potassium iodide. This substance stained the paper a characteristic yellow (as is clearly the case in the present example). Talbot explained that "the specimen of *lace* which I exhibited to the Society, & which was made 5 years ago, was preserved in this manner."[4] He was being very precise in this paper, and the "5 years ago" must have placed the example he exhibited among his earliest successes in the spring of 1834.

Although he had to dig into his old portfolio, what Henry Talbot had shared with the audience at the Royal Institution was "a little bit of magic realised:—of natural magic."[5]

PLATE 8

"*Erica mutabilis*"—a Present to Sir John Herschel

March 1839. Photogenic drawing contact negative, 12.3 x 11.3 cm.
Inscribed in ink on verso: "H.F.T. March 1839 Erica Mutabilis"
The Museum of the History of Science, Oxford (Inventory no. 92949)
SCHAAF 2291

Floating in a dreamy space, almost like a delicate sea creature suspended in the ocean depths, this botanical specimen was a present from Talbot to his scientific friend, Sir John Herschel: "I send you a flower of *heath*," he wrote on 21 March 1839.[1]

The scientific friendship between Herschel and Talbot grew out of their first meeting in Munich in 1821 and was to prove critical to the genesis of photography on paper. Herschel made substantial contributions to the new art. He first identified the hypo fixer that ultimately made photographic printing practical and contributed much to the terminology of early photography. *Negative* and *positive* were Herschel's terms, as well as *photography* itself (replacing Talbot's less versatile *photogenic drawing*). Just months before Talbot got his inspiration for photography at Lake Como, Herschel had departed to South Africa for an extended scientific residence. Talbot never mentioned his new art in their correspondence, and Herschel returned to England in 1838 just months before Daguerre's announcement. Herschel was one of the first people Talbot approached when the art became public, and during this first year of photography, it was Herschel's advice and support and his standing in the world of science that helped to sustain Henry Talbot.[2]

The choice of a specimen of *Erica*, the heath family, was an appropriate one for Talbot to send to his friend. There are more than six hundred species of *Erica* indigenous to the western Cape. In fact, within three weeks of arriving there, Herschel executed a camera lucida drawing of a strikingly similar specimen, *Erica cerinthoides* (the scarlet heath)—it was the first of an extended series of such drawings he accomplished whilst there.[3] Talbot had actively encouraged Herschel to make the most of the rich flora of the Cape: "I almost envy you your intended residence in South Africa, which possesses I am told serene skies & a wholesome climate. It is moreover a most favoured country with respect to its vegetable productions . . . I almost think of troubling you with a request that through your means I may be enabled to employ some gardener or labouring man of intelligence in collecting seeds and roots in different parts of the Colony which I may afterward hope to see flourishing in my greenhouse in Wiltshire. For though a great part (say one half) of the Cape plants have been introduced to England at various times yet many of them are so impatient of culture that not one fourth or one fifth are to be met with in our gardens at any given time."[4] Herschel was more than happy to oblige.

The prominent fold in the paper of this negative was likely done by Talbot himself, for no better reason than convenience in posting. This seemingly careless habit was one that puzzled and annoyed those around him. Admiring the "splendid collection" of his latest photographs, Caroline Mt. Edgcumbe chided her brother that "it is a great pity you folded them as they would have traveled perfectly well between two pieces of pasteboard."[5] He did not take the point, for a year later his wife Constance was still complaining: "Why did you *fold* your picture? You observe the line has copied itself."[6] An extremely close variant of this negative is illustrated on page 23.[7] It was made from the very same plant specimen, almost certainly in the same session, but just a little bit later, for one of the leaves has broken off at the bottom prior to making the second one. It is undated and inscribed in ink on verso "fx" and in pencil on verso "7".[8]

When Talbot sent this particular "flower of *heath*," he emphasized that it was "not fixed."[9] Herschel immediately replied with reassurance, saying "thank you for the very pretty specimen of the heath, which shall be taken better care of than its predecessor."[10] Perhaps it was fixed at some later point by Herschel, or perhaps only careful handling and storage, first by Herschel's family, later by the museum, has kept it fresh.

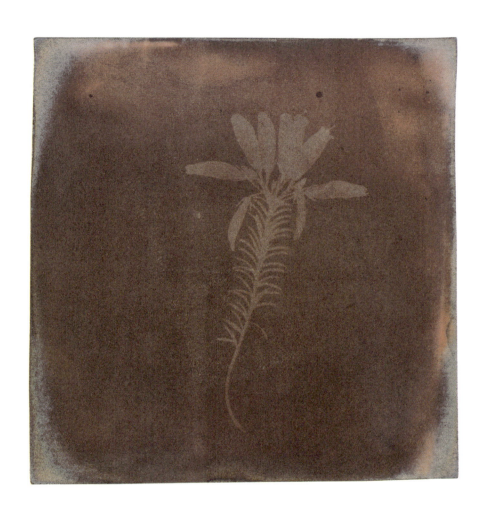

PLATE 9

"*Middle Window, South Gallery, Lacock Abbey*"

April 1839, prior to 23 April. Salt print from a photogenic drawing camera negative,
20.2 x 15.2 cm image on 21.0 x 17.6 cm paper.
Inscribed in ink on verso: "Middle Window South Gallery Lacock Abbey
H.F. Talbot photogr. April 1839"; inscribed in pencil on verso: "fx"
The Russian Academy of Sciences, St. Petersburg
SCHAAF 3694

Talbot's first negatives of his oriel windows (such as the magical image in pl. 1) justifiably celebrated the natural recording of light. The camera was placed squarely to record the window *as an object* as accurately as possible. In this later view, gaining confidence from his own camera images, Talbot has begun to see as a photographer would see. The window is viewed obliquely, delineated as more of a presence in a space than as a clinically detached and catalogued object. The rough character of the photogenic drawing paper gives it a dreamlike quality and simplifies the forms. Lady Elisabeth Feilding must have been one of the first to have seen this image: "I . . . am in great admiration of . . . *particularly* the middle window of the South Gallery which looks *so* conventical & of a Rembrandt tint."[1]

This may be the very first *camera* negative that Talbot had printed—not a single print from one is known that is provably earlier.[2] On 27 April, just before Sir John Herschel went to see the productions of Daguerre, Talbot wrote to him that "our English method must have the advantage . . . having obtained one picture by means of the Camera, the rest are obtainable from this one, by the method of re-transferring, which, by a fortunate & beautiful circumstance rectifies both of the errors in the first picture *at once*; viz. the inversion of right for left; & that of light for shade. N.B. I have found that the Camera pictures transfer very well, & the resulting effect is altogether Rembrandtish."[3] It is surprising that Talbot made this statement at this late date, for he had grasped the underlying concept of the negative/positive process at least as early as 1835.[4] In this letter to Herschel, he must have meant that he had previously tried this approach only with photogram negatives and not with camera negatives.

The survival of this rare example within a collection in Russia may not at first be expected. It was received in the Academy's collection only weeks after Talbot made it; carefully preserved, it has been examined only on rare occasions. As in so many areas, it was Talbot's mother who should be credited for her quick thinking for placing this in a significant archive. On 30 April 1839, she wrote that "this morning before I was visible arrived D[r.] Hamel[5] . . . Membre de l'Académie Imperiale de Science de S[t.] Petersbourg . . . I gave him all mine & some you sent for Matilda . . . he wanted them extremely to send to Russia by *the Sirius* which sails tomorrow. They are for the Emperor's second son, a very scientific young Man. He wishes to lay some before the Czarowitch who arrives in London on Friday, & I promised you would send me some more for him. He was particularly struck with those done from Nature. The Tower-at-Laycock Abbey, windows & *riband* which latter preferences rather surprized me . . . I gave him likewise many botanicals & the black lace. He is extremely eager, & I gave him your works on Photogeny."[6]

The negative for this image has not been discovered and probably has not survived. There were at least three other prints known to have been taken from it—none so intriguing as this one in their coloration.[7] The negative was trimmed down at least once during its printing lifetime and likely became a sacrifice to an exciting but not yet well-understood process. In order to make prints, the negative itself became the subject for other sheets of sensitive paper. It would have been exposed repeatedly to rough handling and to copious sunlight, a rigorous test the early materials could ill withstand.

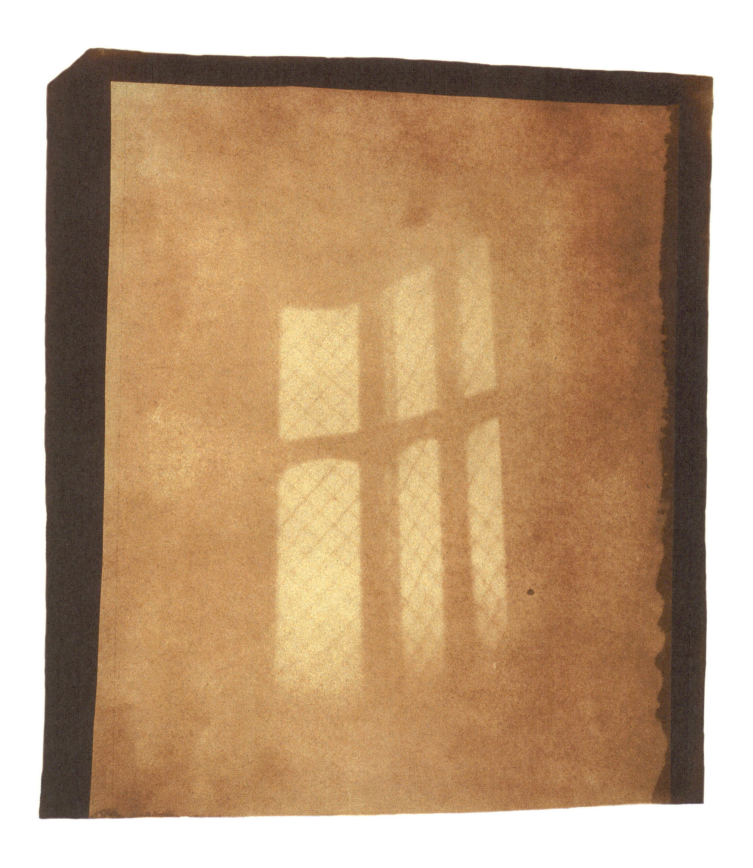

PLATE 10

Bryonia dioca — the English Wild Vine

Probably 1839. Photogenic drawing contact negative, 22.4 x 18.3 cm
The National Museum of Photography, Film & Television, Bradford (1937-2202)
SCHAAF 2097

With its active arrangement of spirals and leaf forms, this negative of the White Bryony entertains the eye as much as it satisfies the need for description. Talbot throught that the etymology of the Viburnum family led to the word *viere*—to twine, or bind, or interlace.[1] The great beauty and relative simplicity of the photogenic drawing process for the recording of plant forms made it a favorite both with Talbot and with his audience. Each of these images is special, in part because each is an original negative that was made in contact with a particular plant. Like the anonymous daguerreotype portrait of an unidentified person, it records a life we will never know, but it does so with such great clarity that the photographic image takes on a life of its own. Several dozen such images are known to survive in Talbot's work, many beautiful, perhaps none so beautiful as this. This visual idea was soon to be adopted by Talbot's friend, the botanist Anna Atkins,[2] and such a schematic approach to plant forms would be echoed a century later by Karl Blossfeldt.[3]

The *Bryonia dioca*, the White Bryony, flowers from June to September, and it is probable that Talbot made this particular example during a rare patch of sunlight in the first public summer of photography. The lines that appear to give an extra three-dimensional quality to the stem are in fact a happy case of unintentional deception; they are actually the result of juices expressed from the fresh and moist stem, staining the paper and interacting with the photographic chemicals. Only a fresh plant specimen would exhibit the full flower and leaf. Is this "defect" the signature of Nicolaas Henneman? Henry Talbot asked his wife Constance to "tell Nicole I don't want any more leaves and branches done. I must make some criticisms on his performances which I wish you to mention. He presses the plants much too tight, so that the juice is squeezed out, & spoils the pictures."[4]

In his first paper on photography, Talbot observed that "it is so natural to associate the idea of labour with great complexity and elaborate detail of execution, that one is more struck at seeing the thousand florets of an Agrostis depicted with all its capillary branchlets (and so accurately, that none of all this multitude shall want its little bivalve calyx, requiring to be examined through a lens), than one is by the picture of the large and simple leaf of an oak or a chestnut. But in truth the difficulty is in both cases the same. The one of these takes no more time to execute than the other; for the object which would take the most skilful artist days or weeks of labour to trace or to copy, is effected by the boundless powers of natural chemistry in the space of a few seconds."[5]

At around the time that this was made, Talbot presented a bold proposition to an old friend, the well-known botanist William Jackson Hooker. He asked: "What do you think of undertaking a work in conjunction with me, on the plants of Britain, or any other plants, with photographic plates, 100 copies to be struck off, or whatever one may call it, taken off, the objects?"[6] In this, as was so often the case, Talbot's imagination ran ahead of what the technology of the day could handle. But it already established his firm linking of his photographic process with the tradition of the book: this dream was to be realized within five years with the publication of *The Pencil of Nature*.

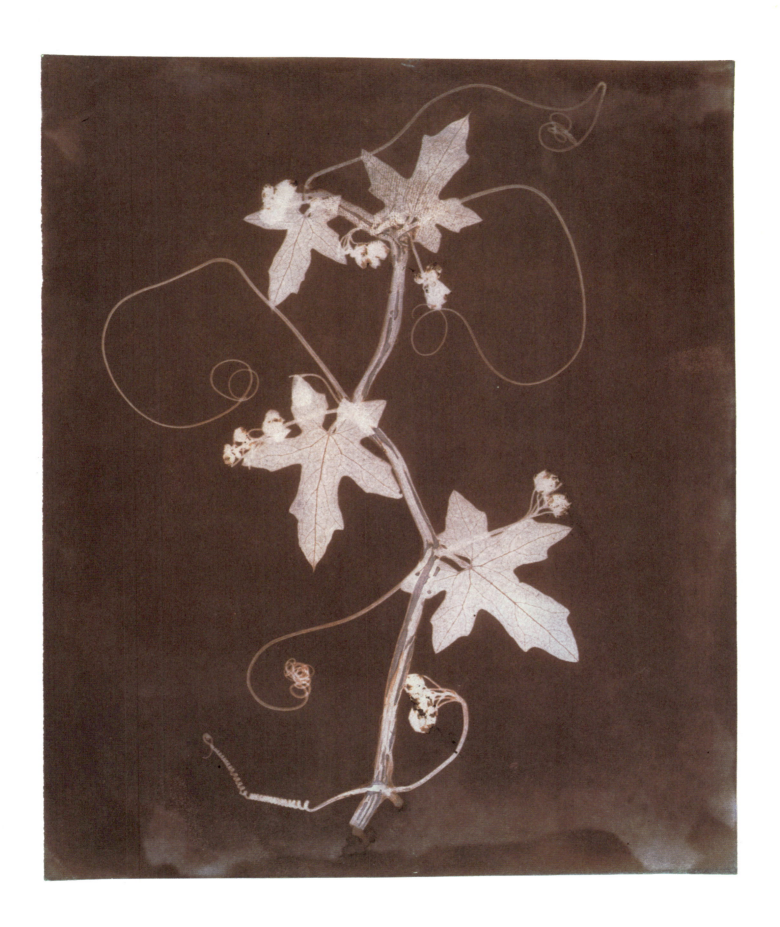

PLATE 11

A Cascade of Spruce Needles

Probably 1839. Photogenic drawing contact negative,
22.7 x 18.5 cm. Pencil "X" on recto
Lacock Abbey Collection, The Fox Talbot Museum, Lacock (LA2070/NB2)
SCHAAF 1653

Amongst the various meanings of the word *spruce* is the sense of brisk, smart, and lively. In one of the most extraordinarily animated of Talbot's early photographs, he has made a clever play on this word. By varying the spacing of inanimate objects, Talbot re-created a sense of cascading motion. Did some needles casually fall on one of his print frames at one time, suggesting this possibility, or was this sprinkling a visual trick he thought to try?

At the British Association for the Advancement of Science annual meeting held in Birmingham in August 1839, Talbot had the unenviable task of explaining the newly revealed details of his rival Daguerre's metal-based process. But he also mounted a large and carefully organized exhibition of photogenic drawings for this meeting, designed to show the greater versatility and longer-range potential of his process on paper. Within his Class I, "Images obtained by the direct action of light, and of the same size with the object," we find item No. 50: "Leaves of Spruce Fir."[1] While the present negative seems to have weathered the years exceptionally well for something that had been on exhibition, perhaps it was the very one that was shown in Birmingham in that first year of photography.

Talbot might have felt more inspired photographing the needles of the spruce rather than the full tree. A contemporary assessment was that "a tree of the common spruce, when young, feathers to the ground, and has a handsome appearance; but when old and in close plantations, becomes ragged and unsightly . . . it is picturesque and sometimes very imposing as one of a group of widely diversified trees in a plantation; but it is too formal, too conical, too uniform, too much destitute of every feature of force and intricacy, to make a good figure by itself."[2] By 1841, Lady Elisabeth implied that the spruce trees were taken for granted on the grounds of Lacock. In a letter to her son, she relegated the spruce trees to a protective role, vowing that she would "put in a good many Spruce Firs *entirely* for Nurses to the others & to be cut down in a few years when they have answered their purpose (a thing most people forget to do). They say Spruce is better for this than Scotch."[3]

No prints from this negative are known, and it is almost certain that Talbot thought of it as the final photograph, not as an intermediate step to a print. The negative is mounted in Talbot's album No. 8 (one he considered "bad"!). Made up of forty prints and eleven negatives, this album has four items positively dated to 1839, eleven dated to 1840, and eight dated to 1841 (none later). The watermarks of items in the album include one from 1838, eight from 1839, and one from 1840.

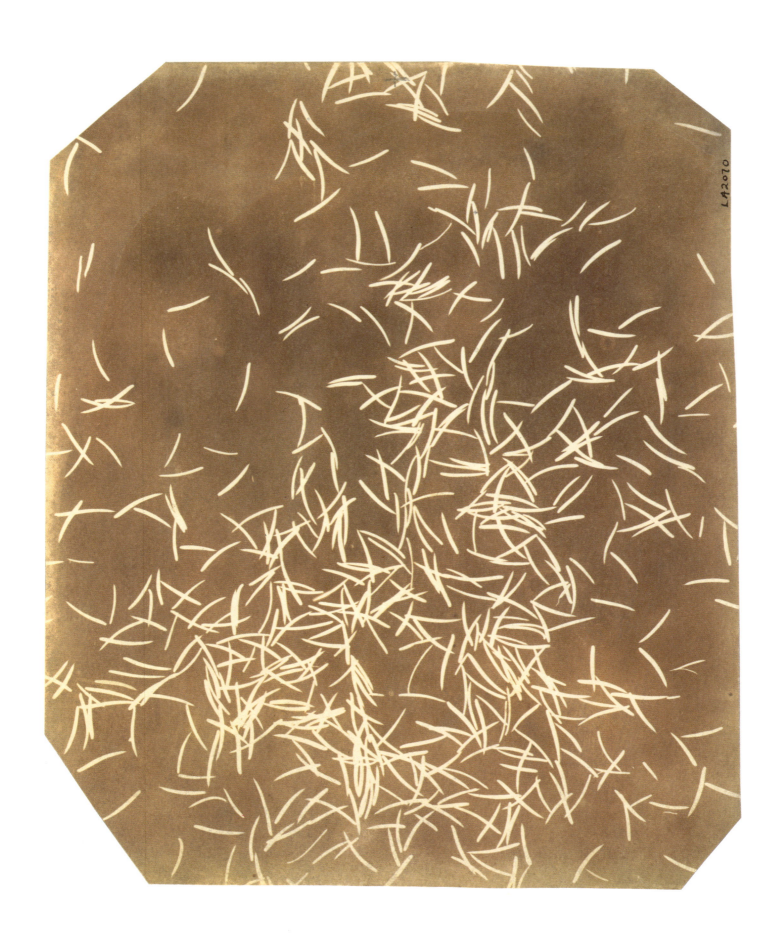

PLATE 12

"Leaves of Orchidea"

April 1839. Photogenic drawing contact negative, 17.2 x 20.9 cm.
Inscribed in ink on verso: "Leaves of Orchidea H.F. Talbot photogr. April 1839"
The J. Paul Getty Museum, Los Angeles (86.XM.621)
SCHAAF 2298

Like a broad-winged dragonfly swooping in on a plant, the elements of this image take on a sense of activity well beyond their static nature. The structure of the plant is clearly revealed. A three-dimensional sense is added where the leaves overlap and all the fine detail of the ravages of the insect world are shown. The size limitation caused by printing in contact was overcome by the simple expediency of selecting the portions of the plant that were of interest, and then arranging them in a visually pleasing fashion.

On 14 April 1839, Talbot recorded having sent a photograph of "Orchis leaf" to the well-known botanist and horticulturalist John Lindley.[1] The two men had known each other through botanical circles for many years, and orchids were Lindley's particular area of study.[2] The early provenance of this negative is not known, although the full ink inscription makes it most likely it was a presentation from Talbot to someone else. It is not unreasonable to assume that it might be the very specimen that he sent to Lindley (his collection of orchids and some of his correspondence are still preserved in the herbarium at Kew Gardens).

The nature of this image is very much like that of the seaweeds—the "flowers of the sea"—that his scientific colleague Anna Atkins printed in the cyanotype process.[3] Although lacking in the striking blue color inherent in her negatives, the modern sense of this *orchidea* is perhaps better served by the effect of black chalk anyway. Atkins's and Talbot's contact images of plants had similar visual strengths and suffered the same limitations. They traced the outline of the plant in the most exquisite detail and even penetrated into parts of its interior. However, X-ray images were long in the future, and nobody in Talbot's day would ordinarily have thought of observing a plant in this way. That difference of vision—the unexpected point of view of photography—was to form one of the criticisms leveled at the new art by botanical illustrators.

This negative was formerly in the collection of Robert Shapazian; no prints from it are known, and it was likely never printed, either by Talbot before he sent it, or by the recipient of the gift.

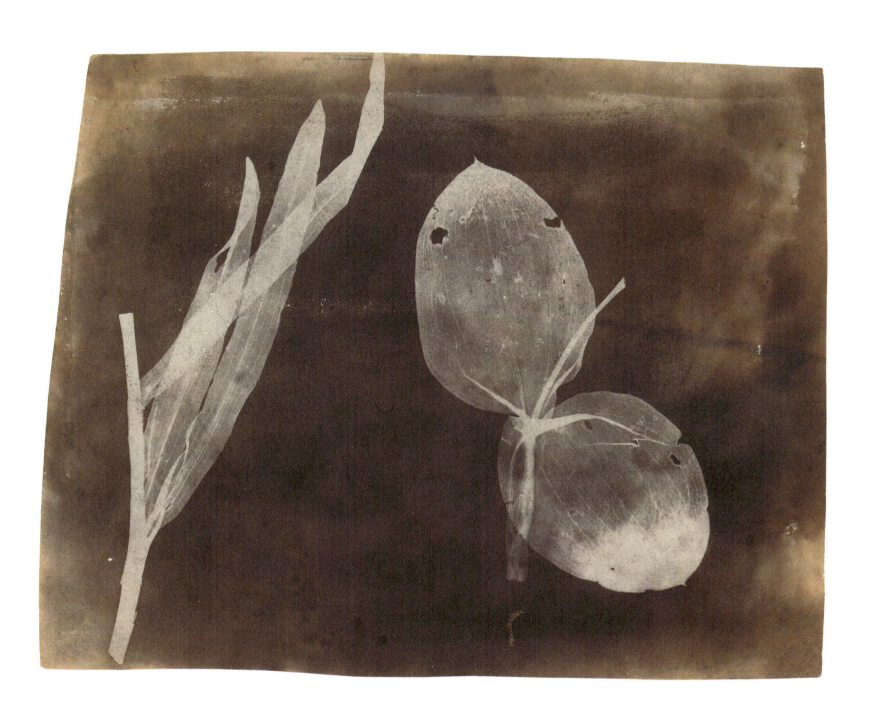

PLATE 13

Leaves of the Pæony

Dispatched June 1839. Photogenic drawing contact negative, 18.6 x 12.0 cm.
Inscribed in ink on verso: "H.F. Talbot photogr. 1839"
The Metropolitan Museum of Art, New York.
Harris Brisbane Dick Fund, 1936 (36.37/08)
SCHAAF 2262

Glowing like some fantastic Chinese lantern, the irregular shape of this mass of the leaves is echoed by the equally flowing trim of Talbot's shears. The handlike image struggles to reach out of the two-dimensional surface of the paper, but its outline form is its strongest element. The effect of light is a visual deception, of course, for in this negative it was the areas where the green leaves blocked the actinic light most effectively that the brightness of the paper was allowed to show through. It is a fine example of Talbot's observation that the structure of things such as plants can sometimes be best seen in a negative form.

Named for the celebrated physician Pæon, who cured the wounds the gods received in the Trojan War, the pæonies are normally prized for their showy blooms in the early summer. In this case, the recipient of Talbot's gift would have been equally happy with a less showy but equally functional part of the plant, the leaves. This example of the "Foglia di Peonia" was sent to Talbot's long-time friend, the Italian botanist Antonio Bertoloni. They had kept up a regular contact since 1826, often through their mutual botanical interests with Talbot's uncle, William Thomas Horner Fox Strangways.[1] When photography was announced to the public, Talbot lost no time in supplying Bertoloni with examples to show in Italy. In June 1839, having heard that his uncle (a diplomat) was sending a courier to that country, he enclosed eight photogenic drawings, including the present one, saying that he felt his new art would be a great aid to botanists.[2]

More photographs followed, at least three dozen, the last of this group being sent in June 1840. Bertoloni carefully assembled these into an album, keeping them in order, adding labeling to Talbot's inscriptions, and taking the final step of binding Talbot's letters into the album. Even though much of its contents have faded over time, this album represents the most completely identified and structurally intact group extant of Talbot's early work in photography. Its unique character was recognized long ago. In 1935, the famous London bookseller, E. P. Goldschmidt, acquired it from Mario Galanit, a colorful Parisian book dealer who was of Italian descent. Goldschmidt showed the album to the innovative Curator of Prints at the Metropolitan Museum of Art, William M. Ivins, Jr. In February 1936, Ivins acquired it for the museum. It was the first purchase of important photographs the museum ever made, and it set the stage for what is now one of the finest collections in the world. Goldschmidt retained his appreciation of this singular album, including it in his 1954 catalogue of the one hundred most important books he had offered since 1923 that had not been in a catalogue.[3]

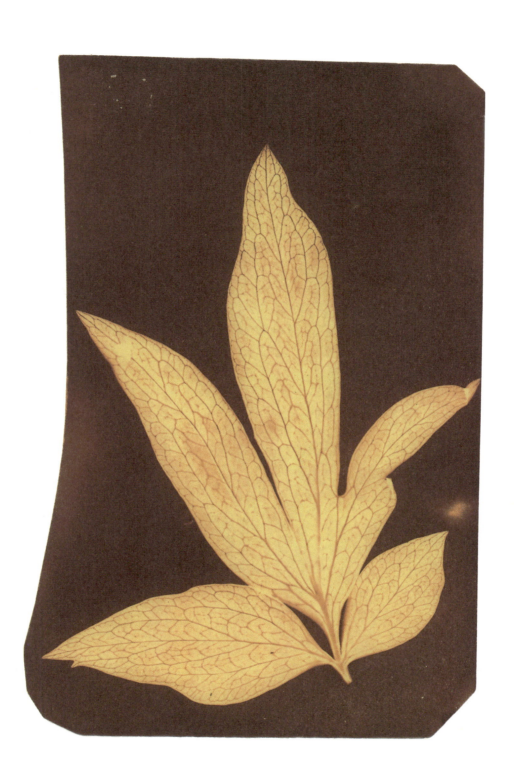

PLATE 14

Branch of Leaves of Mercuriàlis pérennis

14 July 1839. Photogenic drawing contact negative, 11.6 x 17.2 cm.
Inscribed in ink on verso: "A.B. post. July 14 cleared N. Merc."
Photographic History Collection, National Museum of American History,
Smithsonian Institution, Washington, D.C. (1995.0206.029)
SCHAAF 2304

The several overlapping leaves that make up this negative form various images darker and lighter by contrast, entertaining the eye with their activity. The delightful picture within a picture thus formed evokes the negative/positive process pioneered by Talbot. With its reddish tint and fanlike character, this example of *Mercuriàlis pérennis* (more commonly known as the perennial dog's mercury) looks alive. In truth, it was a gloomy crop-plant of damp woods. It received its name from the god Mercury, who supposedly found it useful, but considering its poisonous nature, mortals could apply it only to homeopathy and as a source of a rather unstable blue dye.

It is likely that it was the striking visual character of this particular image that made it an object to preserve in its own right. Its terse annotation provides some hints as to how it was produced, and perhaps the selection of a plant of the mercury class was not a random choice. In Talbot's research notebook *P*, under 14 July 1839, he recorded the observation that "if an old photograph is washed with a solution of nitrate mercury very weak and very hot, it becomes whitened and transparent. Weak designs are wholly discharged. The green tint produced by long sun becomes black and opaque, therefore proper to make 'transfers' with. The back of the paper is quite whitened. The water used for the washing turns yellowish. The figure of a leaf 'overdone' deep red upon green, and barely visible, became white upon black! This was found quite fixed in sunshine."[1] Perhaps Talbot was referring to an earlier state of this very image. Associating contemporaneous descriptions like this with the visual state of photographs more than a century and a half later is fraught with difficulties, for much could have changed in the intervening years. The inscription here, "A.B. Post. July 14. Cleared N. Merc.", remains cryptic. The "A.B." is open to several interpretations: for example, in early 1839 Talbot made a private list of "Marks on Shadow Pictures," where "ab" stood for "not preserved" (i.e., not fixed).[2] The "Post." is likely an abbreviation of the Latin *postremo*, meaning *at last*.

It was not the first time that Talbot had turned to this plant as a subject. On 14 April 1839 he had sent a photograph of "mercurialis" to a friend, likely a fellow Harrovian.[3]

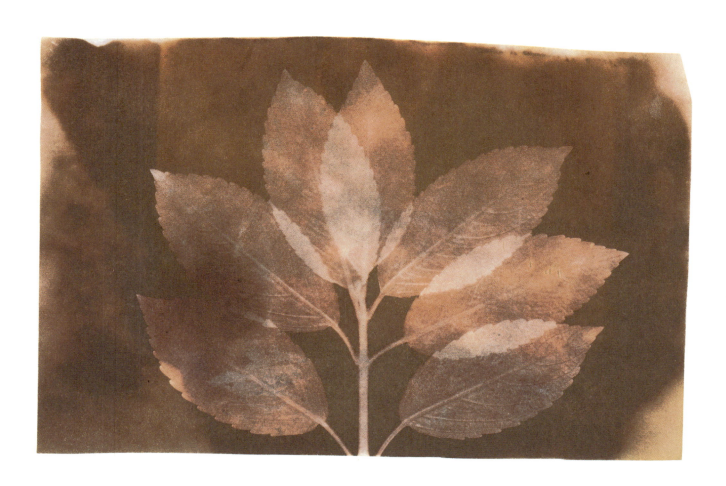

PLATE 15

Band of Lace

Probably 1839. Photogenic drawing contact negative, 15.1 x 20.7 cm
The National Museum of Photography, Film & Television, Bradford (1937-1524)
SCHAAF 1063

At the beginning of 1839, Henry Talbot boasted about how on "one occasion, having made an image of a piece of lace of an elaborate pattern, I showed it to some persons at the distance of a few feet, with the enquiry, whether it was a good representation? when the reply was, 'That they were not to be so easily deceived, for that it was evidently no picture, but the piece of lace itself'."[1]

The piece of lace itself! It is easy to imagine running your fingers lightly over the surface of this negative and feeling the fine threads of which it should be made. But, in reality, it is nothing but frozen light, and, in fact, light inverted. The lace was opaque and blocked the solar rays—all the sun could do was darken the paper around the lace and through its holes. Talbot chose a subject so closely matched to his art that it contributed in yet another way to the optical illusion. The heavier threads appear to the eye to be thicker and to project out from the surface of the paper.

Six years after this image was likely made, Talbot published a plate of lace in his *Pencil of Nature*. He wrote that "as this is the first example of a negative image that has been introduced into this work, it may be necessary to explain . . . what is meant by that expression. . . . [I]f . . . any object . . . be laid upon the paper, this, by intercepting the action of the light, preserves the whiteness of the paper beneath it, and accordingly when it is removed there appears the form or shadow . . . marked out in white upon the blackened paper . . . this is exemplified by the lace depicted in this plate; each copy of it being an original or negative image: that is to say, directly taken from the lace itself." The piece of lace he employed must have been very

stiffly starched indeed, for only by closely comparing different copies can one see the more delicate parts begin to fray. Talbot continued to explain in his text that "if instead of copying the lace we were to copy one of these negative images of it, the result would be a positive image of the lace . . . but in this secondary or positive image the representation of the small delicate threads which compose the lace would not be quite so sharp and distinct, owing to its not being taken directly from the original. In taking views of buildings, statues, portraits, &c. it is necessary to obtain a positive image, because the negative images of such objects are hardly intelligible, substituting light for shade, and vice versa. But in copying such things as lace . . . a negative image is perfectly allowable, black lace being as familiar to the eye as white lace, and the object being only to exhibit the pattern with accuracy."[2]

Talbot tried to encourage the use of this new means of accurately copying the complex lace in a commercial application. With the public announcement of photography in 1839, one of the first persons that he approached was Sir William Jackson Hooker, Regius Professor of Botany at Glasgow (and later director of Kew Gardens). On 23 January, Talbot sent him a photogenic drawing of lace to show to some of the manufacturers in the Scottish mercantile city.[3] Hooker later reported back that "your specimen of Photogenic drawing . . . has interested the Glasgow people very much, especially the *Muslin Manufacturers*—& also excited great attention at a Scientific Meeting."[4]

No prints are known from this negative. To Talbot, it must have looked just right the way it was.[5]

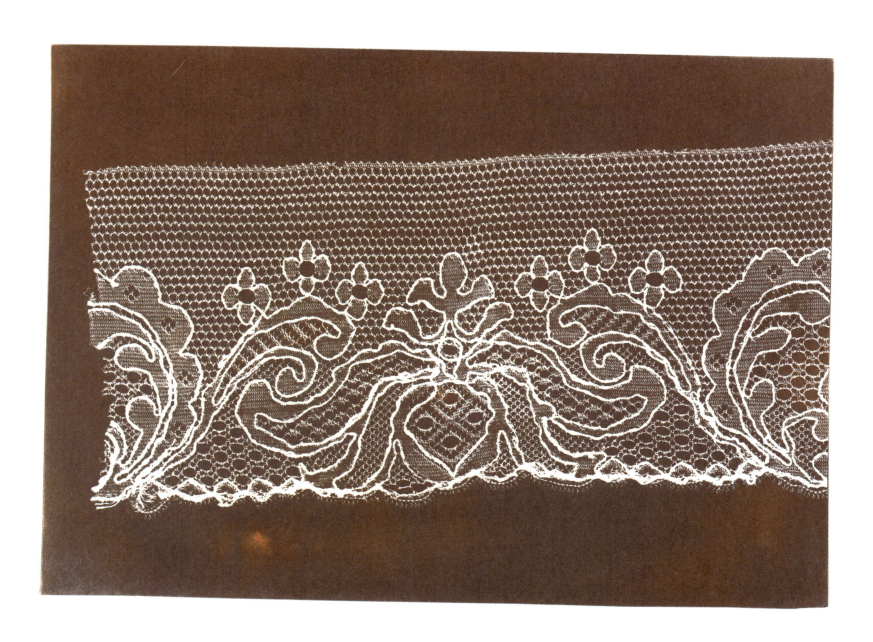

PLATE 16

"*Bookcase*" *at Lacock Abbey*

26 November 1839. Salt print from a photogenic drawing negative,
13.9 x 20.0 cm image on 18.0 x 21.9 cm paper. Watermarked Joynson 1838.
Inscribed in pencil on verso: "b"
The Gilman Paper Company Collection, New York
SCHAAF 2319

Made in the closing weeks of the first year of photography, this exceptional interior image can be seen to encompass the world in which Talbot took comfort. There are the emblems one would expect to see displayed in the houses of the landed gentry: the Dresden china, a mantle clock, and especially the finely bound books. Books in series, books neatly arranged, books whose title blocks on the spines served as windows into other worlds. This was Henry Talbot's world! In a year that started with the revelation that a rival had beat him to the stage of public opinion—in a year when the weather was so miserable as to frustrate many of his attempts to advance in his art—in a year where all seemed turned against him, Henry Talbot still had his books. They were timeless and placeless and priceless to him.

In writing to Sir John Herschel a fortnight later, Talbot enclosed "a little sketch of the interior of one of the rooms in this house, with a bust of Patroclus on a table."[1] He too-modestly felt that "there is not light enough for *interiors* at this season of the year, however I intend to try a few more. I find that a *bookcase* makes a very curious & characteristic picture: the different bindings of the books come out, & produce considerable illusion even with imperfect execution."[2]

This photograph has more "considerable illusion" than "imperfect execution." It is an extraordinary image, made with Talbot's relatively insensitive photogenic drawing paper, probably with an exposure time that was measured in tens of minutes. Flooded with a sense of light and of detail, it is extremely early for such an attempt and is one of the very few actual interiors that Talbot ever produced. Taking it at the end of Novem-ber, when the sun in Wiltshire was weakened at best, was an even bolder attempt. Even after the invention of the much more sensitive calotype negative process, Talbot preferred to construct simulated interior scenes outdoors to take advantage of the light. His justly famous *Scene in a Library* (pl. 79), made with an exposure of perhaps a few seconds, was set up in the courtyard of Lacock Abbey in the full light of the sun.

The two pieces of Dresden were featured in a very different way in Talbot's *Three Jars* (pl. 21). Here, with the print likely a bit faded from its original state, they appear to float above a black void. That dark space, a small table and its deeply raking shadow, is balanced by a similar-sizes light rectangle to the side. The latter is merely an open space in the bookshelves, undoubtedly soon to be filled by Talbot's continuing book acquisitions. The ordered regularity of the scene survives the trapezoidal shape to which Talbot trimmed the negative.

This image, listed under the simple title of "Bookcase," was the very second one recorded in Talbot's newly started manuscript negative list.[3] The negative, dated in pencil in Talbot's hand, still exists, but sadly, because of its iodide fixing, it has almost completely whitened. Its distinctive trapezoidal shape preserves its identity.[4] There is one other known print, in the collection of the University of Glasgow, formerly in an album compiled by Lady Jane Montgomerie. Just like this print, it has a pencil inscription "b," but as it was a presentation print it was inscribed in ink on verso: "H.F. Talbot phot: Nov.ʳ 26. 1839. Camera Obscura."[5]

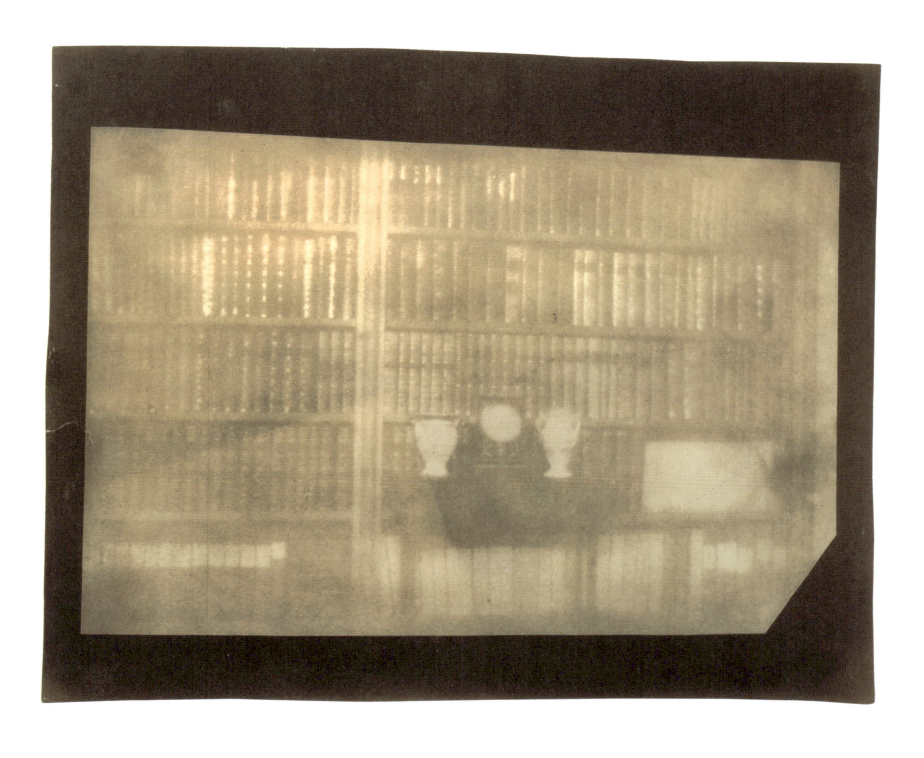

PLATE 17

A Forbidding Stand of Winter Trees

Probably winter 1839/40. Salt print from a photogenic drawing negative,
15.3 x 19.1 cm image on 17.9 x 22.0 cm paper, corners trimmed
The William T. Hillman Collection
SCHAAF 3828

Rising out of an unearthly and unfamiliar landscape, the skeletal form of a tree reaches here through a fiery red sky. It was winter's cold that stripped the common lime tree of its leaves, reducing it to its most essential structure, but the color of this image is especially striking because it implies so much heat. Whichever of Talbot's various chemical experiments led to its production, its boldness stands out amongst Talbot's works. Only a few other examples of this color are known, and none is so dramatic in subject matter.

Several years after this print was made, writing in *The Pencil of Nature*, Talbot talked about the range of colors in his prints. He said that "there is a point . . . which respects the execution of the following specimens. As far as respects the design, the copies are almost facsimiles of each other, but there is some variety in the tint which they present. This arises from a twofold cause. In the first place, each picture is separately formed by the light of the sun, and in our climate the strength of the sun's rays is exceedingly variable even in serene weather. When clouds intervene, a longer time is of course allowed for the impression of a picture, but it is not possible to reduce this to a matter of strict and accurate calculation. The other cause is the variable quality of the paper employed, even when furnished by the same manufacturers—some differences in the fabrication and the *sizing* of the paper, known only to themselves, and perhaps secrets of the trade, have a considerable influence on the tone of colour which the picture ultimately assumes. These tints, however, might undoubtedly be brought nearer to uniformity, if any great advantage appeared likely to result: but, several persons of taste having been consulted on the point, viz. which tint on the whole deserved a preference, it was found that their opinions offered nothing approaching to unanimity, and therefore, as the process presents us spontaneously with a variety of shades of colour, it was thought best to admit whichever appeared pleasing to the eye, without aiming at a uniformity which is hardly obtainable."[1]

Whatever appeared pleasing to the eye! Some might see this color as more unsettling than pleasing, but it is one that rarely fails to attract attention. When Talbot first introduced the calotype, he remembered that "it was said by many persons, at the time when photogenic drawing was first spoken of, that it was likely to prove injurious to art, as substituting mere mechanical labour in lieu of talent and experience. Now, so far from this being the case, I find that in this, as in most other things, there is ample room for the exercise of skill and judgment. It would hardly be believed, how different an effect is produced by a longer or shorter exposure to the light, and, also, by mere variations in the fixing process, by means of which almost any tint, cold or warm, may be thrown over the picture, and the effect of bright or gloomy weather may be imitated at pleasure. All this falls within the artist's province to combine and to regulate; and if, in the course of these manipulations, he, *nolens volens*, becomes a chemist and an optician, I feel confident that such an alliance of science with art will prove conducive to the improvement of both."[2]

Although the negative for this image is not known to have survived, at least one other print from it is known to have been made, sometime after this one.[3]

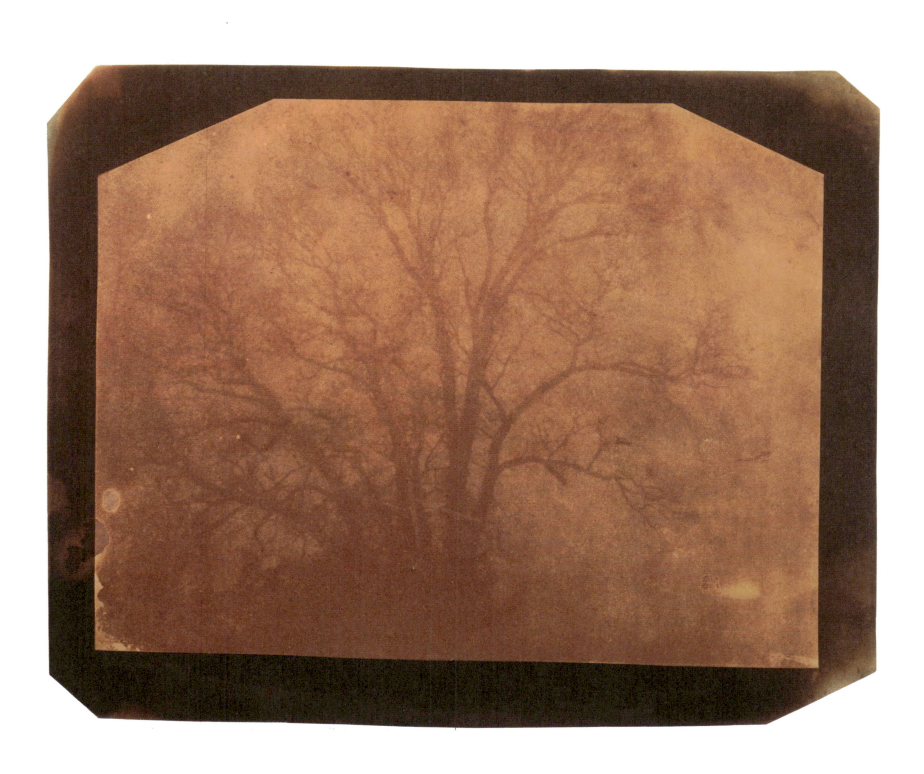

PLATE 18

The Clock Tower at Lacock Abbey

18 February 1840. Salt print from a photogenic drawing negative,
18.0 x 21.8 cm image on 18.5 x 22.8 cm paper
The Janos Scholz Collection of Nineteenth-Century European Photography,
The Snite Museum of Art, Notre Dame, Indiana (85.74.23)
SCHAAF 2342

Springlike weather came early in 1840 and brought with it the wealth of sunshine absent during the miserable year of 1839. With this, Talbot's spirits lifted and his photography took on new life. In his previous view of a clock (pl. 16), Talbot had mastered a technically difficult but carefully managed situation. His techniques had improved by the end of 1839. Indeed, these advances had enabled him to take such a daring photograph of his library, but the seasonal weakening of the light masked these advances. Five days before the present image, Talbot had cautiously attempted a small negative of the clock tower in the north courtyard of the abbey.[1] Here, confidently displayed in a full-size negative, one can feel the new sense of freedom Talbot must have enjoyed. Bold shadows from the sun have replaced the long exposure of the interior, and a jaunty angle replaces the geometrically regular scene. It is one of the first images in what would prove to be an ambitious period of visual growth for Talbot—the emerging photographic artist.

Talbot's camera was placed inside the north courtyard of Lacock Abbey, looking up to the northwest. His view, while easily recognizable today, has changed a little. Even now, once a week and normally on Sunday, the tower is climbed and the weights are cranked up by hand. However, the clock movement was replaced late in the nineteenth century and since then has presented a round face with Roman numerals. The upper front of the tower is half-timbered and painted white; there is a small window just to the left of the clock, its purpose mysterious, as the hands can be adjusted from the inside.

The negative, retouched in pencil, carries various inscriptions: in pencil on the recto is "& W.14" and in pencil on the verso is "7" and the date.[2] One other print is known. It was sent, about a month after this negative was taken, to the French Académie des Beaux-Arts and is still in their collection.[3] This print was formerly in the collection of Janos Scholz.

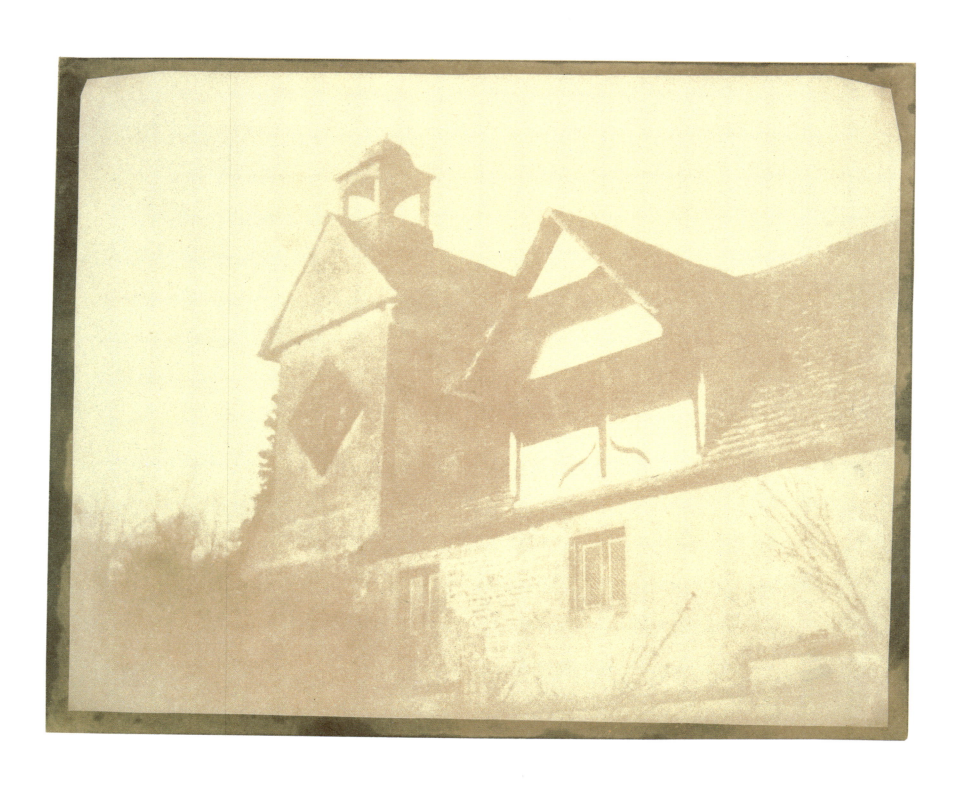

PLATE 19

"Gothick Gateway" at the Entrance to Lacock Abbey

23 February 1840. Salt print from a photogenic drawing negative,
17.7 x 20.8 cm image on 18.6 x 22.9 cm paper
Hans P. Kraus, Jr., Inc.
SCHAAF 2344

Although Talbot complained of not having picturesque subjects in his locale to photograph, his architecturally eclectic home of Lacock Abbey provided many interesting things toward which he might direct his lens. With the reasonable light of a good winter's day, Talbot successfully executed an impressively large camera negative under taxing conditions. A month after this, when the light was presumably much stronger, Talbot returned to this subject, taking a similar negative with an exposure of nine minutes.[1]

In spite of its appearance (and it has changed little since Talbot's photograph), the arch itself is not of great antiquity. In 1754, Henry Talbot's ancestor, John Ivory Talbot, engaged the popular architect Sanderson Miller to transform the medieval Lacock Abbey by adding the Gothic features so prominent to this day. John Ivory Talbot wrote about the "handsome sweep for a Coach and Six" that went past the entrance, leading to a "Ha Ha." Finding that he had some 400 feet of ashlar (square dressed stone) left over from the construction of the Great Hall, the parsimonious Talbot suggested a use. "The present Doorway is in the middle of a Wall of 50 ft. and the Walk from it is 29 d[o.] wide. Could not a Gothick Gateway be contrived in the Middle of the Wall wide enough to admit a Coach?" As Miller's

biographer later wrote: "It could be, and it was. This letter evidently set Miller's 'Ingenuity' to work at once, for the back of it is covered with rough designs for archways. That finally decided on is still standing, and, save for the elaborate pinnacles which disfigure it, is well designed and of pleasing proportions."[2] At least in Talbot's photograph, the effect of the disfiguring pinnacles is suppressed, one hidden under ivy, the other blended into the form of the tree.

Talbot's son, Charles Henry, an architectural historian and archaeologist, thought little of the arch. His niece, Miss Matilda Talbot, remembered that one day a neighbor came to visit, "bringing her young daughter-in-law, who much admired the eighteenth-century pseudo-Gothic arch near the front entrance. 'Yes,' said my uncle rather sadly, 'I suppose you would admire it—elegant but corrupt.' This reply served as a joke in the young lady's family for a long time to come."[3]

This image is listed under the simple title of "Archway" in Talbot's manuscript negative list, rather than under his ancestor's more elaborate "Gothick Gateway."[4] The negative survives, trimmed to the trapezoidal shape evidenced in this print, but no other prints from it are known.[5]

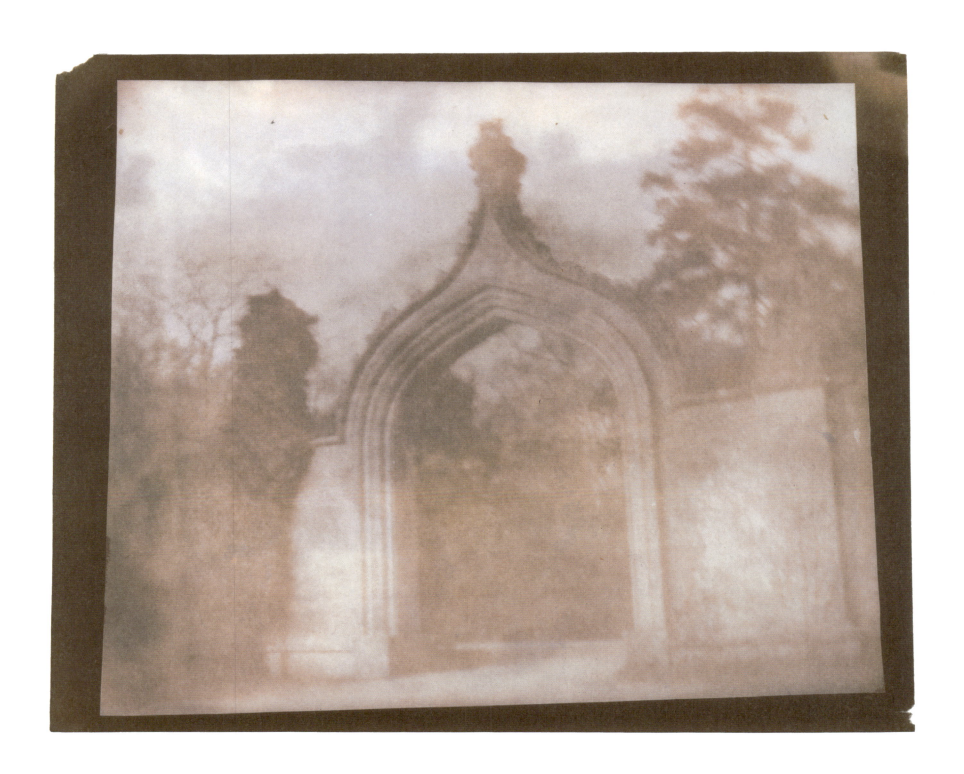

PLATE 20

"Wheel &c"

24 February 1840. Salt print from a photogenic drawing negative,
17.1 x 21.1 cm image on 18.5 x 22.5 cm paper
The National Museum of Photography, Film & Television,
Bradford (1937-0366/094)
SCHAAF 2347

In this scene of picturesque disarray at Lacock Abbey, Talbot has clearly begun to emerge as an artist. Time is taking its toll. The trees are barren. Various broken pieces litter the foreground, and the tools that are visible are those of destruction. The wheel—the wheel of life?—lies cast aside. It is all a scene of disintegration, lacking in formal structure, oddly disturbing. Mysterious dark and angular forms of trees threaten us just beyond the wall. Talbot's exposure time of thirty minutes with his photogenic drawing negative paper allowed the sun and the shadows a little time in which to move, slightly abstracting the details, harmonizing the tones, and adding a dreamy sense to the scene. On 23 February 1841—almost exactly a year later—Talbot returned to this area, executing another negative with a basket and upturned rake in the foreground. It is much more benign and sunny than this image, yet Talbot titled it "A Ruined Wall."[1]

Talbot wrote to his friend Sir John Herschel two months after taking this photograph, enclosing "some photographs, all done with the Camera." Openly showing his excitement, Talbot excitedly said that "the present weather is the finest and most settled, since the birth of Photography. The heat has likewise been excessive for the time of year. Whenever there comes a very bright day, it is as if nature supplied an infinite designing power, of which it is only possible to use an infinitesimal part. It is really wonderful to consider that the whole solar flood of light, should be endowed with so many complicated properties, which in a vast majority of instances must remain latent, since most of the rays pass away into space, without meeting with any object."[2] Herschel replied that "I received this morning in good preservation your extremely beautiful camera pictures which you have sent me in such abundance. I think in another year or two *your art* will beat Daguerre's. In many respects it already equals it—but it seems to me as if the camera were not always well in focus. I presume these are retransfers and I cannot enough admire their evenness of ground. I have nothing to send you in return. All this superb sun for one day of which I would almost have given my little finger last summer, passes without the possibility of my availing myself of a single beam of it . . . this *is* tantalizing!"[3]

This negative is listed under the title of "Wheel &c" in Talbot's manuscript negative list.[4] It survives and now has some retouching in the upper part of the trees; Talbot's inscription on it reveals that this exposure took thirty minutes.[5] There is one other known print, much inferior to this one.[6]

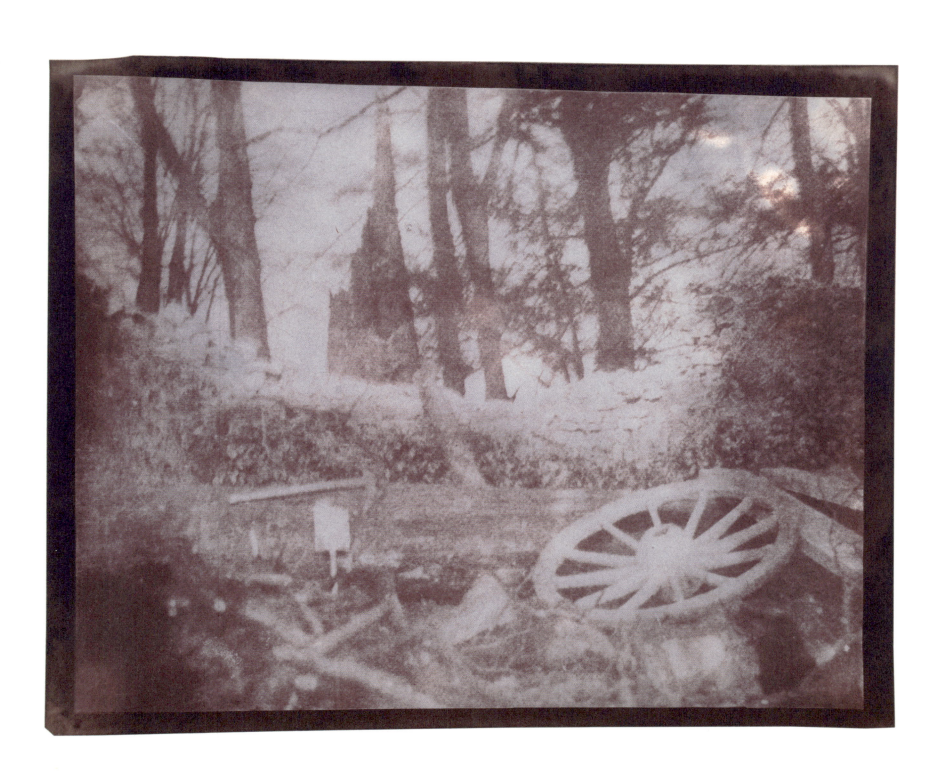

PLATE 21

"Three Jars"

27 February 1840. Salt print from a photogenic drawing negative, 18.6 x 22.3 cm image
on 18.6 x 22.9 cm paper.[1] Pencil "X" on recto; inscribed in ink on verso: "H.F. Talbot"
Niedersächsische Staats- und Universitätsbibliothek Göttingen,
Abt. für Handscriften und seltene Drucke (M26869/Tech II.7565-5)
SCHAAF 2351

Isolated in space, and relating to nothing else, these three jars have no other function than to describe themselves. In his text for the "Articles of China" in *The Pencil of Nature*, Talbot wrote that "from the specimen here given it is sufficiently manifest, that the whole cabinet of a Virtuoso and collector of old China might be depicted on paper in little more time than it would take him to make a written inventory describing it in the usual way. The more strange and fantastic the forms of his old teapots, the more advantage in having their pictures given instead of their descriptions. And should a thief purloin the treasures—if the mute testimony of the picture were to be produced against him in court—it would certainly be evidence of a novel kind; but what the judge and jury might say to it, is a matter which I leave to the speculation of those who have legal acumen. The articles represented on this plate are numerous: but, however numerous the objects—however complicated the arrangement—the Camera depicts them all at once. It may be said to make a picture of whatever *it sees*."[2]

The "pineapple" vase on the right and the two-handled vase in the center feature in Talbot's earlier study of his library room (pl. 16). In that image they were visual supports to represent a style and station in life. Here, they are the subjects of the photograph, parading themselves so that they may be remembered. On 8 April 1840, Talbot's sister Caroline Mt. Edgcumbe wrote: "I cannot let a day pass without thanking you for your splendid collection of Photographs . . . some of them are quite beautiful & shew *great* improvements in the art—L^d. M^t. E— was charmed with the busts, & we were both particularly struck with the beautiful effect & extreme softness in round objects, such as the jars."[3]

It is the exception—and a particularly gratifying one— when the course of a particular photograph can be followed from Henry Talbot's hands at Lacock Abbey to the safety of a repository today. This was one of a group of eight photographs that Talbot sent to his neighbor in nearby Devizes on 13 May 1840, the physician Dr. Robert H. Brabant.[4] Dr. Brabant was about to travel to Germany and was happy to spread the knowledge of Talbot's new art. On 30 June 1840, Brabant made a donation to the University of Göttingen of Talbot's photographs. Six salt prints and one negative are still in their collections, representing nearly all, if not all, of what Brabant carried with him. In the autumn, Constance wrote to her husband that "D^r. Brabant has just called—& asked for me, as you were not at home—He wished to tell you all about his travels & the brilliant success of your Photographics, especially the Manuscripts which were much appreciated by the German Savans."[5]

The title is from Talbot's manuscript negative list.[6] The negative survives; in addition to the date, it is inscribed "& W 20." Six other prints from this negative are known.[7]

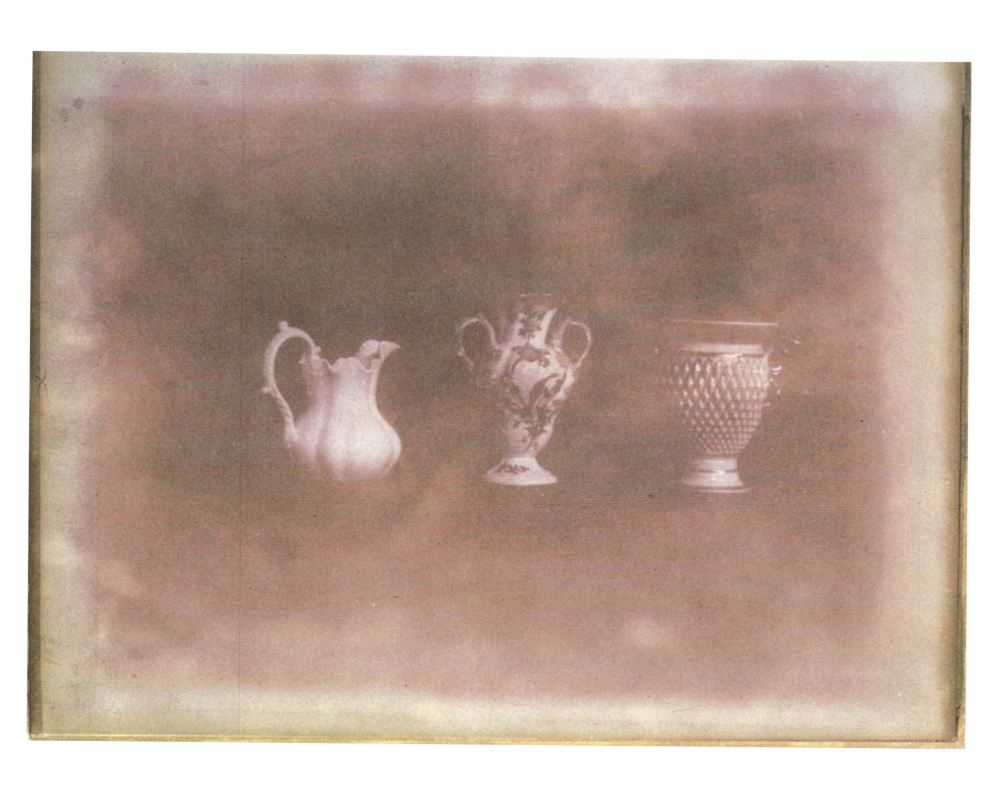

PLATE 22

"A Breakfast Table," Set with Candlesticks

2 March 1840. Salt print from a photogenic drawing negative, 17.5 x 21.6 cm.
Inscribed in ink on verso: "H.F. Talbot phot. 2d March 1840"
Lacock Abbey Collection, The Fox Talbot Museum, Lacock (LA2263/NB6)
SCHAAF 2358

A single generous-sized egg sits in the cup, a knife is carefully placed across the plate, and two candles are ready to be lit on what was likely a cold and dark winter's morning. In an intimate scene based on the comfort of living in a substantial country house, Talbot reveals to the camera a part of his everyday life. The soft lavender tones of this print likely resulted from fixing with ordinary salt, and almost certainly this print has softened since the day when it was first placed in Talbot's album. However, these tones are not wholly inappropriate to the mood of the early morning scene. One can imagine lighting the candles and brightening it all up. In both visual and social terms, this photograph is a contrast to the brightly lit and more elaborate table service set for several people recorded in Talbot's later photograph in plate 47. That photograph was obvious in its construction, using the table as a means of displaying an array of objects, just to see what the camera would make of them in its description. Curiously, the present photograph has more of

an air of reality about it. As soon as the toast fills the rack, the egg will be eaten.

The incongruous visual clues, such as the lawn, that normally betray where Talbot set up this type of picture are not present here. Typically, he took this sort of image with the table erected temporarily in the courtyard or the cloisters. The heavily starched tablecloth has been pinned to resist the motion of the wind.

In his manuscript negative list, Talbot recorded having taken a "breakfast table" on this day.[1] As late as the end of 1845, Henneman was still printing a "half sheet"-size "breakfast table."[2] Continuing in its appeal, as late as the end of 1852, Talbot loaned a negative of a "breakfast table" to Nicolaas Henneman for use in his printing of photographs for sale.[3]

This print is in Talbot's album No. 7 (which he termed "bad"). The negative is inscribed with the date and "W.1.X"; two other prints from it are known.[4]

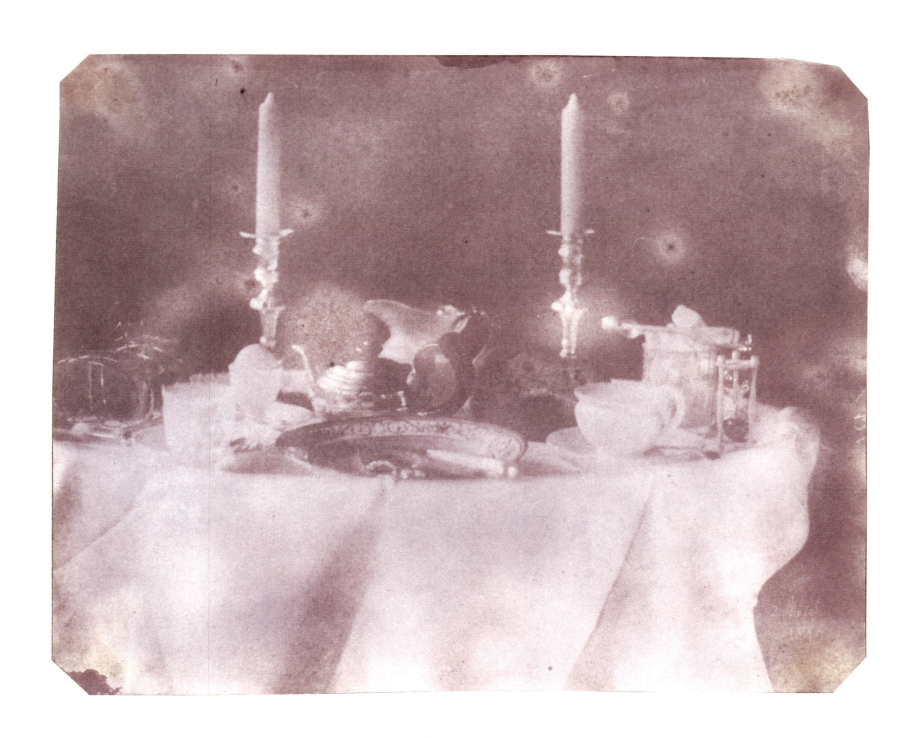

PLATE 23

A Stanza from the "Ode to Napoleon"— in Lord Byron's Hand

Prior to 4 April 1840. Photogenic drawing negative,
from an original ink on paper manuscript, 12.3 x 18.3 cm image
on 13.2 x 19.0 cm paper. Watermarked J Whatman Turkey 183
The Buhl Collection, New York
SCHAAF 604

Yes—One—the first—the last—the best—
The Cincinnatus of the West
Whom Envy dared not hate
Bequeathed the name of Washington,
To make ~~men weep~~ Man blush there was but One!—

Early in 1839, Talbot mused about the possibilities of taking the "Houses of poets, photogenically executed."[1] In a letter to Sir John Herschel in March of that first year of photography, Talbot hoped that "the enclosed scrap will illustrate what I call 'every man his own printer and publisher'." Substituting photography for the printing press would "enable poor authors to make facsimiles of their works in their own handwriting."[2] A year later, right in the middle of a string of research notes, Talbot jotted down the idea for "The Tribute of Science to Poetry, two views of house, and one copy of manuscript."[3] It seems likely that this cryptic statement was, in fact, a proposal for a privately printed memorial publication to Lord Byron, one planned to include the present image.

Byron wrote his *Ode to Napoleon Buonaparte* out of disgust over the rebellious leader's flight into exile.[4] Thomas Moore, the wildly popular Irish poet, was a neighbor and long a close friend of Talbot's mother, Lady Elisabeth Feilding. Moore, the confidant of the mercurial Byron, was ideally suited to become the author and editor of the fourteen volumes of his *Works* after the controversial poet's early death.[5]

Talbot hoped that Moore could contribute something to *The Pencil of Nature*, but the poet replied that "as I could not please myself in any of the trials I made to *pen* something for the Book, I am most glad that I did not send you any thing ~~inferior~~

stale—for, to have been in partnership with Sol without doing any thing worthy of the connexion would never have done for a poet—or rather *would* have *done for* me entirely."[6] After a better explanation from Talbot about the format required, Moore relented: "New things (at least professing to be new) are sure to be carped at, and this it was—the fear and consciousness of this—that paralyzed every effort I made to do something for you. But this new suggestion of yours removes every difficulty and I shall now have all the honour and glory of being solarized in your company without being at the same time criticised for my 'parts of speech.' Let me know if it is any particular kind of paper ~~I must~~ (certainly not the kind I am writing on now) that I must transcribe the two Melodies upon."[7] Sadly, this is one of the plates that was never published.[8]

Talbot's interest in the English romantic poet was not at all surprising and it is plausible that Moore was in a position to loan the original manuscript page.[9] It is likely that Talbot chose the last stanza more for technical reasons than out of literary preference. Since this photographic negative was made by contact printing from the original manuscript, Talbot needed a page that was written on only one side. As it is, the 1811 watermark on Byron's original sheet of writing paper is clearly reproduced (an added touch that was probably one of the few instances where Talbot welcomed the intrusion of the papermaker's mark). Although this photographic negative is undated, on 4 April 1840 Talbot wrote to Sir John Lubbock, enclosing "the facsimile of Byron's writing."[10] There are three other similar negatives known, two of which have prints associated with them. One of the negatives includes a photographed label of "Specimen of Byron's Hand."[11]

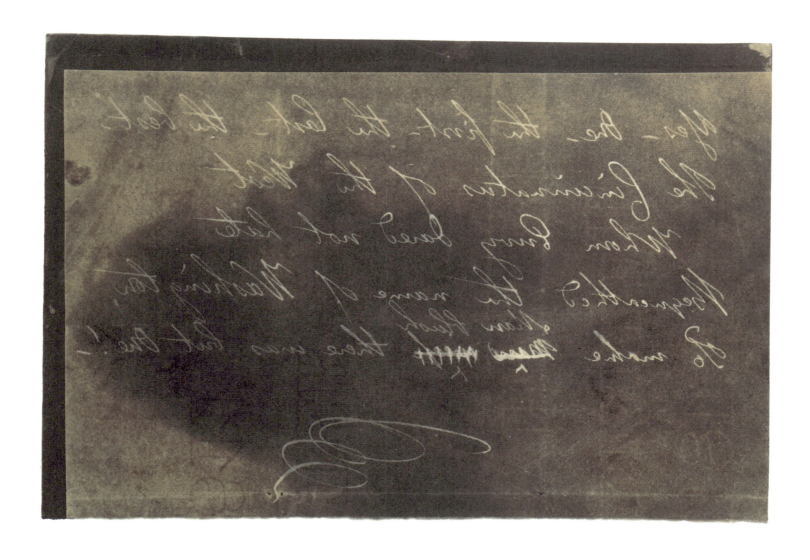

PLATE 24

"Maltese Vase & Boy Reading"

29 April 1840. Salt print from a photogenic drawing negative,
16.8 x 21.2 cm image
Lacock Abbey Collection, The Fox Talbot Museum, Lacock (LA2175/NB4)
SCHAAF 2408

Bathed in sunlight, sitting on a polished tabletop set up outside Lacock Abbey, a young boy studies while surrounded by the trappings of antiquity. Right below the base of the boy, one can see the date that Talbot inscribed in his negative, evidence of a growing awareness of the need to document the progress of his work in his new art.

In his first paper on photography, Talbot devoted an entire section to the "Delineation of Sculpture." In this, he said that "another use . . . of my invention is for the copying of statues and bas-reliefs. I place these in strong sunshine, and put before them a proper distance, and in the requisite position, a small camera obscura containing the prepared paper. In this way I have obtained images of various statues, &c."[1] Expanding on this idea when he discussed the *Bust of Patroclus* (pl. 58) in *The Pencil of Nature*, Talbot wrote that "statues, busts, and other specimens of sculpture, are generally well represented by the Photographic Art; and also very rapidly, in consequence of their whiteness. These delineations are susceptible of an almost unlimited variety: since in the first place, a statue may be placed in any position with regard to the sun, either directly opposite to it, or at any angle: the directness or obliquity of the illumination causing of course an immense difference in the effect. And when a choice has been made of the direction in which the sun's rays shall fall, the statue may be then turned round on its pedestal, which produces a second set of variations no less considerable than the first. And when to this is added the change of size which is produced by bringing the Camera Obscura nearer to the statue or removing it further off, it becomes evident how very great a number of different effects may be obtained from a single specimen of sculpture. With regard to many statues, however, a better effect is obtained by delineating them in cloudy weather than in sunshine. For, the sunshine causes such strong shadows as sometimes to confuse the subject. To prevent this, it is a good plan to hold a white cloth on one side of the statue at a little distance to reflect back the sun's rays and cause a faint illumination of the parts which would otherwise be lost in shadow."[2]

The title for this image comes from Talbot's manuscript negative list.[3] The dated negative, severely faded, survives.[4] This, the only known print from it, is in one of Talbot's albums, comprised of work accomplished in 1840.[5] The "Boy reading" and the "Maltese vase" were the subjects of a number of other Talbot photographs.[6]

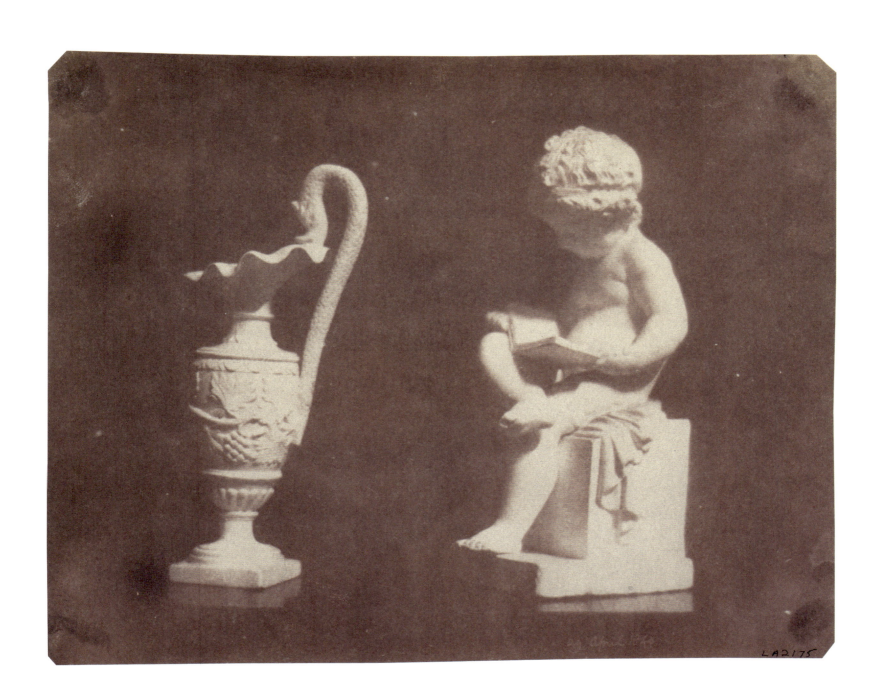

LA2175

PLATE 25

"Wall in Melon Ground"—at Lacock Abbey

2 May 1840. Photogenic drawing camera negative, 17.2 x 21.2 cm.
Inscribed in pencil on verso: "2d May 1840"
The J. Paul Getty Museum, Los Angeles (84.XM.260.6)
SCHAAF 2416

As a picturesque composition, the rhythm of the seasons and the tranquility of a country garden are well expressed here. As Talbot's confidence in his own mastery of the art of photography began to grow through the spring of 1840, he increasingly drew lessons about the visual display of nature from what the lens exhibited to him. His photographs show more careful composition of the elements, evoking existing scenes that he found, but coaxing the elements into more artistic arrangements. He was still using his original photogenic drawing process to make his negatives—even with greater sophistication in the manipulation of the chemistry his sunlight exposure times would have been reckoned in minutes—but with the right subjects and sufficient patience with the fickle English sunlight, Talbot was finally able to create the drawings that he had so longed for on the shores of Lake Como less than seven years before. Seen as an expression of technology, a negative like the present one is a thing of beauty. It is a fully functional object and, in spite of whatever advances photography was to make in the future, it could never be improved on in any really significant way.

On seeing a print from this negative, Talbot's friend Sir John Herschel was so excited that he momentarily set aside his nor-

mally guarded language: "I am very much obliged indeed by your *very very* beautiful Photographs. It is quite delightful to see the art grow under your hands in this way. Had you suddenly a twelvemonth ago been shewn them, how you *would* have jumped & clapped hands (ie. if you ever *do* such a thing)." Commenting on "the corner of a sunny wall with garden tools," Herschel enthused about "how admirably the broom shews—& the shine of the spade."[1]

Three years later, on 18 March 1843, Talbot had perhaps lost some of his initial excitement and had become too conscious of what he was doing. When he returned to this same section of wall, he utilized the same elements of broom and spade, but with a basket substituting for the pitchfork and the water bucket. His later view actually had a less daring composition, with three simple elements rigidly arranged in a pyramid.[2]

This negative is listed under this title in Talbot's manuscript negative list.[3] It was a deservedly popular one with Talbot, and five (unfortunately all very pale) prints are known to have survived, including the one to Herschel, one to Sir David Brewster, and one to the Italian botanist and gardener Antonio Bertoloni.[4]

PLATE 26

"*Trunk of Larch,*" *Supporting a Basket*

3 May 1840. Salt print from a photogenic drawing negative,
17.0 x 20.7 cm image on 18.7 x 22.8 cm paper
Lacock Abbey Collection, The Fox Talbot Museum, Lacock (LA2288/NB6)
SCHAAF 3839

Contrasting the man-made texture of the basket with the natural texture of the tree trunk, Talbot has isolated these elements in sharp relief against a softly focused background. He placed his camera at an unusually low position, not from the point of view of a mouse as was once encouraged by his simple little boxes (pl. 3), but rather to concentrate the viewer's eye on the strength and mass of the trunk. The cropping of the subject is peculiarly photographic.

A fortnight after making this photograph, Henry Talbot courageously exhibited a large group of his latest photographs before a very critical audience. The one hundred professional artists who made up the Graphic Society[1] were the "*élite* of the professors of Art, painters in oil and water-colours, sculptors, architects, and engravers."[2] Six times a year they held their *conversazioni*, and for each of these meeting they encouraged their members and visitors to show "rare and interesting Works of Art."[3] It was to be the second time in 1840 that Talbot had shared his work with them. In February, not long after the sun had started being more kind to him, Talbot exhibited a select group of framed and glazed photographs, first at a London soirée hosted by Charles Babbage, and a few days later when Charles Wheatstone took them to display at the meeting of the Graphic Society.[4] The verdict that these were "superior to any we had before seen" must have been greatly encouraging to Talbot.[5]

He continued to produce a steady flow of fine new photographs throughout the spring and by May was in a position to provide a much larger exhibition. Since he journeyed to London specifically for this period, he must have presented his work in person. In a preview of what he was to show, the *Literary Gazette* considered what Talbot had created "during his spring residence in the country; and certainly they are not only beautiful in themselves, but highly interesting in regard to art. The representation of objects is perfect. Various views of Lacock Abbey, the seat of Mr. Talbot; of Bowood; of trees; of old walls and buildings, with implements of husbandry; of carriages; of tables covered with breakfast things; of busts and statues; and, in short, of every matter from a botanical specimen to a fine landscape, from an ancient record to an ancient abbey, are given with a fidelity that is altogether wonderful . . . among the curious effects to be observed is the distribution of lights and shades. The former, in particular, are bold and striking, and may furnish lessons to the ablest of our artists . . . indeed, there is nothing in these pictures which is not at once accurate and picturesque."[6] Frustratingly, this advance review is the most complete information we have on the subject, for no record has been traced of what the members thought of the freshly produced photographic art. Perhaps as some indication of their reaction, however, in 1849, they made William Henry Fox Talbot an Honorary Visitor, a privileged group shared that year by the likes of John Ruskin.

As in most of his examples throughout 1840, Talbot dated his negatives in a position that would be evidenced in each print (the now-faint date here is at the bottom just to the right of the trunk). The negative itself is not known to have survived; perhaps the brutally severe cropping of the only other known print hints at a tragedy that befell it during Talbot's day.[7] The title is from Talbot's manuscript negative list,[8] and this print is in his album No. 7.

PLATE 27

Slice of Horse Chestnut,
Seen through the Solar Microscope

28 May 1840. Salt print from a photogenic drawing negative,
17.1 x 20.5 cm image on 18.6 x 22.5 cm paper. Watermarked J Whatman 1838
Hans P. Kraus, Jr., Inc.
SCHAAF 2432

The parallel between images created by the telescope and those by the microscope is strong. Both rely on such a radical change of scale that a normally unseen world is brought into view. Here we see mysterious leaflike masses being drawn into a vortex composed of what appears to be seething energy. The camera might just as well be reaching into the vast recesses of space as closely examining something too small for the eye to see. Microcosm or macrocosm, it is a world unknown.

In his first paper on photography, Talbot wrote about "a branch of the subject which appears to me very important and likely to prove extensively useful, the application of my method of delineating objects in the solar microscope. The objects which the microscope unfolds to our view, curious and wonderful as they are, are often singularly complicated. The eye, indeed, may comprehend the whole which is presented to it in the field of view; but the powers of the pencil fail to express these minutiæ of nature in their innumerable details. What artist could have skill or patience enough to copy them? or granting that he could do so, must it not be at the expense of much most valuable time, which might be more usefully employed? Contemplating the beautiful picture which the solar microscope produces, the thought struck me, whether it might not be possible to cause that image to impress itself upon the paper, and thus to let Nature substitute her own inimitable pencil, for the imperfect, tedious, and almost hopeless attempt of copying a subject so intricate . . . when a sheet of . . . 'sensitive paper,' is placed in a dark chamber, and the magnified image of some object thrown on it by the solar microscope, after the lapse of perhaps a quarter of an hour, the picture is found to be completed."[1]

In 1853, responding to some questions, Talbot disclosed some more details about his earliest photographs: "The first person who applied photography to the solar microscope was undoubtedly Mr. Wedgwood . . . but none of his delineations have been preserved, and I believe that no particulars are known. Next in order of time to Mr. Wedgwood's, came my own experiments. Having published my first photographic process in January, 1839, I immediately applied it to the solar microscope, and in the course of that year made a great many microscopic photographs . . . the size of these pictures was generally . . . about eight inches square. The process employed was my original process, termed by me at first 'Photogenic drawing,'—for the calotype process was not yet invented. I succeeded in my attempts, chiefly in consequence of a careful arrangement of the solar microscope, by which I was enabled to obtain a very luminous image, and to maintain it steadily on the paper during five or ten minutes, the time requisite. From the negative, positives were made freely, in the usual way. The magnifying power obtained was determined by direct measurement of the image and the object itself, which gave for result a magnifying power of seventeen times in linear dimensions, and consequently of 289 in surface. The definition of the image was good. After the invention of the calotype process, it became of course a comparatively easy matter to obtain these images; and I then ceased to occupy myself with this branch of photography, in order to direct my whole attention to the improvement of the views taken with the camera."[2]

Talbot's photomicrographs were matched in the daguerreotype process: Andreas Ritter von Ettingshausen's strikingly similar *Section of Climatis* was made within two months of Talbot's horse chestnut.[3]

This print was formerly in the collection of Harold White. The negative for it is listed under the title of "Slice H. Chesnut microscope" in Talbot's manuscript negative list and is inscribed with the date.[4] One other print is known, in Talbot's album No. 7 (which he listed as "bad"—in this case the label is appropriate as that print is very pale).[5]

PLATE 28

Lacock Abbey in Reflection

Summer 1840? Salt print, probably from a photogenic drawing negative,
16.6 x 19.2 cm image on 18.4 x 22.9 cm paper.
Watermarked J Whatman Turkey Mill 1839. Pencil "X" on recto
The National Museum of Photography, Film & Television, Bradford (1937-366/24)
SCHAAF 1102

In a beautiful massing of lights and darks, Talbot has artfully framed the distinctive tower of his home with carefully placed forms of his favored trees. The scale is deceptive, for on close examination the initially massive tree framing the left is really a rather modest one on just the other side of the small pond. If the tree were nearer to the horizon, more at the distance of the abbey, it would have to be huge to balance this composition, and the angle of its reflection would place the broad mass of its leaves (instead of the narrow line of its trunk) into the water, blocking too much of that sheet of white for it to balance the sky. The near branches in the upper right redirect the eye into the picture. Talbot achieved this composition by actually placing his camera on the ground, much as he had done for his first "mouse trap" images (such as pl. 3). However, the extremely low point of view in this later image was a conscious visual decision, not just an expediency. The view is from the northeast, looking at the east front of the abbey. The small pond in which this is reflected survived the changes made by Lady Elisabeth Feilding and is still on the grounds of the abbey. It is near the area where in the eighteenth century there was once an extensive, L-shaped picturesque *canale*.

Talbot was fascinated with reflections in general and made a number of different photographs of Lacock Abbey mirrored by water. The earliest explicit record of such an attempt is an 18 April 1840 listing of "Abbey: image in river."[1] The best known of these was plate XV in *The Pencil of Nature*.[2] That was taken from the southeast , just across the China Bridge (pl. 39), and emphasized the south front of the abbey, showing just a portion of the east front. On 8 June 1840, Talbot recorded sending a print of a "reflectn. in river" to Jean-Baptiste Biot, his most ardent scientific supporter in France.[3] Only small portions of Biot's collection have surfaced thus far, and no image like this is known to be among them. Although the present image uses a pond rather than the river, perhaps Talbot had applied a bit of poetic license in the title he sent to Biot, and perhaps he sent a print matching this.

This print is in an album generally thought to have been compiled by Lady Elisabeth Feilding. It was Talbot's album No. 10 in his listing and is comprised of four negatives and fifty-four prints. Of the positively dated items in this album, six are from 1840, twenty-six are from 1841, and two are from 1842, making an 1840 or perhaps 1841 date for this image plausible. If from 1840, the negative would have had to be a photogenic drawing negative, and the coarse tones and slightly reduced definition of this image supports that attribution. By the following year Talbot most logically would have used his new calotype negative process. The negative for this survives but is inscribed with only a "30", which might indicate an exposure of thirty minutes.[4] One other print is known and is also on Whatman 1839 paper.[5]

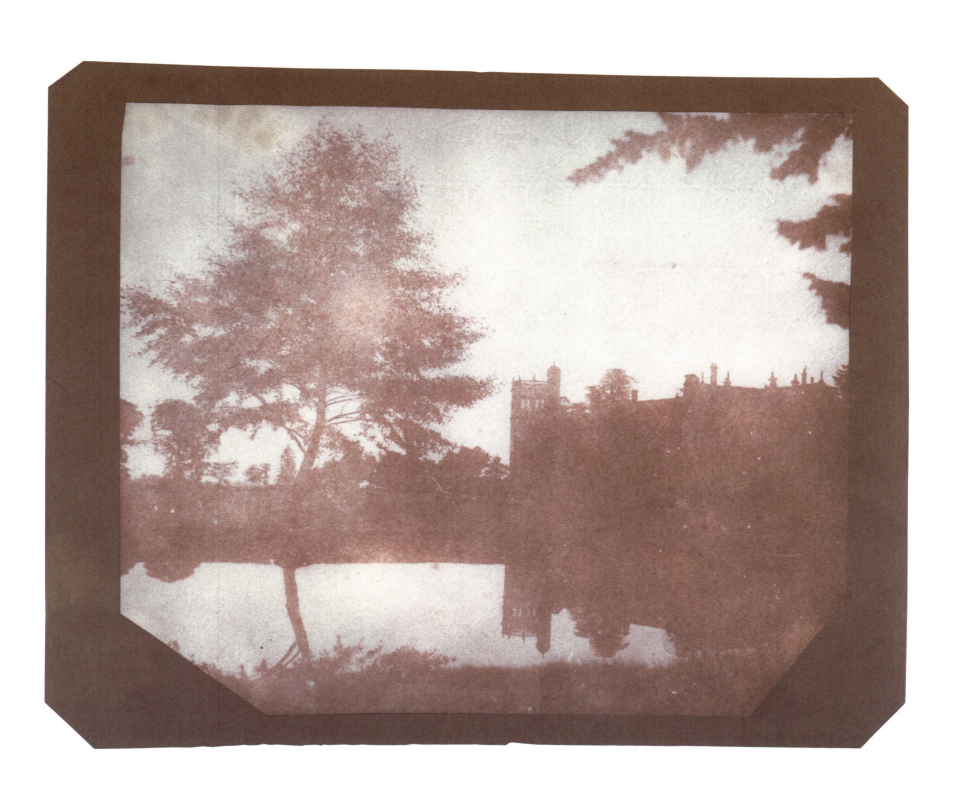

PLATE 29

Diogenes, in the Great Hall of Lacock Abbey

29 September 1840. Salt print from a calotype negative,
12.3 x 8.8 cm image on 18.5 x 11.3 cm paper. Pencil "X" on recto
The National Museum of Photography, Film & Television, Bradford (1937-365/23)
SCHAAF 2478

Standing in the Great Hall of Lacock Abbey in the late afternoon, one becomes aware of the rapid flight of the light as the Gothic Revival windows, with their insets of ancient glass, direct patterns across the room. These forms move with a visible speed. In his first paper on photography, Talbot wrote about the "Art of Fixing a Shadow": "The phenomenon . . . appears to me to partake of the character of the *marvellous*, almost as much as any fact which physical investigation has yet brought to our knowledge. The most transitory of things, a shadow, the proverbial emblem of all that is fleeting and momentary, may be fettered by the spells of our *'natural magic,'* and may be fixed for ever in the position which it seemed only destined for a single instant to occupy . . . such is the fact, that we may receive on paper the fleeting shadow, arrest it there, and in the space of a single minute fix it there so firmly as to be no more capable of change, even if thrown back into the sunbeam from which it derived its origin."[1]

It is an extraordinarily happy coincidence that such a beautiful and haunting image also represents such a major technical advance for Talbot. It was one of the first of his calotype negatives, made using a process he had discovered only a few days before. In his research notebook *Q*, the last four days of September are a gap.[2] Talbot recorded having made only three other negatives in this period, none approaching the spectacular nature of this one. In his manuscript list, Talbot gave the present image the prosaic name of "Diogenes (small) with g."—recognizing the gallic acid that was the key to his new success.[3] The powerful symbol of the fourth-century B.C. cynical philosopher, Diogenes of Sinope, carrying his lantern through the light of day in the search of truth is inescapable. Talbot would have observed the daily rush of afternoon light brushing across the statue long before he conceived of photography. Recording this in his camera would have appealed to him immediately, but he simply would not have been able to make this image with his slower photogenic drawing negative paper. It exists for only moments each day.

The Great Hall itself was a mid-eighteenth-century addition by John Ivory Talbot, but the full story of the very special terra cotta statues in its niches has yet to be uncovered. In 1753, after having been introduced to the architect Sanderson Miller by Richard Goddard, he wrote to request "that you would fix on proper Places for a few Niches, having an Intention of placing a Plaister of Paris Figure of the Foundress (about 3 feet high) in one, and I should be glad of two or three smaller niches for nun's heads, etc. An Italian lately come to Salisbury executes these Figures well and reasonable."[4] In January 1756, John Ivory Talbot reported to Miller that "the foreigner who has been here ever since May has executed his Performance in a very Workmanlike manner and your Niches are filled by a set of inhabitants worthy of such Repositories. I presume you are acquainted with the method of making Models for Statues. He proceeds on the same Principles, only Bakes them afterwards, by which means they become of a Red Colour and ring like a Garden Pot . . . his Performances, which are both Easy and not Expensive. His name is sonorous, no less than Victor Alexander Sederbach and yet lodges at one King's a Grocer in Green Street, near Castle Street, Leicester Fields. I am sorry he did not show all his Performances to the Gentleman you sent a note by, but on asking the Reason, was told that someone the day before had Broke a Figure, which had made him extremely Captious."[5]

Mike Weaver was so impressed with this photograph that he named Henry Talbot a "Diogenes with a Camera."[6] Curiously, this is the only known print from this spectacular negative.[7] The inscription on the negative reveals that this was done with a 1'20" exposure.[8] On 6 October, Talbot took another view, titled "Diogenes, without sun, 17' (small)."[9] Judging by the number of prints he distributed of this latter, far less visually pleasing view, Talbot must have been swayed by the ability of his calotype material to accumulate the weak interior light.

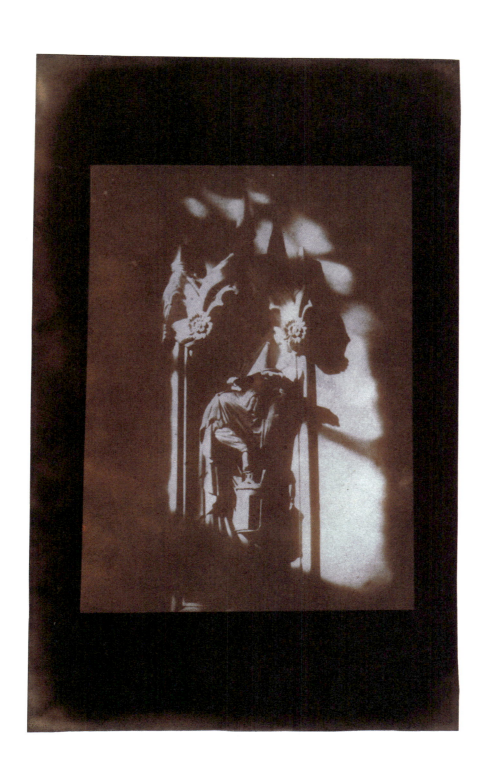

PLATE 30

"Three Chimnies (Large)"

7 October 1840. Calotype negative, 13.4 x 12.7 cm.
Inscribed in turquoise ink on verso: "3' evening sun large C. smallest aperture"
and "Oct. 7. 1840"; inscribed in pencil on verso: "7"
Photographic History Collection, National Museum of American History,
Smithsonian Institution, Washington, D.C. (1995.0206.109)
SCHAAF 2495

In this surrealistic view of three of the fantastically sculpted chimney shafts that crown Lacock Abbey, Talbot pushed his newly sensitive calotype negative paper to its limits. With the weak sun of an autumnal evening, using the smallest aperture on the lens of his largest camera, he demonstrated to himself that the need for his diminutive "mouse trap" cameras and extended exposures was over.

The general view is a reasonably familiar one to the modern visitor; the twisted chimneys predominate in the southeast corner of the north courtyard of Lacock Abbey. However, the point of view is somewhat deceptive here. The prominent chimney in the center of this composition is in fact the right-hand one of the group of three. The left-hand one is partially obscured by a dormer roof and the central one (the right-hand one in this view) is behind the main roof. The arrangement reveals that Talbot took refuge in the "Bottle Room," in the west range of the abbey, above the main kitchen. Looking through its window, the camera was protected from the chill air and gusty winds of October in Wiltshire. It seems that the Bottle Room was christened after Henry Talbot's death, as much of his experimental glassware remained on its shelves for many years. Although just where in the abbey Talbot did the bulk of his chemical preparations has never been established with certainty, this would have been a logical room to employ. As in all early photography, the kitchen was the source for many of the chemicals and preparation tools that were required, and its proximity to this room would have been a bonus. If this was in fact his "laboratory," in an excited train of discovery, simply pointing the camera out the nearest window as the light began to fail would have been a logical step.

As evidenced in another of Talbot's photographs, sometime around 1843 to 1845 one of these chimney shafts was stripped of its disfiguring pot, perhaps because it was a failure at suppressing the smoke.[1] The chimneys of Lacock Abbey have had a rather peripatetic life.[2] When Henry Talbot was converting the south gallery in the 1830s, his mother reported that "they are going to put up the old twisted chimney that lay in the Cloisters, so as it is all ready, it will be soon done & very pretty."[3] A spectacular double-columned chimney shaft topped with Benjamin Carter's Sphinx has served as a garden ornament since the eighteenth century.[4]

This negative is listed under the title of "3 chimnies (large)" in Talbot's manuscript negative list.[5] The only known print is a very pale one in Talbot's album No. 8 (which he listed as "bad").[6]

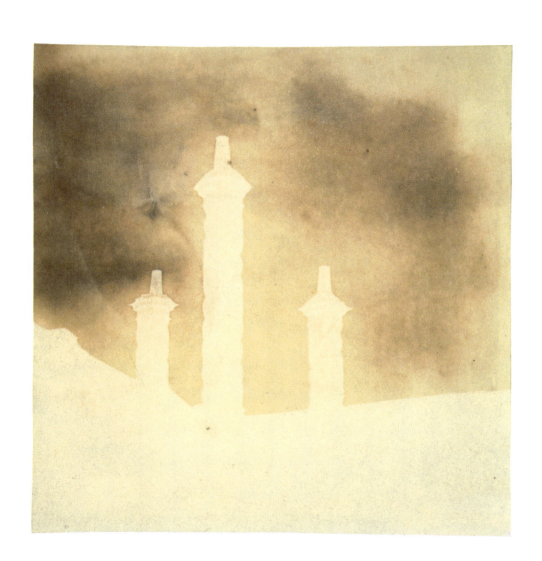

PLATE 31

The Ancient Vaulted Ceiling of the Cloister, Lacock Abbey

9 October 1840. Salt print from a calotype negative,
11.3 x 12.2 cm image on 11.3 x 18.2 cm paper
Photographic History Collection, National Museum of American History,
Smithsonian Institution, Washington, D.C. (1995.0206.154)
SCHAAF 2501

Like an image from the distant past just barely retrieved, it is easy to imagine that this scene represents the thirteenth century just as much as the nineteenth. The remains of the medieval nunnery at Lacock are the finest preserved and most complete of any in England; sketching them in this sort of detailed perspective would have been challenging for any artist. For Talbot, this image was doubly a technical triumph, not only accurately recording the fine ribs, tiercerons, and liernes, but doing so by penetrating the gloom of a ceiling area barely reached by the rays of the sun. The double column establishes that this was at the east end of the cloister, but whether on the north or south walk is impossible to determine because of the restorations effected at the end of the nineteenth century. The day before he took this image, Talbot had employed a thirty-minute exposure to record the interior of the Chapter House at Lacock. For the present view, he extended the exposure to thirty-five minutes, the longest he ever recorded for a calotype negative. Since his calotype paper was most sensitive when exposed while still moist, this would have approached the limits of what was practical. The deep purple tone of the print, indi-cating that it was fixed with salt (or perhaps even not fixed), adds to the somber and contemplative tone of this photograph.

Hardly more than a month before taking this, Talbot had written to his colleague Sir John Herschel about his progress in photography. In spite of his rapid advances in vision in the early part of 1840, it proved to not be an easy year for him: "I have not been able this summer to give more than a desultory and divided attention to the subject. I had & still have the intention of making a little photographic tour, in search of objects more picturesque than my own immediate neighbourhood supplies. A great desideratum is more sensitive paper, in order that the tourist may make many sketches in one day with one instru-ment."[1] Then came the discovery of the latent image and the tremendous amplification power of the gallic acid developer.

This negative is listed under the title of "*interior* of Cloisters 35'" in Talbot's manuscript negative list;[2] the surviving nega-tive is dated and inscribed with the exposure time.[3] One other print is known, in Talbot's album No. 8 (which he described as "bad").[4]

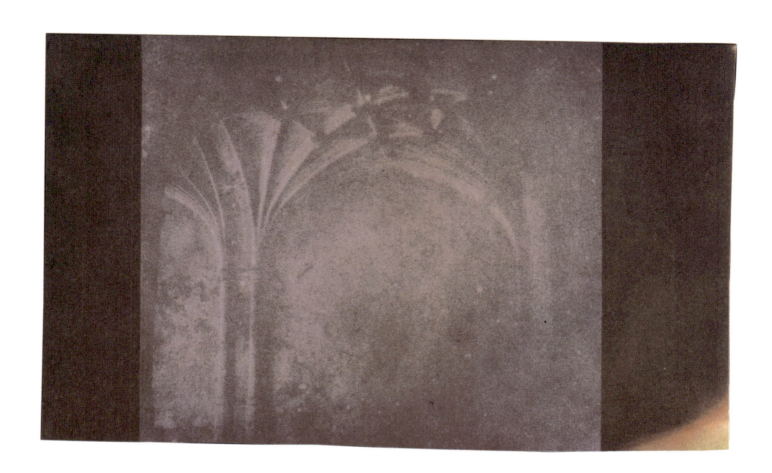

PLATE 32

Constance Talbot

10 October 1840. Salt print from a calotype negative,
9.3 x 7.6 cm image on 11.4 x 8.6 cm paper.
Inscribed in pencil on verso: "Oct. 10. 1840" and "30""
The Royal Photographic Society, Bath (RPS025130)
SCHAAF 2503

In this intimate and loving view, Constance Talbot gazes beatifically up to the light. She is made more majestic by the low camera angle. The very first portrait Henry Talbot ever took of a human being was just five days before this—it was also of Constance, and the present image was the fourth one of her that he attempted. In this case, he got it right. The other three, while extraordinarily important historically as records of technical advances, could most charitably be described in visual terms as informal portraits (the kind that we would associate with the output of modern snapshot cameras). These first portraits came just a fortnight after his discovery of the calotype.[1] This one alone transcends the context of experiment. Carefully and sensitively composed and artistically executed, it rises above the others.

In the following spring, in Talbot's announcement of the potential of the calotype negative process, he wrote that "one of the most important applications of the new process, and most likely to prove generally interesting, is, undoubtedly, the taking of portraits. I made trial of it last October; and found that the experiment readily succeeded. Half-a-minute appeared to be sufficient in sunshine, and four or five minutes when a person was seated in the shade, but in the open air. After a few portraits had been made, enough to shew that it could be done without difficulty, the experiments were adjourned to a more favourable season."[2]

In addition to being a beautifully executed record of a loved one, this portrait has a technical significance beyond the fact that it is such an early calotype. The exposure time was thirty seconds, much improved from the tens of minutes that photogenic drawing required, and not too difficult an interval in which to hold a pose. However, staring into the bright sun for this long could have been most unpleasant. Talbot's solution was one that was generally associated with the commercial portrait studios that would follow two decades after this. By filtering the sunlight through blue glass, Talbot could put his sitter at ease. While the blue glass protected Constance's eyes by screening out the red rays, this filter had little effect on the exposure time of the calotype negative. In common with other early photographic materials, it was sensitive primarily to this blue light—the *actinic* light—a point particularly emphasized by the researches of Sir John Herschel.[3] In a letter six months before this portrait was taken, Constance recalled the "photogenic wants" of her husband for a shopping trip: "the foremost of which, *good paper* & *blue glass*."[4] The idea of restricting the light to the blue range had been employed by Talbot for some time. For example, on 10 February 1839 he recorded the thought to "have a brass frame made, with squares to hold blue glass and perhaps also green glass. Fix before 17 inch mirror therefore rays will pass twice through it, and throw them on a flower, a bust, or on the lens of the microscope."[5]

This is the only known print of this important image. It was folded most likely in Talbot's day as an indication of where it should be trimmed—thankfully, these instructions were never carried out.[6] The negative is listed under the title of "C's portrait, 30" blue glass" in Talbot's manuscript negative list;[7] the surviving negative is dated and inscribed with the exposure time.[8]

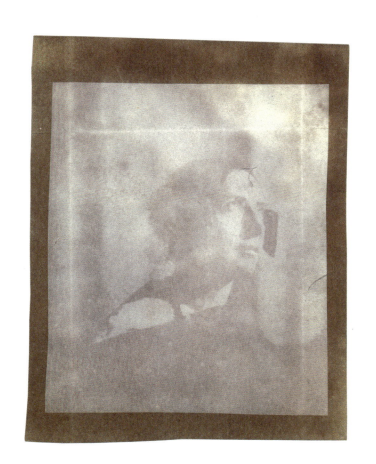

PLATE 33

"The Footman"

14 October 1840. Salt print from a calotype negative,
16.3 x 21.0 cm image on 18.5 x 22.5 cm paper
Collection of Wm. B. Becker
SCHAAF 2507

In dispatching a new group of photographs to his friend Sir John Herschel, Talbot allowed himself the modest boast that "the footman opening the carriage door is also a good likeness, done in 3 minutes sunshine."[1] The strength of the sunshine here matches the strength of the imagery. The footman welcomes his passengers—the viewers—with an upraised hand, an open door, and steps dropped to the ready. The fine lines tracing the outline of the coach maker's art are echoed by the trim on the coat. It is a scene of splendor and power and pride, captured by Talbot's still-new calotype process. With the three-minute exposure required to obtain this amount of sharpness,[2] the stance of the footman is surprisingly lifelike, even considering the conceit of grasping the door and turning the feet out to form a solid human stand.

This is not just an image of a typical moment at a country house, but rather more like the modern practice of getting photographed proudly standing in front of one's new motor car. By the command of Her Majesty, on 30 January 1840, William Henry Fox Talbot was appointed Sheriff of the County of Wilts.[3] It was a prestigious position that demanded a certain amount of elegant trappings. His ever-proud mother, Lady Elisabeth Feilding, was not sparing of her advice, and prodded her son into outfitting his staff to properly reflect his new position. The New Bond Street tailoring firm of G. & H. Fletcher in London sprang into action.[4] Lady Elisabeth was pleased with her work and related to Henry that "I have just seen your two footmen *dressed* & paraded in their new Liveries, which look extremely handsome. Everything is now settled, except the hats, which I think should be round *with silver cords* like the Duke of Devonshire's—and will order them so if you please."[5]

Just why Lady Feilding, acutely conscious of the impact of names, would have tolerated the misspelling of her own surname on the driver's box is impossible to understand. Perhaps what we are seeing is a temporary piece of luggage? Or a hasty chalking by Nicolaas Henneman (whose freedom with the fine points of spelling in the English language was frequently apparent)?

This was the last human being that Talbot was to photograph until his portrait of *Nicolaas Henneman in the Cloisters* (pl. 40) more than four months later. This negative is listed under the title of "footman (2) at carriage door 3' (large)" in Talbot's manuscript negative list.[6] The negative itself is now in a very strong visual state, having been redeveloped by Harold White, likely in the 1940s or 1950s.[7] The fading that led to White's strengthening this negative likely occurred because the negative was printed so many times in the sun. Sadly, none of the known prints of this spectacular image is very strong, probably because they were shown to visitors with great frequency.[8]

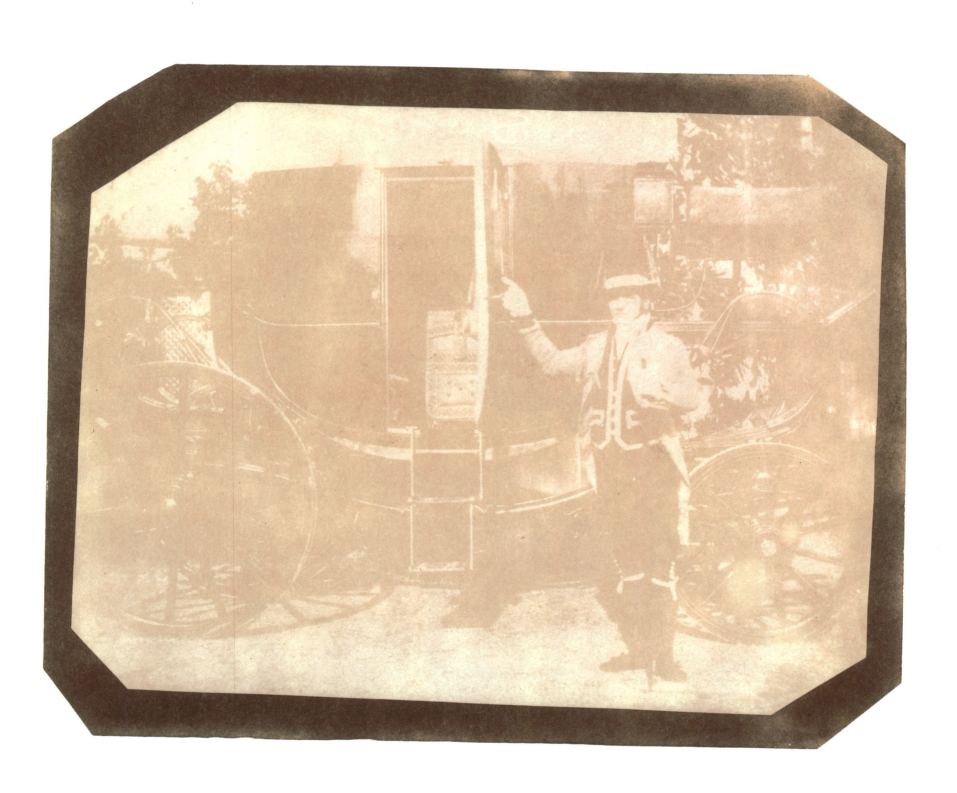

PLATE 34

Inside the South Gallery of Lacock Abbey

Late 1840? Salt print from a calotype negative, 16.2 x 22.6 cm image
on 18.8 x 22.9 cm paper. Watermarked J Whatman 1840
Lacock Abbey Collection, The Fox Talbot Museum, Lacock (LA2287/NB6)
SCHAAF 1040

Although the generations before and after him worked extensively to adapt Lacock Abbey to their needs, the only major change to the complex that Henry Talbot made during his lifetime was the rebuilding of the south gallery. This 1830s project was a major undertaking, possibly with a view toward installing a gallery of art, and led to the installation of the famed oriel windows. These opened it up so much to the light that Lady Elisabeth Feilding enthused in 1831 that "nothing can be so delightful as the Gallery. I do nothing but walk up & down & *look at it*."[1] Even with his much more rapid calotype negative process, Talbot was brave to attempt an image of this scene. We are looking toward the east, down the long gallery, and Talbot's library was just beyond the gloom at the end. The afternoon sun streams in, relatively unimpeded by trees on this face of the abbey. In order to secure enough depth of field to convey a sense of sharpness throughout, Talbot would have had to use a very small aperture on his lens, and this led to the exposure time of ten minutes in spite of the bright sunshine.[2] Perhaps he felt a sense of disappointment at the result, but it was an ambitious attempt, and must be the earliest photographic record of a broad expanse in the interior of a house.

Dating this image presents enormous difficulties. The undated negative has various markings but these have yet to be correlated with anything in his research notes. This print (the only one known) appears in Talbot's album No. 7 (one he labeled as "bad"). Of the fifty-three prints and one negative in this album, five can be positively dated to 1839 and twenty-nine to 1840. None are later and the watermarks on the prints range from 1837 to 1840. Thus, an 1839 or 1840 date is most likely. Talbot recorded taking and keeping both a large and a small negative of the "Interior S. Gallery" on 23 November 1839.[3] Although the smaller negative has yet to be located, the larger one is a less ambitious view of Patroclus bathed in the full light of the large oriel window.[4] On 2 March 1840 (the same day he photographed the breakfast table in pl. 22), Talbot again recorded a view of "Interior S. Gallery."[5] That image has not been located; however, the ten-minute exposure recorded for the present image precludes the possibility that it was done with the photogenic drawing material that was the only medium available to Talbot early in 1840. It is likely that this earlier negative, using what must have been a very extended exposure time, was not successful, forcing Talbot to wait for this scene until after his discovery of the calotype. A more limited view of the south gallery, similar to the present one but taking in only about half the length of the hall, is also undated.[6]

Several markings in the negative are reproduced faintly within the print. The negative is inscribed with an "X" in each corner, "1+2 Water much iod.", "I29", and "10'."[7]

PLATE 35

Oriel Windows, South Front, Lacock Abbey

24 December 1840. Salt print from a calotype negative,
17.2 x 21.3 cm image on 18.6 x 22.8 cm paper
Private collection, courtesy of Hans P. Kraus, Jr., Inc.
SCHAAF 2540

In 1835, well before the public knew about photography, Constance Talbot described to her husband a visit where she had been out "on the water, rowing in the bright moonlight. We were fully rewarded by the beauty of the scene—so much prettier everything looked than by daylight . . . the colouring reminded me a good deal of some of your shadows."[1] Indeed, the scene Constance described might just as well have been this view of the south front of Lacock Abbey. The effect is like that of bright moonlight. The glare on the windows hides the interior of the house. One can imagine a peaceful Christmas Eve, a time when the moonlight might appear to the eye just about as vigorous as the weak sunlight of an overcast winter's day. At the close of the second public year of photography, Talbot had every reason to be pleased. In the previous winter, the growth of his personal vision had been extraordinary. The spring and summer of 1840 had yielded a steady stream of ever-improving photographs. Then in the autumn came the discovery of the calotype negative. Although the new process had not yet been disclosed to the public when Henry Talbot took this picture—indeed, it was not yet even named—he knew he could go into the new year confident that his concept of negatives on paper was finally fully practical.

That his negatives were made on sheets of ordinary paper, combined with the lack of any factory-standardized negative holders for his cameras, meant that Talbot could take certain liberties in their trim. One can readily understand the minor irregularities of trim in his earliest photograms, and even perhaps the wandering of the shears in a trapezoidal negative like the *Bookcase* (pl. 16). The neat trimming of the corners of negatives (such as the *Melon Ground*, pl. 25) can be interpreted either as a visual style, mimicking French prints of the time, or perhaps just as a practical expedient for the repeated handling of a vulnerable piece of paper. But nothing serves to explain how a scientific man like Talbot could arrive at the fantastic trim of the present piece. The top left looks as though he began to cut a traditional arch, but this is belied by the sharp stop in the upper right. The lower left might have been gently nipped away to remove defects, but then the lower right is lopped off far more brutally. One can hardly defend this shape on aesthetic grounds. The subject has been violated, with essential elements of the architecture casually left dropping to the floor.

The negative is preserved in very good condition and in this exotic trim; it is dated in Talbot's hand and has some modern inscriptions;[2] numerous prints are known.[3]

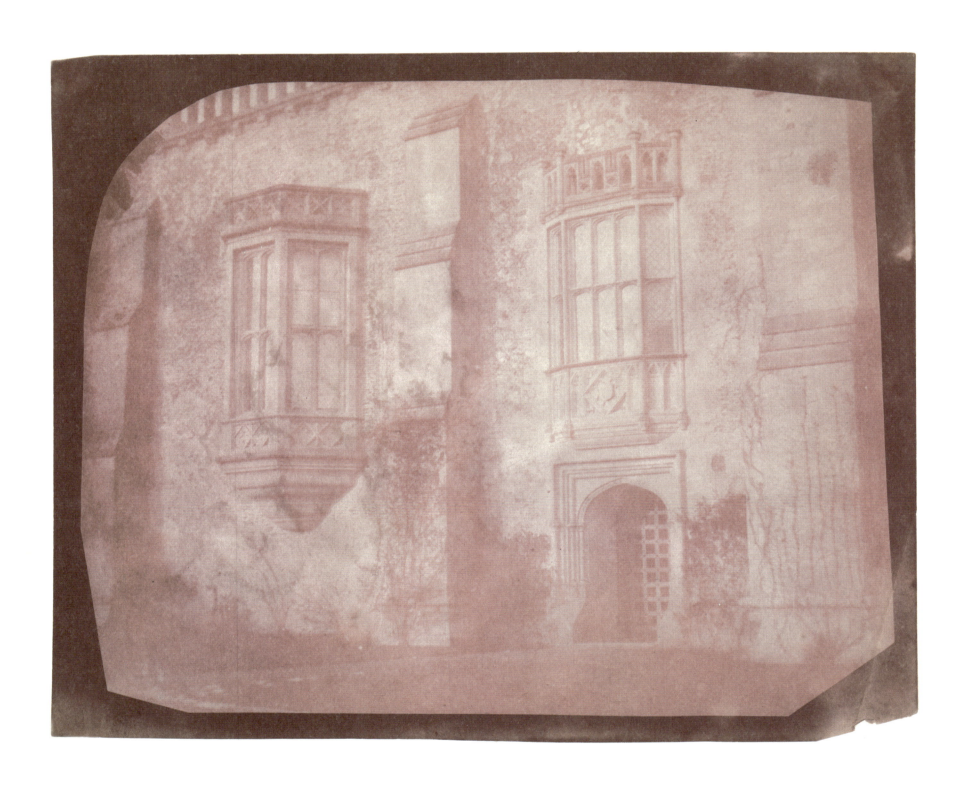

PLATE 36

Hand

1840/41? Salt print from a calotype negative,
8.8 x 6.8 cm image on 10.9 x 8.6 cm paper, with a stationer's blindstamp
The National Museum of Photography, Film & Television, Bradford (1937-0369/29)
SCHAAF 3684

Next to the face, nothing represents the human existence more than a hand. Long a symbol in art and more broadly in culture, the hand is most typically portrayed with the palm facing toward the viewer. Does this photograph have a symbolic meaning, or is it a simple examination of something attached to oneself—a simple little act of wonder? If it was such a recording, would it not be easier and more natural to contemplate the palm rather than the traditional back? Or is it a Masonic signal? This image is so enigmatic that it prompted one biographer of Talbot to seek the reading of a palmist.[1] Another author compared it to the hand of God.[2] Talbot himself found that it was a "most curious fact . . . that the ancients should have seen or imagined so great a similarity between the ideas of *straightness*, and *the right hand*, as to induce them to call them by the same names and almost to identify them. But this is not all, for they have combined with these two ideas, a third, viz. that of a *King*,

so closely that they can hardly be separated . . . the notion of *power* is strongly connected with *the right hand*, which, for that reason, is called in Anglo-Saxon, *the stronger hand*."[3]

The only two other prints known of this image are in Scottish albums (Dr. John Adamson's and Sir David Brewster's), which suggest a possible influence that Talbot may have exerted.[4] The Scottish engineer and artist James Nasmyth knew both men, and there is every reason to believe that with his early interest in photography he saw their albums. Three decades after Talbot's photograph would have entered these albums, Nasmyth extended the back of his own aging hand in front of a camera lens. The intent was to bolster his theory on how certain mountain ranges on the moon resulted from the shrinkage of the interior.[5]

The negative for Talbot's thought-provoking image is not known to have survived.

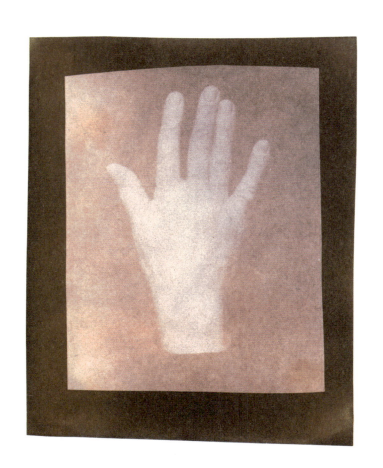

PLATE 37

"The Soliloquy of the Broom"

21 January 1841. Salt print from a calotype negative,
15.3 x 17.3 cm image on 18.7 x 22.5 cm paper
Private collection, courtesy of Hans P. Kraus, Jr., Inc.
SCHAAF 2548

The Open Door (pl. 82) is perhaps the most readily recognized of Henry Talbot's photographs. Here we see just how early he had started thinking about the basic idea for this image. It was Talbot's mother, Lady Elisabeth Feilding, who conceived of the poetic title for the present image: *The Soliloquy of the Broom*.[1] And this broom is, in fact, carrying on a conversation with itself, unaware of any audience. Although its diagonal acts as a barrier across the doorway, the light (and its shadow) invites the viewer into the room. The symbolic tradition of the doorway is as the boundary between life and death. The door ajar represents hope. The latticed windows here are far more sinister than in the final version and the sinewy vines more prominent. It would be two years before Talbot returned to this scene, remaking much the same image, no more successfully.[2] In the final, 1844 version, the elements of the com-

position work in greater harmony, and more sense of hope prevails.

This is the first of four drafts leading up to the full realization of the final composition. The essential elements are the same: a wall, the light beyond, a broom standing at an angle, and, of course, the door swung open. In this, as in the other three early attempts, the angle of the broom runs counter to the angle of the shadows. By the time of the final version three years after this, Talbot sharpened the sense of the diagonals by having the broom lean on the left side, using its angle to reinforce that of the shadow cutting across the door. In the last version, he also tightened up the framing and made bolder use of lighting.

The negative for this image is not waxed and has several coating skips; it is dated in Talbot's hand and inscribed "16 30."[3] Five other prints from it are known.[4]

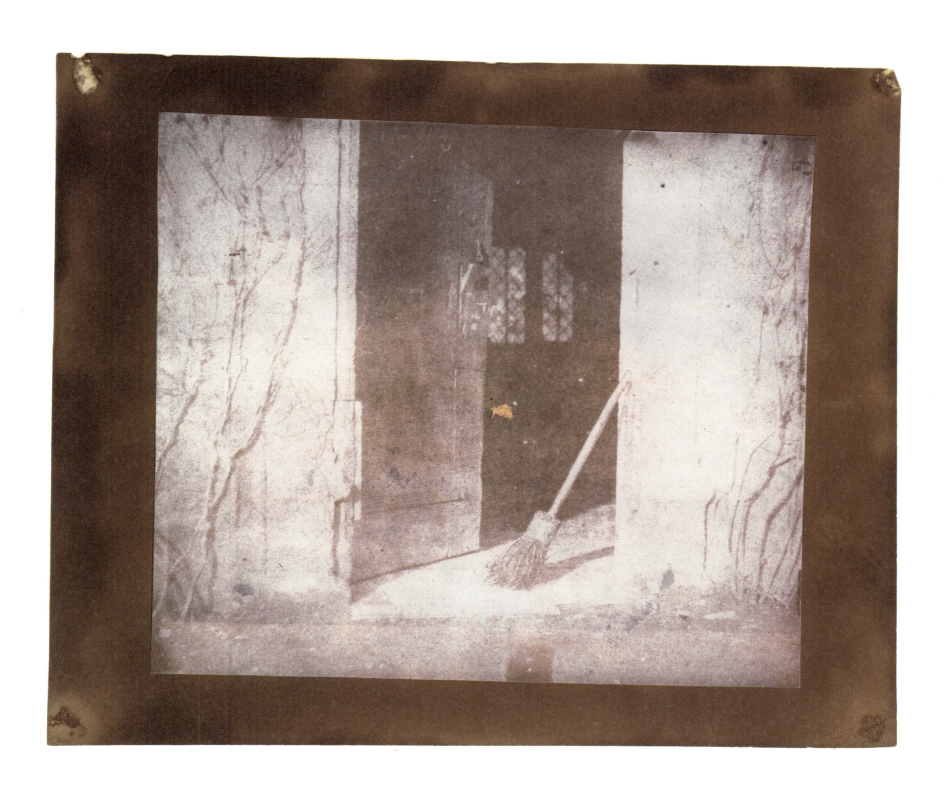

PLATE 38

The Window of Talbot's Library at Lacock Abbey

25 January 1841. Salt print from a calotype negative,
16.1 x 17.4 cm image on 18.6 x 22.7 cm paper. Watermarked Whatman 1840
Lacock Abbey Collection, The Fox Talbot Museum, Lacock (LA2114/NB3)
SCHAAF 2551

As a voyeur, the viewer's eye is tempted here by the promise of an open window, inviting at first, but frustratingly inaccessible. It is high up on a blank wall that offers no footholds, visual or literal. Even the creepers have not reached its space. The glare on the glass shields the room from our view, and the only part of the window that is open presents nothing more than a void. We are tempted by our easy recognition of the pen pots on the windowsill, but further puzzled by the semitransparent object that dominates the center. As befits the haunts of the scholar, is it a glass bell, covering some instrument, or perhaps an inspiring cast? Or, more prosaically, is it a chandelier, lowered for cleaning?[1] The shadowy trace of a once-larger window in the masonry hints at a different time. But what at first appears to be the fading graffiti of a past period finally reveals itself as a watermark in the paper.

This is surely one of Talbot's most enigmatic images, made in a particularly fertile time for his imagination, just four days after his first attempt at the *Soliloquy of the Broom* (pl. 37). Yet his image is lacking in the obvious pictorial grounds of the *Soliloquy*. Talbot examined his window on 25 January, two years to the day after he first publicly displayed his new art of photo-genic drawing at a meeting of the Royal Institution. Ten days after he exposed this negative, Henry Talbot made his first public announcement of "Calotype Photogenic Drawing."[2]

This room is now known as the "blue parlour." Casual visitors to the abbey today could be excused for making no associations between the scholar's study and its current use as a music room. In fact, the conversion was made earlier in the twentieth century. Miss Matilda Talbot remembered that "during many years the panelling was hidden by a number of bookcases which practically covered all the walls. After my uncle's death, we were able to move the bookcases and their contents to other rooms, and we examined the paneling . . . but the original colours could no longer be distinguished . . . our village painter took great trouble and mixed many pots of paint for us . . . three or four years later, I was looking through an album of water-colour sketches, when I found one, dated 1829 . . . and we found we had . . . hit on the original shade of blue."[3]

The negative for this image is preserved in a private collection in North America; it is dated in Talbot's hand but otherwise not marked. This, the only known print, is in Talbot's album No. 9 (which he labeled as "bad").

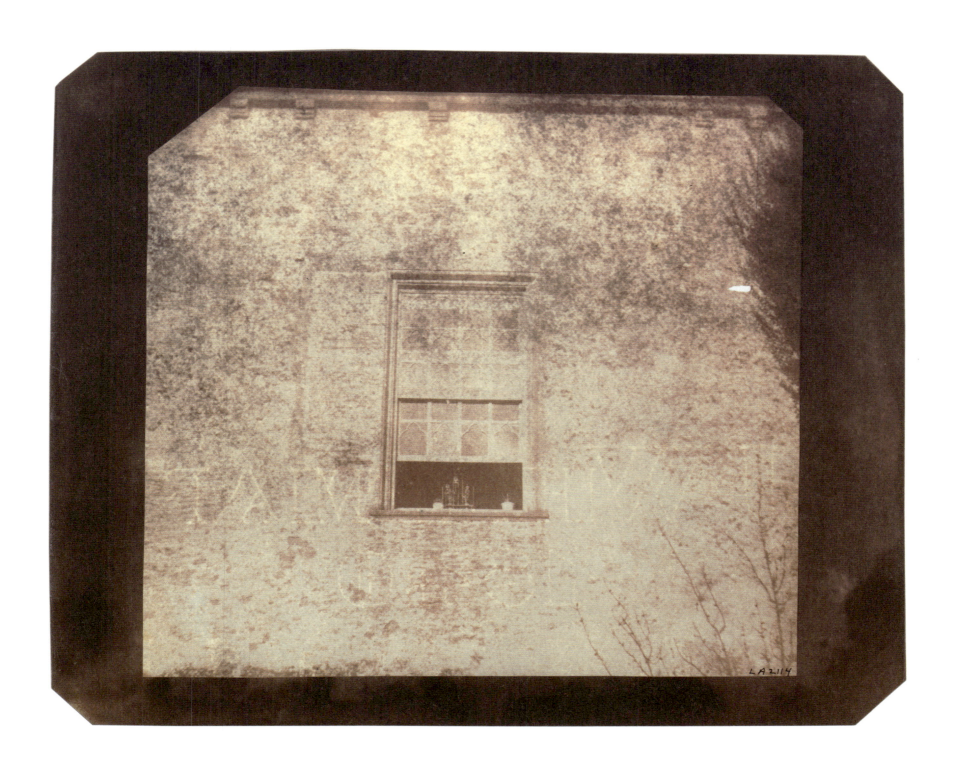

PLATE 39

The China Bridge at Lacock Abbey

21 February 1841. Salt print from a calotype negative,
16.6 x 21.6 cm image on 18.6 x 22.7 cm paper. Pencil "X" on recto
The National Museum of Photography, Film & Television, Bradford (1937-0366/120)
SCHAAF 2553

Although Talbot complained of a lack of picturesque scenes in his vicinity, in fact the grounds and buildings of Lacock Abbey were ripe with them. This stylized and graceful footbridge, which long stood on the easternmost grounds of Lacock Abbey, provided a convenient and quiet path across the River Avon. Talbot placed his camera on a small promontory at a bend in the river, facing toward the northeast. The inscription on the negative reveals that his calotype paper needed a ten-minute exposure on an overcast winter's day to build up sufficient light. This time period happily allowed the water to move just enough to lend a satiny quality to its surface, gently breaking up the reflection of the trees, and avoiding the harsh abstraction of his *Winter Trees, Reflected in a Pond* (pl. 50). This blending of tones also lends a great sense of depth to the image. It introduces a subtle sense of time into what would otherwise be a static scene.

The spring before this one, Talbot had photographed the bridge, placing his camera almost immediately opposite the span in a frankly descriptive shot.[1] A more severe treatment, undated but probably later, suppresses the water in favor of the approach to the bridge; a dead tree trunk and glaring stone wall convey a completely different visual impression of the scene.[2] Today, only the footings of the bridge remain, but the highly descriptive nature of Talbot's photographs of the bridge raise some hope that someday it may be re-created as an authentic part of the tourist experience in the well-preserved village of Lacock.

The waxed negative for the present print is dated in Talbot's hand. For some reason, the negative was progressively trimmed on the bottom—it started out at least four centimeters taller and a bit wider—eventually winding up severely cropped (it now measures 13.6 x 21.0 cm).[3] This print, in Talbot's album No. 4 (thought to have been compiled by Lady Elisabeth Feilding), represents the second largest known state of the negative.[4] The present print is the strongest cropping.

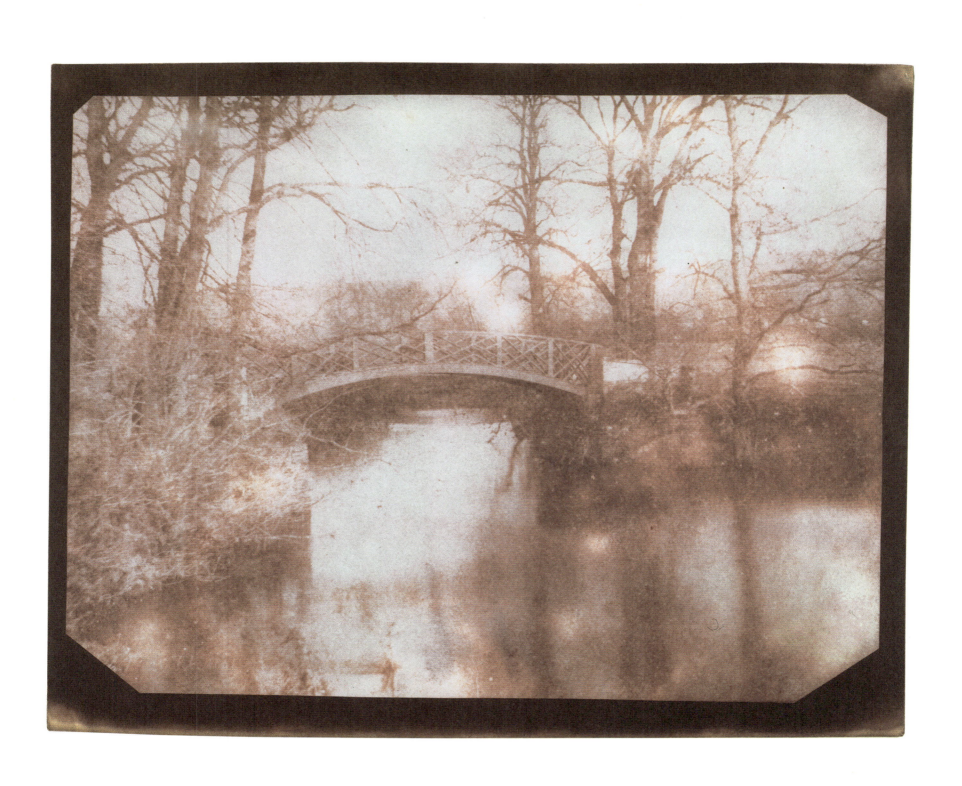

PLATE 40

Nicolaas Henneman in the Cloisters of Lacock Abbey

23 February 1841. Salt print from a calotype negative,
10.5 x 11.2 cm image on 18.5 x 22.7 cm paper.
Watermarked J Whatman 1840. Pencil "X" on recto
Private collection, courtesy of Hans P. Kraus, Jr., Inc.
SCHAAF 2559

Just four days before he took this photograph, Henry Talbot had revealed to the world his secret of employing a latent image, chemically amplifying a short exposure to light in the camera in order to make a much more sensitive negative material.[1] The photograph, taken in the inner courtyard of Lacock Abbey's cloister, had an exposure time of one minute, even in the weak winter sun. With its fine sense of light and shade and realistic portrayal of the person who had helped him so much in photography, this image immediately took Talbot's fancy. It was appropriate that the subject of this relaxed and naturalistic portrait using this radical new process was Nicolaas Henneman, Talbot's loyal valet, and increasingly his working partner. It is the earliest positively dated and identified image of Henneman, and his confident stance reveals his growing independence. Still in Henry Talbot's employ, his role was increasingly as a photographic partner, and their relationship was changing as a result. Two years after this portrait, Henneman would begin to move into a world of independent entrepreneurship, setting up the first commercial establishment designed to meet the needs of photographic publication.

When Talbot first announced his new *calotype* process, he staked out the claim that "one of the most important applications of the new process, and most likely to prove generally interesting, is, undoubtedly, the taking of portraits. I made a trial of it last October; and found that the experiment readily succeeded. Half-a-minute appeared to be sufficient in sunshine." Then, in obvious reference to his earliest portraits, those of his wife Constance (see pl. 32), Talbot explained that a good exposure could be made with the calotype in "four or five minutes when a person was seated in the shade, but in the open air." Unintentionally stressing the extreme rarity of these early calotype portraits, Talbot admitted that "after a few portraits had been made, enough to shew that it could be done without difficulty, the experiments were adjourned to a more favourable season."[2]

After he had taken *The Footman* (pl. 33) on 14 October 1840, Talbot suspended his photography of people, probably in deference to the weakening light of the season. But now, with the public announcement of the calotype process, Henry Talbot needed examples to distribute to the public. He must have shown this portrait in person to numerous people immediately, for in sending a print to Sir John Herschel three weeks after the negative was made, Talbot introduced it as "a specimen which had been much liked by the artists in London, it is the portrait of a young man, done in *one minute*. The background is an ivied cloister."[3] More importantly, Talbot sent a copy of this portrait to his ally in France, the physicist Jean-Baptiste Biot. On 15 March 1841, Biot presented this photograph at the Académie des Sciences, where the members examined this "strikingly unique" portrait "with great interest."[4] The next day, Biot reported to Talbot that "it was not only *some* of my colleagues who wished to see it; they all passed it from hand to hand in succession and were struck by the air of individuality which makes itself noticeable in the face and the realism of the pose. The foreigners who were present at the session took part, with as much pleasure as I have in telling you this." Biot continued: "I think I discovered on your print an indication that might well uncover the particulars of the sequence of your operations. It is the date, 23rd February 1841, that I find in the normal manner of writing. As it no doubt was not traced in reversed letters on the ivy, this would make one presume that here as in your first processes, there are two processes that succeed one another; at first one that gives the print with the whites in place of the blacks and the second that restores them to their true place by transmission." He went on to warn Talbot that if he meant to protect his secrets he must not leave such clues![5]

Happily, this print was left untrimmed, revealing the hand coating of the silver salts (likely with a ball of cotton wool). It evokes an extraordinary sense of mystery of the photographic image floating in a sea of chemistry, appropriate for a visual announcement of something so mysterious as a latent image. The negative is now pale,[6] probably because it was printed so often.[7]

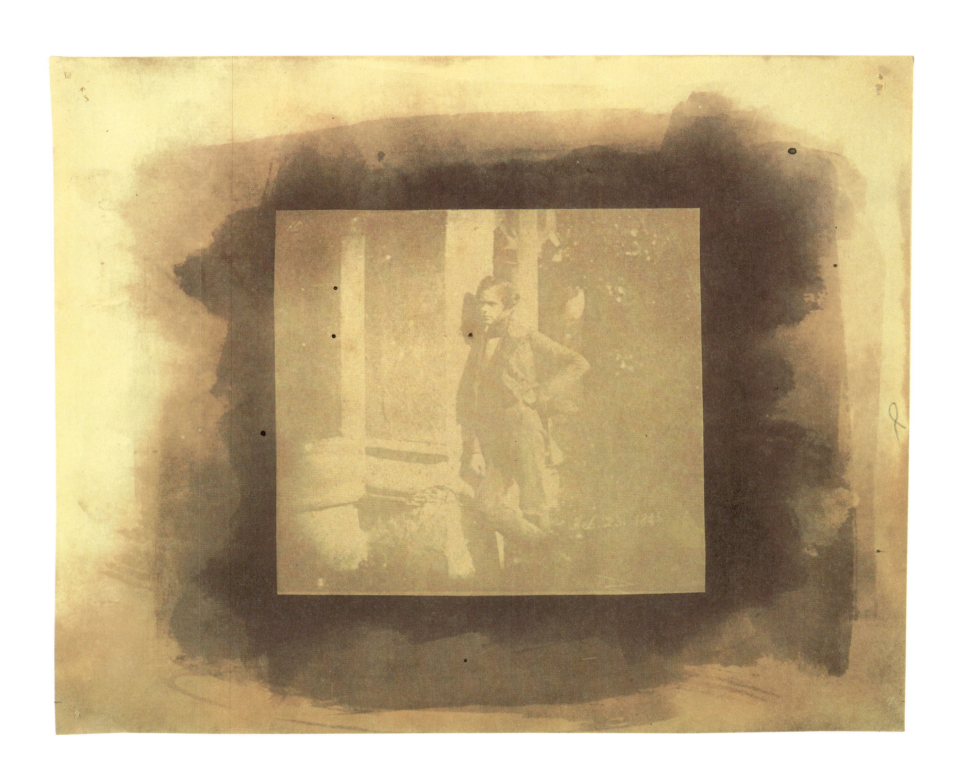

PLATE 41

Horatia Feilding and Constance Talbot
Visit Corsham Court

17 April 1841. Salt print from a calotype negative,
16.1 x 21.0 cm image on 18.9 x 22.8 cm paper
Collection de la Société Française de Photographie, Paris (412/17)
SCHAAF 2590

In her diary, Lady Elisabeth Feilding noted that on this day "Henry went with Horatia & Caroline to make Photographs at Corsham."[1] Talbot's much-loved sisters, Caroline and Horatia, parade under their parasols in the courtyard of Corsham Court. A low camera angle emphasizes the perspective, establishing a frame of rigid suspension, secured by lines to the corners of the image. It appears to be a timeless view of a way of life. But Talbot's photograph actually represents a scene of deceptive stability—within four years the character of Corsham Court would be changed enormously.

Corsham Court, the home of Talbot's friend Paul Methuen, was the nearest large house to Lacock, being only three miles away. Dating from the sixteenth century, since 1745 it has been the home of the Methuen family. Capability Brown was called on to redesign the house and gardens shortly after the Methuens moved in. The impetus was to house the massive collection of Continental artwork assembled by Sir Paul Methuen. The pressures of the ever-expanding art collection led to further changes. Unlike Lacock Abbey, which has been altered surprisingly little over the years, Corsham underwent a major change in 1800 at the hands of John Nash. It is essentially his work that is depicted in this image. Four years after this picture was taken, much of Nash's work (which turned out to be badly built) was torn down. The essentially Elizabethan structure was refaced in a heavy Jacobean style.[2]

In his first paper on photography, Talbot hoped that "to the traveller in distant lands, who is ignorant, as too many unfortunately are, of the art of drawing, this little invention may prove of real service; and even to the artist himself, however skilful he may be. For although this natural process does not produce an effect much resembling the productions of his pencil, and therefore cannot be considered as capable of replacing them, yet it is to be recollected that he may often be so situated as to be able to devote only a single hour to the delineation of some very interesting locality. Now, since nothing prevents him from simultaneously disposing, in different positions, any number of these little *cameræ*, it is evident that their collective results, when examined afterwards, may furnish him with a large body of interesting memorials, and with numerous details which he had not had himself time either to note down or to delineate."[3]

By the time he introduced the calotype two years later, Talbot had begun to learn the real potential of his new art, and he spoke much more confidently about what it could do: "I think that the art has now reached a point which is likely to make it extensively useful. How many travellers are almost ignorant of drawing, and either attempt nothing, or bring home rude unintelligible sketches! They may now fill their portfolios with accurate views, without much expenditure of time or trouble; and even the accomplished artist will call in sometimes this auxiliary aid, when pressed for time in sketching a building or a landscape, or when wearied with the multiplicity of minute details."[4]

In a later generation, Miss Matilda Gilchrist-Clark (later Talbot) continued the visits enjoyed by Caroline and Horatia. She had moved into Lacock Abbey to help take care of Charles Henry (Talbot's son) in his later years: "Uncle Charles realised, I think, what good neighbours Lord and Lady Methuen were, and what a difference they made in my life. It seems to me, looking back to that time, that there was hardly a weekend when I was not asked over to some meal at Corsham, or that they did not come over to Lacock. These meetings used to be like pages of gold and colour in a rather monotonous black and white book of life."[5]

The negative survives, and this is one of two known prints—the other is still preserved by Methuen's descendants at Corsham Court.[6]

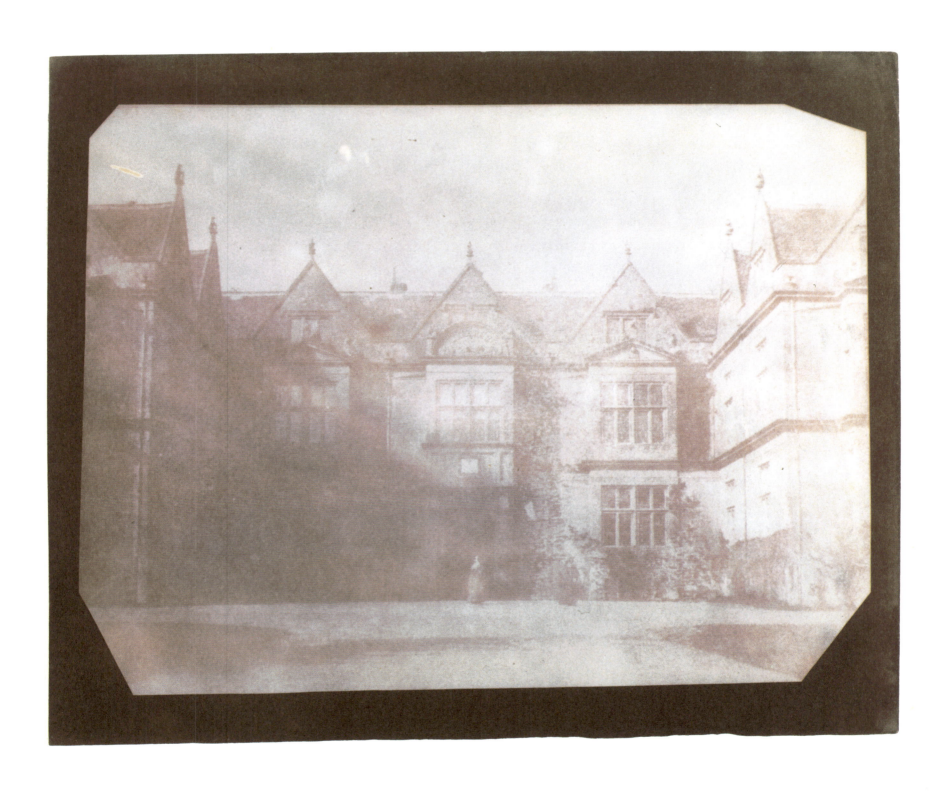

PLATE 42

River Thames in London,
from Talbot's Cecil Street Flat

June 1841. Salt print from a calotype negative,
13.4 x 18.4 cm image on 18.8 x 22.0 cm paper. Pencil "X" on recto
The National Museum of Photography, Film & Television, Bradford (1937-0366/050)
SCHAAF 3705

In a sprawling aquatic landscape, uncommon in his photographic work, Talbot has employed the bright highlights of the water to good effect, tracing a serpentine path for the eye over a complex of jutting forms. The foreground, highlighted in the gentle morning light, proves to be tables set up for dining on a pier. This is the earliest known photographic vista of London. But for anyone familiar with the City, it is a quietly discomforting view. Missing, of course, are Big Ben and the Victoria Tower. Just to the left of Westminster Abbey's spires is the finest timber-roofed building in Europe, Westminster Hall, happily a survivor of the spectacular 1834 fire that leveled the Houses of Parliament. At the extreme right is the roof of Inigo Jones's Banqueting Hall, now hidden in a mass of urban building. The Westminster Bridge extending across the Thames is the one built in 1750; in 1854, construction would begin on its replacement, in use to this day. Talbot was overlooking the busiest point on the Thames for river traffic: Percy Wharf, Middle Wharf, Draw Dock, Crown Wharf, and Great Scotland Yard Wharf march on toward Westminster. Prominent in the foreground are the lower reaches of Hungerford Market; within four years, Brunel's spectacular Hungerford Bridge (pl. 92) would extend from there, blocking this view. Both the footbridge and the market would be swept away in 1859, destroyed by the railroad in the construction of Charing Cross Station and the unlovely Charing Cross Bridge.

Talbot had gone to London specifically to photograph the metropolis and had taken up residence at a flat in Cecil Street,[1] not far from his familiar haunts of Kings College and the Society of Arts. On 15 June 1841, Lady Elisabeth Feilding recorded in her diary that she "went to see Henry make Calotypes in his new domicile in Cecil Street."[2] Writing to his wife Constance that evening, Talbot explained that "my windows in Cecil St. command a good view of the river but unfortunately I find that the London atmosphere prevents a good result, even the fog is hardly visible to the eye."[3] Four decades before this photograph was taken, standing on the Westminster Bridge, William Wordsworth could write:

> Earth has not anything to show more fair:
> Dull would be the soul who could pass by
> A sight so touching in its majesty:
> This City now doth, like a garment, wear
> The beauty of the morning; silent, bare,
> Ships, towers, domes, theatres and temples lie
> Open unto the fields, and to the sky;
> All bright and glittering in the smokeless air.[4]

Talbot was being too critical of his own work here. Even without the legendary fog of London, he could not have expected too much more of his calotype negative material. It was sensitive primarily to blue light, the range of light whose rays are most scattered by the atmosphere, often producing a hazy effect in the distance even to the eye. In the present photograph, the finest preserved of the numerous ones he took, the effect of the coal fires is minimal and perhaps even supportive of the composition. Talbot's Uncle William, yearning for a more romantic setting than the metropolis, still recognized the power of this image: "I have received your beautiful Calotypes . . . would not the Avon at Clifton do as well as the Thames at Wapping?"[5] Uncle William could not escape progress for long; ironically, Brunel's chains from his Hungerford Bridge would soon wind up completing the breathtaking suspension bridge at Clifton, on the River Avon.

The negative for this particular view is not known to have survived, but there are three other known prints from it, one of which belonged to the notorious bibliophile and Talbot's friend Sir Thomas Phillipps.[6] Talbot kept his camera busy in his brief stay on Cecil Street.[7] There are five other known images of the Thames taken by Talbot from the same flat, making use of different windows to incorporate different aspects of the river scene.[8]

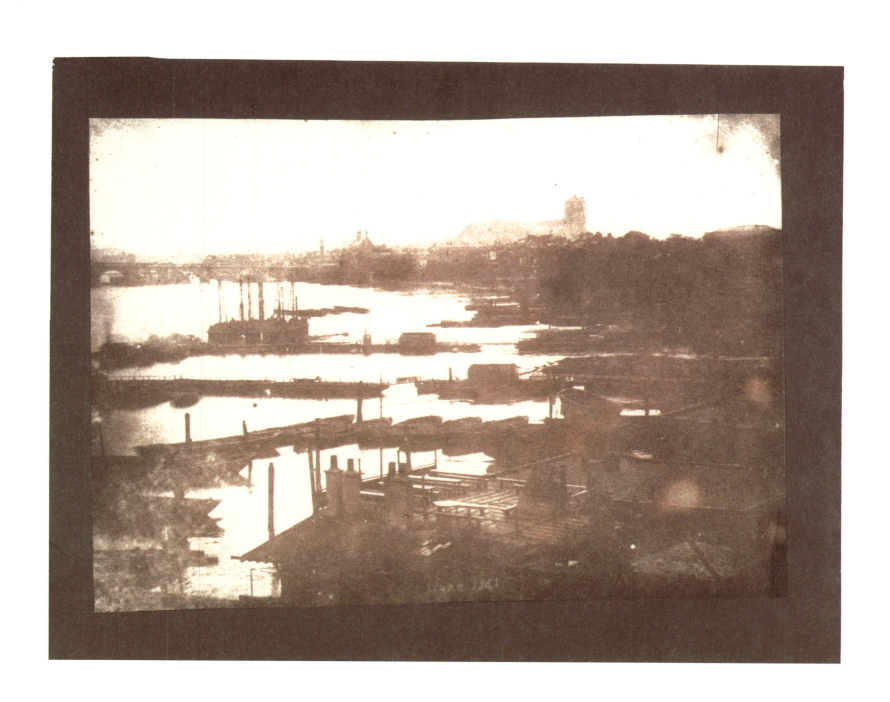

PLATE 43

"An Aged Red Cedar on the Grounds of Mt. Edgcumbe"

1841? Varnished salt print from a calotype negative,
15.8 x 19.6 cm image on 18.4 x 22.1 cm paper
Collection of Michael Mattis and Judith Hochberg
SCHAAF 22

In a haunting vision of an ancient red cedar, Henry Talbot evokes the very personae of trees. Mysterious and animated, its limbs twisting and tormented, the venerable cedar's truncated head is shrouded in darkness. Bright sunlight rakes across the rough texture of the trunk, adding to the sense of age. The tight framing at the base of the cedar contributes to the portrait, putting the viewer at eye level with this strange but unmenacing sorcerer that has suddenly blocked his path. The eye is forced upward until inhibited by the dark space. In a happy application of a technical attribute, Talbot has pushed the contrast between the bare trunk and the green leaves even higher—his calotype negative material suppressed the green foliage, here enhancing the overall effect. The coating of varnish adds to the sense of life and activity, an effect possibly heightened by the accidental slight unevenness of the brush.

This photograph was taken at Mt. Edgcumbe, the marital home of his sister Caroline. It was then in Devonshire, just across the Tamar from Plymouth, but has since been incorporated into the boundaries of Cornwall. Caroline was constantly encouraging him to come there to take photographs and may well have led him to this particular tree. Writing from home in 1844, she said: "I wish you would . . . come & see us . . . I should think you *might* manage to make Calotypes even in company . . . particularly in our Italian climate, you w^d have fewer obstacles than you generally meet with."[1]

A possible reason for the fine preservation of this print is that it was varnished. As fading problems with prints became more troublesome around 1845, Talbot thought of protecting the surface under a coat of varnish, as one might the fine wood of a piece of furniture. This did not work for all prints, but in this case it might have provided just enough barrier against atmospheric-borne pollutants. In September 1845, Antoine Claudet's studio billed Talbot for varnishing sixteen large views.[2] A month later, Nicolaas Henneman, writing in his characteristically phonetic English, talked about visiting the respected artists' supply firm of Winsor & Newton: "I have been to town last Monday and M^r Windsor showed mee how to varnish the Pictures, but in *my* opinion it is not a bit better than those I varnished my self in fact the method is the same and far from having that plesant gloss of M^r Mansions, how ever I shall leave you to judge for your Self. I have done about a Doz in diferent degrees of Strengt."[3] In December of that year, Henneman billed Talbot for varnishing seventy-three large prints and eighty-three small ones.[4] In the print of *The Haystack* (pl. 83), the varnish has been applied more evenly.

This image was so popular that Nicolaas Henneman had a printed title made up to attach to the printed mounts of copies for sale.[5] The waxed negative survives,[6] but of the numerous prints that are known, only one other is varnished.[7] There is also a close variant negative in a smaller format, less surefooted in its composition.[8]

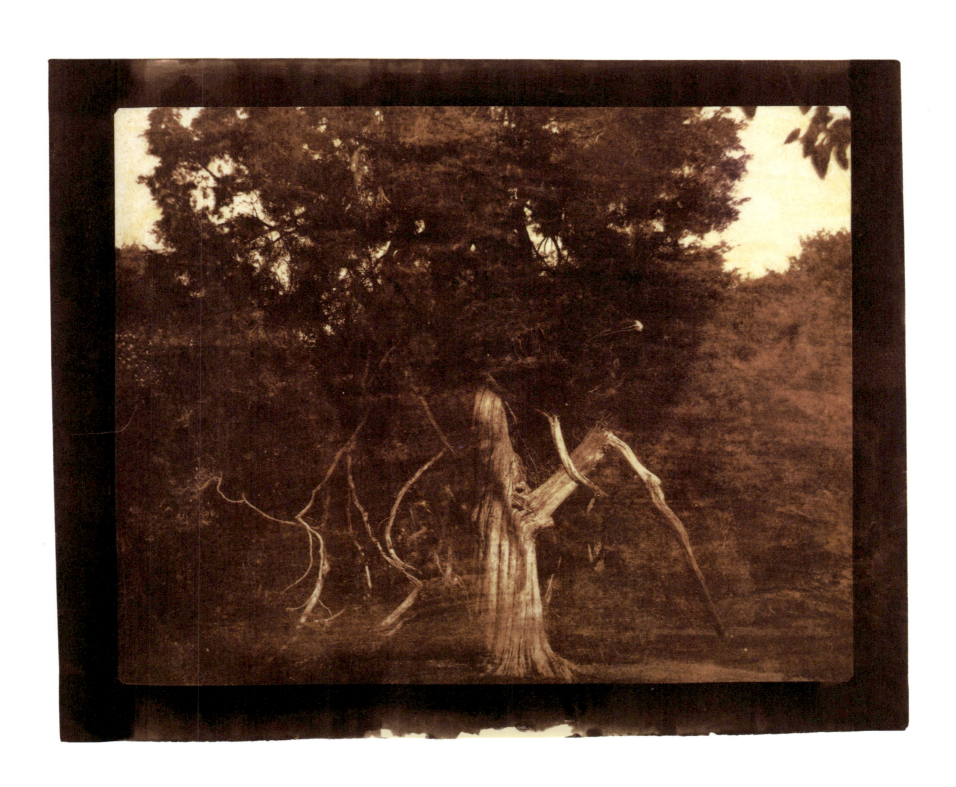

PLATE 44

"Oak Tree, Carclew Park, Cornwall"

Probably August 1841. Salt print from a calotype negative,
16.7 x 20.8 cm image on 18.9 x 22.9 cm paper
The National Museum of Photography, Film & Television, Bradford (1937-2059/3)
SCHAAF 1355

The oak-tree swiftly moving,
Before him tremble heaven and earth,
Stout doorkeeper against the foe,
Is his name in all lands.

The Battle of the Trees[1]

Of all the majestic trees, surely the oak stands foremost as a symbol of British identity. Whether rising high above the landscape, as in the *Oak Tree in Winter* (pl. 59), or forming the stout protectors depicted in *An Ancient Door* (pl. 62) and *The Open Door* (pl. 82), the oak is the embodiment of all that is strong. In the present image, it is mysterious and alive and ancient as well. A low camera angle, with its emphasis on the foreground, makes the viewer look up in respect to this gnarled tangle of tree trunks. This was one of the many strange and exotic trees on the grounds of Carclew, the home of Talbot's uncle, Sir Charles Lemon. Perhaps this tree reminded Talbot of the famous "Four Sisters" oak that grew near his home of Lacock.[2]

The dating of this image is strongly implied by the documentary record. In her diary for 21 August 1841, Lady Elisabeth Feilding recorded the fact that "H went to Carclew."[3] A fortnight later, on 7 September, Talbot recorded having sent Henry Collen a print of the "Carclew Oak."[4]

This print represents an early state of the negative and is the only known survivor of this state. The corners of the waxed negative were trimmed down during its printing life and eventually had all four corners trimmed, the top ones more so.[5] Two prints clearly identify the subject of this undated negative and several other prints are known.[6] Like the *Aged Red Cedar* (pl. 43), this image was so popular that Nicolaas Henneman had a printed title made up to attach to the mounts of copies offered for sale.[7]

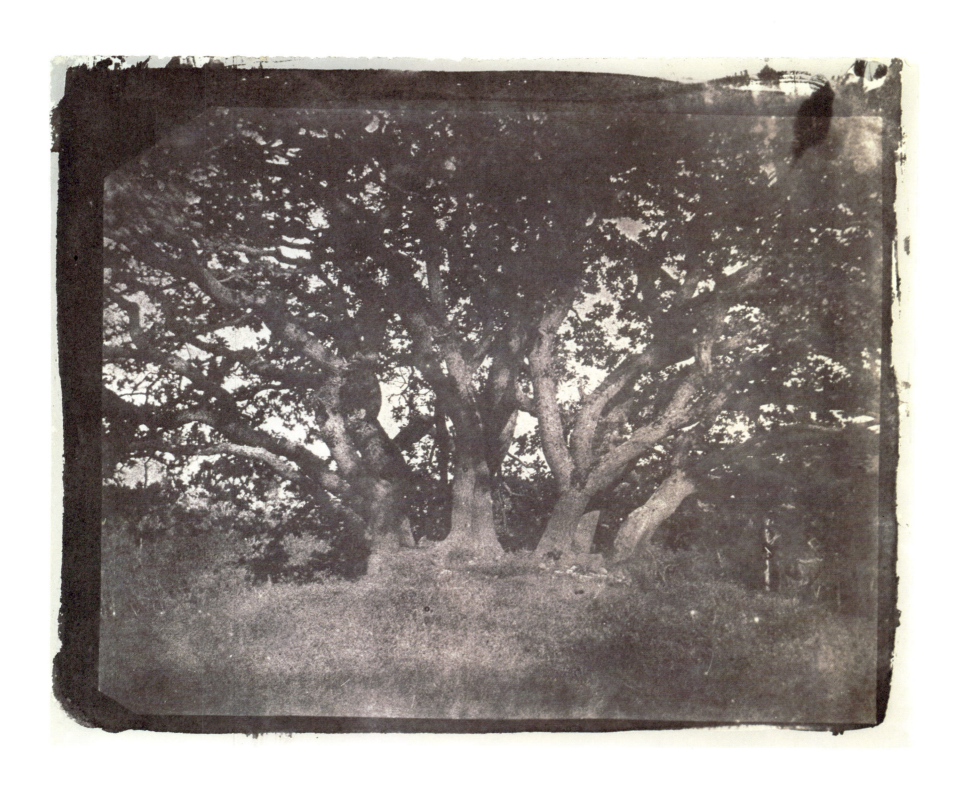

PLATE 45

The Porch of Carclew, the Home of Sir Charles Lemon

27 or 28 August 1841. Salt print from a calotype negative, 17.0 x 20.9 cm image
on 18.9 x 22.7 cm paper. Watermarked J Whatman Turkey Mill 1840
The National Museum of Photography, Film & Television, Bradford (1937-2534/14)
SCHAAF 227

Sir Charles Lemon, Talbot's uncle, stands casually with his knee jauntily raised at the left of this picture. A Member of Parliament and a scientific man, he was one of seven who proposed Henry Talbot's election into the prestigious Royal Society of London in 1831. He was a prominent landowner, a geologist, the President of the Royal Cornwall Polytechnic Society, a Freemason, and on the board of inquiry for the British Museum. Henry Talbot has made a fitting tribute to such a man of power and wealth, for the porch of Carclew dwarfs the people and stretches out toward the horizon.

A month after this was taken, Sir Charles enthusiastically wrote to his nephew that "the Photogenics are come & very satisfactory they are. The group is our favorite here, and I should be vʸ thankful for 2 (may I say 3) copies more of it— The purple tint has the best effect; it is more mellow . . . if we had made Bunbury sit down & put a wheelbarrow opposite the long side front of the Balcony what a pretty composition that would have made."[1]

Charles (later Sir Charles) James Fox Bunbury was a young man who would soon became a Fellow of the Royal Society. A day or two after Talbot took this photograph, John Sterling, the literary figure and would-be revolutionary, wrote to his father that he had just returned from a couple of days' stay at Carclew: "Sir Charles is a widower . . . but had a niece staying with him, and his sister Lady Dunstanville . . . there were also Mr. Bunbury, eldest son of Sir Henry Bunbury." This almost certainly identifies the two women in the picture, Lady Dunstanville and the niece most likely to be visiting Sir Charles, Louisa Emilia Fox. Sterling continued that the party was completed by "Mr. Fox Talbot . . . a man of large fortune, and known for photogenic and other scientific plans of extracting sunbeams from cucumbers. He also is a man of known ability, but chiefly employed in that peculiar department."[2] Sterling had apparently been enjoying his political satire, thinly disguised as travel literature: he would have learned that upon reaching the Academy of Projectors, Captain Lemuel Gulliver reported that the "first Man I saw . . . had been Eight Years upon a Project for extracting Sun-beams out of Cucumbers, which were to be put into Vials hermetically sealed, and let out to warm the Air in raw inclement Summers."[3]

At least one print was made before the bottom right corner of the negative was lopped off due to poor coating in that area (one must agree that Mr. Bunbury and his wheelbarrow could have made a contribution here but the correction does seem a bit severe!).[4] Whether the young man actually depicted near Sir Charles is Bunbury or Sterling (born within three years of each other) is not quite clear. If the latter, this would be one of the last images of him before he died in 1844.

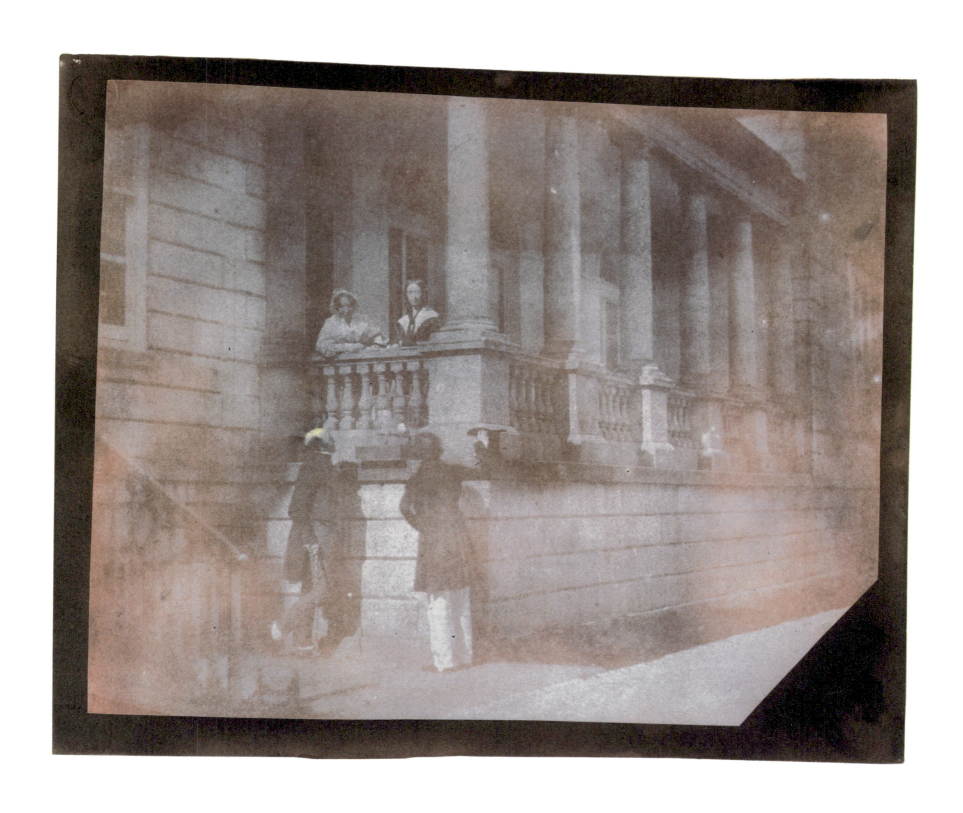

PLATE 46

Nicolaas Henneman Contemplates His Move in a Game of Chess

Probably September 1841. Salt print from a calotype negative,
16.2 x 20.3 cm image on 18.8 x 22.5 cm paper
Lacock Abbey Collection, The Fox Talbot Museum, Lacock (LA2110/NB2)
SCHAAF 975

Nicolaas Henneman, sitting on the right, looks supremely confident here. Unschooled in written English, he nevertheless came from a background of some education and a good polishing of social skills gained in Paris. He appears in many of Talbot's photographs of chess players, convincingly as an authentic player rather than simply as an actor. By the time this image was taken, Henneman would have had ample training in the skills of posing for photographs as well. The braced elbow and slight forward pitch in his chair would have helped him keep still during an exposure that was certainly at least tens of seconds. The identity of the man against whom he is playing has not been established. A simple white backdrop has been set up on the lawn of Lacock Abbey to allow the sun to look in on the game.

In his research notebook Q early in 1840, Talbot had included in his thoughts of "objects to be copied in camera obscura" the idea for a photograph of a "Chessboard and men." Presumably he meant chessmen, rather than male players, but the idea of the game board was with him early on.[1] Talbot is known to have taken at least nine other views of chess players.[2] One is dated September 1841, another is dated 7 April 1842 (featuring John Frederick Goddard, a subject in pls. 52 and 53), and two are dated July 1842.[3]

This print is mounted in Talbot's album No. 8. It is an album that he mysteriously labeled as "bad"—this can only apply to the print quality and cannot be an evaluation of the photographic ideas contained within. Made up of forty prints and eleven negatives, this album has four items positively dated to 1839, eleven dated to 1840, and eight dated to 1841 (none later). The watermarks of items in the album include one from 1838, eight from 1839, and one from 1840. The dating for the negative of the present print is established by an extremely close variant negative, partially dated in Talbot's hand.[4] One other print is known, in an album that once belonged to Talbot's sister Horatia, but it was printed after the negative was further trimmed from this state.[5] The remains of the negative for the present print can now really be called only a partial negative as it has been so severely trimmed.[6]

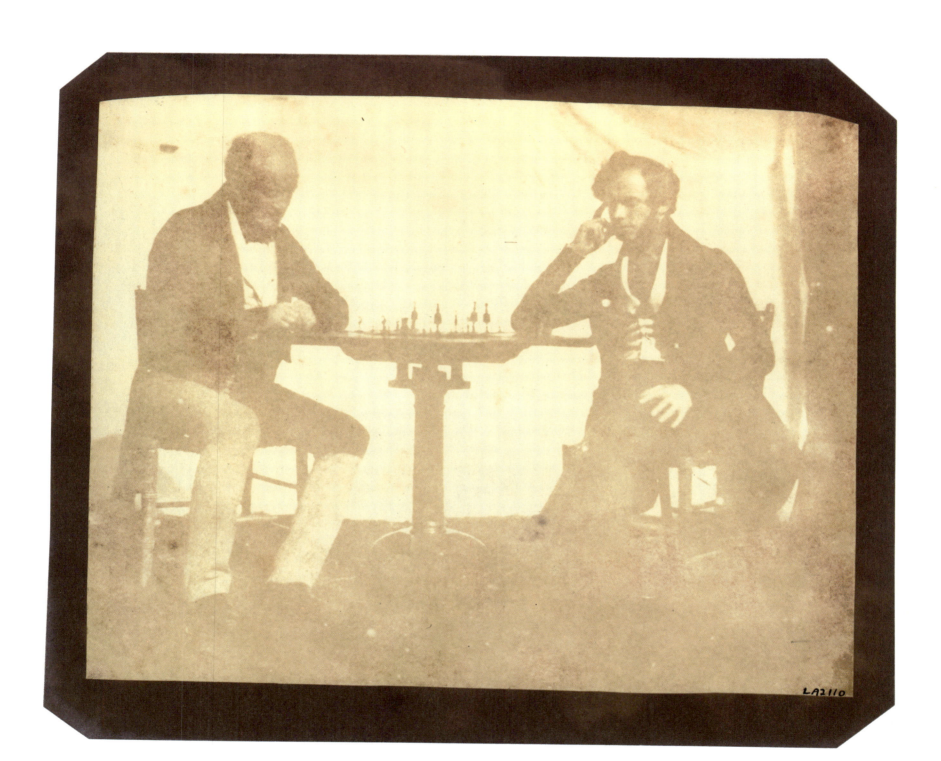

LA2110

PLATE 47

An Elegantly Set Table

Probably 1841/42. Salt print from a calotype negative,
11.9 x 20.0 cm image on 17.6 x 22.3 cm paper.
Watermarked J Whatman Turkey Mill 1842
The National Museum of Photography, Film & Television, Bradford (1937-2533/48)
SCHAAF 1903

With all the trappings of comfortable and proper living, Talbot's photographs of tables ready to receive diners offered a conceit to present various objects to the camera lens for its inspection and description. In these, he was also projecting the style of life within the society with which he was familiar. His peripatetic family members were always acting as his ambassadors, and Caroline wrote from Teplitz where she had just shown Lord Munster (the president of the Asiatic Society) the first photographs he had ever seen. He immediately took her to see the librarian of the public library, Dr. Falkenstein, who expressed such an interest in them that she gave him several. Amongst these were a "round table with a tablecloth très bien drapée."[1] Referring to an image in this series, Talbot's cousin Mary pleaded: "Pray bestow one of your table covered with ornaments (& 2 lumps of sugar on the breakfast table)."[2] Writing from Germany, Uncle William said that "I have received your beautiful Calotypes . . . I particularly admire . . . the breakfast table & folds of the tablecloth prove to me that it would be invaluable to a painter for taking off natural copies of a difficult & troublesome part of the art, namely draperies, in which many even good artists fail."[3] This type of image, one of several similar ones executed by Talbot,[4] provided a less intimate examination than the single breakfast sitting of plate 22 but more opportunity to examine the objects than was presented in the accoutrements of the dining party in plate 70.

In 1864, claims were made that a photograph of a breakfast table taken by Thomas Wedgwood late in the eighteenth century had been located. This story was discredited almost immediately, when the secretary of the Photographic Society established that it was, in fact, one of Talbot's breakfast scenes (the framed print—virtually the same as the present image—is still in the Royal Photographic Society).[5] Nonetheless, Eliza Meteyard amplified and actively promoted the story, and it persists in some photographic histories. Even the efforts of Wedgwood's biographer to quash it proved futile.[6] Talbot's reply to the controversy, however, gives some additional insight. Replying to an inquiry from Dr. Hugh Welch Diamond, he recalled that "I *did* make a photograph of knives and forks, &c., disposed upon a round table, which is seen very obliquely in the photograph. It was an early attempt, about 1841 or 1842. The view was taken out of doors, on the grass-plot in the centre of the cloisters of Lacock Abbey."[7] Two weeks later, he added in another letter: "I believe I have still at Lacock Abbey the *negative* of the photograph . . . in that case it will probably have a date endorsed upon it, as that was my usual practice at the time."[8]

An image of this style (it is impossible to tell precisely which one) was so popular that Nicolaas Henneman had a printed title made up to attach to the mounts of copies offered for sale.[9] This print is in Talbot's album No. 15 (an album he listed as "partial fill"). The waxed negative survives and two other prints are known.[10]

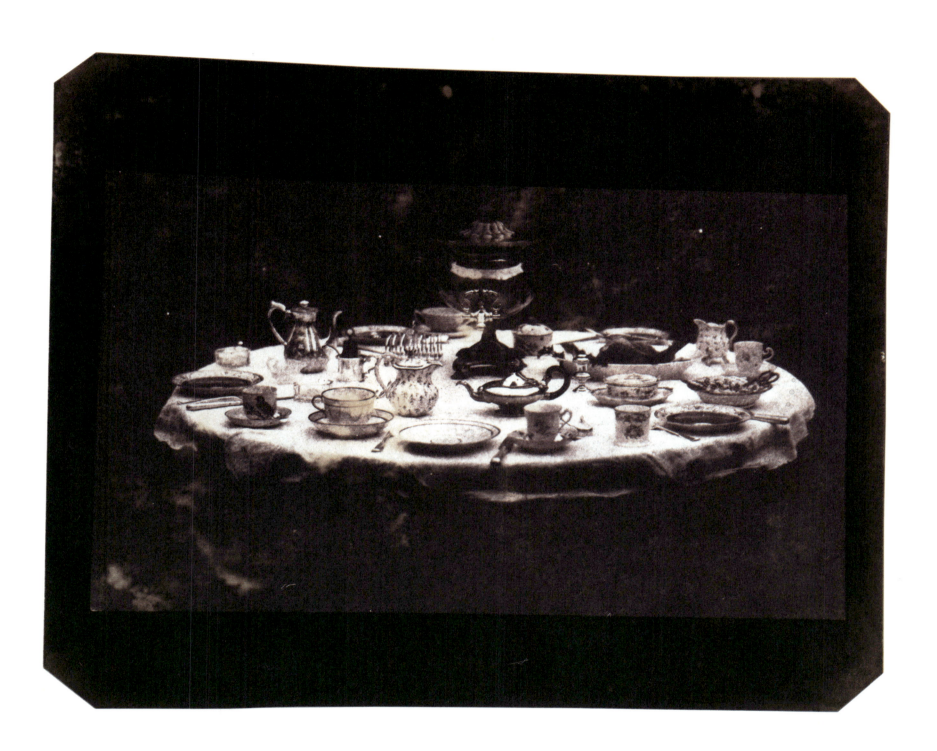

PLATE 48

Statuette of "Eve at the Fountain"

Probably 1841/42. Salt print from a calotype negative,
13.9 x 16.5 cm image on 18.8 x 23.1 cm paper
The National Gallery of Canada, Ottawa (33487.26)
SCHAAF 4164

As I bent down to look, just opposite
A shape within the watery gleam appeared,
Bending to look on me: I started back,
It started back; but pleased I soon returned,
Pleased it returned as soon with answering looks
Of sympathy and love: There I had fixed
Mine eyes till now, and pinned with vain desire,
Had not a voice thus warned me: "What thou seest,
What there thou seest, fair Creature, is thyself . . .

JOHN MILTON
Paradise Lost[1]

The marble original of *Eve at the Fountain* was immensely popular. Finished in 1822, a public subscription secured its purchase by the Bristol Art Museum in 1826, and it is still proudly exhibited there. The sculptor was a recently elected Royal Academician, Edward Hodges Baily, the son of a Bristol ship's carver, who later executed the statue of Horatio Nelson that would crown the column to be built in Trafalgar Square (see pl. 81).

In spite of the relative proximity of the original, Talbot did not work from the marble statue, but rather from a small plaster cast.[2] Perhaps his reason was that he found Eve, like Patroclus, a useful and versatile subject for his studies of the effects of light. The first positively dated negative of Eve is on 24 April 1840 and the latest is 9 August 1843.[3] All in all, Talbot is known to have taken at least twenty-nine negatives of her, nine of which are positively dated, and at least some of which were printed. In this, she rivals Patroclus. In some of these experiments, Talbot placed her on a highly polished tabletop, evoking the reflection central to Milton's poem.

Some version of this image—we can no longer tell which one—inspired Nicolaas Henneman to have a printed title made up for attaching to the mounts of copies offered for sale.[4]

The print is in the Bath Photographic Society album. This album, hand-selected from prints in the abbey's archives by Talbot's son, Charles Henry Talbot, was presented on 27 February 1889 to the Bath Photographic Society, which sold it at Sotheby's in 1975. The negative survives and there are two other prints known from it.[5]

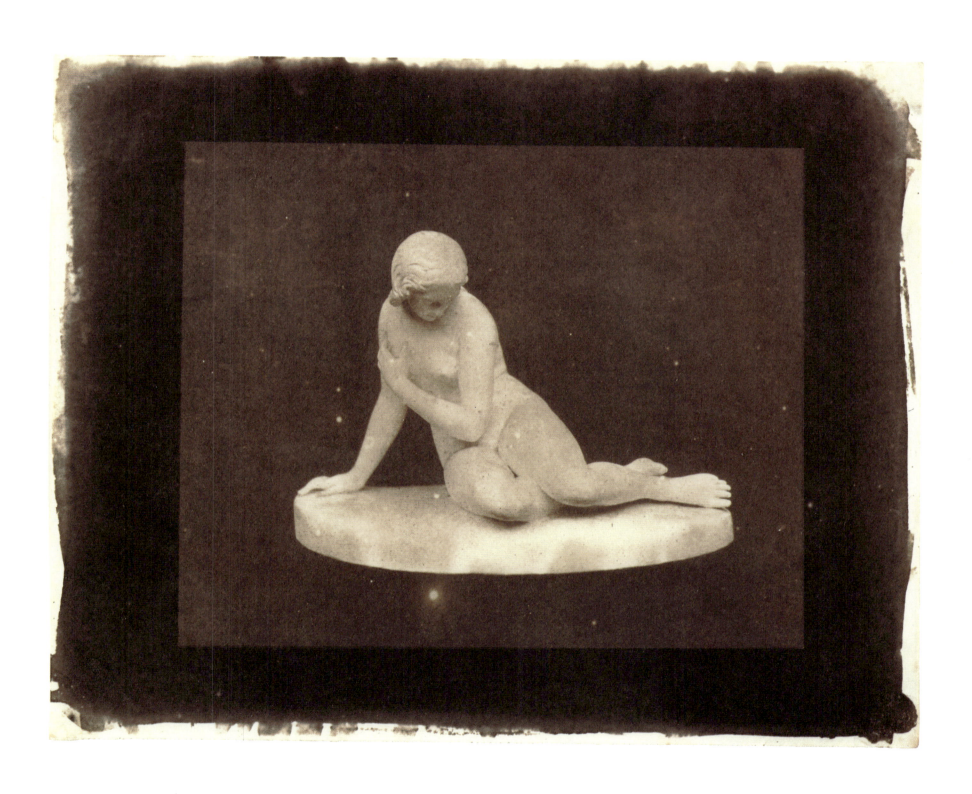

PLATE 49

Wild Fennel

Probably 1841/42. Photogenic drawing contact negative,
18.8 x 22.8 cm, corners trimmed. Paper watermarked J Whatman 1840
The Gilman Paper Company Collection, New York
SCHAAF 757

Uncle William hoped that Talbot's young daughter would carry on the artistic legacy that was native to the upbringing of her mother. William urged Talbot to "pray take some portraits of trees without leaves, & the same in leaf, in the summer. Also branches, twigs, leaves, for studies for drawing for Ela when she begins landscape."[1] Talbot followed this advice. With a negative like the present one, who would need a print to understand the intricate and marvelous structures of nature? A peculiarly frantic specimen of the plant world, this particular wild fennel is more demonstrative than its cultivated cousin. This photograph in many ways looks like the inspired and energetic naïve sketch that a child might make. Henry Talbot himself was still very young in his artistic development, but it was building rapidly as he steadily received more and more lessons from his new art of photography.

When writing about his "Leaf of a Plant" in *The Pencil of Nature*, Talbot explained the process of superimposing a leaf on the sheet of sensitized paper in a frame. "This done, it is placed in the sunshine for a few minutes, until the exposed parts of the paper have turned dark brown or nearly black. It is then removed to a shady place, and when the leaf is taken up, it is found to have left its impression or picture on the paper. This image is of a pale brown tint if the leaf is semi-transparent, or it is quite white if the leaf is opaque. The leaves of plants thus represented in white upon a dark background, make very pleasing pictures, and I shall probably introduce a few specimens of them in the sequel to this work." Sadly, these were some of the images left out when technical difficulties ultimately suspended the production of the *Pencil* less than halfway through its intended course. The dramatic contrast of pure white against the intense brown-black of this image is at once striking and eminently appropriate for a subject of this sort. It is likely that Talbot exploited one of the liabilities of hypo fixer to produce this contrasty monochromatic rendition. One of his complaints about hypo was that a too-vigorous solution very quickly attacked the lighter tones. He had become accustomed to the appearance of his salt-fixed prints and negatives, where the residual chemicals almost invariably imparted a lilac tint to the highlights, softening the effect. Hypo could easily bleach the highlights. Here, Talbot turned this to advantage. By exposing the negative to the sun far longer than was normal, he caused a massive reduction of the silver. The strong hypo bleached the negative, eating away at the middle tones and raising the highlights to a bright white. The very intense dark areas of the surround were little affected. Full and effective washing would have been necessary to have retained these pure highlights over the decades. As an unanticipated long-term effect, a negative like this is almost certain to possess greater long-term stability as a result.

Within Talbot's massive body of work, examples as electrifying as this are extremely rare.[2] There are no known prints from this negative, but there is one other negative known to have been made from the same type of original specimen.[3]

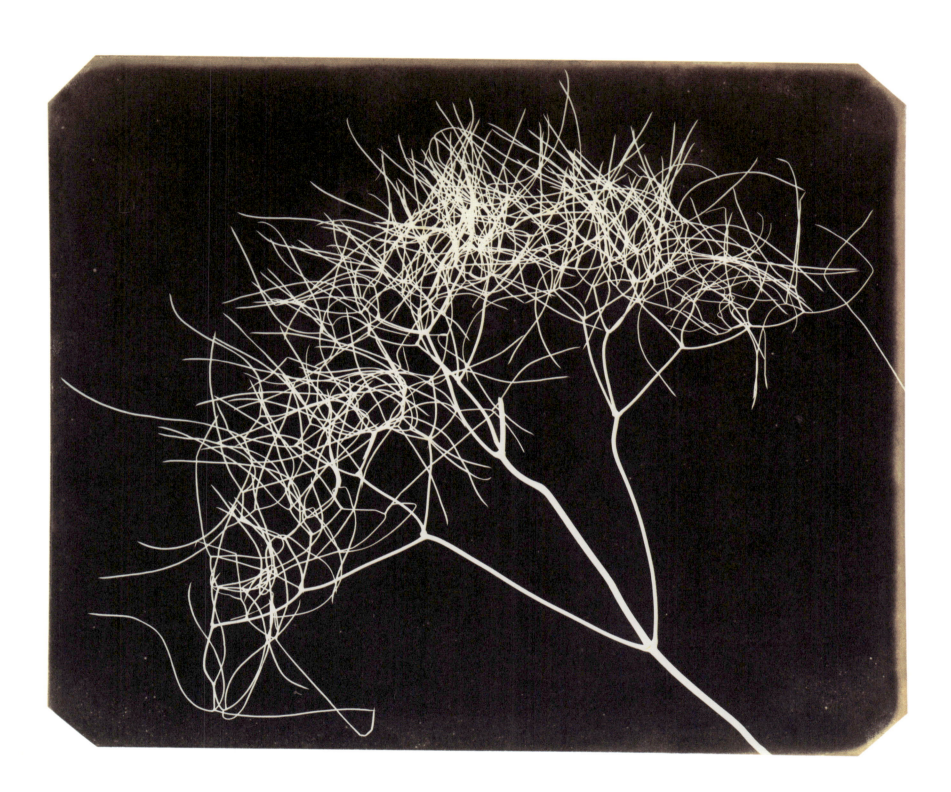

PLATE 50

Winter Trees, Reflected in a Pond

Probably 1841/42. Salt print from a calotype negative,
16.5 x 19.2 cm image on 19.6 x 24.9 cm paper
Private collection
SCHAAF 2135

In his *China Bridge* (pl. 39), Talbot made good use of the abstracted and diffuse reflections of trees in water. The footbridge was likely photographed earlier in the year 1841, when Talbot was actively exploring his newfound powers of visual expression. In the present highly sophisticated image, he has transformed the reflections into a bold graphic element, fully as strong as the trees they mirror. Go ahead and turn this book upside down. In many ways, an even more powerful image reaches the eye, and one is tempted to wonder if Henry Talbot ever allowed himself the same brief peek. After all, upside down is the way that the lens would have presented the image to his eye in the camera. Talbot apparently had the idea for this image early on. During May 1840, he made up a list of things "to be copied"—included was "trees in pond."[1] He might just have been able to accomplish this image with a photogenic drawing negative. The scale is actually smaller than the eye first expects, and on a calm day an extended exposure would have secured this image. It is more likely, however, that this wonderfully successful execution came in the following winter, after the discovery of the calotype negative process, when the exposure time was reduced to a minute or three, and the demands of keeping the wind from the surface of the water would have been less severe.

In March 1841, Sir John Herschel, having just received Talbot's first articles on the calotype, wrote from his new home at Collingwood: "I wish I had a sheet of it here at this moment where I am sitting in a warm summer house on the edge of what we call our *lake* with the brightest sunshine sparking on the water and the reflexions of the oak trees in all the Bays and creeks touch out most delicately in the most heavenly sky and temperature it is possible to concieve. Never was surely such a succession of blue Skies and Photographic weather since Britain was an Island as we have had since this time 12 months, and finely indeed you have availed yourself of it."[2] Talbot replied that "lakes and old oak trees are very much to my taste."[3]

The view here is almost certainly taken from the opposite side of the pond as the *Lacock Abbey in Reflection* (pl. 28). This is near the site of the old decorative *canale* northeast of the abbey and the Bowden Hill forms a backdrop exactly like what is seen here. This pond may have resulted from an ill-fated commercial venture. Less than a decade before this photograph was made, Henry Talbot wrote to his uncle William, saying that "you will be glad to hear the Canal Company have quitted the gravel pit . . . and I have begun planting it with pretty large young trees, already they make a good effect."[4] These trees are regularly spaced, as if planted, and they certainly make a "good effect." Perhaps this was the image that N. P. Lerebours wrote to Talbot about. Known as a print seller, he was also a landscape painter, and he told Talbot he had an ardent desire to get a print with such lovely trees as that he had seen displayed at Chevalier, the optician, in Paris.[5]

The negative survives in excellent condition despite the evidence that it was printed from for some years.[6] Its timeless visual appeal and high quality ensured that numerous prints made their way into permanent collections.[7] This print was formerly in the Bokelberg Collection.

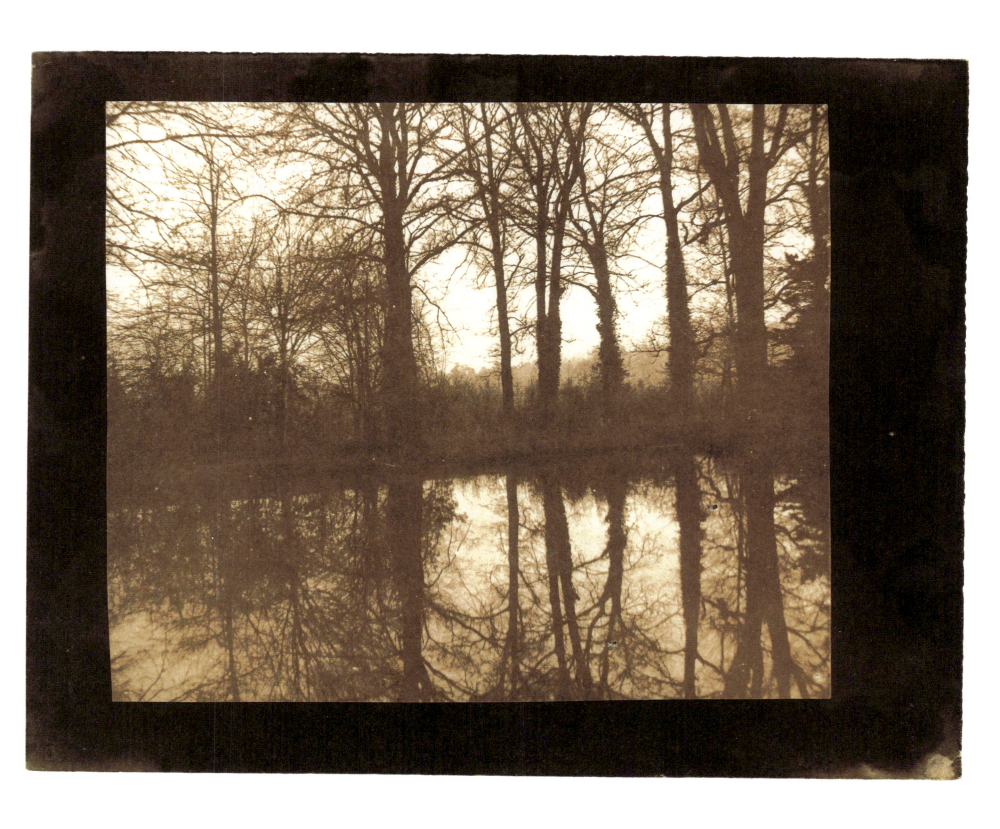

PLATE 51

Eliza Frayland Holding Charles Henry Talbot, with Ela and Rosamond Talbot

5 April 1842. Salt print from a calotype negative, 12.7 x 15.0 cm image
on 18.8 x 22.5 cm paper. Watermarked J Whatman 1841
The National Museum of Photography, Film & Television, Bradford (1937-2494)
SCHAAF 2636

While the young Talbot children were already well-practiced as photographic subjects by the time this photograph was taken, the nurse must be forgiven for not holding her pose. She had been in the employ of the Talbot family for little more than a month before she was drawn into the strange activities of the world of photography.[1] Photographic snapshots are so ubiquitous today that we have to remind ourselves that most likely she had never seen a camera before. Absent were the conventions of posing that stultify so many modern pictures, but also absent was an awareness that she had to hold still for perhaps tens of seconds. If one makes allowance for the dress (and perhaps for the color of the print), today's snapshot, done with some marvelous highly automated—even digital—camera, could claim no more life or truth than this image. As personal photographs still do today, Henry Talbot's loving view of his young family provides an insight into the way they lived and the values they espoused. The toys that mimic the work of adults are readily at hand.

A wall of safety surrounds the children. Nature provides its majestic inspiration and promise in the backdrop of grand trees.

Charles Henry Talbot, the only son, had been born just two months before, on 2 February 1842. Upon receiving an early portrait just the year before this, Talbot's uncle William suggested that "Constance, with the three babies on their donkey & the tower of Lacock behind would make a pretty picture!"[2] There is no evidence that such a complicated picture was ever attempted by Talbot.

The present print must have been made almost immediately after the negative was produced, perhaps in a rush of excitement encouraged by other family members. As was typical in this period, Talbot dated the negative in a careful pencil inscription that would print in the lower right corner of the grass. This print was made before he had a chance to add the date. The now-dated negative survives, along with one other print, made later.[3]

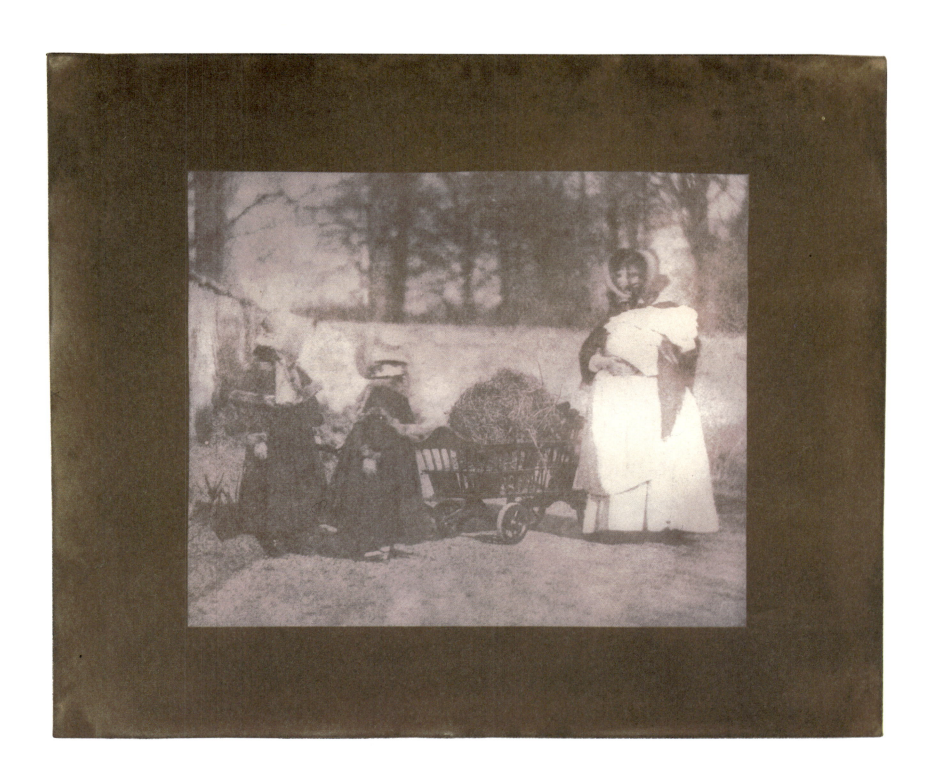

PLATE 52

The Handshake

8 April 1842. Calotype negative, 12.2 x 10.8 cm.
Inscribed in pencil on verso: "8 April 1842"
The Thomas Walther Collection, New York
SCHAAF 2646

It was a most extraordinary meeting! At the birthplace of the calotype, Talbot's loyal servant, Nicolaas Henneman, greets John Frederick Goddard, the scientific man who made the rival daguerreotype practical for portraiture. By improving on the method Daguerre had employed for sensitizing his silver plates, in a stroke Goddard reduced the exposure times for daguerreotype portraits from an excruciating several minutes to a matter of seconds.[1] So important was this breakthrough that the daguerreotypist and historian Jabez Hughes generously offered that "with the exception of M. Fizeau's method of gilding the plate no vital discovery was ever afterwards made in connection with the Daguerreotype; all the other improvements were matters of detail."[2] What was he doing at Lacock Abbey? And why was he welcomed so warmly?

By 1842, the competition for photographic portraiture in London was heating up. Just the summer before, Talbot had licensed Henry Collen, a prominent and successful miniature portrait artist, to promote calotype portraiture in London.[3] Collen's portraits were well received, but by the summer of 1842 he had actually sold little more than two hundred of them. Thus, Talbot was already open to the idea of extending the license elsewhere at the time Richard Beard approached him. Beard obviously hoped to gain a commercial edge over archrival daguerreotypist Antoine Claudet by being able to offer both daguerreotype and calotype portraits. He responded quickly to Talbot's consideration and agreed to "sending down

one of my most competent assistants (Mr. Goddard)."[4] We know from the diary of Lady Elisabeth Feilding that this meeting took place promptly: on 7 April 1842 she recorded that "Mr Goddard came to learn about photography."[5] At first, it might seem that Goddard was simply a clever assistant sent to learn from Talbot. In reality, the relationship had to have been much closer. Goddard had received the prestigious silver medal from the Society of Arts in 1838 for work in a subject very close to Talbot's interests, the polarization of light. Quite by coincidence, the first public showing of Talbot's photographs in Scotland was in Edinburgh at the same 1839 exhibition where demonstrations of Goddard's polariscope were the primary attraction.[6] The two men would have had much to talk about in addition to photography. Through this meeting, they forged a working relationship independent of Beard that lasted many years. Surprisingly, Goddard has dropped from the literature, and one of the best summaries of his life is the unusually discursive epitaph on his tombstone.[7]

This image inspired two similar studies, both in a smaller format, and probably arranged two or three years later by Nicolaas Henneman as he was experimenting at his new "Reading Establishment."[8] Talbot was justifiably proud of this dynamic image, and several prints from it are known to have survived. Curiously, more of these seem to have been modified by handwork than is usual in Talbot's prints.[9]

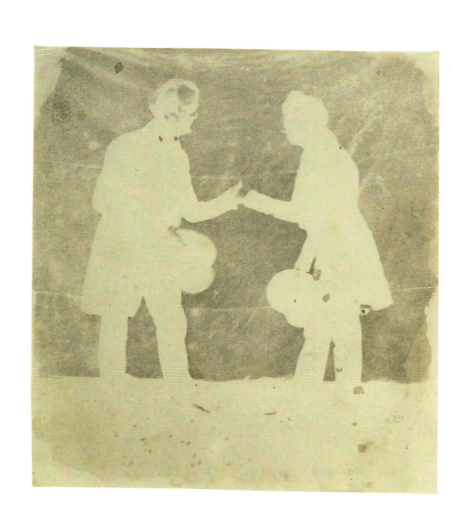

PLATE 53

"From the Life"— Goddard Instructs Henneman and Porter

8 April 1842. Salt print from a calotype negative,
16.3 x 17.5 cm image on 18.5 x 22.5 cm paper. Watermarked J Whatman 1841
Bayerische Akademie der Wissenschaften, Munich (X 131)
SCHAAF 2641

When Talbot dispatched a copy of this print to his collaborator, Sir John Herschel, he proudly inscribed it as being "from the life."[1] Taken with an exposure of little more than a minute, it is indeed a lively and rhythmical composition, full of life despite the need for the players to have held their pose for more than a minute. They were successful, and the casual droop of the sheet draped up outside Lacock Abbey seems not to have provoked any comment. Herschel enthusiastically thanked Talbot for "the exquisite specimens of the Calotype which surpass anything I had heard of. The power of depicting scenes of conversation & acting between living persons is a wonderful stride."[2] The pioneer photographic historian Robert Hunt, in thanking Talbot for the "very interesting specimens of your Photographic process," marveled that "M^r Goddard appears to the life in the group."[3]

In this, his first visit to Lacock, Goddard got along famously with Talbot and his associates, and the stay was highly productive. Fifteen distinct images are known to have survived from his brief visit, and it is likely that more were attempted.[4] Lady Feilding rarely noted departures of guests in her diary, but after his three days there she found it worthwhile to record that "Mr Goddard went back to London."[5] Although their plans to work together never materialized, Talbot and Goddard maintained a friendly contact over the years.[6] In 1854, Talbot wrote thanking him for his offer of support in the upcoming trial over Talbot's calotype patent. Still clearly remembering the photographs

they made together when they first met, Talbot closed with the comment that "I have got the original negative of the portrait made at Lacock Abbey in April 1842, from which a new copy may be struck off."[7] What happened to Goddard after the early 1840s is unclear. He left the employment of Beard and practiced daguerreotypy "in the provinces, but never appears to have been very successful. Whatever ability he may have possessed as a teacher of science, it is certain that he was weak in commercial matters; and, after a while, when others were deriving handsome incomes from the practice of the Daguerreotype process, he had to retire from the struggle, and subsisted by the aid of charitable donations given by old friends who had known him in prosperity."[8] Given the erratic behavior later in life of this promising individual, is it possible that he was one of the many pioneering daguerreotypists poisoned by the fumes of mercury so essential to their process?

This particular print was sent by Talbot to his longtime correspondent, the botanist Dr. Carl Fredrich von Martius, probably in a group of calotypes being transmitted to the Königliche Akademie der Wissenschaften on 10 June 1842. The negative was progressively trimmed throughout its printing life and now measures 14.8 x 17.4 cm. It is still fairly strong visually but has suffered more than some; both bottom corners are now trimmed, the right one doubly, and the top left-hand corner has been torn off and lost.[9] This print was made from the fullest known state of the negative.[10]

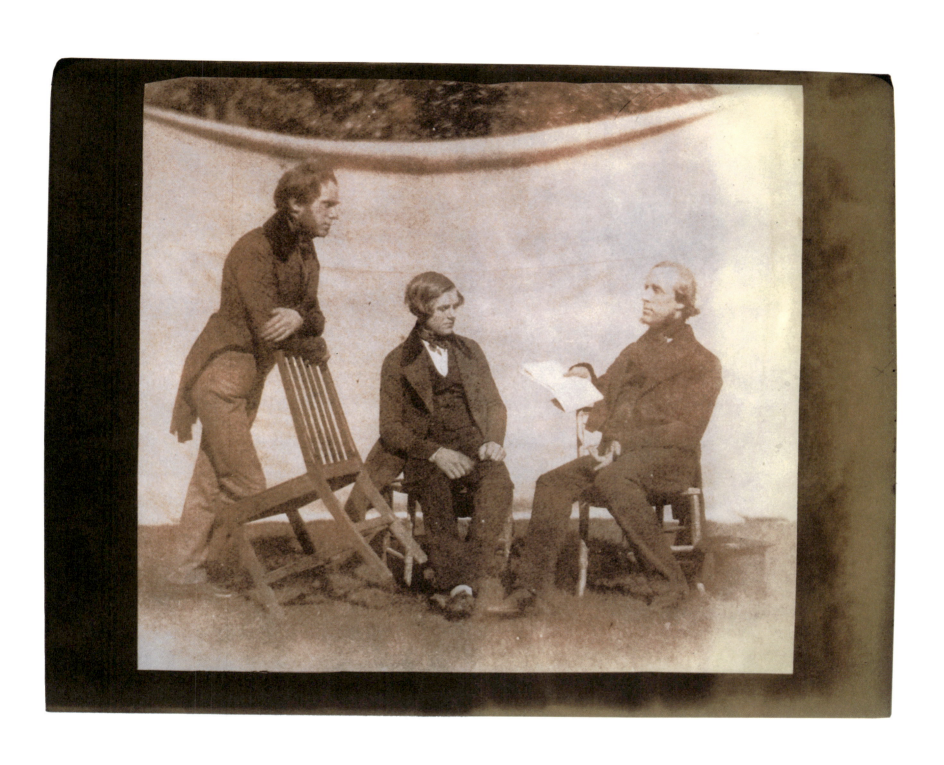

PLATE 54

Charles Porter, Drinking Wine

19 April 1842. Salt print from a calotype negative,
13.2 x 19.2 cm image on 18.7 x 22.4 cm paper.
Watermarked J Whatman Turkey Mill 1840. Pencil "X" on recto
The National Museum of Photography, Film & Television, Bradford (1937-2534/12)
SCHAAF 2657

What at first might appear to be a modern photograph of a wedding guest seated outside the reception tent on the lawn was actually an image meant to evoke an interior setting. Charles Porter, a vision of contentment in a bright and sunny room, enjoys his wine, a cigar resting in his outstretched fingers. A virtually identical negative, made the same day, depicts Henneman as the drinker.[1] The highly accomplished Scottish portraitists, Robert Adamson and D. O. Hill, used this approach of trundling the furniture outdoors to gather in the sunlight at their Rock House studio in Edinburgh (although, one must admit, with substantially more success in concealing the location).[2]

As Talbot and Henneman gained confidence with the shortened exposure times of the calotype negative, they increasingly photographed people depicted in simulated real-life situations. It is tempting to think the visit of John Frederick Goddard (pls. 52, 53) inspired this turn, but it would be more accurate to conclude that his visit seemed to have stimulated a renewed interest in this type of subject. Talbot had explored this visual theme before, although with somewhat less clarity. An example is a portrait of Nicolaas Henneman reading on a couch in front of a background, made on 2 October 1841.[3]

Identifying the people in photographs of a century and a half ago is an imprecise science at best (often no worse, however, than identifying the unlabelled snapshot of a generation ago). The balance of evidence suggests this young man is Charles Porter, a servant at Lacock Abbey.[4]

He appears in quite a number of Talbot's and Henneman's photographs, and his identity has always been the subject of some controversy. According to the 1841 census records for Lacock Abbey, he was a thirteen-year-old member of the household staff, which means he would have been fourteen at the time this portrait was taken. That seems a bit young, even allowing for differences of a long-ago society and dress, but it is plausible (errors in the 1841 census—the first real public one in Britain—were not uncommon). He does not appear in the 1851 census, and no other legal records on him have been located thus far.[5] However, Porter is referred to frequently in the family's correspondence and was given many responsibilities in photography, second only to those delegated to Nicolaas Henneman. Most often, he made prints for Talbot and for Lady Feilding. He also assisted Constance Talbot in her early efforts at photographing. In fact, Porter became so closely identified with the new art that by July 1841 Constance had to defend him to her husband by pointing out that he had other responsibilities at Lacock in addition to photography![6]

The negative survives, along with one other known print.[7]

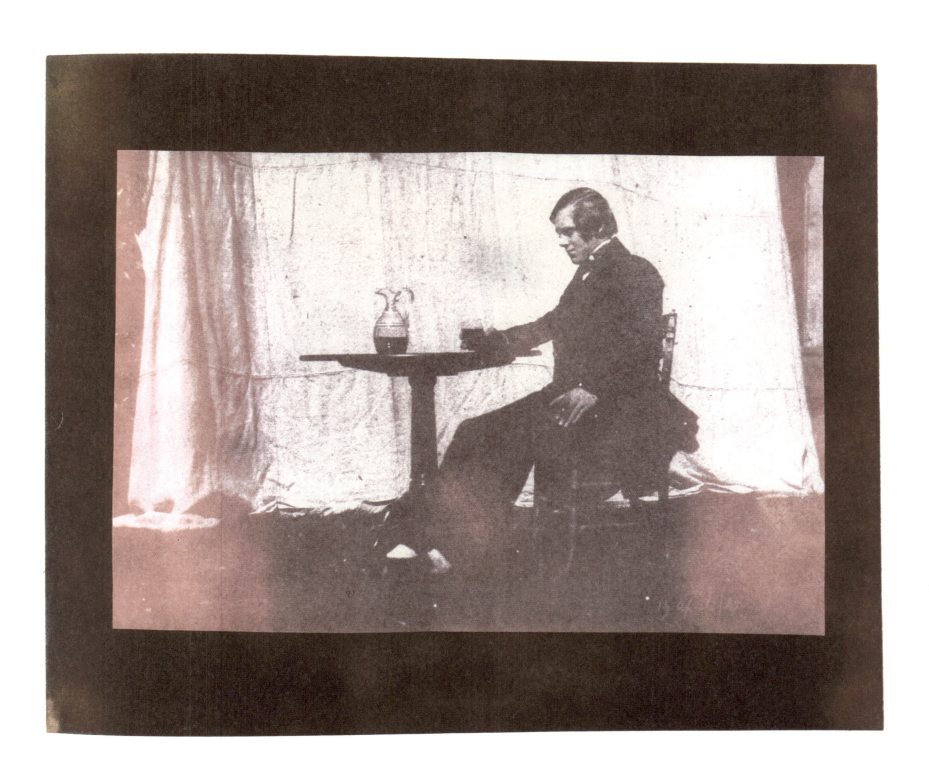

PLATE 55

Lady Elisabeth Feilding as Paolina Borghese

20 April 1842. Salt print from a calotype negative,
12.3 x 16.1 cm image on 18.3 x 22.2 cm paper.
Watermarked R Turner Chafford Mills 1840. Pencil "X" on recto
The National Museum of Photography, Film & Television, Bradford (1937-2536/30)
SCHAAF 3693

In a *tableau vivant* invoking Antonio Canova's portrait of the sister of Napoleon, Henry Talbot's mother maintains a somewhat more modest dress than that featured in the original marble.[1] Only a Wiltshire apple is lacking to complete the picture. Talbot's innocent portrait forms a charmingly incongruous vision, where a magic boat floats above the stars, transporting a goddess bathed in ethereal light. Although her face is shaded from our view, the resolute determination revealed by the set of her arm is obvious. Henry Talbot's formidable mother, the Lady Elisabeth Feilding, becomes an odalisque on the lawn, a carpet strewn with flowers. Canova's translucent marble was meant to be viewed in candlelight, but the fixing of Talbot's prints had long passed the point where they had to be seen that way. In his text for *The Pencil of Nature*, Talbot observed that "blue objects affect the sensitive paper almost as rapidly as white ones do. On the contrary, green rays act very feebly—an inconvenient circumstance, whenever green trees are to be represented in the same picture with buildings of a light hue, or with any other light coloured objects."[2] Yet here, the "feeble" green rays act to suppress the foliage, heightening the sense of light on Lady Elisabeth and her chintz chair.

Even if more modestly draped than Canova's subject, Lady Feilding was easily her match in the task of mediating the dispute between Juno (power), Venus (love), and Minerva (the Arts and Sciences). If one could travel back in time, surely one of the first people a serious photohistorian would want to call on would be Lady Feilding. She must have known more about the *real* story of the development of the art of photography in England than just about anyone else. Her letters—often written in a frantic hand and just as often unsigned—and her diaries are a constant source of information on Henry Talbot's

thoughts and doings. The daughter of the Earl of Ilchester, she was well educated, fluent in several languages, and possessed of an agile mind; it was from her family name that Henry acquired the "Fox" so often cojoined with his surname. Her helpful social connections and drive to see her son achieve fame (one in which he did not always share) demonstrably influenced Henry's public approach to photography, and her personal artistic attainments, both in draftsmanship and in criticism, must have become a part of her son's vision. When Henry Talbot attained his majority, his mother forthrightly claimed that "for myself I shall reserve the right *which Nature gives me*, of suggesting any thing which from your youth & inexperience may not occur to you." And exercise that right she did! Never one to mince words, Lady Elisabeth continued through her life to supply an ambition and a power to Henry Talbot that may not have been central to his nature. She openly confessed to her son that "you cannot judge of the rapture with which I first beheld you," but this enchantment went even beyond a mother's natural love for a child.[3] Lady Elisabeth knew that Henry Talbot was an exceptional individual and that he was destined for great accomplishments. She did everything in her power (which was quite considerable) to assure Henry's success—especially in attempting to shield him from his own worst traits.

This print is in a large-format calotype album, mostly titled by Lady Elisabeth herself. Sadly, the negative for this marvelous image seems not to have survived; three other prints are known.[4] Talbot produced a close variant of this image on the same day, using essentially the same framing of the chintz chair. In the variant, Lady Elisabeth is in profile, contemplating an open album or illustrated book.[5]

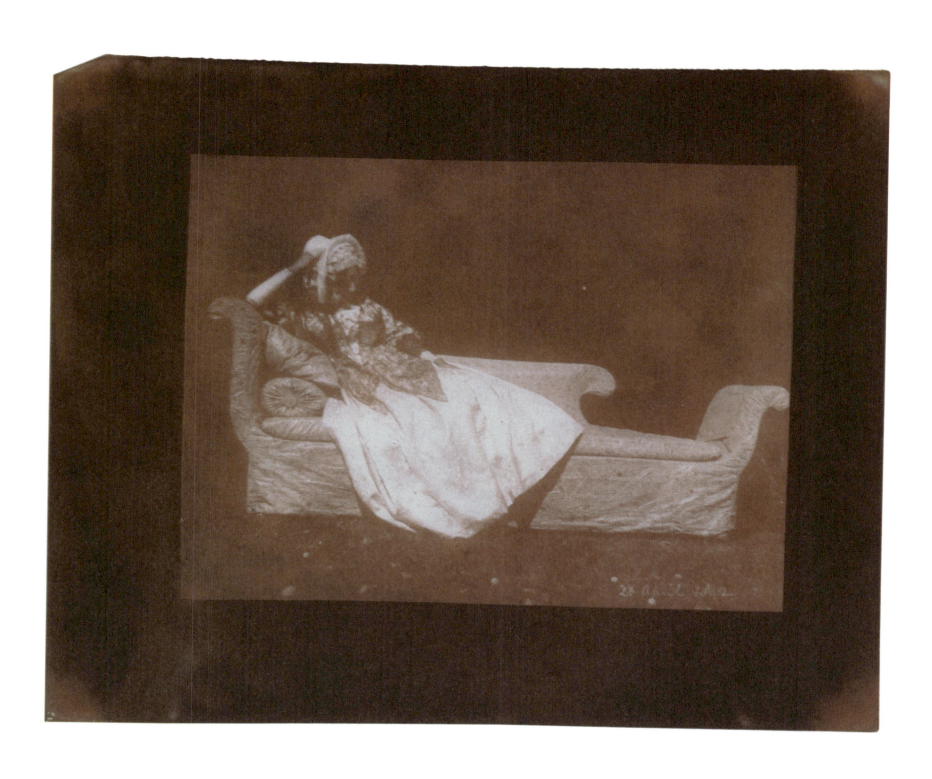

PLATE 56

"A Bush of Hydrangea in Flower"

c. 1842. Salt print from a calotype negative,
15.6 x 19.8 cm image (with borders)
Collection of Lawrence and Sybil Hite
SCHAAF 165

Of all the plants competing for the gardener's eye, the hydrangea is perhaps the most flamboyant. In Talbot's photograph, their immodesty is offset by the impertinent string of little flowers on the right. The inclusion of this counterpoint is not an oversight. Talbot has carefully framed his image with the mass of the hydrangea to the left of center, neatly balanced by the delicate little blooms on the other side. The colossal hydrangea dance to the command of the string of flowers, almost as if mesmerized by a snake. Without this tension, the composition would have been more static, a mere descriptive picture of a bush.

The flood of full sunshine (for that is when hydrangeas are at their best) is effective here. The deep shadows showcase the bright flowers. Talbot took advantage of one of the characteristics of his medium here. His calotype negative material was rather insensitive to green light. Just as in the portrait of Lady Elisabeth in plate 55, this made the background leaves seem even darker than they would have been in nature, and brought out the main subject in brilliant relief. It brought the emotional value of the flowers to the prominence they had in Talbot's eye (and, perhaps, did the same for the image of his mother as well).

As can be seen in the outline of the print, the paper negative was slightly and neatly trimmed in the corners; these vulnerable points were the most susceptible to damage, even in normal handling during printing, and this step helped to preserve a sense of neatness for a longer time. The negative survives and there are other prints.[1] There are two other similar Talbot negatives of a hydrangea bush, both smaller in format.[2] All three were so popular that Nicolaas Henneman had a printed title made up to attach to the mounts of copies offered for sale.[3]

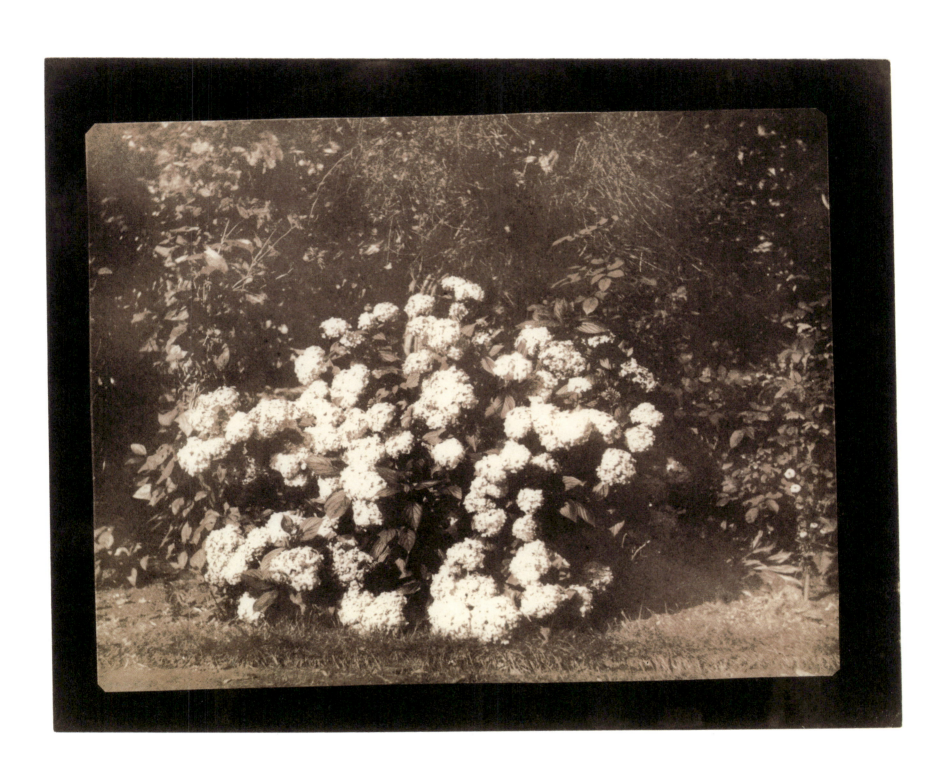

PLATE 57

"Scene in a Wood"

Probably summer 1842. Salt print from a calotype negative,
15.8 x 19.3 cm image on 18.0 x 19.8 cm paper
The National Museum of Photography, Film & Television, Bradford (1937-2043/1)
SCHAAF 97

Filled with a sense of light and space, this trio of beech trees represents the best of an English summer. In spite of their mass and strength, these three are drawn to the energy of the sunlight. Talbot has placed them to the right of the visual center of this composition, balancing them with the great mass of dark foliage at the left. This, aided by the sparkling highlights of the leaves, keeps the image alive.

This photograph is one of many that Talbot took of trees. It differs from many (for example, the *Oak* in pl. 59) by its sense of place. Rather than being a portrait of particular specimens to be examined, this photograph is an invitation to the viewer to join in the scene. Perhaps that is why it seems so warm. Most of the trees that Talbot photographed at Lacock he viewed in isolation, and perhaps a change of locale was what changed his photographic interpretation. This image was possibly taken at Mount Edgcumbe, the marital home of Talbot's sister Caroline.

Above her house was a beautiful and widely admired "Beech Wood," attracting visitors until it was flattened in the great blizzard of 1891, and this is surely a place to which she would have directed her brother.[1]

That great authority on the mystical meaning of trees, Robert Graves, relates that "Beech" is a common synonym for "literature": "the English word 'book', for example, comes from a Gothic word meaning letters and, like the German *buchstabe*, is etymologically connected with the word 'beech'—the reason being that writing tablets were made of beech."[2] Was this scene a natural reflection of Talbot's intense interest in his library?

Nicolaas Henneman selected this as one of twenty-four plates for his 1847 *Talbotypes or Sun Pictures, Taken from the Actual Objects Which They Represent*, under the title of "Scene in a Wood."[3] The negative is not waxed and not dated; several prints are known.[4]

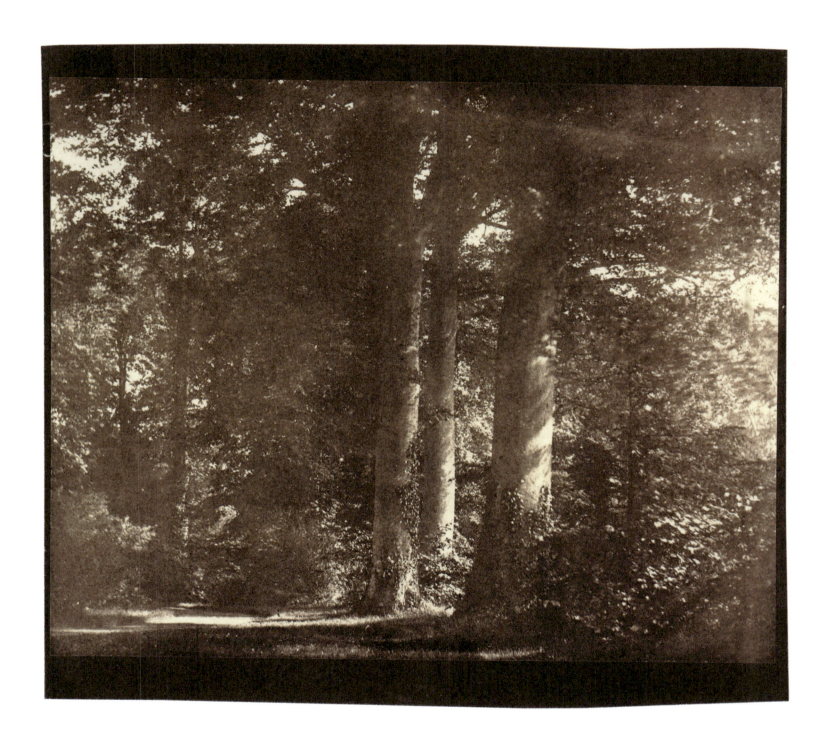

PLATE 58

"Bust of Patroclus"

9 August 1842. Salt print from a calotype negative,
13.8 x 12.9 cm image on 23.1 x 18.9 cm paper
Private collection, courtesy of Hans P. Kraus, Jr., Inc.
SCHAAF 190

On 28 February 1840, Talbot wrote to Sir John Herschel to "enclose Patroclus and Venus, done yesterday in fine weather . . . these are from plaster casts, I have no marble bust here to copy from."[1] Patroclus, the loyal defender of Achilles, was Talbot's first—and his most favored—portrait sitter. The patience (and high light reflectivity) of the bust was crucial when Talbot's materials were primitive. The boldly sculpted head could modulate light and shadow in an infinite number of ways. The easily handled bust could be oriented to stand in any sort of light, and he made an attractive figure from a wide variety of angles. Patroclus starred in at least forty-seven distinct Talbot photographs (not counting those images where he appears as an element of a larger scene), and one assumes that the total must have been even higher.[2] Of these, twenty-two distinct images can be dated precisely. The earliest was on 26 November 1839 (surely, not the first time Talbot used his trustworthy companion as a subject!),[3] and the last dated image was on 9 August 1843; the latter is related to the present image and was employed as plate XVII of *The Pencil of Nature*.[4] The present image was plate V in the work, included in the first part and issued in June 1844.

But just how did Talbot come to know his friend as Patroclus, the warrior who sacrificed his life when he bravely donned Achilles' armor? His cast was made from a marble bust excavated by Gavin Hamilton at Hadrian's Villa in 1769. It was purchased by Charles Townley for the not inconsiderable sum of £200 and was variously described in his inventories as the "Head of a Titan," "Head of Diomedes and or Ajax," or "Head of a Hero Unknown." In 1812, Taylor Coombe, the British Museum's first Keeper of Antiquities, described it as the "Head of a Homeric Hero," the name widely employed by the museum (where the bust is still preserved).[5] It was generally thought to be a Roman copy of a Greek marble. Then, in 1957, workers

excavating a new coastal road from Rome to Naples stumbled across the "most sensational discovery of recent years in Italy," the Grotto of Tiberius at Sperlonga.[6] In this, Talbot's "Patroclus" is seen as a full figure, clutching a goatskin, and drawing back in horror from the Scylla he has just poisoned. Scholars now disagree on which head is the copy of which. The story of Talbot's own bust of Patroclus involves archaeology as well. The loyal subject had been long forgotten until unearthed in a Lacock Abbey shed in the 1950s by Harold White, whose daughter remembers laboriously cleaning the plaster with a toothbrush when she was a young girl. The bust now sits proudly in the Fox Talbot Museum on the grounds of Lacock Abbey, slightly softened in contour. His identity may be in question in the halls of the British Museum, but to photohistorians he will always be *Patroclus*.

In addition to prints in copies of *The Pencil of Nature*, numerous loose examples of this are known.[7] None is quite as spectacular as the present print, appropriately framed in the brush strokes that are the sign of Talbot having coated this sheet of paper by hand. He had a choice early on between doing this and either floating or dipping the paper, but this approach is usually associated with earlier prints. Talbot never commented on this publicly, but the account book of the Lacock village carpenter, John Gale, Jr., reveals billings in April 1839 for work on camera obscura "remaking and painting dipping trough" and on 1 January 1841 for "contrivance for dipping paper and 2 troughs for same."[8]

The negative for this view has not been located and, in fact, was one of those to which Talbot referred in the text for plate XXIV in *The Pencil of Nature* as having met with misfortune in his own day.[9]

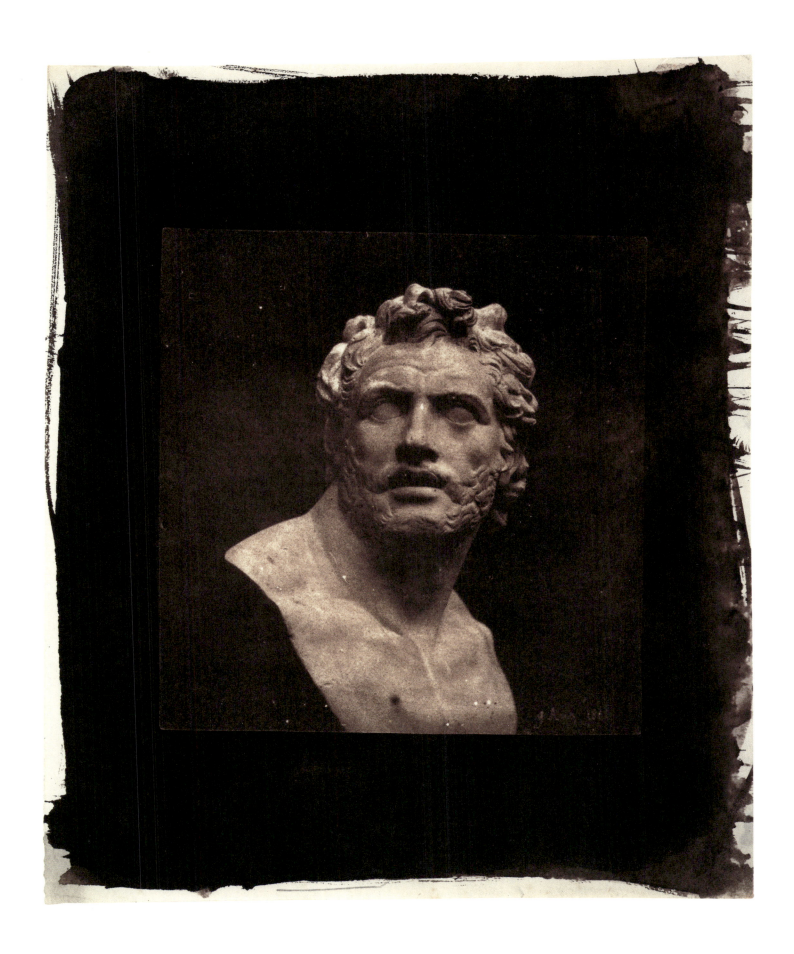

PLATE 59

Oak Tree in Winter

Probably 1842/43. Salt print from a calotype negative,
19.6 x 16.7 cm image on 22.3 x 18.5 cm paper
Private collection
SCHAAF 1981

Majestic and alone, the oak presents itself here as master of the landscape. Delineated in form as clearly as one of the smaller plants that had earlier left its impression directly on Talbot's paper, the mighty oak is perfectly diminished in size but not in stature. Using Talbot's visual description, our minds can reconstruct it in its original state.

Even as late as 1841, Dr. George Butler, Talbot's childhood tutor and headmaster at Harrow, clearly remembered his former student's early interest in botany. He suggested that "what I should like to see, w^d be a set of Photogenic Calotype drawings of Forest Trees, the Oak, Elm, Beech, &c. taken, of course, on a *perfectly calm* day, when there should not be one breath of wind to disturb and smear-over the outlines of the foliage. This would be the greatest stride towards effective drawing & painting that has been made for a Century. One Artist has one touch for foliage, another has another; and we may from such characteristic touch divine the intended tree & perhaps name the Artist. But your photogenic drawing would be a portrait; it would exhibit the *touch* of the great Artist, Nature: and by copying *that touch*, in a short time our modern artists would acquire a facility & accuracy & decision in the characterizing of trees & delineating their respective foliage, as has never been surmised in all bygone Ages. What a beautiful Set of *Studies* of Trees, Shrubs, etc. might thus be prepared in a very short time! . . . try your hand at this, my dear Talbot: You may have to wait many weeks for a *perfectly clear* and *calm* day."[1]

Like all the landed gentry, Talbot was keenly aware of the value of the timber on his estates. But perhaps more than many, he also knew the deeper and more lasting value of the place of grand trees in his landscape. When his friend Sir John Herschel moved to remote Kent in 1840, Talbot admired his descriptions of the new property, confessing that "lakes and old oak trees are very much to my taste."[2] Lacock's trees led a more active life than many. In fact, in 1834 a neighbor asked to borrow Talbot's "Machine for moving large Trees."[3] But it was his mother, Lady Elisabeth Feilding, who concerned herself the most with the trees at Lacock. She was constantly planting and thinning and moving them around. Trees were almost her children, and after one particularly bad windstorm, she lamented "how I grieve over the trees! & the old Elms! & the young Tulip tree! It puts me in mind of that comparison in Homer, of a young Warrior killed on the plains of Troy."[4]

Lady Elisabeth might have left us a clue to dating this photograph. In the late summer of 1842, with great pride she informed her son that "I have been filling up the other two Stew ponds left undone last Spring . . . that great Oak stands out now, & looks superb."[5] Perhaps that "great oak" in its "superb" setting is what inspired Henry Talbot that winter.

This is one of the rare cases where the particular print can be established as having been taken off early in the negative's life. There was a tiny paper snag in trimming the negative, on the right edge about a third of the way down from the top. This fragile little bit dropped off sometime after this particular print was made. The waxed negative survives, along with numerous prints, some in fine condition.[6] This print was formerly in the Bokelberg Collection.

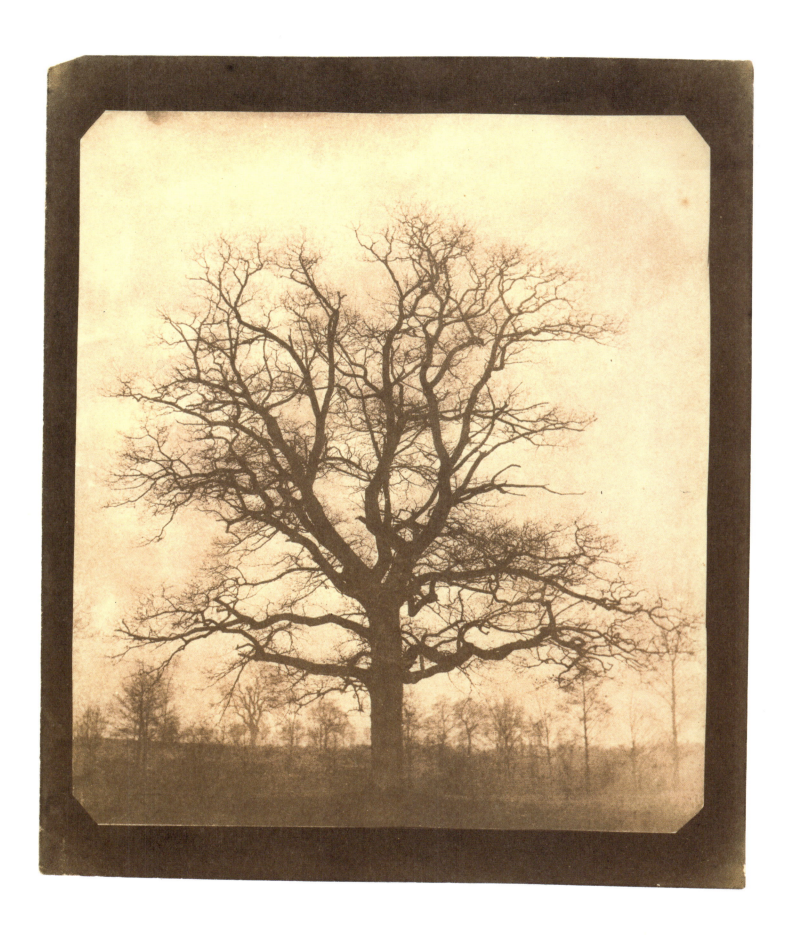

PLATE 60

High Street, Oxford

July 1842? Salt print from a calotype negative,
18.7 x 17.2 cm image on 25.1 x 19.6 cm paper
The San Francisco Museum of Modern Art. Fractional Gift of
Prentice and Paul Sack and Collection of the Prentice and Paul Sack
Photographic Trust of the San Francisco Museum of Modern Art
SCHAAF 1005

I slight my own beloved Cam, to range
Where silver Isis leads my stripling feet;
Pace the long avenue, or glide adown
The stream-like windings of that glorious street—
An eager Novice robed in fluttering gown!

WILLIAM WORDSWORTH[1]

Like Wordsworth, Talbot being a Cambridge man did not preclude his experiencing the thrill of the ancient buildings of Oxford. (There was also the practical matter that Oxford was much easier to reach from Lacock than was Cambridge, no small consideration when so much equipment and materials had to be carried to a site in order to photograph it.) Today, ever-watchful for the menacing tourist coaches barreling down the High Street, it is more than a little difficult to re-create the feeling of awe that this renowned Oxford vista inspired in Talbot's era. A tourist guidebook of his period gives some sense of what he must have felt: "We must first visit the famous High-street—Oxford's pride—a place which never fails to surprise the stranger with its beauty, and one which no amount of intimacy with ever lessens in our estimation. Had it been designed merely with a view to the general effect, the result could not have been better. The great and rich variety of buildings—colleges and churches mingling with modern shops and old-fashioned dwellings—and the diversity of the styles in which they are constructed—are brought, by the gentle curvature of the street, into combination and contrast in the most pleasing manner. Nothing can well surpass the way in which the splendid architectural array opens gradually upon the passenger who descends it from Magdalen Bridge . . . there is none other like it in England."[2]

Talbot's camera was placed in what is now part of the busy roadway. The exact point is just immediately below Longwall Street. Just visible in the shadows at the right of Talbot's image is the stone wall of St. Swithin's, now precariously at the very edge of the street. In Talbot's day, this end of the High Street was the eastern and principal entrance into the city by the coach from London. Just after crossing the elegant Magdalen Bridge, the Street revealed its curve, and the unique character of this sweep had long been appreciated. In 1806, James Dallaway wrote that "by its curvature, the High Street gradually expands the scenes of academic splendour. The succession is not too sudden, nor does it suffer from the want of continuity or neatness in the private houses."[3]

The bank of buildings along the left side of Talbot's photograph pretty much retains its original character and must take on the duty of providing most of the visual continuity between his image of the 1840s and the busy scene presented today. It now houses the Ruskin School and the Examination Schools. The buildings on the right side of the street—central in this image—have changed substantially. The visitor can see their elegant and proud date signs proclaiming the years 1901, 1950, and 1952. Gone now is the lively dance hall that was popular in the 1950s, replaced by St. Edmund Hall. Anyway, most visitors today arrive from the vicinity of the unlovely railway station at the opposite end of town and see this vista only if they turn back from their path.[4]

On 30 July 1842 Talbot reported to Amelina Petit that he had made many fine views of Oxford.[5] The mysterious streaks in the foreground area might at first be mistaken for the traces of moving people (which gently intrude in other Talbot photographs of Oxford).[6] These streaks are actually flow lines of chemicals in the original negative, a mechanical defect in no way fatal to the effect of the image. That negative, along with numerous prints, survives.[7]

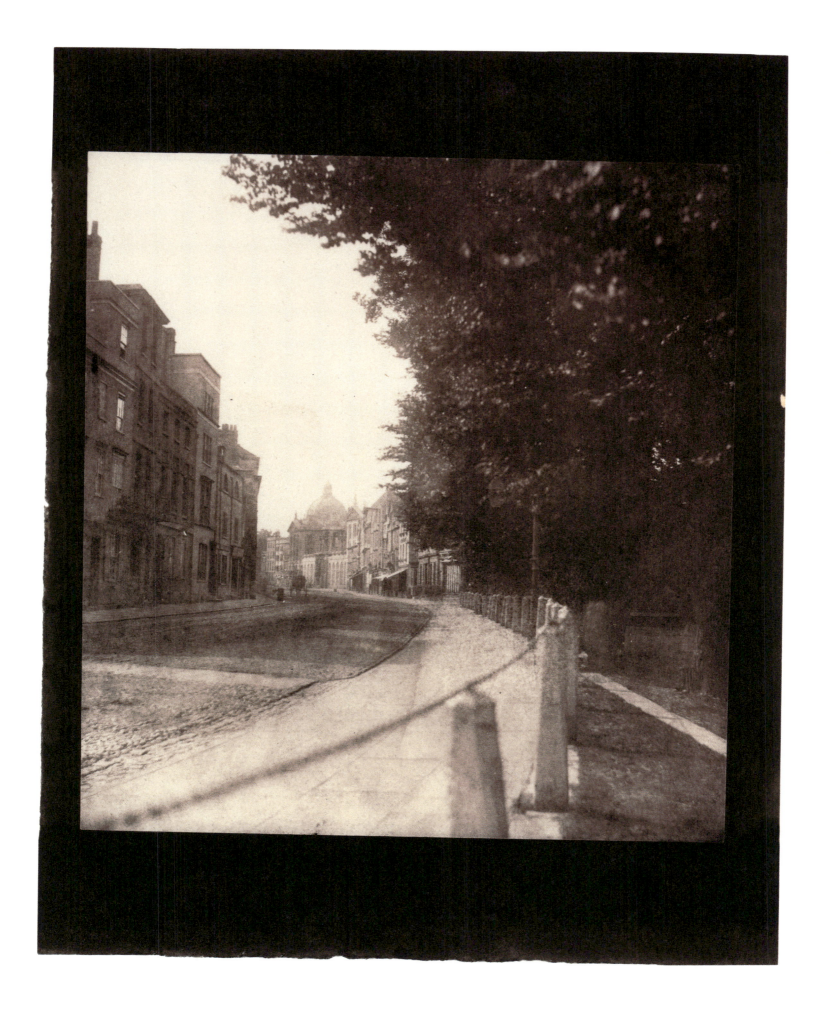

PLATE 61

"Queen's College, Entrance Gateway, Oxford"

9 April 1843. Salt print from a calotype negative,
17.3 x 21.2 cm image on 19.6 x 24.8 cm paper
Collection of Michael and Jane Wilson, London (96:5519)
SCHAAF 1574

As early as 1806, James Dallaway could observe that "for variety and magnificence of publick buildings no city in Europe can offer a competition" to Oxford.[1] This part of Queen's is just around the bend of Talbot's *High Street* (pl. 60). Talbot described this as "a view of the Gateway and central portion of the College. It was taken from a window on the opposite side of the High Street. In examining photographic pictures of a certain degree of perfection, the use of a large lens is recommended, such as elderly persons frequently employ in reading. This magnifies the objects two or three times, and often discloses a multitude of minute details, which were previously unobserved and unsuspected. It frequently happens—and this is one of the charms of photography—that the operator himself discovers on examination, perhaps long afterwards, that he has depicted many things he had no notion of at the time. Sometimes inscriptions and dates are found upon the buildings, or printed placards most irrelevant, are discovered upon their walls; sometimes a distant dial-plate is seen, and upon it—unconsciously recorded—the hour of the day at which the view was taken."[2]

It is likely that any attention Talbot might have paid to the clock was distracted by the dominant cupola covering Henry Cheere's statue of Caroline, the consort of George II, who gave £1000 toward the college building. Talbot's camera position was a window above the Alfrods Head Inn (now the university buildings near Bridle Way).

This image was selected by Talbot as plate XIII for *The Pencil of Nature* (issued in fascicle 3 in May 1845). The *Athenaeum* was impressed that in this plate "the truth-telling character of photographic pictures is pleasingly shown. It appears by the turret clock, that the view was taken a little after two, when the sun was shining obliquely upon the building. The story of every stone is told, and the crumbling of its surface under the action of atmospheric influences is distinctly marked."[3] The *Literary Gazette* was even more taken with this view, and more direct in its comments, saying that it "appears to us to be a perfect study for the architectural artist. Examined, as recommended by Mr. Talbot, with a magnifying glass, it is quite a photographic wonder and memorial of realities."[4]

The waxed negative survives; there is some unevenness in the sky area, which typically manifests itself in the prints, as well as a defect that produces a small irregular black spot in the prints, in the frieze below the roofline between the second and third windows from the right. There are also several prints known that are not in copies of *The Pencil of Nature*.[5]

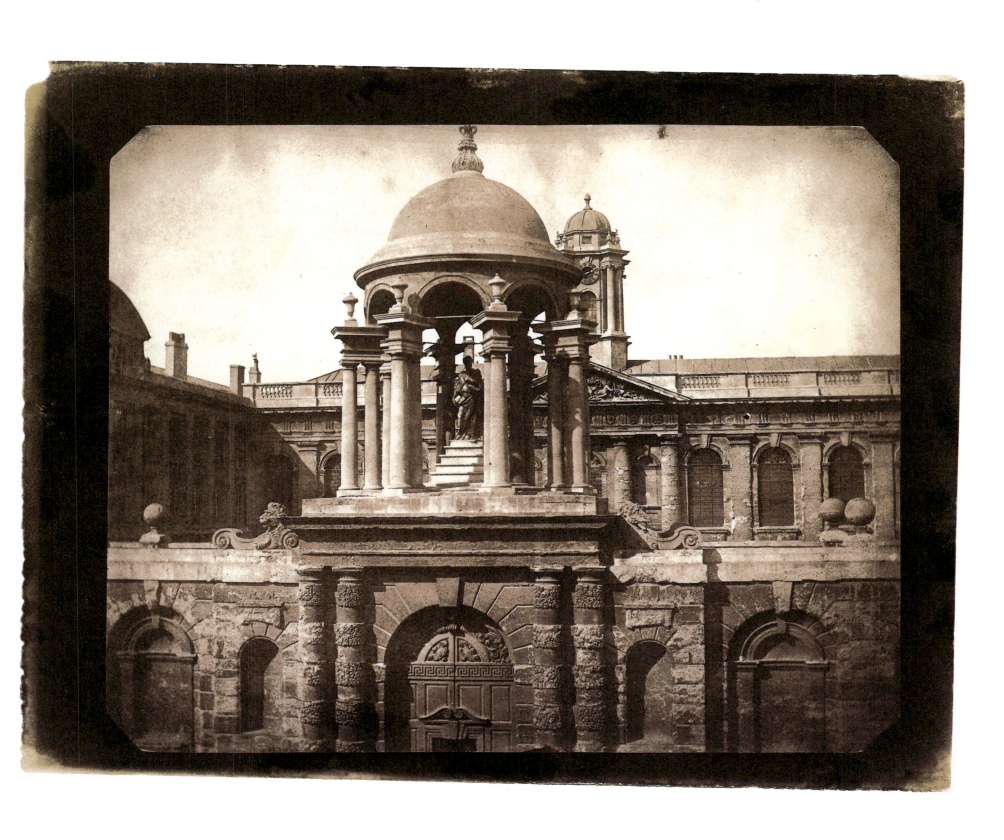

PLATE 62

"An Ancient Door, Magdalen College, Oxford"

9 April 1843. Salt print from a calotype negative,
16.2 x 20.7 cm image on 18.5 x 22.8 cm paper
The Richard Menschel Collection
SCHAAF 44

Henry Talbot's recorded thoughts on this photograph, although brief, are more revealing of what arrested his eye than what we have available in many cases. In thinking about this image, he observed that "when we visited this interesting spot ye summer sun was getting low, & ye shadows of ye neighboring buildings were fast incroaching upon it the object we wished to delineate. Perhaps the resulting effect is none the worse on that account. Painters love objects visited in partial gloom."[1]

Henry Talbot the artist had emerged! Not only is this a beautiful and evocative photograph, but it was one that he took quite conscious of the aesthetic components of which it was made. His use of the pronoun here was not an example of the "royal plural," but rather a recognition that Nicolaas Henneman was an invaluable partner in his excursions. Calvert Jones wrote enthusiastically that he thought "the entrance to the chapel the finest that has yet been done."[2] This doorway is without known precedent in Britain. It was put in—likely retrieved from an earlier building—when the west window was installed in the 1630s.[3] Over the doorway are statues of St. John the Baptist, St. Mary Magdalen, St. Swithin, Edward IV, and the founder of Magdalen, William of Waynflete. Augustus Pugin was sufficiently intrigued by the ancient door to include a drawing of it in his *Specimens of Gothic Architecture*.[4] In 1844, shortly after Talbot took this photograph, Pugin built the new entrance gateway nearby (since demolished).

Talbot wrote the above text with a mind toward including this image in *The Pencil of Nature* (sadly, the publication was suspended before this particular view was published). In a section of published text for another Oxford plate, he observed that "those who have visited Oxford and Cambridge in vacation time in the summer must have been struck with the silence and tranquility which pervade these venerable abodes of learning. Those ancient courts and quadrangles and cloisters look so beautiful so tranquil and so solemn at the close of a summer's evening, that the spectator almost thinks he gazes upon a city of former ages, deserted, but not in ruins: abandoned by man, but spared by Time. No other cities in Great Britain awake feelings at all similar. In other towns you hear at all times the busy hum of passing crowds, intent on traffic or on pleasure—but Oxford in the summer season seems the dwelling of the Genius of Repose."[5]

In February 1845, after receiving three hundred prints of "Magdalen College Gate" from Nicolaas Henneman, Talbot loaned him the negative for this image for further use in his own printing.[6] Sometime in the period between when part 4 of *The Pencil of Nature* was issued in June 1845 and when part 5 was ready by December, Talbot's stock of "Doorway Magdalen College" dwindled to only twenty-two prints.[7] The waxed negative survived this extensive printing, but surprisingly few prints seem to have been preserved.[8] In addition, Talbot took two smaller negatives of this view; neither of them is as successful.[9]

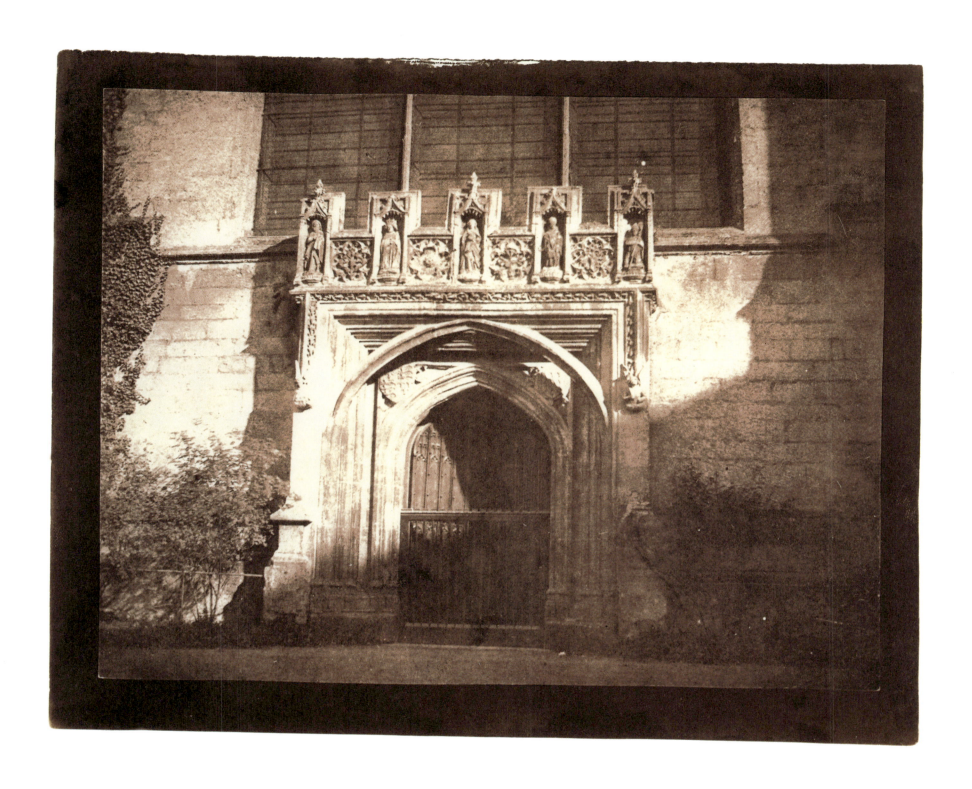

PLATE 63

The New Chain Suspension Bridge at Rouen

Mid-May 1843. Salt print from a calotype negative,
14.8 x 20.3 cm image on 18.3 x 22.5 cm paper. Watermarked J Whatman 1840
The National Museum of Photography, Film & Television, Bradford (1937-2533/14)
SCHAAF 1899

Talbot's work in Oxford led up to an important expedition. By 1843, he had every reason to be confident of his own artistic growth and of the aesthetic capabilities and technical attainments of his calotype negative process. Henry Talbot was ready to take his cameras into the land of his arch rival Daguerre, with the express intent of promoting the calotype process in France. With Nicolaas Henneman for support, he made a monthlong visit. His reception (by the weather, not the French!) was not at all encouraging, for he recorded that his visit of 14 to 18 May in Rouen was "generally stormy."

Talbot reported to his mother on 15 May that "the first view of Rouen is very fine, from the top of a hill rather higher than Bowden Hill and not more than a mile from the city—I drove to the Hotel l'Angleterre on the quai. A new suspension bridge crosses the river before my windows. Great bustle and commercial activity manifest everywhere. From early dawn to dewy eve incessant rumbling of carts & wagons—Ships constantly loading, unloading, and moving away—at one moment the quai strewed with large barrels—an hour afterwards not one of them left. Weather grown extremely stormy and rainy—nothing to be done in Calotype until it clears up—I think of stopping 2 or 3 days here. This Hotel is pretty comfortable, but his charges are such as only princes can pay."[1]

Halfway between Paris and the sea, receiving the benefits of a lively cotton trade, Rouen was considered the "Manchester of France"—a proud boast. It was separated from its suburb, St. Sever, on the south side of the Seine, by the seventeenth-century "Pont-à-bateaux" (a bridge of fifteen boats) that crossed the river. Closer to Talbot's time, a stone bridge was built higher up the river, taking advantage of an island to cross the wide span in two sections. By 1836, however, advancing technology made it possible to erect a chain suspension bridge in a more central location. Suspended from a central tower (that incorporated a drawbridge for larger vessels), this very elegant toll bridge was more than two hundred meters (six hundred feet) long. It was this example of modern technology that Talbot photographed. Looking northward toward Rouen from the Cirque de St. Yvres, a line drawn from Talbot's camera through the center of the bridge would have reached his lodgings in the popular Hotel d'Angleterre.

Talbot had planned to use a study of Rouen's Palais de Justice as a plate in *The Pencil of Nature*.[2] Although this plate was never published, in the manuscript text he outlined for it he observed that "Rouen possesses many edifices of great architectural beauty, which lovers of Photography would love to delineate. On my way to Paris in May/43 I stopped several days at Rouen expressly on this account, but I delayed my journey to very little purpose, as heavy showers of rain continued nearly ye whole time of my stay. Once only it cleared up, during a short interval."[3] Writing to his mother on 22 May, Talbot revealed that he had sent a now-lost letter "to Constance from Rouen enclosing 2 pictures . . . I staid 4 days at Rouen, but the bad weather continued almost all the time—I made however a pretty sketch of the Palais de Justice during an éclairci."[4]

The waxed negative survives, along with a few other prints.[5] Talbot is known to have taken four other negatives of the bridge.[6]

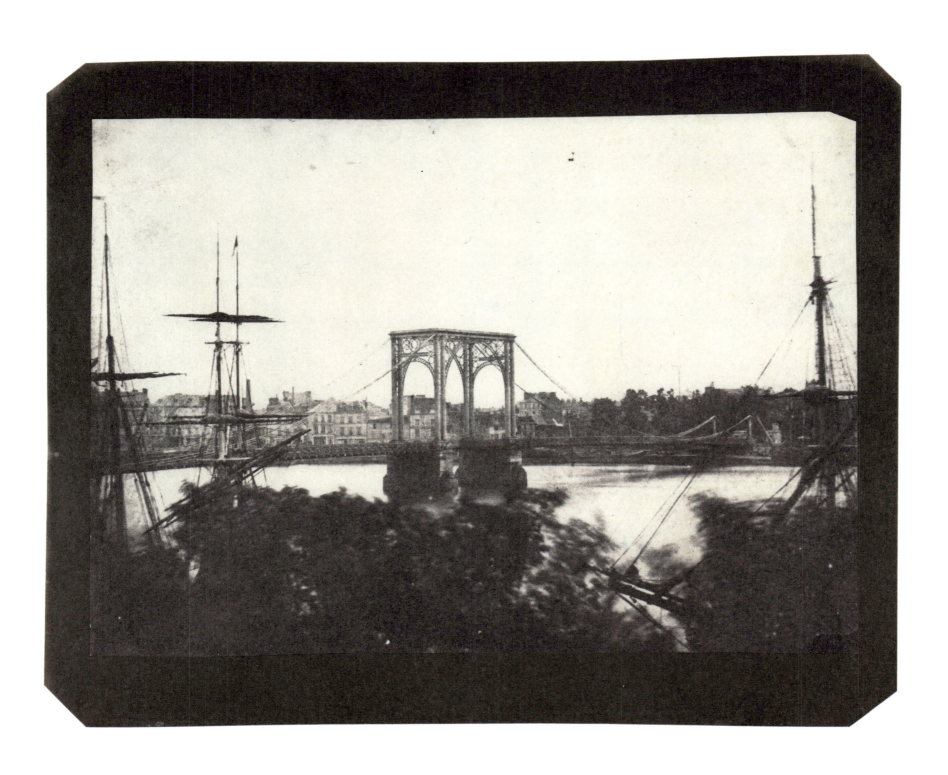

PLATE 64

"The Boulevards of Paris"

(19 May–12 June) 1843. Salt print from a calotype negative,
16.1 x 21.3 cm image on 18.1 x 22.6 cm paper
Private collection, courtesy of Hans P. Kraus, Jr., Inc.
SCHAAF 128

Writing to his mother just after arriving in Paris, Talbot enthused that "Saturday was a day of magnificent sunshine; I never saw Paris look so well and so gay" and asked her to send a reply to the "Hotel de Douvres, Rue de la paix. It is the corner house with the Boulevards—I chose it on account of the view. My sitting room is circular."[1] It was in an area of deluxe hotels and fine shops, in the heart of fashionable Paris in 1843, and although Baron Haussmann would soon tear into it, somehow it manages to retain this character to this day.[2]

Talbot's well-sited room in the exciting capital of France inspired both his photography and his prose. He chose this photograph as the second image in his seminal book, *The Pencil of Nature*, and his observations on it are some of the most complete and satisfying that he ever put into print: "This view was taken from one of the upper windows of the Hotel de Douvres, situated at the corner of the Rue de la Paix. The spectator is looking to the North-east. The time is the afternoon. The sun is just quitting the range of buildings adorned with columns: its façade is already in the shade, but a single shutter standing open projects far enough forward to catch a gleam of sunshine. The weather is hot and dusty, and they have just been watering the road, which has produced two broad bands of shade upon it, which unite in the foreground, because, the road being partially under repair (as is seen from the two wheelbarrows, &c. &c.), the watering machines have been compelled to cross to the other side. By the roadside a row of *cittadines* and cabriolets are waiting, and a single carriage stands in the distance a long way to the right. A whole forest of chimneys borders the horizon: for, the instrument chronicles whatever it sees, and certainly would delineate a chimney-pot or a chimney-sweeper with the same impartiality as it would the Apollo of Belvedere. The view is taken from a considerable height, as appears easily by observing the house on the right hand; the eye being necessarily on a level with that part of the building on which the horizontal lines or courses of stone appear parallel to the margin of the picture."[3]

The Spectator expressed amazement that Talbot's paper print was "almost equal in distinctness of detail to a Daguerreotype."[4] The aspiring calotypist William Thompson expressed a similar reaction: "In your picture of the Boulevards, the ~~long~~ line of chimneys are as sharp as Bains' house."[5] The *Literary Gazette* marvelled that this view "takes in vast masses of building, a distant horizon of chimneys, and also trees in the foreground; the effects of light and shade are remarkable, and well deserving the attention of the landscape-painter. The angles of vision, too, merit his study, as determining perspective lines in a singular manner."[6] The *Art-Union* found that "it is curious to observe the entire absence of human life in the picture; this will forcibly strike those who know how crowded is the Boulevard des Italiens in the afternoon, for that is the time of day. This, however, will be a matter of surprise only to persons unacquainted with the nature of photography; and it is only necessary to say in explanation, that no moving object can be represented."[7]

Sometime after his first print order to Henneman for this photograph, Talbot sent a note asking him to call a halt to the printing and to "try to expunge spots w^ch have fallen on ye *original* [negative]."[8] In his announcement of *The Pencil of Nature*, commenting on the figures frequently introduced into French engravings, Talbot claimed that "the plates of the present work will be executed with the greatest care, entirely by optical and chemical processes. It is not intended to have them altered in any way, and the scenes represented will contain nothing but the genuine touches of Nature's pencil."[9] Her pencil was certainly augmented, however, for in June 1844 Talbot paid his bookbinder, Alfred Tarrant, for "touching up 150 each of 3 plates."[10]

The waxed negative survives, exhibiting the three defect spots in the foreground typically observed in published prints; there are several prints known that are not mounted in copies of *The Pencil of Nature*.[11]

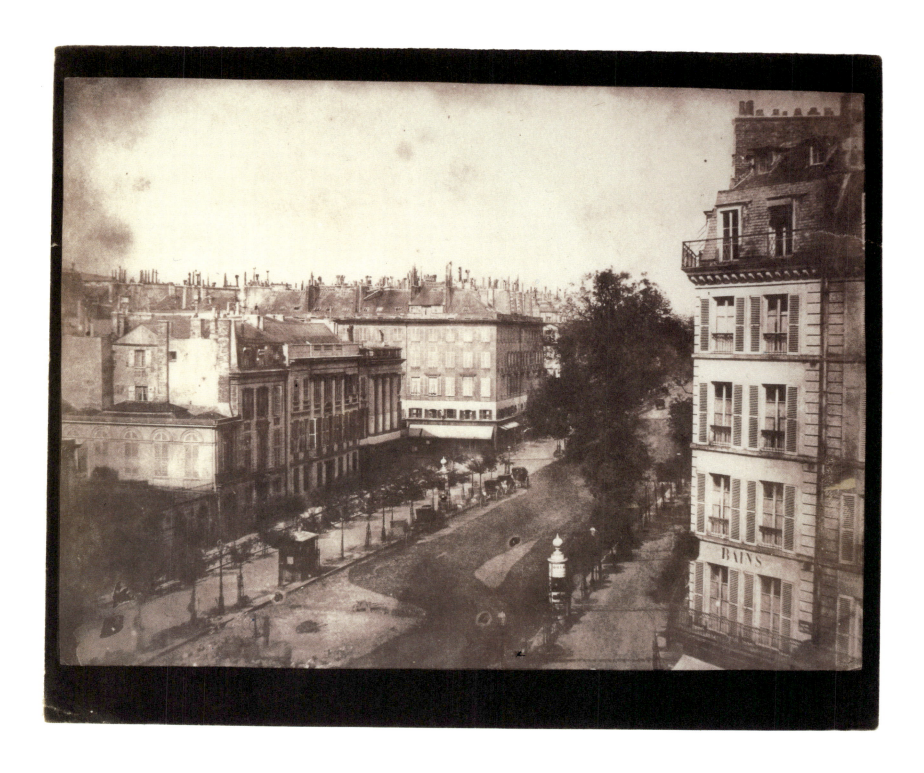

PLATE 65

Bird's-eye View of the City of Orleans

14 June 1843. Salt print from a calotype negative,
15.1 x 20.4 cm image on 18.2 x 22.8 cm paper
Canadian Centre for Architecture, Montréal (PH1985:0211)
SCHAAF 1413

At the age of eighteen, Talbot wrote to his family that "being an admirer of extensive views" he had climbed to the top of a hill three times for the sights.[1] In this view of the city of Orleans, he has followed the advice of the guidebooks toward a good panoramic view and mounted the hill across the Loire. His angle is somewhere between the Quai de Prague and the Quai du Fort des Tourelles. The atmosphere's scattering effect on the blue light, to which his calotype paper was overly sensitive, is evident here, even more so than in his view of the *River Thames* (pl. 42), but it adds to the sense of distance in this print.

At this point, Talbot's spirits were high. On 14 June he wrote to his sister Horatia that "today was splendid weather, being the first summer day we have had since 20th May; twenty four days of weeping skies—and that was a solitary instance, having been preceded by a week of winds and storms. However today was a grand exception to the general rule, and I made a good many pictures, tho' I lost time in looking for views & rambling about streets unknown to me . . . whether I extend my tour further than this is doubtful."[2]

In the view of Orleans he eventually published in *The Pencil of Nature*, Talbot chose badly. One can understand his attraction to the idea of "The Bridge of Orleans" that he published, but it is uniformly the worst print in copies of the publication.[3] Undoubtedly the unstable weather was the culprit. These prints were obviously sickly when issued, and George Montgomerie railed to Lady Elisabeth that this plate was "*cloudy & indistinct* the fore ground (which is water) & the sky being so exactly alike & a flat surface whether water or gazon being the most difficult to represent as *to the perspective, in calotype*, other subjects should be chosen in preference."[4] Why he chose this view for publication is not known. After seeing what else Talbot had photographed in the city, his uncle William wrote encouragingly that "I am much obliged to you for the most liberal supply of Calotypes, a name which I can not get people to adopt, it is hard work to stop their calling them Daguerreotypes, & having once adopted the term Photographes, they will not unsettle their minds any further. Orleans & Chambord are particularly good."[5]

In February 1845, after receiving twenty prints of this image for himself, Talbot loaned the negative of the "Orleans Birds-eye View" to Nicolaas Henneman for use in his own printing.[6] It survives today, along with a handful of prints.[7]

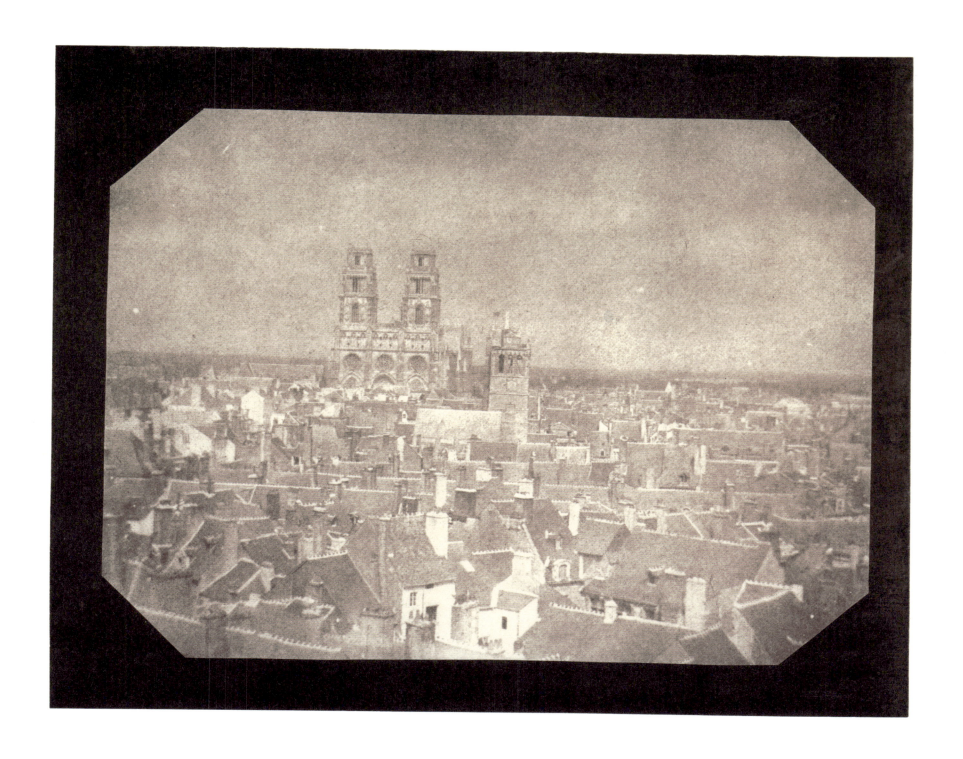

PLATE 66

"One of the Towers of Orleans Cathedral, as Seen from the Opposite Tower"

21 June 1843. Salt print from a calotype negative,
16.1 x 20.0 cm image on 18.8 x 22.9 cm paper
The Howard Stein Collection
SCHAAF 2728

When his Uncle William first saw Henry Talbot's view of the *Boulevards of Paris* (pl. 64), he admired it but lamented that "I grudge the fine delicate effects of the shutters on the Parisian houses. I wish it was all Gothic tracery."[1] Upon seeing this image, he must have felt he had been granted his wish. Sharply delineated, with a fine sense of texture and outline, the elaborate crown of the famous cathedral at Orleans is rendered well. Talbot was actually fortunate that the weather was not overly good, for too strong a summer's sunlight would have taken away from the inherent composition of the stonework. Talbot visited the cathedral at sunset, taking advantage of a diffuse sun, still with direction to create the shadows so critical to understanding the structure, but soft enough to keep them from going too dark. The nature of the paper calotype negative was ideally suited to this subject, for the fine texturing of the negative simplifies the tonalities and restores a sense of texture to the stone. In this particular print, the brush strokes from the hand-coated printing paper heighten the effect.

Talbot must share some of the credit for the sharpness of his depiction with the timing of the stonemasons. As so often is the case in Talbot's photographs, what appears to be ancient is not. In 1825, the present towers replaced the medieval ones, and the atmosphere had some years to go before it would begin softening the sharply chiseled lines in the stone.

It is likely that this marvelous photograph was part of a larger plan. Just three months before, the pioneering photographer and photohistorian Robert Hunt had written to Talbot to say that "Mess$^{rs.}$ Longman have informed me that it is your intention to publish Calotype Views of the Cathedrals &c."[2] This project had got off to an uncertain start. On arriving at Paris, Talbot wrote to his mother on 22 May 1843 that, during a break in the weather at Rouen, he had "asked permission to draw the Cathedral but it was entirely refused—Jamais on n'accorde la permission de dessiner[3]—I suppose that it is a monopoly belonging to somebody, & I was interfering with vested rights!"[4] Talbot observed that Orleans was "a city rich in historical recollections, but at present chiefly interesting from its fine Cathedral; of which I hope to give a representation in a subsequent plate of this work."[5] Had the publication of *The Pencil of Nature* not been prematurely stopped, it is likely that he would have done so, for in a manuscript list of proposed plates for forthcoming parts, views of "Orleans Cathedral" were proposed for both part 4 and part 6.[6]

The negative and numerous fine prints survive.[7] There is also a very similar Talbot negative that shows a somewhat more open section of the tower, with a bit more of the city of Orleans on the horizon; although numerous prints of this exist, none of the known ones is in very good condition.[8]

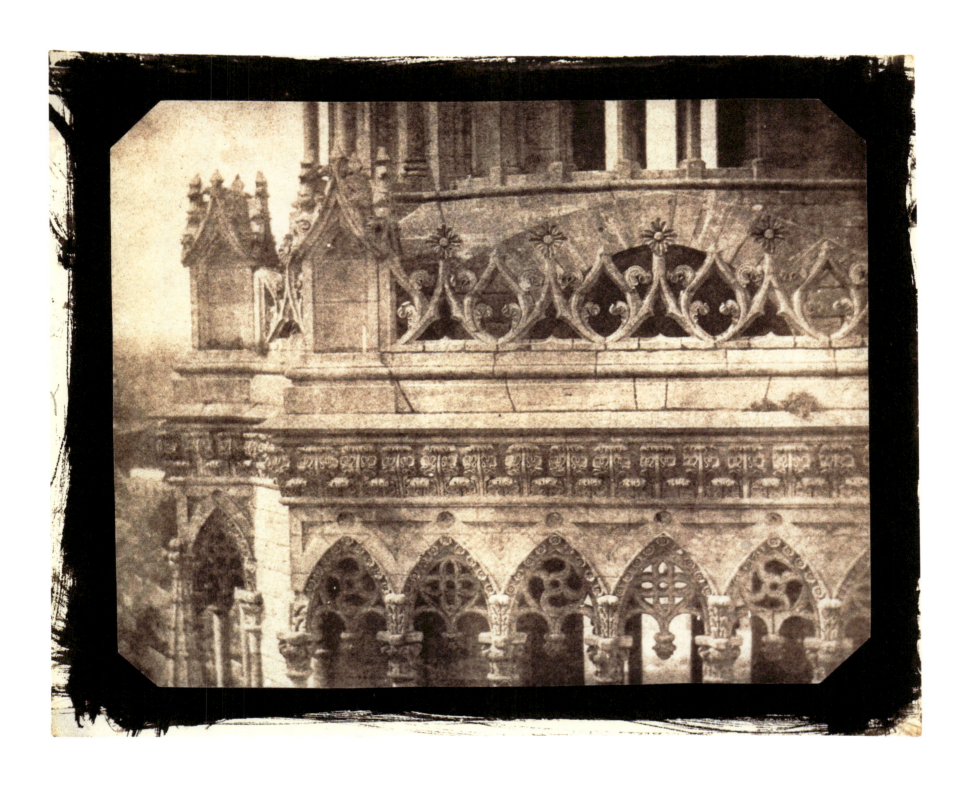

PLATE 67

Le Château de Chambord

16 June 1843. Salt print from a calotype negative,
16.0 x 20.5 cm image on 17.6 x 21.9 cm paper
Museum Ludwig/Agfa Foto-Historama, Cologne (FH2771)
SCHAAF 1164

Chambord remains "a fantastic dream rather than an orderly design . . . it gives you the impression of some monstrous village in the air, some weird construction out of the *Arabian Nights* wrought by wild genies for the Sultan of a day."[1] The great Renaissance structure of Francis I, modeled on Vincennes, is sometimes rumored to have been based on a design by Leonardo da Vinci. Various Royalist associations undertook to buy it and subscriptions were secured from many municipal governments. It was made a gift of the nation to the heir to the throne, the duc de Bordeaux, and was his only real possession by the time of his exile in 1830. The picturesque jumble of timber in the foreground reflects the fact that Talbot photographed this grand building during its long period of restoration.

Talbot's desire to delineate this fantasy might well have dated back as far as 1822, when he watched his aunt Louisa, the marchioness of Lansdowne, create her impressively intricate and precise pencil drawing of the structure.[2] As he wrote after taking this photograph, "the Château de Chambord was built by Francis I in 1519, four years after the young prince had ascended to the throne. During an excursion in France in ye summer of 1843, I bent my footsteps towards this venerable pile. It was with ye recollection of a long previous visit in May 1822. For Chambord had ever since dwelt upon my memory as one of ye most remarkable objects I had seen in ye course of my wanderings. But on [this occasion] Fortune did not altogether smile, [for I] was impeded by very unfavorable circumstances."[3]

Talbot noted in his travel diary that his visit to Chambord was accompanied by thunder and rain. His uncle William was encouraging about the results, writing to him that "I am much obliged to you for the most liberal supply of Calotypes . . . Orleans & Chambord are particularly good."[4] However, his mother, Lady Elisabeth Feilding, was much more critical: "Lord M^t. E. was much struck with your having told him that the view of Chambord was bad because it was such a rainy day as if you could not have remained there until the weather was clear, particularly with such an interesting object before you. He thinks if you had more perseverance your success would be more complete, & that if you were an Artist instead of an *Amateur* your Art would be soon at the summit of perfection."[5]

In one of the proposed lists for forthcoming parts of *The Pencil of Nature*, "Chambord" was proposed for part 3; another image was eventually chosen in its stead.[6] In spite of the limitations of the weather, Talbot was proud of this image; he sent this particular print to the influential naturalist and traveler Alexander von Humboldt, and it is from his album that the present example is taken. The waxed negative survives and apparently had a chemical defect right from the start, as it produces a spot in the prints , about a third of the way in from the right of the line of trees. Numerous prints are known.[7] Talbot took at least two other negatives that are close variants of this, but no prints from them are known.[8]

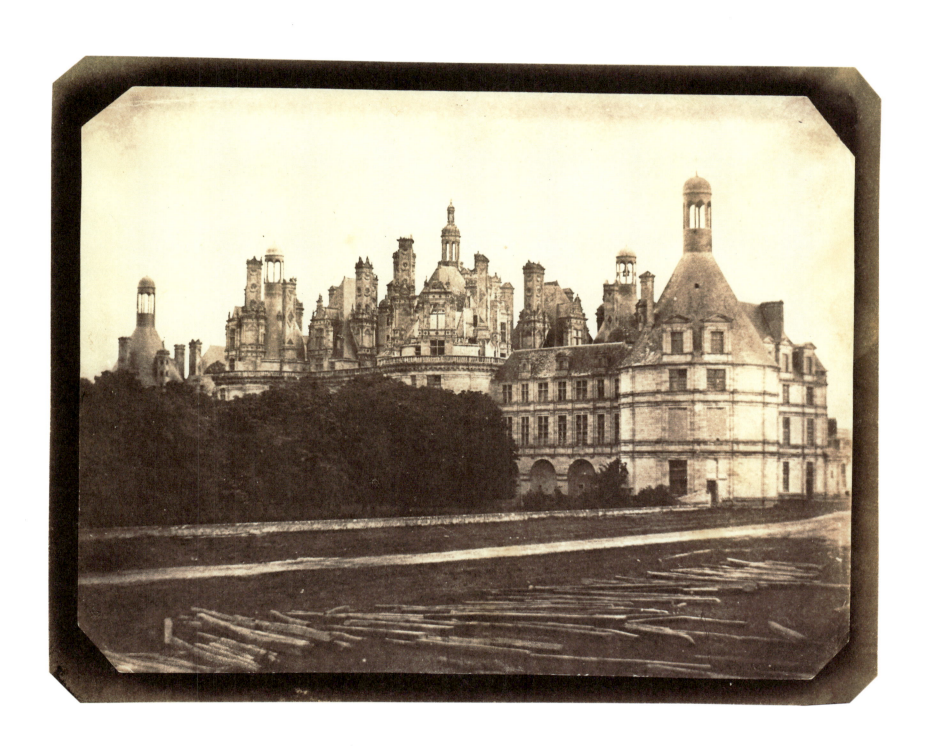

PLATE 68

"Firefoot"—the Rocking Horse at Lacock Abbey

c. 1843. Salt print from a calotype negative,
8.6 x 9.7 cm image on 10.0 x 12.1 cm paper
The National Museum of Photography, Film & Television, Bradford (1937-2439/2)
SCHAAF 1611

Miss Matilda Talbot remembered that in her youth "one of our great joys was a cream-coloured rocking horse, beautifully made and very strong. He was called Firefoot, because we said he galloped so fast that he struck fire from the stones in the road. Firefoot was given to my grandfather for his children about 1840, and is still in excellent condition at Lacock Abbey."[1]

Firefoot is now stabled in the Stone Gallery, readily admired but just out of reach of admiring little fingers of visitors to the abbey. At the time of Talbot's photographs, Firefoot was little more than a yearling and almost certainly resided in the nursery room. He chose to gallop out to the lawn for this sitting, in order to take better advantage of the sunlight and perhaps to graze a bit on the grass that is just barely revealed under his feet. In so doing, Talbot gained a heightened sense of sculptural qualities, if not of reality. The foliage in the background rendered itself very dark, its green color registering weakly on Talbot's blue-sensitive calotype negative material.

Talbot's great-great-grandson, Anthony Burnett-Brown, recalls that Firefoot's "present saddle and bridle were made by the Bath Academy of Art in the early 1950s, while his present mane and tail were made by my great-aunt at the same time (it took three conventional rocking horse manes—from Hamleys—to make his mane . . . my mother could also remember her brothers catching bumblebees and putting them into Firefoot through the side-saddle holes so that he made a most satisfactory buzzing sound."[2] Even with these replacements, Firefoot's appeal is timeless, and he continues to captivate visitors to Lacock Abbey. Imaginations and memories young and old speed along with him.

The borders of Talbot's prints were a necessary device to ensure that the hand-coating extended throughout the full image area. In some cases, such as this, it seems that Talbot paid careful attention to where he placed the negative within this print area. The extra border area at the right gives *Firefoot* (and the eyes that are following him) extra room to roam. It would be a shame to trim it.

This is one of three known surviving negatives that Talbot took of the rocking horse; although none are dated, they appear to have been taken during the same session.[3]

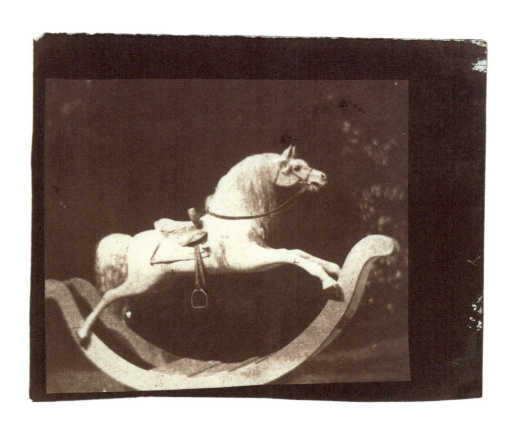

PLATE 69

Matilda Caroline Talbot, in the Cloisters of Lacock Abbey

11 August 1843. Salt print from a calotype negative,
8.9 x 7.8 cm image on 11.4 x 9.2 cm paper
The National Museum of Photography, Film & Television,
Bradford (1937-3476/3)
SCHAAF 3795

In a charming flood of light in the cloisters of Lacock Abbey, Talbot's youngest daughter arranges herself in the pattern of the ancient stonework, her tilting head and outstretched arm serving to get the viewer's eye moving. Just enough play of light and shadow behind adds depth to the scene. A year before this photograph, Talbot's first portrait licensee, the miniaturist Henry Collen, observed to Talbot that "the light background which you have much recommended, and make great use of, gives certainly a clear sharp outline, but not an artistical effect,—you also make your pictures almost always in sunshine, which is however not to be used when the public please to sit."[1] In the present image, Talbot made good use of both the light and the background.

Identifying Talbot's children in his photographs is a sport fraught with peril. They dressed alike and were separated by only two years of age. Many of Talbot's images of them are not dated and the coarseness of the calotype can mask critical details. With all those caveats in place, the subject of the present image is most likely Matilda, the third child, who first met the world at about the same time photography did, being born on 25 February 1839. So close was the tie that Talbot's favorite cousin Hariot suggesting naming her "Photogena."[2] In 1859, Matilda became the only Talbot child who would wed when she married John Gilchrist-Clark of Speddoch. Visits to her new home in Scotland gave Henry Talbot the opportunity to continue his research on photoglyphic engraving near the printing capital of Edinburgh, and much of his later life was spent in Scotland rather than in Wiltshire.

Miss Matilda Gilchrist-Clark remembered that "my mother painted well, both in oils and in water colours, and she had a sort of studio near our nursery. She could gild her own picture frames, and I have a very early recollection of seeing her delicately open leaves of goldbeaters' skin, between which lay the precious gold leaf, and warning us not to breathe on it . . . she had very pretty hair, deep chestnut brown and wavy. She wore it very simply, with a centre parting, and I thought she looked rather like a madonna. She was a good botanist and took a special interest in every variety of fungus . . . my mother was a member of the Scottish Cryptogrammic Society . . . my mother wanted us all to share her love of astronomy; we had no telescope in the house, but I can remember her waking us up in the middle of the night (as it seemed to me), and taking us to the big window of our schoolroom, sometimes to look at an aurora, sometimes to see meteors shooting by. Once I remember seeing an eclipse of the moon, and on yet another occasion looking at a comet."[3]

The daughter of this subject was startled in 1916 when Charles Henry Talbot, the only son of the inventor, left Lacock Abbey to her in his will. Changing her name to Matilda Talbot, Maudie (as she was known to her friends) made active use of the abbey until she gave it to the nation in 1944. The abbey's copy of the *Magna Carta* is the one now proudly displayed in the British Library. It was Miss Talbot's indefatigable efforts to safeguard the memory of her grandfather that led to the organization and preservation of his correspondence, research notes, and early photographs. Her generous gifts to the Science Museum and many other institutions insured that this legacy would be preserved. Matilda Caroline, the mother of Maudie, and the subject of this portrait, died in 1927.

The negative for this survives and three other prints are known.[4] The only positively identified portraits of Matilda are a negative dated "Aug/43" and inscribed "M.T." and two labeled "Matilda April/44" in Talbot's hand—the images are not very distinct.[5] Her sisters are little better identified.[6]

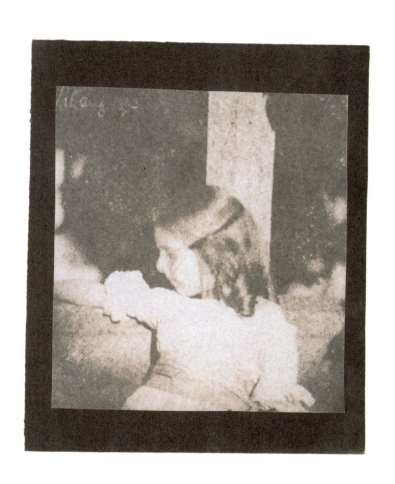

PLATE 70

A Group Taking Tea at Lacock Abbey

17 August 1843. Salt print from a calotype negative,
12.8 x 18.9 cm image on 18.7 x 22.6 cm paper. Watermarked J Whatman 1840,
with gilt edging on paper. Pencil "X" on recto
Private collection, courtesy of Hans P. Kraus, Jr., Inc.
SCHAAF 2755

In this spirited *tableau vivant*, the rhythmic pattern of the group is frozen as in a frieze. Yet so active is their placement that a lively air is conveyed to what was obviously a carefully composed scene. A cloth suspended over the lawn outside Lacock Abbey provides a neutral backdrop in the sunshine. Although he could not draw well himself, Talbot understood the labor of observation that was required to compose each and every figure in a scene. In writing about *The Ladder* (pl. 84) in his *Pencil of Nature*, Talbot claimed that "when a group of persons has been artistically arranged, and trained by a little practice to maintain an absolute immobility for a few seconds of time, very delightful pictures are easily obtained. I have observed that family groups are especial favourites: and the same five or six individuals may be combined in so many varying attitudes, as to give much interest and a great air of reality to a series of such pictures."[1] Anyone who has arranged a group photograph (a task sometimes compared to the hopelessness of herding cats) might take exception to this observation, but once everyone is settled into place, the marvels of photography do act at once.

While it appears that the domestic staff of Lacock Abbey was called on to provide most of the troupe here, the top-hatted man seated at the right may be Talbot's cousin "Kit"— Christopher Rice Mansell Talbot. This photograph was taken in a period when tableaux were increasingly becoming a common form of parlor entertainment. These had begun to move away from the strict German roots where the images were tied to works of art and literature, and instead began to derive their structure from a wider range of inspiration.[2] Talbot's sister Horatia wrote him in 1830 that "we had *tableaux* again last Tuesday at Lady Dudley Stuarts. They had me act *Rowena* in the last scene in Ivanhoe."[3]

Talbot may have benefited from some extra advice in structuring this particular scene. On 24 May 1843, Thomas Longman wrote to Talbot that "I have this morning called on Mr. J. Calcott Horsley, a nephew of Sir A Calcott, who has taken a very great interest in your process and will be quite willing to assist in the arrangement of some out of door tableaux . . . I have the specimens at my house, with which Mr. Horsley is delighted."[4] Horsley immediately sent a note to Talbot saying that he had heard from Longman and would "have much pleasure in meeting you at his house on Sunday next."[5] Horsley was intensely busy right then working on his designs for the frescos in the new buildings of the Houses of Parliament, and it is not known what, if anything, came of this contact.

The interest in recording structured groups of living beings remained with Henry Talbot. In 1845, rather late in his (short) period as a photographer, he wrote to Lady Elisabeth Feilding from London that "today I made a picture of a boy with a cage and a grey parrot at Claudet's—It will make a very pretty tableau Flamand. The parrot *sat* beautifully, evidently understanding what we were doing."[6]

Rarely can observations be made about a particular print (beyond, of course, its present appearance), but this one is special. The variable quality of printing paper offered to Talbot was a constant source of frustration. Just like a fine wine, a good batch of paper—one from a certain year by a certain maker at a certain mill—was highly prized. The trace of gilding on the edge of this print reveals that it came from such a highly favored batch. Two weeks after this negative was made, Constance wrote to Henry Talbot that "your paper arrived this morning—20 quires of gilt edged Whatman Turkey Mill 1842—you said it was to be 1840. In consequence of this difference I have given none to Porter but await your directions. Can the variation in the date be of any importance?"[7]

We don't know how the 1842 vintage compared to the original 1840 on which this particular print was finished. In fact, no other prints from this negative made on any sort of paper have been traced, but at least the dated negative survives.[8] A print (possibly this very one?) is visible on one of the display panels for the 1934 centenary exhibition at Lacock Abbey.[9]

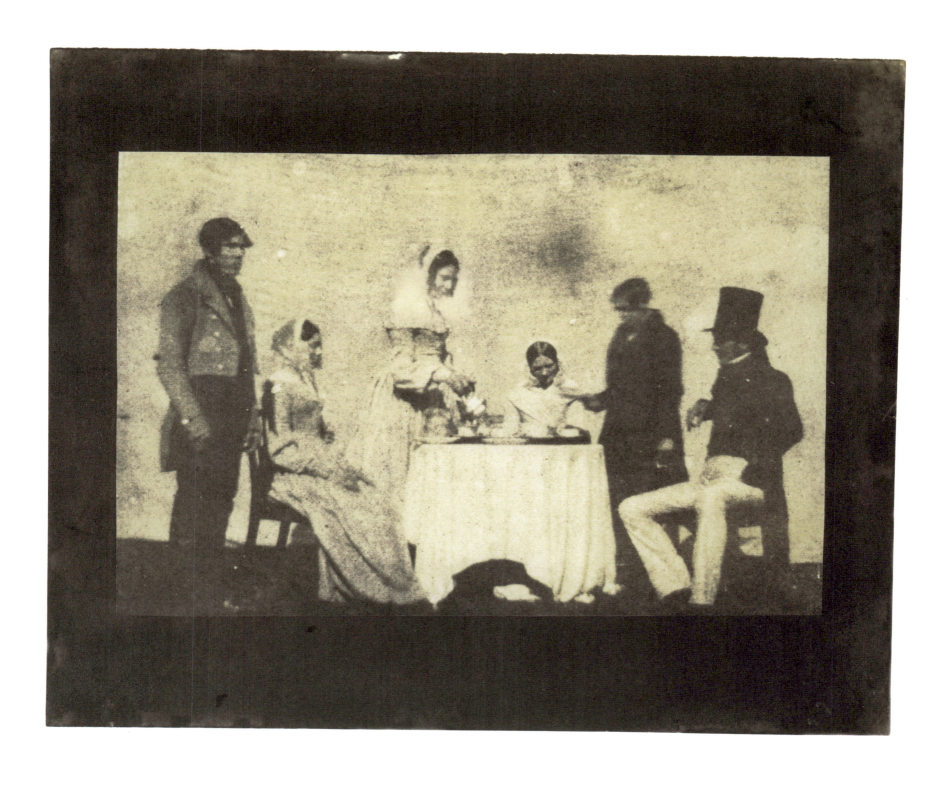

PLATE 71

Four Out of Five Orders on the
Tower of Five Orders, Oxford

c. 1843–44. Salt prints from calotype negatives, forming a vertical panorama,
9.9 x 7.6 cm image on 11.4 x 9.1 cm paper and 9.5 x 8.5 cm image on 11.2 x 9.3 cm paper
The National Museum of Photography, Film & Television,
Bradford (1937-1471/3 and 1937-1762/4)
SCHAAF 1439 AND 1438

Yet, O ye spires of Oxford! domes and towers!
Gardens and groves! your presence overpowers
The soberness of reason; . . .

WILLIAM WORDSWORTH[1]

Spires and towers are the essential character of Oxford—not of its sister/rival university town of Cambridge—and their variety is outstanding. "The Schools form a magnificent Quadrangle . . . divided by a gateway, and lofty tower, somewhat fantastically ornamented with a display of the five orders."[2] In 1619, Thomas Holt of York built the "Schools Tower" in a Jacobean style. The five Roman orders of architecture are represented, one for each storey. Once used for lectures by the various faculties, these rooms came to be used primarily for university examinations. The Bodleian Library expanded into them when the "New Schools" were built in the High Street in the 1880s (seen as the bank of buildings on the left side of pl. 60). Today, readers exiting the Bodleian Library face this tower. Few pass through its arch on the way to Catte Street, however, the majority being more likely to turn left in a pilgrimage to the seductive contents of Blackwell's bookshop.

Boxed within the confines of the quadrangle, Talbot was presented with a formidable photographic challenge. In addition to this pair of negatives, he took one other small one (which captured only three of the orders) and two larger ones. One attempt, quite logically, was done with the camera in the courtyard, facing up steeply; it has too much vertical convergence to be satisfying. On first seeing photogenic drawings, his uncle William exclaimed that "I wish you could contrive to mend Nature's perspective—we draw objects standing up & she draws them lying down which requires a correction of the eye

or mind in looking at the drawing."[3] The most commonly seen view is shot obliquely from a higher angle, with the camera pointing down. Its awkward cropping was dictated by the shadow of an adjacent wing dominating the right third of the image.[4] The present views were taken from the roof above the upper reading room, to the right of Duke Humphrey's room.

The crane on the roof might provide clues both to his opportunity to get up there and to the dating of this image. Although specific records have not been preserved, major stone repairs were undertaken starting around 1843 or 1844 and continuing until 1847. With workmen on the roof anyway, it would have been more likely that he could have found a way up to the better vantage point.[5]

The solution Talbot attempted here was one also employed by his colleague, the Reverend Calvert R. Jones. By using more than one negative placed adjacently—"joiners," as Jones styled them—the whole of the image could be pieced together.[6] Horizontal panoramas had a long tradition in representation, well before the advent of photography, but the concept of the vertical panorama could be seen fairly as a Talbot innovation. The imperfect join and excess overlap in the present example may indicate that he was merely taking a series of "snapshots," intended to be joined together in contemplation more than on paper. At least one other example of this approach is indicated.[7]

Both waxed negatives survive.[8] In February 1845, after receiving three hundred prints of the "Schools," Talbot loaned a negative to Nicolaas Henneman for use in his own printing.[9] Nicolaas Henneman had every reason to believe that images of "The Schools" would be popular amongst those who knew Oxford, and he had printed titles made up for three versions to attach to the mounts of copies offered for sale.[10]

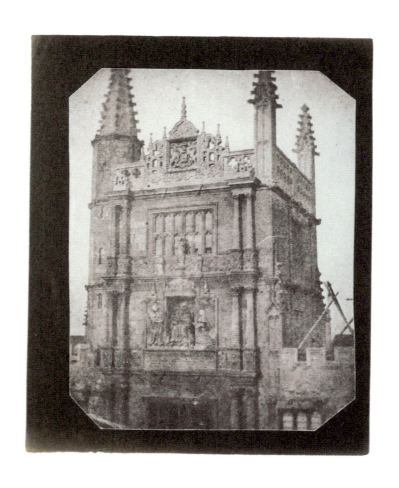

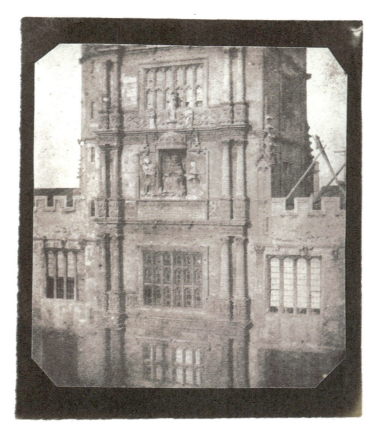

PLATE 72

"Part of Queen's College, Oxford"

4 September 1843? Salt print from a calotype negative,
16.1 x 20.3 cm image on 18.8 x 23.1 cm paper
The National Museum of Photography, Film & Television, Bradford (1937-1296/3)
SCHAAF 1461

Boldly truncating the buildings and celebrating the play of light and texture, this dramatic view is the most frankly photographic image in Talbot's entire body of work. It was an inspired choice as the first plate in *The Pencil of Nature* (indeed, it was probably one of the most sound decisions he made in this seminal publication). The jagged shadow, so perfectly placed in the middle of Queen's Lane, demands attention as the subject. In one of the first public reactions to photography, a reviewer for the *Saturday Magazine* borrowed liberally from Talbot's own words when he observed that "the reader may probably have heard of one of the legends of that intellectual and extraordinary people, the Germans; where Peter Schlemihl sells his shadow, the purchaser of which kneels down in the broad sunshine, detaches the shadow from its owner's heels, folds it up and puts it in his pocket. By the spells of our scientific enchanter, Mr. Talbot, this most transitory of things, the proverbial emblem of all that is fleeting and momentary, may be permanently fixed in the position which it seemed only destined for a single instant to occupy. Such is the fact, that we may receive on paper the fleeting shadow, arrest it there, and in the space of a single minute, fix it there so firmly as to be no more capable of change, even if thrown back into the sunbeam, from which it derived its origin."[1]

Talbot's text for this image in *The Pencil of Nature* revealed clearly that he knew this image was about time: "This building presents on its surface the most evident marks of the injuries of time and weather, in the abraded state of the stone, which probably was of a bad quality originally. The view is taken from the other side of the High Street—looking North. The time is morning. In the distance is seen at the end of a narrow street the Church of St. Peter's in the East, said to be the most ancient church in Oxford." *The Spectator* felt this plate showed "the abraded surface of the stone front with a strikingly real effect"[2] and the *Literary Gazette* echoed that "the time-worn abrasions in the stone are felicitously recorded."[3] The *Art-Union* found the representation "the most perfect that can be conceived; the minutest detail is given with a softness that cannot be imitated by any artistic manipulation; there is nothing in it like what we call touch; the whole is melted in and blended into form by the mysterious agency of natural chemistry."[4]

The point of view is just past the shadowy horse cart seen in his *High Street* (pl. 60). Talbot placed his camera in a room above the Angel Inn, one of the numerous coaching inns that were declining rapidly with the advent of the railways. The view is much the same today. The stone front of Queen's has been refaced.[5] The building on the right remains, as it was in Talbot's day, a coffee house (now minus its chimney). St. Peter's in the east has become the library for St. Edmund's Hall, and the Angel Inn has given way to a succession of shops, trading on the busy demands of the High Street.

By early spring 1846, this negative had been damaged by an accidental splash of chemicals, leading to a need for replacement.[6] In spite of its damage, the original negative was preserved; loose prints (outside those bound in copies of *The Pencil of Nature*) are met with fairly commonly but are rarely in good condition.[7] The replacement negative also survives, along with numerous loose prints. It was possibly taken by Nicolaas Henneman; the framing is awkward, encompassing the entire wing of Queen's, with vertical convergence caused by the camera pointing up. The shadow fills the entire street and cuts in at the bottom of Queen's. The lower part of the church is covered in scaffolding, indicating that the variant negative was most likely produced in 1844 or 1845.[8]

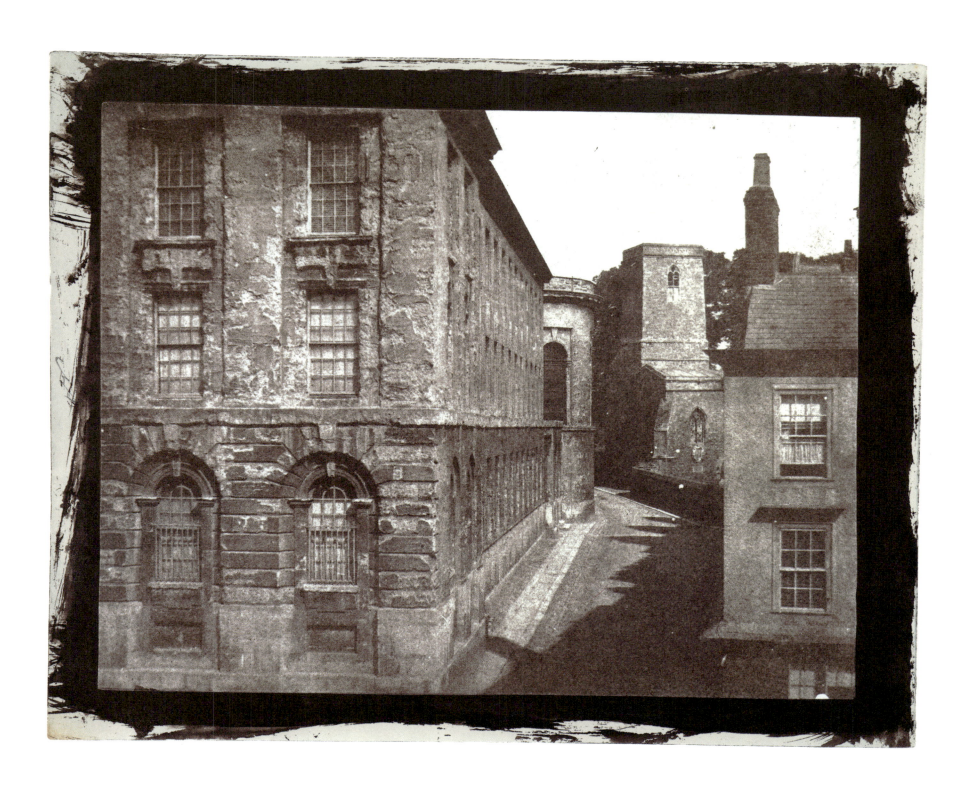

PLATE 73

"The Martyr's Monument, Oxford"

Probably 7 September 1843. Salt print from a calotype negative,
20.4 x 14.4 cm image on 22.6 x 18.7 cm paper
The National Museum of Photography, Film & Television, Bradford (1937-1912)
SCHAAF 1923

This is yet another example of something that looks ancient in a Talbot photograph that really was quite modern. Sir George Gilbert Scott's monument to the three martyrs burned in the square in 1555 and 1556 was erected by public subscription between 1841 and 1843. In his text for this plate in *The Pencil of Nature*, Talbot wrote that "Oxford has at length, after the lapse of three centuries, raised a worthy monument to her martyred bishops, who died for the Protestant cause in Queen Mary's reign. And we have endeavoured in this plate to represent it worthily. How far we have succeeded must be left to the judgment of the gentle Reader. The statue seen in the picture is that of Bishop Latimer."[1]

The monument, completed just before being photographed by Talbot, was immediately judged to be a success: "One of the latest and most graceful of the recent architectural additions to Oxford—the Martyr's Memorial . . . stands at the northern entrance to the town, just by Mary Magdalen Church, being the nearest suitable spot to the scene where the martyrs Cranmer, Ridley, and Latimer met their doom . . . the first stone of the memorial was laid on the 19th of May, 1841, exactly three centuries after Cranmer's English Bible was finished . . . the total height is 73 feet, and the gradations are so easy, that the whole is at once airy and substantial."[2]

The negative resulted from Talbot and Nicolaas Henneman's highly productive trip to Oxford in "exceedingly fine" weather in 1843. Talbot reported to Lady Elisabeth Feilding that "the weather has been exceedingly fine both Monday, Tuesday & today, and I have made about twenty views each day, some of which are very pretty—but the number of picturesque points of view seems almost inexhaustible, and I think tomorrow evening I shall return."[3] Constance was delighted at her husband's lift in spirits: "We have been expecting you home from Oxford . . . I did not fancy you would persevere in Calotyping as long as four days but I am extremely pleased that you did & that some of the views pleased you so much."[4] Talbot's chosen

view was taken from a window in the present-day location of Randolph's Hotel. The small building strangely dominant in the background, Cesar's Lodgings, was demolished in the 1850s to make room for the long edifice of the Salvin Building of Balliol College. Behind, and just to the left of Talbot's camera position, was the building site of the Taylorian Building (generally known today as the site of the Ashmolean Museum).

Although it was not included until part 5 in December 1845, this image was one of Talbot's first choices for *The Pencil of Nature*, and it was included in his initial print order to Henneman in January 1844.[5] Lady Elisabeth wrote that "I took the Martyr's Tower to Lady Holland; she was perfectly enchanted & I left the magnifyer with her that she might contemplate it at leisure. She asked immediately if it was to be in the *next* number of the Pencil of Nature, by which I found she knew more on the subject than I supposed."[6] Only Uncle William seems to have been a dissenter: "The Oxford Monument seems never to come out as well as it ought tho' that must be sharp & fresh."[7]

The dating for this negative is fairly certain, being established by both an entry in Henneman's account book[8] and by the inscription for a close variant print in Alexander Humboldt's album.[9] The waxed negative survives, along with numerous prints not in copies of *The Pencil of Nature*.[10] In February 1845, after receiving three hundred prints of "Martyrs Monument," Talbot loaned this negative to Nicolaas Henneman for use in his own printing.[11] It was popular enough that he had a printed title made up to attach to the mounts of copies offered for sale.[12] There are nineteen other known Talbot negatives of the monument, most of them views similar to this one, some this size and some small. One is from an angle that shows St. Giles Church in the background.[13] Another, very unusual one, possibly taken by or with Calvert R. Jones, is taken from a position to the left of this one; it follows the long-established conventions of prints by showing two men standing off to the side, admiring the monument.[14]

PLATE 74

"Neapolitan Conveyance"—
Copy of an Oil Painting at Lacock Abbey

Prior to 23 January 1844. Salt print from a calotype negative,
13.8 x 21.3 cm image on 18.8 x 22.9 cm paper
The Art Institute of Chicago. Edward E. Ayer Endowment
in memory of Charles L. Hutchinson (1972.337/15)
SCHAAF 377

Virtually all art historians alive today have received a good part of their training not from original objects, but rather from Henry Talbot's black magic. Photography has become absolutely essential to the spread of knowledge about works of art, sometimes through slides in a lecture, more often in the carefully reproduced plates of a book. It is so commonplace that most students of art hardly give it a second thought. To Talbot's peers, however, this was one of the most exciting applications of photography. Interpretations of sculpture such as Talbot's exploration of the potential of *Patroclus* (pl. 58) were in many ways no more important—possibly even less important—to the nineteenth-century public than was the ability to disseminate accurate images of drawings and paintings. As one seminal study emphasized about the photography of art: "Paradoxically, although this application played a pivotal role in the origins and commercial development of photography, and also acted as the catalyst that transformed the study of art from a form of connoisseurship into what today is called art history, it has been largely neglected by twentieth-century scholars."[1]

In 1889, when Talbot's son, Charles Henry, compiled an album for the Bath Photographic Society, he revealed that this painting was then hanging in Lacock Abbey.[2] Judging by the photograph, it was not in the best shape even in Henry Talbot's day. Long hidden safely in storage in Lacock Abbey, it was finally relocated in 1998. It is an oil painting, as would be apparent from Talbot's photograph, of somewhat muted colors now, but accurately reproduced by the calotype. The size is 35.5 x 46.3 cm. Although the original has no signature, date, or other markings, one print is inscribed "from an oil painted at Naples."[3] The "original"—likely a copy itself, in oil rather than Talbot's silver—undoubtedly was acquired as a tourist's souvenir during one of the family's frequent trips there.

Talbot likely took this negative as a winter activity late in 1843. On 23 January 1844 he acknowledged receiving a large box of prints from Nicolaas Henneman, including eleven copies of a "Neapolitans in a Carriage."[4] In two different proposed lists of plates for forthcoming parts of *The Pencil of Nature*, a slightly ambiguous idea for "Neapolitans" was recorded in one but put forward more definitely for part 4 as "Neapolitan Caratella" —*caratella* was almost certainly a phonetic spelling for *carrozella*, a term special to the Neapolitan region for a horse-drawn conveyance.[5]

The negative and a few prints survive.[6] One other Talbot negative of this painting is known, taken while it was in a now-missing frame.[7]

PLATE 75

"Copy of a Large Italian Print, Reduced in the Camera"

Prior to 23 January 1844. Salt print from a calotype negative,
17.8 x 15.4 cm image on 22.9 x 18.8 cm paper
Gernsheim Collection, The Harry Ransom Humanities Research Center,
The University of Texas at Austin (964:054:021)
SCHAAF 778

It is so often assumed that Talbot's copies of engravings are early (and boring) experiments in printing by contact that it might come as something of a surprise to learn that many of these were produced in the camera. Talbot's "large Italian print," an 1829 Rossini engraving of a Roman arch in Cora, measured 47.5 x 40.8 cm.[1] It has been reduced to about a third of that height—less than fifteen percent of its original area—all the time retaining the precision of the line and, equally importantly, the character of the original.

In writing about a "Copy of a Lithographic Print" in *The Pencil of Nature*, Talbot observed that "all kinds of engravings may be copied by photographic means; and this application of the art is a very important one, not only as producing in general nearly fac-simile copies, but because it enables us at pleasure to alter the scale, and to make the copies as much larger or smaller than the originals as we may desire. The old method of altering the size of a design by means of a pantagraph or some similar contrivance, was very tedious, and must have required the instrument to be well constructed and kept in very excellent order: whereas the photographic copies become larger or smaller, merely by placing the originals nearer to or farther from the Camera. The present plate is an example of this useful application of the art, being a copy greatly diminished in size, yet preserving all the proportions of the original."[2]

Talbot displayed several "copies of lithography" at the British Association for the Advancement of Science meeting in August 1839, but these were contact prints the same size as the original.[3] It was Talbot's friend Sir John Herschel who first accomplished enlarging and reduction, and Talbot freely gave him credit for the idea.[4] The lithograph Talbot chose to repro-

duce in *The Pencil of Nature* was Louis Leopold Boilly's popular *Réunion de trente-cinq têtes diverses*, measuring 37 x 50 cm. So novel was the idea in 1845 that the publishers stressed in their advertisements the fact that this copy was "greatly diminished from the original."[5] The *Athenaeum* thought this copy "very pleasing evidence of the correctness with which the details of an engraving, and consequently of a manuscript, may be copied with the camera. In the group of heads from this French caricature, we have the most delicate lines copied with surprising strength, and the decision with which the whole is made out is really extraordinary, when all the details of the process are considered."[6] The *Literary Gazette* noted that "the reduction of a well-known popular French caricature, with a multitude of human countenances, affords another proof of the diversity of uses to which photography can be put."[7] Surprisingly (well, perhaps not), Lady Elisabeth Feilding took the very modern point of view, telling her son that "before you chuse for Nº. 3 I would suggest that copies of Prints are what *take* the least, because of course they copy exactly *all* the inaccuracies & the great merit of this invention is its extreme accuracy, & truth to Nature."[8]

Like the previous plate, this copy was likely a winter activity accomplished late in 1843. On 23 January 1844, Talbot acknowledged receiving from Nicolaas Henneman a large box of prints, including three copies of an "Arch in Italie from a Book."[9] This image was so popular that Nicolaas Henneman had a printed title made up to attach to the mounts of copies offered for sale.[10] The negative and numerous prints survive.[11] One other negative of this engraving is known;[12] this print is in the Gernsheim Collection.

PLATE 76

"Microscopica" Given to Hippolyte Bayard

c. 1844. Salt print from a calotype negative,
10.8 x 10.7 cm image on 11.0 x 11.6 cm paper
The J. Paul Getty Museum, Los Angeles (84.XO.968.14)
SCHAAF 1487

Sometimes when the size of a familiar object is altered sufficiently, and perhaps further confused by depicting it by transmitted rather than reflective light, it can take on an entirely new character. The identity of this specimen, animal or vegetable, remains a puzzle. In writing to Talbot in March 1840, William Thomas Horner Fox Strangways told his nephew that he personally classed photogenic drawings into ten divisions. Landscape, plants, and lace were predictable categories, but one of Uncle William's ten was "microscopica."[1]

The precise identity of this specimen has proven elusive. Talbot did not provide us with any known labeled print, and in the absence of a record of the amount of magnification, it is unfamiliar to the modern eye. In the first public exhibition of his photographs, held at the Royal Institution in London on 25 January 1839, Talbot selected examples of his photogenic drawing process meant to demonstrate "the wide range of its applicability . . . among them were . . . some images formed by the Solar Microscope, viz. a slice of wood very highly magnified, exhibiting the pores of two kinds, one set much smaller than the other, and more numerous."[2] That description fits in some ways, but modern slices of common wood specimens do not appear like this. Perhaps it was wood changed by time? On 7 October 1839, Talbot recorded having borrowed "five specimens of fossil wood" from the famous Scottish botanist Robert Brown.[3] Another possibility comes from one of Talbot's lists of proposed plates for future copies of *The Pencil of Nature*—in early 1845, he proposed an image of "magnified coralline," a marine growth with cell structures not unlike this.[4]

Further complicating the issue is the format and size of this image. Many of Talbot's photomicrographs are known to have been produced in 1839–40 and are visually consonant with the *Slice of Horse Chestnut* (pl. 27). Some are smaller, but Talbot's procedure was ordinarily to project the image of the solar microscope onto a sheet of paper on the wall, and only a few record the sharp outline of the microscope's field as is done here.[5]

A third level of mystery is how this print wound up in the collection of the French photographic pioneer Hippolyte Bayard. This is particularly intriguing and part of a story as yet little understood. Calvert R. Jones may have been the go-between. On 23 February 1843, he wrote to Talbot: "As I hear you are going to Paris, I hasten to enclose a note of introduction to M. Bayard with whose photographs you will be much charmed" (since the letter of introduction remains to this day in Talbot's archives, it seems unlikely that he used it).[6] Visual evidence of contact between Bayard and Jones is evident in the composition of Calvert Jones's personal album. In addition to early works by Henry Talbot, there are early Bayards as well.[7] There is no substantial evidence of direct contact between Talbot and Bayard, but Talbot's interest in and respect for the "other" French inventor of photography seems to have increased after he visited France in the summer of 1843.

There are fourteen other Talbot photographs in this particular Bayard album. They all date from the period of 1843–44.[8] The circular waxed negative for this image is inexplicably trimmed on one side. It is one of nine similar negatives with a sharp circular outline, none of which carries any inscriptions or other identifying marks; there are eleven different prints made from these negatives, three of which are printed with two negatives on one sheet of paper.[9]

PLATE 77

Honeysuckle

c. 1844. Salt print from a calotype negative,
15.4 x 20.0 cm image on 18.9 x 22.8 cm paper. Watermarked J Whatman 1844
The National Museum of Photography, Film & Television, Bradford (1937-2000)
SCHAAF 1015

Sleep thou, and I will wind thee in my arms,
So doth the woodbine—the sweet honeysuckle
Gently entwist.

WILLIAM SHAKESPEARE[1]

In a beautiful rendering of light and form, scores of fingers reach out in a rhythmic pattern toward the viewer. They are beckoning rather than menacing and form an image tactile and alive. In folklore, the honeysuckle stood for fidelity and affection, and it is just possible that this photograph had a more personal meaning for Talbot. When he was young, his beloved mother sometimes signed her letters to him "Honeysuckle."[2]

But here the fidelity was to the original. Before the invention of photography, Sir John Herschel worked in concert with the camera lucida and his wife Maggie's watercolor brushes to produce marvelously detailed and accurate records of the exotic plants that he encountered in South Africa.[3] Another of Talbot's associates, Anna Atkins, was an accomplished illustrator and amateur lithographer long before she turned to photography for book illustration.[4] Shortly before the famous botanical illustrator Franz Bauer died at Kew in 1840, Talbot met with him, partially because of his role as the staunch defender of Nicéphore Niépce's reputation in Britain against the claims of the supporters of Daguerre.[5] But Bauer was so accomplished in his draftsmanship and analytical powers that his work rightly convinced the botanical historian Gavin Bridson that "competent botanical artists were never defeated by intricacy alone."[6] Yet what intricacy of the natural world Talbot was able to draw here! In an exposure of probably less than a minute, dozens of petals and thousands of accidents of light and shade were laid down on the paper in total accuracy.

Part of the modernity of this image comes from its total reliance on pattern. The other image in Talbot's body of work that is directly comparable is a field of long stems of grass. It is only a fourth of the size of the *Honeysuckle*, however, and much less appealing in its connotations, but when the images are reproduced in the same scale there is a great deal of similarity in them.[7]

The lightly waxed negative survives, but this is the only known print from it.[8]

PLATE 78

"The Milliner's Window"

Prior to 23 January 1844. Salt print from a calotype negative,
14.3 x 19.5 cm image on 18.2 x 22.5 cm paper
The National Museum of Photography, Film & Television, Bradford (1937-4317/5)
SCHAAF 1924

The wonderful descriptive powers of the calotype are so well invoked in this image that one can easily imagine standing in front of a plate glass shop window, admiring the pride of the merchant in his display. This must have been what prompted Lady Elisabeth Feilding's fanciful title,[1] for this collection of caps and bonnets was photographed, not by Nicolaas Henneman in the bustling thoroughfares of Reading as might be expected, but rather in the familiar confines of the courtyard of Lacock Abbey.[2] Still, with the viewer's mind framed by the title, this becomes not a picture of ownership attained, but rather one of desire raised.

One wonders if during Talbot's trip to Paris in 1843, he might have been shown some of the earliest examples of work by Louis Jacques Mandé Daguerre. One of the most famous of these was the French inventor's *Arrangement of Fossil Shells* of 1837. Might Talbot have been inspired by a sight of this arrangement?[3] The structures of the two images are virtually identical. Whatever the inspiration, once he started on this theme, Talbot kept his set of portable shelves busy. They were trundled out, draped in black velvet, and made to hold bonnets, books, glassware, china, plaster casts—in short, all sorts of objects that might be ranged out for comparative display.

It is likely that this image was taken late in 1843 (Lady Elisabeth's own print is in an album dominated by images from that year).[4] No reference to it has been traced prior to a note of 23 January 1844, when Talbot acknowledged receiving a large box of prints from Nicolaas Henneman, some of the first fruits of Henneman's new printing establishment at Reading. Included in this shipment were three copies of "Caps & Bonnets."[5]

The negative and numerous prints survive.[6]

PLATE 79

"A Scene in a Library"

Prior to 22 March 1844. Salt print from a calotype negative,
13.2 x 18.0 cm image on 19.0 x 23.2 cm paper
The Gilman Paper Company Collection, New York
SCHAAF 18

Recalling the first days of photography from a remove of some forty years, a writer for the *Daily Telegraph* reminisced that "some eight-and-thirty years ago there used to be visible in the corner of an optician's shop window in Regent street, a pale and dingy vignette on which, probably, few passers-by ever cared to bestow a glance . . . the little picture somewhat puzzled the inquisitive, since, with all their lengthened experience, they were fain to confess that they had never seen anything of the same kind before anywhere else. It was on a thin yellowish paper, and its hue was the monochrome of an uncertain bistre; but whether the thing itself was a mezzotint engraving, or a lithograph, or an Indian ink drawing, none but the initiated—and the *flâneurs* were not yet initiated—could tell. It represented only a few shelves full of variously bound books; but the marvel about it was that every particular volume, from bulky folios to 'ragged back' paper pamphlets, was delineated with an accuracy of draughtsmanship and a microscopic fidelity in texture and detail which might have aroused the envy of Gerard Douw or a Wilkie. No modern pre-Rafaellites ever produced such exquisite 'finish' as was visible in the contents of those miniature shelves; and, abating the depressing sepia tint pervading the whole, the books looked alive—as much as objects of still life could look indeed."[1]

The impact of a Talbot photograph of books, seen in the earliest days of photography, carried through four decades of memory in this writer just as freshly as when it was first seen. When did Talbot first view his books as a subject to be photographed in their own right? In his late 1839 *Bookcase* (pl. 16), the books are supporting objects in an overall view. A year later, however, on 10 October 1840, Talbot recorded having taken a group of books as the subject itself. The theme was not new—a negative titled "books, 1'" is listed for 10 October 1840 in Talbot's manuscript negative list.[2] It has not been identified with certainty, but one from 28 November 1840 has. In addition to the *Scene in a Library*, four other negatives are known where Talbot set up his books on artificial shelves outdoors, just to con-

centrate on their spines as subjects.[3] In any case, the present image, selected by Talbot for plate VIII in *The Pencil of Nature*, is one of the photographs most powerfully associated with his name.[4]

Some of these books are still on the shelves at Lacock Abbey (although much of the library was dispersed at auctions early in the twentieth century). It was André Jammes who first suggested that this in fact might have been a self-portrait of the inventor. He identified three volumes of Wilkinson's *Manners and Customs of the Ancient Egyptians*, *Philological Essays*, *Miscellanies of Science*, *Botanische Schriften*, *La storia pittorica dell'Italia de Luigi Lanzi*, the first three volumes of the *Philosophical Magazine* (its pages were rich with articles by Talbot), and three volumes of Thomas Gaisford's edition of *Poetæ Minores Græci* (some years after this image was taken, Talbot's beloved sister Horatia would marry Thomas Gaisford).[5]

Not everyone was quite so impressed. Previewing her son's choices for an upcoming part of *The Pencil of Nature*, Lady Elisabeth Feilding said that "I have been careful not to shew the Book scene which is in my Portfolio for fear they should be struck with its great superiority to the forthcoming 'Scene in the Author's Library'."[6] The budding calotypist William Thompson wrote that "I think also that such a picture as the bookshelves in No. 2 hardly deserves a place in by the side of such pictures as the Haystack, the Boulevards & the Open Door & I am not alone in this opinion; from all I can learn, the feeling among the amateurs of the art is identical with my own."[7] In spite of their comments, this image was so popular that Nicolaas Henneman had a printed title made up to attach to the mounts of copies offered for sale.[8]

There are various spots in the negative that show in the prints; only the one on the fifth book from the right on the top shelf is worth noting. The waxed negative survives, along with numerous prints not bound into copies of *The Pencil of Nature*.[9] At least one print survives that was printed from a slightly larger state of the negative, when it measured 13.3 x 18.3 cm.[10]

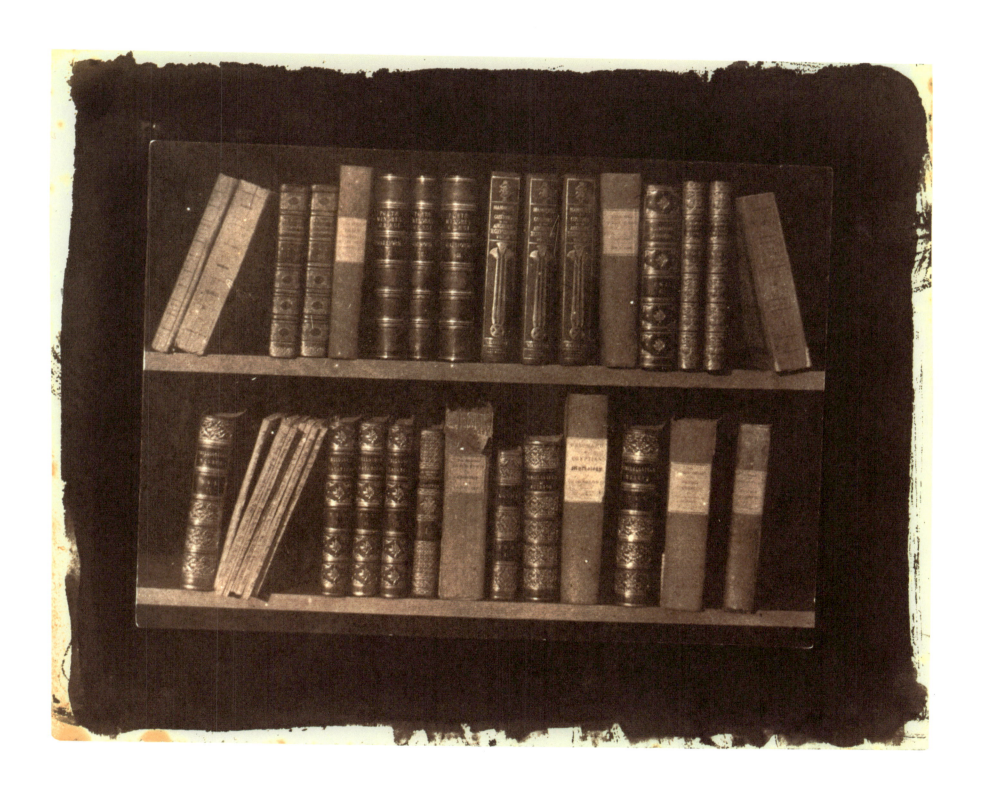

PLATE 80

"Articles of Glass"

Prior to June 1844. Salt print from a calotype negative,
12.6 x 15.3 cm image on 19.0 x 23.2 cm paper
Private collection, courtesy of Charles Isaacs Photographs, Inc.
SCHAAF 69

Much of the fascination with glass is its intimate relationship with light. When Talbot displayed his newly growing portfolio of photographs to London's Graphic Society in 1840, a reviewer found that "the crystal bottles on the breakfast-table are also well worthy of attention; their transparency is marked with singular truth . . . indeed, there is nothing in these pictures which is not at once accurate and picturesque."[1] At once a reflector, a modulator, and a passer of the rays, glass can present infinite varieties of dark and light. It is even more interesting when faceted and cut, as in these examples. Glass is great fun for an artist to photograph today, and was no less so to Talbot. He chose this image, and its companion "Articles of China," for inclusion one right after another in the first part of *The Pencil of Nature*. Both entertain the eye, but for different reasons, and the china is admirable for the diversity of the subjects. The articles of glass, however, are arranged in a more visually active pattern, one both rhythmic and musical.

Talbot explained to his readers that "the photogenic images of glass articles impress the sensitive paper with a very peculiar touch, which is quite different from that of . . . china . . . it may be remarked that white china and glass do not succeed well when represented together, because the picture of the china, from its superior brightness, is completed before that of the glass is well begun. But coloured china may be introduced along with glass in the same picture, provided the colour is not a pure blue: since blue objects affect the sensitive paper almost as rapidly as white ones do."

Even though Talbot wrote here of the complications of exposure, it was the exquisitely fine detail of this photograph which most strongly struck the critics. The *Athenaeum* observed that "the minute details exhibited in the two plates displaying porcelain ornaments and glass, are exceedingly curious and beautiful, and they improve under examination with a powerful lens."[2] *The Spectator* was impressed with the representation of "some articles of cut glass, exhibiting with matchless truth the peculiar quality of the lights on transparent substances."[3] The *Literary Gazette* found "the reflected lights [were] the most remarkable portion of the spectacle."[4] The *Art-Union* explained that "glass does not, of course, come out so forcibly, but that, also, is described with inimitable truth."[5]

In writing about the companion "Articles of China" in *The Pencil of Nature*, Talbot observed that "from the specimen here given it is sufficiently manifest, that the whole cabinet of a . . . collector . . . might be depicted on paper in little more time than it would take him to make a written inventory . . . and would a thief afterwards purloin the treasures—if the mute testimony of the picture were to be produced against him in court—it would certainly be evidence of a novel kind. . . . The articles represented on this plate are numerous: but, however numerous the objects—however complicated the arrangement—the Camera depicts them all at once."

Talbot's original manuscript title for this image was "~~objects~~ articles of glass, with a dark background."[6] The waxed negative survives, along with numerous other prints that are not bound into copies of *The Pencil of Nature*.[7] There is one extremely close variant negative, along with a similar image with glass on two shelves—this latter negative is severely trimmed and may have started with three shelves.[8] There are also variant negatives displaying a mixture of glass and china.

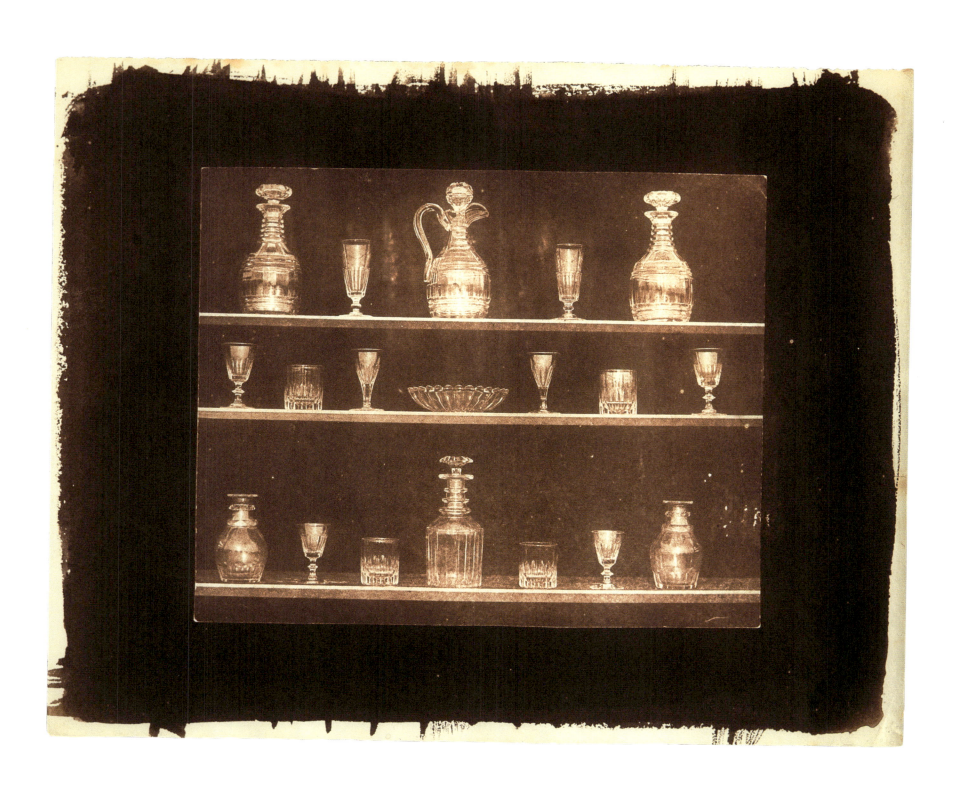

PLATE 81

Nelson's Column under Construction, Trafalgar Square, London

First week of April 1844. Salt print from a calotype negative,
17.0 x 21.0 cm image on 18.7 x 22.5 cm paper
Private collection
SCHAAF 3662

In a busy scene of urban building and civic pride, Talbot has recorded the column being constructed to commemorate the hero of Trafalgar. Its statue was then being sculpted by Edward Hodges Baily, the artist of *Eve at the Fountain* (pl. 48). A rare patch of sunlight struggles through the fog to add relief to the base, and St. Martin-in-the-Fields lends an air of dignity and stability.

There are some obvious clues to dating this image. Sir Francis Chantrey's statue of George IV at the left had just been put in place on 24 February 1844. The first of the bronze reliefs would not be attached to the base until 1849. Yet the most precise way to date this image is also one of its most compelling visual aspects, the wonderfully jumbled collection of posters and announcements decorating the hoardings. These promotions of special railway schedules and burlesque extravaganzas were seen as unattractive in Talbot's day (in much the same way that graffiti is generally received now). The *Times* sarcastically commented that "for the great edification of the sight seeing world, and doubtless to the great happiness of that useful class of Her Majesty's subjects—the bill stickers—a wooden barrier . . . may still tell of Jullien's concerts, Adelphi and Circus attractions . . . so that the most elegant and complete square in Europe, with its massive and finely-chiselled granite . . . its handsome fountains and fine jet of water . . . will be disfigured and disgraced by another unsightly hoard."[1] The perennially flagging Theatre Royal Lyceum regained its old name on 29 January 1844 and launched its season with *Open Sesame* on Easter Monday, 8 April. Henry Talbot was in London from 31 March through 7 April, meeting with Antoine Claudet, and it is almost certain that he must have taken this photograph during that week.

Although continuing progress is implied in Talbot's image, in fact the monument was stalled at this point. Its building committee had again run out of money, and the government was forced to take over the project in 1844. Another decade was to pass before it was completed, inspiring *Punch* to publish a "Nelson Column Emeute":[2]

O'er Nelson's Column, by a hoard concealed
All London cried to have the base revealed;
Those dismal hoards have shut it in for years.

Their "hoards" may have had a double meaning. In the 1930s, Morley's Hotel (in the background on the right) had been replaced by South Africa House, and visitors to London in the 1960s to 1980s are likely to remember the almost daily demonstrations that took place in Trafalgar Square. There was a long tradition of this. The square was the first open public space in London. The huge circular fountains were placed, not so much as decorative relief from urban pressures, but rather to break up and channel any large crowds that might be tempted to assemble. Even the column's base was modified, making it more difficult for a rogue dissident to appropriate it as an impromptu speaker's platform. Henry Talbot's sensitive management of Lacock had forestalled any problems there, but surely he could not help but have been aware of the special considerations for Trafalgar Square while he directed his camera at the scene. Given his unusual framing in this photograph, was it not so much the monument rising that he was seeing, but perhaps the broader implications of a new type of public area being introduced into London? If Talbot did reflect the concerns of his peers in this, his emphasis would soon be borne out. In the tumultuous year of 1848, four years after this photograph was taken, Trafalgar Square became the site of the greatly feared rally, ironically not about Chartism, but rather about income tax.[3]

Talbot had this image in mind for his *Pencil of Nature* and "Nelson's pillar" appears in one of his lists of planned future plates.[4] Nicolaas Henneman had a printed title made up to attach to the mounts of copies offered for sale.[5] Although the negative for this is not known to have survived, there are numerous other prints.[6] While Talbot took several views of the buildings around Trafalgar Square, only one other image of the base of the monument is known: taken from a lower camera angle, it silhouettes a cab and driver in the foreground; and to judge from the state of the scaffolding, it must have been taken in 1845.[7] This print was formerly in the Bokelberg Collection.

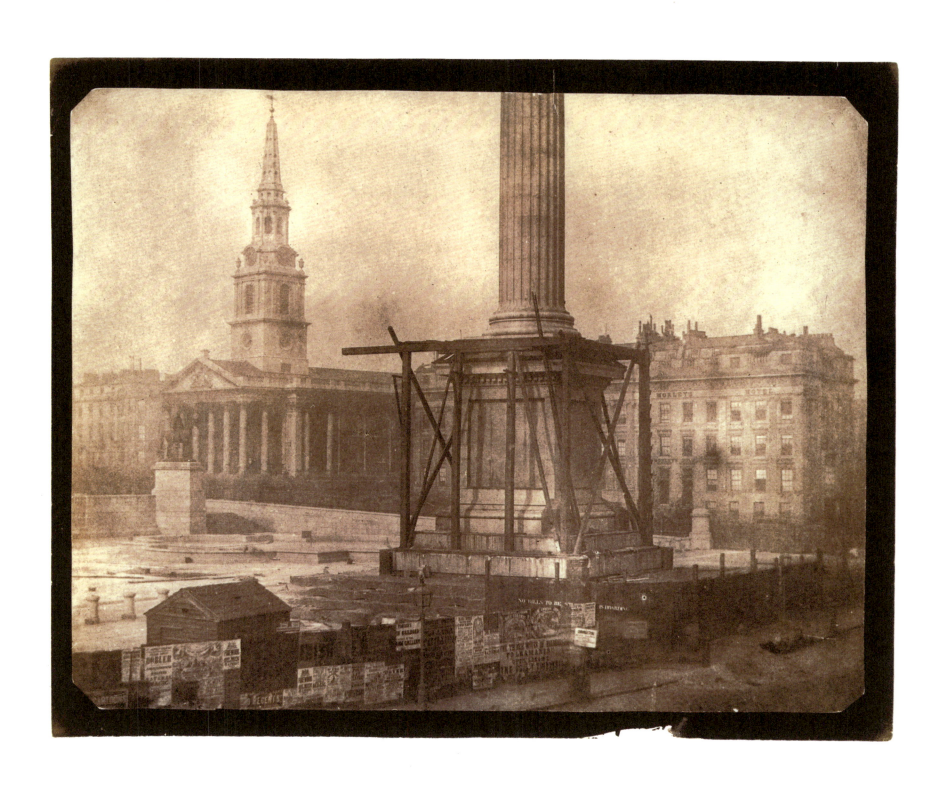

PLATE 82

"The Open Door"

Late April 1844. Salt print from a calotype negative,
14.4 x 19.4 cm image on 18.8 x 23.1 cm paper
The National Museum of Photography, Film & Television, Bradford (1937-1249/6)
SCHAAF 2772

Considering the sheer visual power of this photographic icon, Talbot was self-effacing in his *Pencil of Nature* when he said that "the chief object of the present work is to place on record some of the early beginnings of a new art, before the period, which we trust is approaching, of its being brought to maturity by the aid of British talent. This is one of the trifling efforts of its infancy, which some partial friends have been kind enough to commend. We have sufficient authority in the Dutch school of art, for taking as subjects of representation scenes of daily and familiar occurrence. A painter's eye will often be arrested where ordinary people see nothing remarkable. A casual gleam of sunshine, or a shadow thrown across his path, a time-withered oak, or a moss-covered stone may awaken a train of thoughts and feelings, and picturesque imaginings."[1]

Talbot chose this as the first plate in the second part of his book. This was at a period when the generally positive reviews of his photographic endeavors were starting to flow in. The *Open Door* was meant to be as powerful a beginning to this part as *Queen's College* (pl. 72) had been to the initial one. The *Art-Union* could hardly contain its praise—the plate "presents literally an open door, before which stands a broom, and near which hangs a lantern. It is of course an effect of sunshine, and the microscopic execution sets at nought the work of human hands. With this broom the famous broom of Wouvermans must never be compared: it becomes at once a clumsy imitation."[2] The *Literary Gazette* was delighted with the "broom and a lantern, perfect in reflected form, and rich in tone of colour. A back window in the darker central tint is deliciously bright, yet dim and faithful to the reality."[3]

Three years before arriving at this tightly structured and carefully composed image—indeed a candidate for the "Dutch school of art"—Henry Talbot had photographed his first draft of this idea, *The Soliloquy of the Broom* (pl. 37). Right from the time that Lady Elisabeth first admired the nascent version from three years earlier, the image concept of *The Open Door* never lost its popularity with those who saw it. Nicolaas Henneman selected this as one of twenty-four plates for his *Talbotypes or Sun Pictures, Taken from the Actual Objects Which They Represent* (1847), under the title of "The Broom."[4] In some commercial prints issued from Nicolaas Henneman's establishment at Reading, it was titled "Stable Yard in Talbot-type" on a printed title sheet.[5] In the seminal Society of Arts exhibition of photography in 1852, Talbot himself gave it the more conventional title of "The Stable Door."[6]

The negative is inscribed in pencil on the verso in Talbot's hand "April/44" and "No. 6." It is not waxed but has been lightly retouched in pencil in the lower right corner; this shows in all the prints, but only if one is looking for it. There are numerous prints of this popular image that were not mounted in copies of *The Pencil of Nature*.[7] In a Talbot "List of Negatives," number 6 is "The Broom a stable yard scene from nature."[8] The variant view is so close in appearance that its differences often get overlooked—the easiest way to spot it is by the much smaller triangle of light formed by the shadow of the broom. It is not known to have been used in any copies of *The Pencil of Nature* but this difference may have been overlooked. Prints from it are less common, and that negative is not known to have survived.[9]

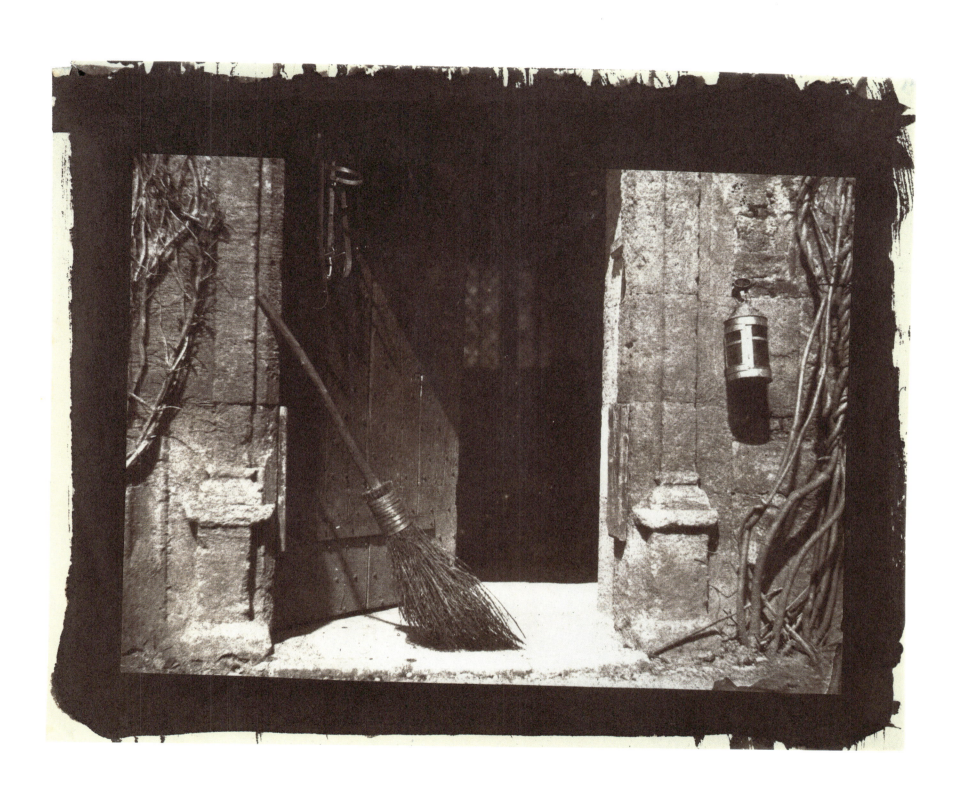

PLATE 83

"The Haystack"

Late April 1844. Varnished salt print
from a calotype negative, 16.2 x 21.0 cm
The Thomas Walther Collection, New York
SCHAAF 2770

This is a photograph that speaks about time and timing—about place and placement—about the nature of materials and the materials of nature. Selected by Talbot for inclusion in *The Pencil of Nature*,[1] it is a compelling and arresting image. It is evocative of an entire way of agrarian life, encompassing both traditional ways of doing things along with a sober look toward the needs of an impending future. Its time is spring, when the light assumes a soft but direct character, and more specifically its time is precisely at the brief moment when the moving shadow of the ladder places itself in the correct patch of light. The materials of its subject are rough and textured, ideal for modulating the light. Nature has provided them in a bewildering confusion of repetition. The tightly thatched roof has done its job well over the winter, protecting the precious food from rain as well as a roof protected the master's house. The knife casts its equally sharp shadow, symbolically marking the line where it is ready to slice a block of the now well-aged fodder.

Talbot was well aware of all this. In the text he wrote for this plate in *The Pencil of Nature*, he knew that "one advantage of the discovery of the Photographic Art will be, that it will enable us to introduce into our pictures a multitude of minute details which add to the truth and reality of the representation, but which no artist would take the trouble to copy faithfully from nature. Contenting himself with a general effect, he would probably deem it beneath his genius to copy every accident of light and shade; nor could he do so indeed, without a disproportionate expenditure of time and trouble, which might be otherwise much better employed. Nevertheless, it is well to have the means at our disposal of introducing these minutiæ without any additional trouble, for they will sometimes be found to give an air of variety beyond expectation to the scene represented."[2]

The *Athenaeum* recognized that "in the haystack we have a delightful study—the fidelity with which every projecting fibre is given, and the manner in which that part of the stack which has been cut, is shown, with the ladder which almost stands out from the picture, and its sharp and decided shadow, are wonderful; the foliage, however, is very indistinctly made out, and a prop placed against the stack, appears as if cut in two, owing to the large amount of light which has been reflected from the object behind it."[3] The *Art-Union* was even more enthusiastic about the haystack "which is represented with a truth which never could be expected by any skill or trick of Art; and of this let us observe (although the same may be said of the other plates), that with all this minute detail of hay and straw—where not one projecting point is omitted—there is nothing hard or edgy, but the whole is presented with a harmony of parts which at once shows that when detail is associated with undue severity there is a sacrifice of truth."[4] The *Literary Gazette* drew a connection that would strike a chord with modern viewers when it observed that the "haystack resembles the open door in general effect."[5]

The varnish on this print contributes to its exceptional quality. In addition to providing a barrier against the atmosphere, which almost certainly served to keep the print in such fine condition, the varnish has naturally yellowed over time. The added warmth only serves to emphasize the sunlight in the original image. The varnish here was applied much more evenly than in the *Aged Red Cedar* (pl. 43); although that certainly would have been the original aim of Henneman, each print works very well in its current state. On 16 September 1845, Antoine Claudet's studio billed Talbot for varnishing sixteen large views.[6] In December 1845, Henneman billed Talbot for varnishing seventy-three large prints and eighty-three small ones.[7]

This image was so popular that Nicolaas Henneman had a printed title made up to attach to the mounts of copies offered for sale.[8] The negative survives, along with numerous prints not published in *The Pencil of Nature*.[9]

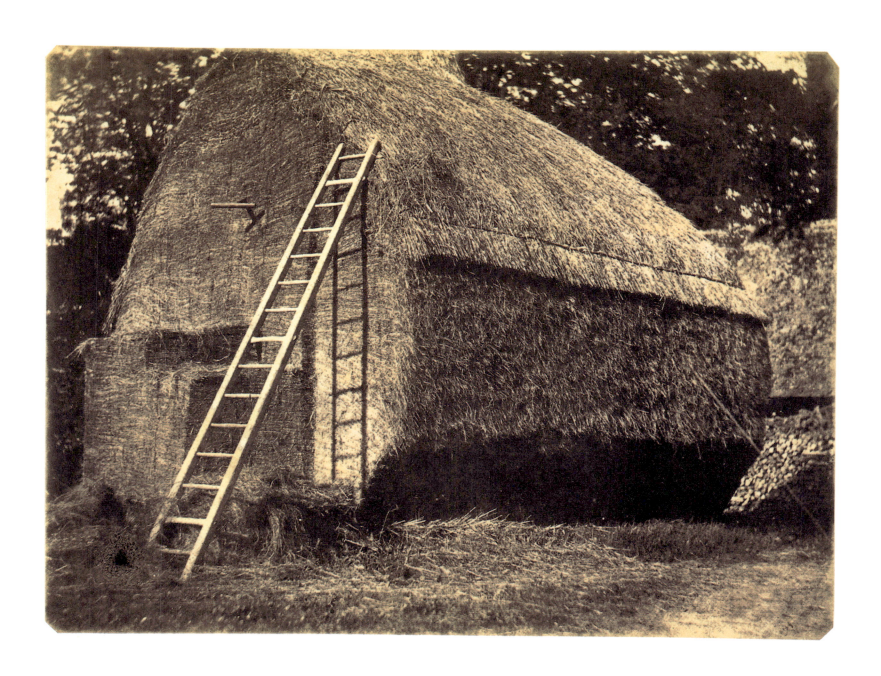

PLATE 84

"The Ladder"

Late April 1844. Salt print from a calotype negative,
17.2 x 18.3 cm image on 18.7 x 22.8 cm paper
The National Museum of Photography, Film & Television, Bradford (1937-1295/1)
SCHAAF 2771

Henry Talbot's relationship with the people around him has always been the subject of mystery. He was reserved, to be sure, perhaps even beyond the norms of his own society, but this was balanced by a lively imagination. His management of the village of Lacock during difficult political times speaks well of his character.[1] The lack of people in his photographs could be excused by the very long exposures of photogenic drawing, but even after the invention of the calotype, it would be fair to say that Talbot included people less often than he could have. Although Talbot's photographs lacked the presence of human beings, more often than not these same photographs did not lack in human presence. One is well aware that Talbot's world is populated. Indeed, very few of his photographs are of places where the influence of man is not obvious. This is the only plate in *The Pencil of Nature* that shows people, but Talbot had planned otherwise. He wrote that "portraits of living persons and groups of figures form one of the most attractive subjects of photography, and I hope to present some of them to the Reader in the progress of the present work."[2] His manuscript notes outline hopes to include "Pullen" (a Lacock servant) and a "group of Scotch fishermen" (likely a photograph to be contributed by Robert Adamson and D. O. Hill).[3]

Talbot explained that "when the sun shines, small portraits can be obtained by my process in one or two seconds, but large portraits require a somewhat longer time . . . groups of figures take no longer time to obtain than single figures would require, since the Camera depicts them all at once, however numerous they may be: but at present we cannot succeed in this branch of the art without some previous concert and arrangement . . . when a group of persons has been artistically arranged, and trained by a little practice to maintain an absolute immobility for a few seconds of time, very delightful pictures are easily obtained . . . the same . . . individuals may be combined in so many varying attitudes, as to give much interest and a great air of reality to a series of such pictures."[4]

It is possible that the portraitist and amateur scientist Henry Collen managed to influence the composition of this view: "On one occasion . . . Mr. Collen, an artist, was experimenting with Mr. Talbot, and it was proposed that they should take a ladder and a loft door, which was very much above the level of the ground. Mr. Talbot of course pointed the camera up, and produced a very awkward effect, from the peculiar manner in which the lens was placed with reference to the object. Mr. Collen said, 'You are not going to take it so, surely!' Mr. Talbot replied, 'We cannot take it in any other way;' and, then Mr. Collen said, 'As an artist, I would not take it at all'."[5]

Surprisingly, the critics responded more to the tonal renditions of this image than to the inclusion of figures. The *Athenaeum* thought the figures "prettily arranged, but the face of the boy is distorted, from the circumstance of its being so very near the edge of the field of view . . . in looking at this picture, we are led at once to reflect on the truth to nature observed by Rembrandt in the disposition of his lights and shadows. We have no violent contrasts; even the highest lights and the deepest shadows appear to melt into each other, and the middle tints are but the harmonizing gradations. Without the aid of colour, with simple brown and white, so charming a result is produced, that, looking at the picture from a little distance, we are almost led to fancy that the introduction of colour would add nothing to its charm."[6] The *Art-Union* said that "what kind of engraving could, with such inimitable harmony, render effect and detail as we see them here given . . . the wall of the building—apparently a stable—is covered with climbing shrubs, leafless as in winter, of which each infinitely fine tendril is represented with its shadow, and every gradation of light, in a manner which sets at naught the imitation of human hands."[7]

Nicolaas Henneman printed up a title to attach to the mounts of copies offered for sale.[8] The waxed negative survives, slightly retouched in a way that just shows in the upper left part of the prints; there are also a number of prints not issued in copies of *The Pencil of Nature*.[9]

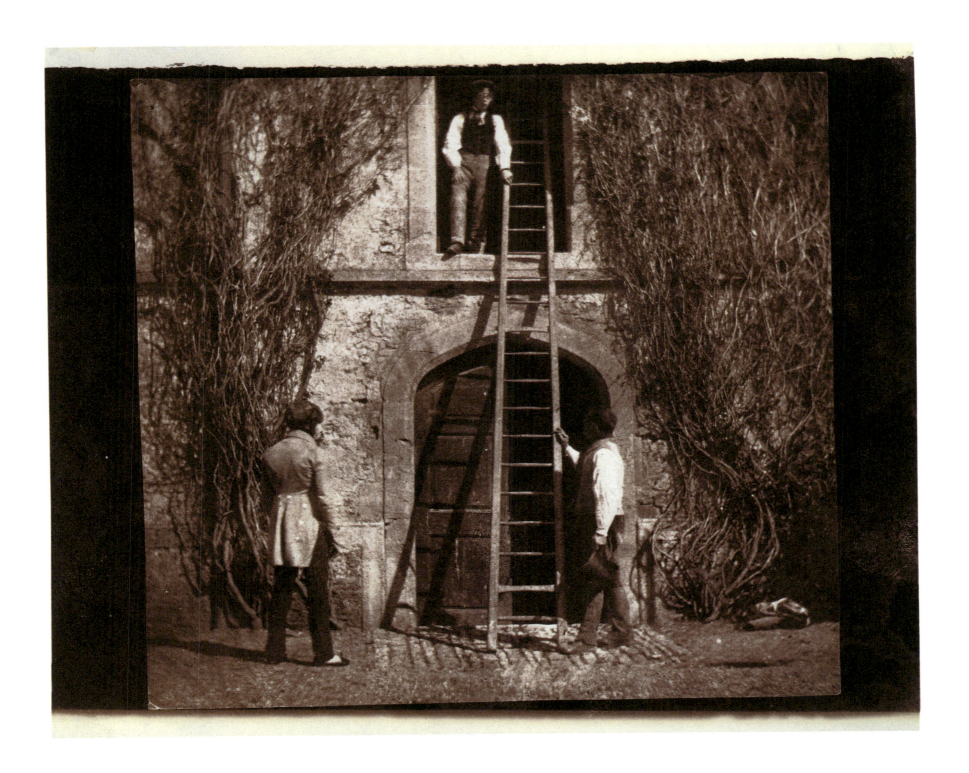

PLATE 85

"*Sir Walter Scott's Monument, Edinburgh, as It Appeared When Nearly Finished*"

Mid-October 1844. Salt print from a calotype negative,
19.7 x 15.8 cm image on 22.7 x 18.8 cm paper
The Canadian Centre for Architecture, Montréal (PH1981.0989)
SCHAAF 2800

In October 1844, after departing from the annual meeting of the British Association for the Advancement of Science in York, Talbot and Nicolaas Henneman headed north. With *The Pencil of Nature* safely underway and proceeding toward its second fascicle, Talbot was ready to undertake a new publication. The enormously popular writings of Sir Walter Scott had caught the royal imagination, and along with Victoria's interest in the land north of the borders, all Britain became enchanted. In the words of the publisher's broadside, "most of the views" that made up Talbot's *Sun Pictures in Scotland* "represent scenes connected with the life and writings of Sir Walter Scott." Unlike *The Pencil of Nature*, which was freely available through conventional booksellers, this new publication was to be sold strictly by subscription. Lady Elisabeth Feilding was the main impetus behind the project, and her social connections and persuasive pen insured that all one hundred copies were subscribed for. Indeed, the lists of subscribers could have been torn from her social diary. In one case, however, it is more likely that Talbot's sister Caroline Mt. Edgcumbe played a role: heading the list of subscribers was Her Majesty the Queen.[1]

Talbot based himself in Edinburgh, the "Athens of the North," arriving there on 12 October. He ranged about the countryside before finally departing on 22 October.[2] Responding from Lacock Abbey to one of his early letters from there, Constance Talbot cheerfully said that "today *our* weather is very fine & I hope it is the same with you & that you are at this instant engaged in taking the likeness of some interesting building—The sky has been gradually putting on a serene look & the wind is nearly gone, so I think there is a good prospect for your works."[3] In Scotland, as is so often the case, the weather was anything but serene.

While in Edinburgh, Talbot engaged a particular room in Robert Cranston's Hotel. Just a year before Talbot's visit, it had gained the distinction of becoming the first registered temperance hotel in all of Britain, but even though Talbot was known to be abstemious, this would not have been the main attraction of the establishment.[4] The notoriously predictable Scottish weather ("wait five minutes and it will change") was not so helpful to Talbot, and he needed to shelter his camera from the wind in a place where he could wait for the sunshine. The result was this image, destined to become the second plate in *Sun Pictures in Scotland*.

In spite of the recent tragic drowning of its architect, George Meikle Kemp,[5] the monument was proceeding on schedule (unlike the Nelson monument in pl. 81). It is difficult to believe that Talbot carelessly cut off the last bit of the unfinished top, but this decapitation is uniform in his several negatives. It was likely a limitation imposed by the window frame of his room. The monument reached its full two-hundred-foot height on 26 October, just days after Talbot photographed it—the last stone having been put in place by Kemp's young son Thomas. In addition to our lament today that he missed photographing this ceremony, there is another reason to wish that Henry Talbot's stay in Edinburgh had been prolonged by just a few more days. On 1 November, shortly after Talbot's departure, an even greater spectacle occurred. The twenty-ton block of Carrara marble (which had already sunk one boat) intended for the statue of Scott was pulled up Leith Walk by a team of twenty horses. It passed right by David Octavius Hill and Robert Adamson's Rock House studio on Calton Hill, bound not for glory in photography, but rather for the chisels of Sir John Robert Steell's studio, immediately opposite the monument and next to what had been Talbot's room at Cranston's. Perhaps they had not yet returned from York, perhaps the conditions were too challenging, but the spectacle of moving the stone was apparently not photographed by Adamson and Hill either.[6] Not surprisingly, though, given their base in Edinburgh, they photographed the monument numerous times before and after its completion.[7]

Talbot's view of the rising monument to the great Scott was so popular that Nicolaas Henneman had a printed title made up to attach to the mounts of copies offered for sale.[8] The negative and a few prints not in copies of *Sun Pictures in Scotland* survive.[9] There are five other known negatives Talbot took of the monument from this same camera position.[10]

PLATE 86

"A Mountain Rivulet Which Flows at the Foot of Doune Castle"

19–21 October 1844. Salt print from a calotype negative,
17.0 x 21.4 cm image on 18.5 x 22.5 cm paper
The National Museum of Photography, Film & Television, Bradford (1937-1353/4)
SCHAAF 17

In an image of classic beauty and sylvan repose taken in the earliest years of the art, Talbot has captured the essence of landscape photography. The trees sway seductively, and a string of conveniently placed stepping stones lures our eye into the scene. With the right kind of label and a thought-provoking title, this beautiful 1844 image could have hung in a 1984 exhibition by Thomas Joshua Cooper.[1] Capable of complex readings, it is a universally appealing image, thoroughly timeless, and essentially placeless. The scale of the trees shifts dramatically when one begins to perceive the bulk of Doune Castle rising out of the left; what had seemed to be a distant mountain behind the trees now reveals itself as a bank. This is a close variant of the smaller (8.4 x 10.5 cm) image employed by Talbot as plate 20 in his *Sun Pictures in Scotland*.[2] In the smaller, published version, Talbot has placed his horizon line more centrally, giving more prominence to the water, at the expense of the sky area and the base of the castle.

Doune was amongst the largest and finest ruins of its kind in Scotland. Located about four miles from Dunblane, it is situated midway between Loch Katrine and Stirling. Its commanding position on a mound overlooking the smaller River Ardoch, at its confluence with the more important River Teith, speaks of a time when protection was all, a time already well removed from the tranquil scene that Talbot rendered.

It is highly likely that before his trip (or at least once he got to the famous bookshops of Edinburgh), Talbot would have armed himself with a copy of the freshly published third edition of *Black's Picturesque Tourist of Scotland*. If so, the "Sixth tour" started at Stirling, proceeded on from there to Doune, past Loch Achray and then through the Trossachs to Loch Katrine (the scene of pl. 87).[3] Nicolaas Henneman kept good track of the expenses, and the fact that on 18 October he boarded an omnibus in Edinburgh and later in the day paid a porter at Stirling is a good indication that the two men were heading toward Loch Katrine. They would have passed Doune Castle going and returning; by 22 October, they were back in Edinburgh and packing for the return to England.[4]

In spite of the tranquility and sunny character of this photograph, it was not an easy journey. Constance, safely at Lacock, replied to Talbot that "I *did* receive your charming letter from the banks of Loch Achray—In it you draw the Sunny side of the picture—but your letter from Edinburgh today discloses the sad reverse and reveals the cold discomforts of the Inns— I quite pity you for lying awake shivering with cold!—what must those wretched places be in really severe weather!"[5]

This larger version of the image published in *Sun Pictures* seemed to have so much potential that that Nicolaas Henneman had a printed title made up for two versions to attach to the mounts of copies for sale.[6]

In February 1845, after receiving three hundred large-size prints of "Doune Castle, different view," Talbot loaned this negative to Nicolaas Henneman for use in his own printing; it still survives today, with four nasty spots in the stream area in the lower right retouched in pencil.[7] One print is known from when the negative measured 18.4 x 22.5 cm.[8]

PLATE 87

"Loch Katrine Pier, Scene of the Lady of the Lake"

19–21 October 1844. Salt print from a calotype negative,
17.3 x 21.2 cm image on 18.5 x 22.9 cm paper
The Museum of Modern Art, New York. The Family of Man Fund
SCHAAF 2787

In a carefully symmetrical composition, balancing pairs of triangles of dark and light, Henry Talbot has at once captured the beauty and mystery of the haunts of *The Lady of the Lake*. A rustic pier inserts itself into the silvery sheet of water, as a spindly tree reaches into the sky. Talbot chose this photograph for inclusion in his *Sun Pictures in Scotland*.[1] If there was any doubt about Talbot's point of reference, one of his image lists cited "Loch Katrine Pier scene of the Lady of the Lake."[2]

Carrying on from Duone Castle (depicted in pl. 86), Talbot and Henneman took advantage of a recently constructed road to enter an area once impenetrable to the casual tourist. Emerging from the wild gorge of the Trossachs Dell (Gaelic for "bristled territory"), a scene of great beauty suddenly emerged, as if extracted by Talbot's black magic from the very pages of Sir Walter Scott's poem. As we learn from a letter from Constance, the sun had become more kind to Talbot after he left Edinburgh: "I am charmed to hear that you had such fine weather for Loch Katrine—&c—and I am very glad that you did not turn back at Edinburgh as I fancied you would."[3]

As is so often the case, Talbot set up his camera in an area charged with the tension of something appearing to be ancient that was in reality in the throes of great change. *Black's* guidebook for tourists found it necessary to append a note in July 1843, saying that "an attempt is now making to establish a steamboat on Loch Katrine, but the intrusion of steam-power into such a spot, appears to be regarded by tourists as an indignity to nature and to poetical sentiment, and the preference is still given to the oar-boat."[4] For some reason, Talbot lacked the courage of Ellen, Scott's Lady of the Lake, and did not take to a skiff to go to the island. Perhaps the fact that he ventured no further than this shore was because of the constraints of time, or maybe he had a reluctance to commit his cameras and his chemicals to the uncertainties of a small oar boat. Another well-known image from *Sun Pictures in Scotland*, one showing a man and two of the oar boats, was taken from a position only a few steps to the right of this.[5]

An attempt was made two years after Talbot's visit to replace the oar boats: "The steamer is a comparatively recent innovation. A set of stout rowers had established themselves at Loch Katrine . . . the Loch Katrine boatmen thought that they had not only a life-lease of their pleasant and profitable occupation, but looked to their children inheriting it; when, in the year 1846, they were superseded by an invidious little steamer. The spirit of Clan Alpine had not, however, departed. One fine morning when the usual cargo of passengers came up to the Loch the steamer had disappeared."[6] Eventually, however, tranquility gave way to progress, and the Trossachs pier became the landing point for the *Rob Roy* steamer.

Since Talbot's time, interest in the unique character of this area has continued.[7] Today, although much altered, Loch Katrine remains beautiful. The rapidly expanding city of Glasgow was faced with chronic shortages of clean water, and tapping the loch was first seriously suggested in 1852. Against much opposition, an Act of Parliament was passed in 1855 authorizing this, thus beginning one of the largest public works projects of ancient or modern times. The twenty-six-mile-long aqueduct, running past Ben Lomond towering thousands of feet above, conveys the Loch's water through four-foot diameter cast-iron pipes.[8] By the time G. W. Wilson photographed this same scene two decades after Talbot, much of the picturesque roughness was gone, replaced by a carefully groomed tourist experience.[9]

The negative for the present image has two minor chemical spots together in the upper right which are apparent in some prints.[10] A small-camera variant of this image, measuring 8.6 x 10.6 cm, was reproduced as plate 16 of *Sun Pictures in Scotland*.[11] The reflections of the trees are very sharp, indicating a short exposure, but this would be expected for a smaller format camera. A close variant negative was apparently never printed. It is waxed but not trimmed for printing, and was made with a shorter exposure time. The tree reflections in this are more defined but the overall shadow detail is lacking.[12]

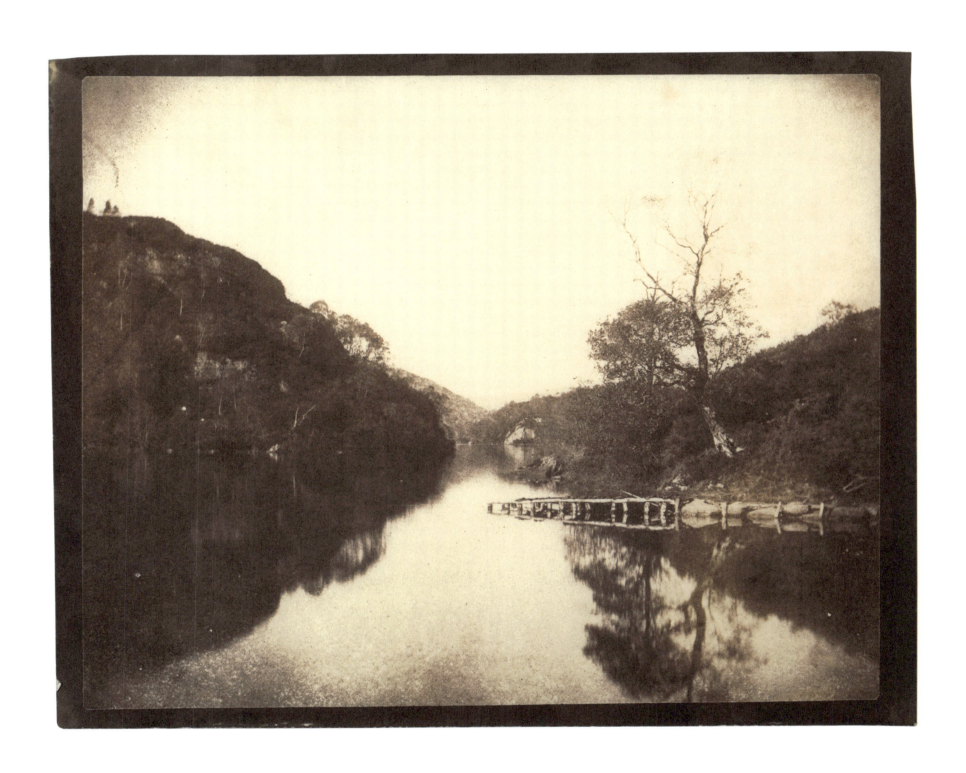

PLATE 88

"The Tomb of Sir Walter Scott, in Dryburgh Abbey"

Probably 25 October 1844. Salt print from a calotype negative,
16.8 x 17.9 cm image on 18.8 x 22.6 cm paper
The Metropolitan Museum of Art, New York. The Rubel Collection, Purchase,
Lila Acheson Wallace and Jennifer and Joseph Duke Gifts, 1997 (1997.382.4)
SCHAAF 2801

Somber and mysterious, charged with feeling, Talbot's photograph of the final resting place of Sir Walter Scott evokes an image that might well have come from the bard's own words. The severe angle infuses life into the stones, and the spindly trees add an air of tension. The abbey struggles to remain above the earth. Talbot's photograph poetically conveys the contemporary description that "the ruins of Dryburgh abbey are so overgrown by foliage, that . . . every where you behold the usurpation of nature over art."[1] Talbot's choice of lighting is especially appropriate, with his full title revealing that the exposure was "taken late in a autumnal evening." The air is still. The light is softened but clear. This powerful photograph was to become the final full-size plate in Talbot's *Sun Pictures in Scotland*.[2]

Sited on a peninsula in a crescent of the River Tweed, Dryburgh occupies an unusually beautiful position. In Talbot's day it was thirty-six miles out on the post road leading away from Edinburgh. With the vicinity thought to have originally been a place of worship for the Druids, the name of Dryburgh derived from the Celtic Darach-Bruach—"the bank of the sacred grove of oaks."[3] The abbey was founded in 1150. In November 1544, three hundred years before Talbot's visit—almost to the day, an English raiding party of seven hundred men rode out of Berwick and descended on Dryburgh. They described it as "a pratty town, and well buylded"—and promptly burnt the town and its abbey.

The texture and form displayed in Talbot's day (and little changed now) came from the nature of the stone, which was quarried near the river immediately below; it was stone of exceptionally high quality, that cut easily and weathered well, retaining its sharp incisions. "The ruins, on whatever side they are approached, are seen mingled with the surrounding trees, and have a reddish appearance, from the colour of the stone, which is of an excellent and very durable quality."[4]

We see here the north transept, which contained two chapels built in the late twelfth century. Sir Walter Scott's fantasy residence of Abbotsford was only six miles distant. Twelve years before Talbot's photograph, on 21 September 1832, Scott was buried next to his wife in an aisle owned by his predecessors. The day must have been very much like the one on which Talbot photographed: "The train of carriages extended . . . over more than a mile; the Yeomanry followed in great numbers on horseback; and it was late in the day ere we reached Dryburgh . . . the day was dark and lowering, and the wind high. The wide enclosure at the Abbey of Dryburgh was thronged with old and young; and when the coffin was taken from the hearse . . . one deep sob burst from a thousand lips."[5]

One would be tempted to date this image to early in Talbot's sojourn—on 6 October Nicolaas Henneman recorded having paid for a ferryboat at Dryburgh.[6] However, Talbot had been reporting his progress in a series of letters (now mostly lost) back to Lacock Abbey. On 29 October, Constance replied to one of these that "we are so glad that you have been successful at Abbotsford & Dryburgh Abbey—and we think the latter part of your tour has made amends for the disappointments at the beginning."[7] The register book at Abbotsford still preserves Henry Talbot's signature when he visited and photographed there on 24 October—this photograph of nearby Dryburgh would likely have been made the next day.[8]

Demand for this image was expected to be so high that Nicolaas Henneman had a printed title made up to attach to the mounts of copies offered for sale.[9] This splendid print came from the Rubel Collection. The waxed negative survives and exhibits coating defects in the lower left and two spots in the area of the trees; these show as black patches in most of the prints made from this negative, but Talbot wisely decided they were of minimal impact on the visual quality of the image.[10] Some prints show the effect of a temporary retouching of the negative.[11] There is also a close variant negative, waxed, but no prints from it are known.[12]

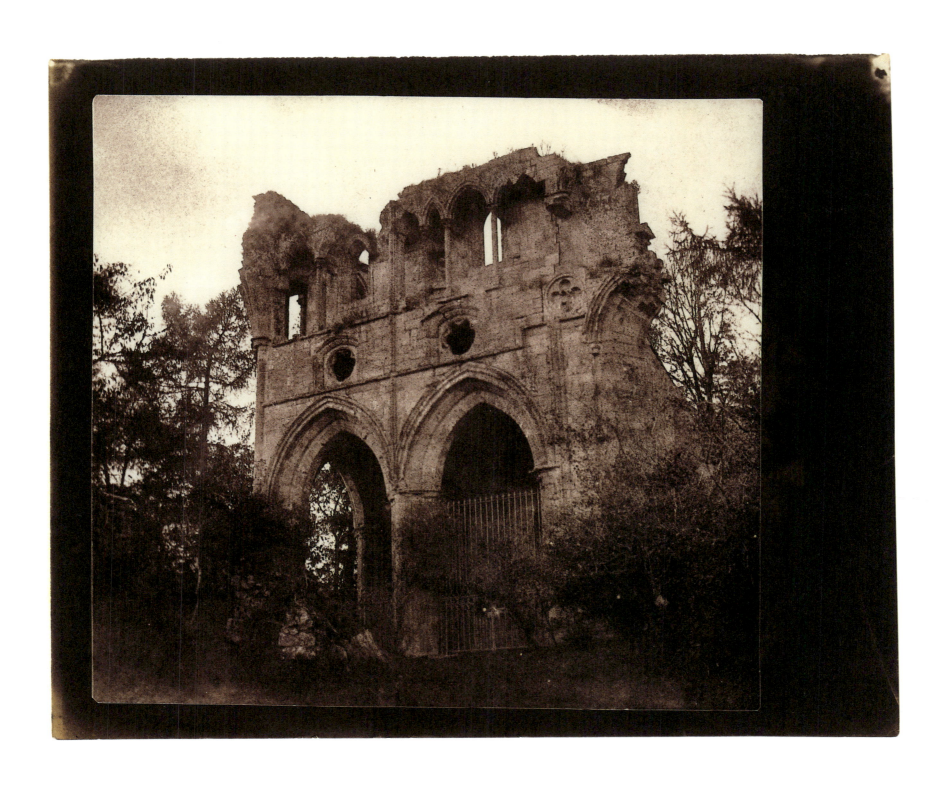

PLATE 89

"In Scotland"—Stone Bridge near Harden Castle, outside Hawick

Probably 26 October 1844. Salt print from a calotype negative,
16.5 x 20.5 cm image on 18.3 x 22.6 cm paper.
Inscribed in ink on recto (twice!): "Scotland"
Lacock Abbey Collection, The Fox Talbot Museum, Lacock (LA453)
SCHAAF 3807

Looking back toward the Scotland that he was about to depart, Henry Talbot must have brought to mind Sir Walter Scott's strong boast that "every Scotsman has a pedigree. It is a national prerogative, as unalienable as his pride and his poverty. My birth was neither distinguished nor sordid . . . my [great-great-great-great] grandfather was Walter Scott, commonly called in tradition *Auld Watt* of Harden."[1] He "was, in fact, one of the 'prowest knights' of the whole genealogy—a fearless horseman and expert spearman, renowned and dreaded," recalled Scott's son-in-law. Scott maintained these ancient ties, for "so long as Sir Walter retained his vigorous habits, he used to make an autumnal excursion, with whatever friend happened to be his guest at the time, to the tower of Harden, the *incunabula* of his race."[2] If Talbot had been able to record this scene with his primitive photogenic drawing process soon after he invented it in 1834, he would have missed Scott's ritual by only a couple of years.

A decade later, Talbot and Henneman must have had quite an adventure in their travels north, for their journey was undertaken just as the tourist industry was really beginning to build. Contemplating this stone bridge, they must have felt very powerfully what one historian later observed: it is "curious to find that the word 'road' does not appear to be used in any of the histories of Scotland earlier than the sixteenth century . . . up to the fifteenth century the movements of the chief expeditions seem to have been across open country, and it was only the erection of bridges in the fifteenth, sixteenth, and seventeenth centuries that made definite the lines of traffic, which afterwards gradually developed into roads."[3]

The legendary family of Harden was famed in border history for the extent of their depravations. Harden Castle (now all but demolished) was on the post road from Edinburgh to Carlisle, and this photograph must have been taken during a change of coaches. Nicolaas Henneman recorded that on 27 October, they left Hawick and passed through Carlisle on the way to Newcastle.[4] Perhaps the reason they had time to photograph a scene like this was an experimental approach that Talbot was trying at the time. Eight years after this photograph, he revealed that he had been testing a "traveller's camera" of his own devising on this journey. Recalling the views taken at Abbotsford immediately before this, Talbot said his "paper was prepared in the inn, at Galashiels, several miles distant, and it retained its sensibility during some hours sufficiently well." In what sounds like an extraordinary example of the woodworker's art, Talbot had built for him a camera with an extended tailboard. Vertical tanks hung below this and the camera body was mounted to it on sliding rails. Previously prepared iodized paper (not yet sensitive to light) was placed into the focus of the lens, the camera was slid back to a mark and a lever was moved, and the paper thereby plunged into a sensitizing bath. Withdrawn from the bath, it was then exposed while wet (when it was at its highest sensitivity anyway). The camera body was slid back to another mark for the developer, then to another mark for a water bath. At this point the exposed negative was no longer really sensitive to light and could be stored until the evening to be properly fixed! No tent nor darkroom was required in the field.[5]

Nicolaas Henneman had good reason to think that images associated with Scott would enjoy a wide sale, and he had printed titles made up for two versions of this image to attach to the mounts of copies offered for sale.[6] The waxed negative, which Talbot inscribed "near Harden Castle" in pencil, survives but has been trimmed to 13.5 x 20.5 cm; no prints are known to have been made from this reduced size.[7] Talbot took one other negative of this bridge from a slightly different camera position.[8]

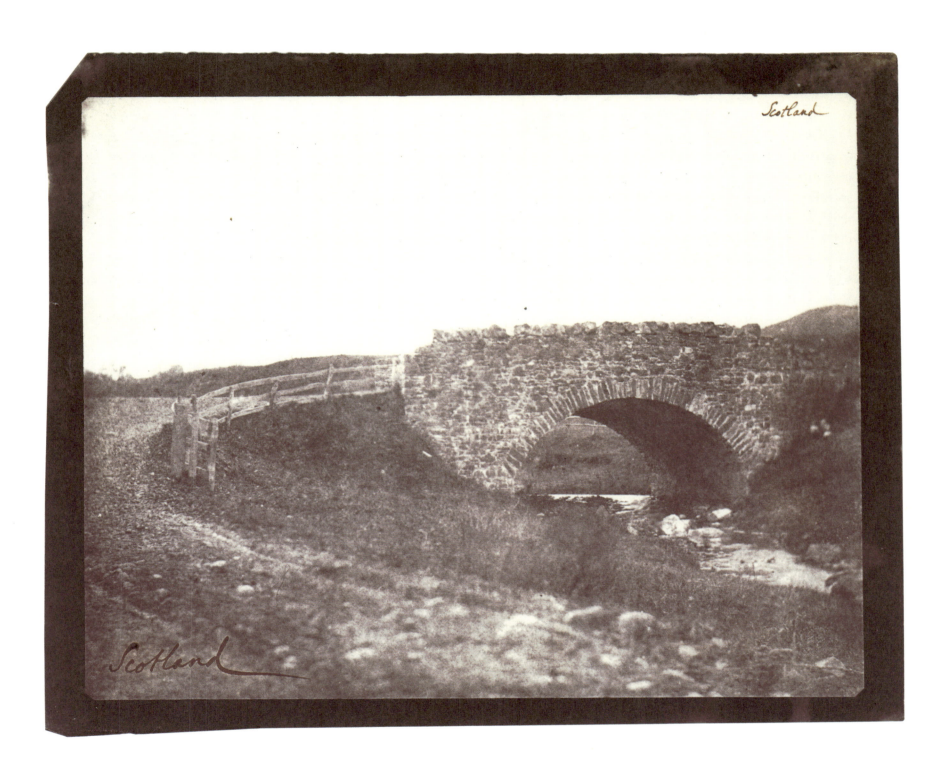

Scotland

Scotland

PLATE 90

Clare College Bridge, Cambridge

c. 1845. Salt print (varnished on verso only) from a calotype negative,
6.0 x 8.8 cm image on 6.2 x 11.1 cm paper
The National Museum of Photography, Film & Television, Bradford (1937-2275)
SCHAAF 299

In this tranquil scene, Talbot has transformed the graceful ancient bridge and its symmetrical reflection into a giant pair of eyeglasses, much as one might see hanging outside an optician's shop. Photography had helped him to see, and by this period his vision had grown strong and sure—his new art had become Henry Talbot's spectacles.

Talbot was a Cambridge man and he must have thought of it often. Because of the railway connections, then as now, it was far more difficult to travel there from Lacock Abbey than it was to reach Oxford. When he could manage, though, he brought his cameras to Cambridge. After photographing so many subjects that were new or in a state of flux, the university towns of Oxford and Cambridge offered Talbot a wealth of subjects that had been as they had been for a good long time. Such is the case here. At the beginning of the seventeenth century, long before Talbot's photograph, the Clare College buildings were in such a bad state of repair that they had to be torn down and replaced. To facilitate access to open country, the scholars petitioned King's College to sell them a parcel of land in order to erect a bridge. After much politicking, this was finally agreed, and the bridge was built to Thomas Grumball's graceful design in 1640. The quiet punting on the River Cam belied the main reason permission was given to erect the bridge. It had originally been requested to "enable the members of the College to escape into the fields in time of infection."[1]

Why a print like this would be varnished on the verso only is not clear from Talbot's notes. Most of the time, varnishing (such as that employed in the *Aged Red Cedar*, pl. 43 and the *Haystack*, pl. 83) was done in hopes of protecting the image and perhaps providing an attractive surface gloss. It is most likely that this print was varnished on the reverse side in order to increase its transparency. Sometimes, but usually in earlier years, Talbot waxed or oiled his prints so they could be hung in windows (the rapid fading this engendered soon discouraged such practice). He might have wanted to increase this print's transparency in order to use it as the positive in his experiments toward photogravure. That would have involved printing the positive in direct contact with the surface of the sensitized metal plate, and Talbot would not have wanted an uneven layer of varnish to disrupt this optical contact. In any case, this is too pretty a print to simply have been used as a scrap of paper on which to test a brush.

The negative is presently trimmed to the size of this print (the only one known of this cropping). However, another print from an earlier state of this negative reveals that Talbot's photographic outing that day was not as tranquil as it seems. The camera was very severely tilted—perhaps on the bank of the River Cam—and the negative cleverly trimmed to restore the sense of order.[2]

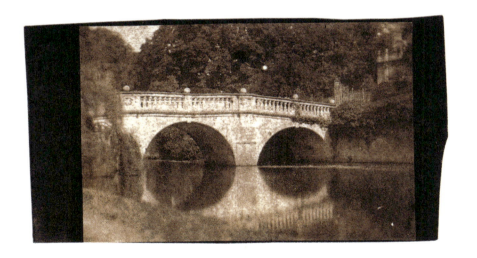

PLATE 91

The Bridge of Sighs, St. John's College, Cambridge

c. 1845. Salt print from a calotype negative,
16.2 x 20.7 cm image on 19.5 x 24.7 cm paper
The Manfred Heiting Collection
SCHAAF 143

In 1826, Henry Talbot had written to his mother (a fine sketcher herself) that "I wish Claude were here to take a view for me . . . I never saw so perfect a view; for generally in real views, something is too much or too little but with this view the most critical judgment must be contented. The same view, looks nothing in the morning, when the lights fall the wrong way."[1] When the lights fell the wrong way! Talbot's sense of timing in this image is exquisite. At any other time of day, as the sun traced out its daily path, the lovely Bridge of Sighs would come into competition when the ancient college buildings at the right became illuminated. Gone would be the silvery mass of water under the bridge, carefully contained by the shadow blocking the lower left corner.

The prominent date of 1624 on the library building suggests an overall sense of antiquity in this scene; this was the New Library, completed that year. But in contrast to Talbot's photograph of the *Clare College Bridge* (pl. 90), this implied passage of time was not real. By the beginning of the nineteenth century, St. John's College had a pressing need for more space. As was a typical problem for both Cambridge and Oxford, the college was unable to fit satisfactory buildings within its existing site. It was forced to look immediately across the river, but this necessitated a communication between the two quadrangles—the celebrated Bridge of Sighs was the happy result. Narrow but high and bright on the inside, its arched exterior presents a

Gothic appearance. Completed in 1831, it was designed by Mr. Hutchinson, junior partner of Rickman & Hutchinson, who died the year before it was finished. Seen as "an ingeniously contrived bridge, whose passage is roofed, and enclosed at the sides by open tracery, [it] forms the communication from the older quadrangles. By this device the nocturnal inclosure of the students within the walls is preserved without interfering with free communication between the courts."[2] The Venetian Bridge of Sighs took its name from its role in connecting the palace to the public prisons. Talbot's photograph replicates this feeling for Cambridge. Symbolically bright on the left side of Talbot's image is the relative freedom of the halls of residence. On the right, shrouded in dark mystery, are the symbols of power and restraint, the chapel and the administrative offices.

The waxed negative is near perfect, although the uninterrupted areas of deep black demanded a clean printing glass to avoid white spots in the print. The negative has two visible flaws that one can find reproduced in most prints. There is a spot in the water on the left side under the arch; the edge of the negative was slightly damaged, and some prints show a small sharp angled line at the bottom left. However, this negative is still of good quality, and the attractiveness of this image has insured that prints from it have been incorporated in numerous collections.[3]

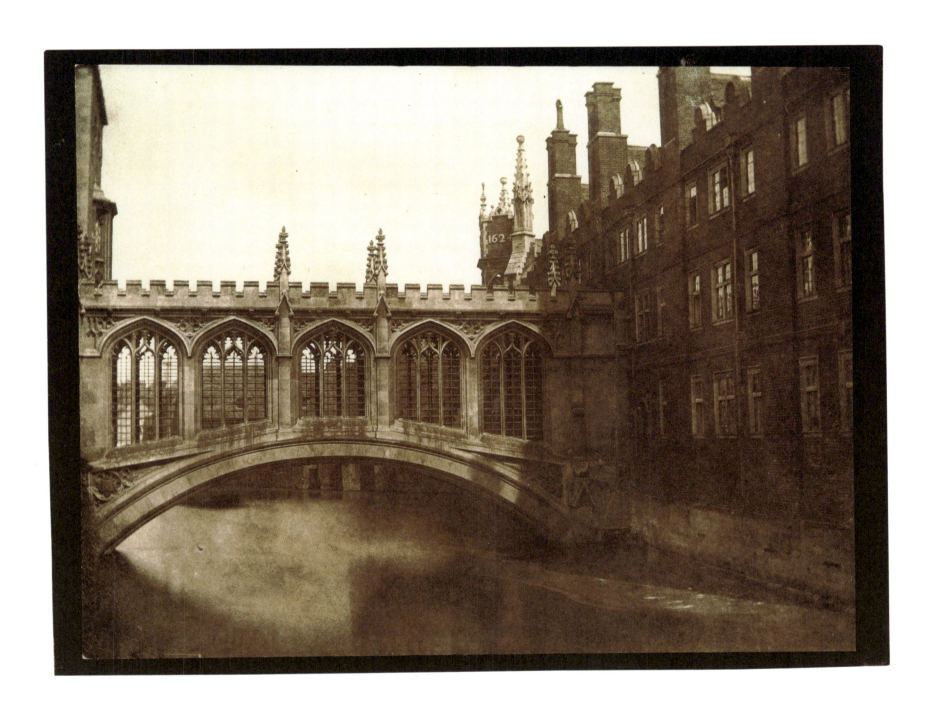

PLATE 92

The Hungerford Bridge, London

c. 1845. Salt print from a calotype negative,
16.9 x 21.3 cm image on 19.8 x 24.9 cm paper
The Gilman Paper Company Collection, New York
SCHAAF 1219

Speed and bustle and strength and directed movement are all emphasized in Talbot's photograph of modern London. For an image strangely devoid of actual people, the combined sense of purpose in mankind's structures is powerfully stressed here. The influence of commerce is clear.

The Hungerford Bridge was another of the excited projects achieved by the daring engineer Isambard Kingdom Brunel. It was designed to cross the physical barrier of the Thames, in order to enable the populations of potential laborers living in squalor on the South Bank to contribute their backs to the booming economy on the North. The ruts they created with their coal carts are evident in the foreground of Talbot's photograph. Construction on this toll bridge was begun in 1841. In the rapid pace of the day, it was opened to pedestrians on 1 May 1845—Talbot's photograph must have been taken right around this time. Just about four years before this, in taking his view of the *River Thames* (pl. 42), Talbot had chosen a site not far from the left-hand extremity of this bridge, in a view now blocked. The peaceful sense of that image is nowhere present here.

Never again would London feel so powerful. Hidden behind the mast jutting into the sky area is the brewery that would provide the site for the hope-filled 1951 Festival of Britain. The shot tower prominent in the background, built in 1826, survived into the 1960s. But the graceful Hungerford Bridge would not be so fortunate. Conceived as a pedestrian bridge linking commerce on the two sides of the Thames, it was almost immediately considered too limited in a London that was changing so rapidly. Pressure from the ever-expanding railroads ensured its demise. In 1860, just fifteen years after Talbot recorded its opening days, it was torn down to make way for the "horrible" Charing Cross railway bridge.[1] The long chains from which it was suspended went into storage, eventually to serve as a sort of memorial to Brunel when they were incorporated into the breathtaking suspension bridge across the gorge at Clifton.

Talbot also took a very similar view, somewhat less dramatic, of the Waterloo Bridge.[2] The waxed negative survives in good condition and, not surprisingly for such an attractive image, prints from it are in several collections.[3] This particular print was formerly in the Harold White Collection.

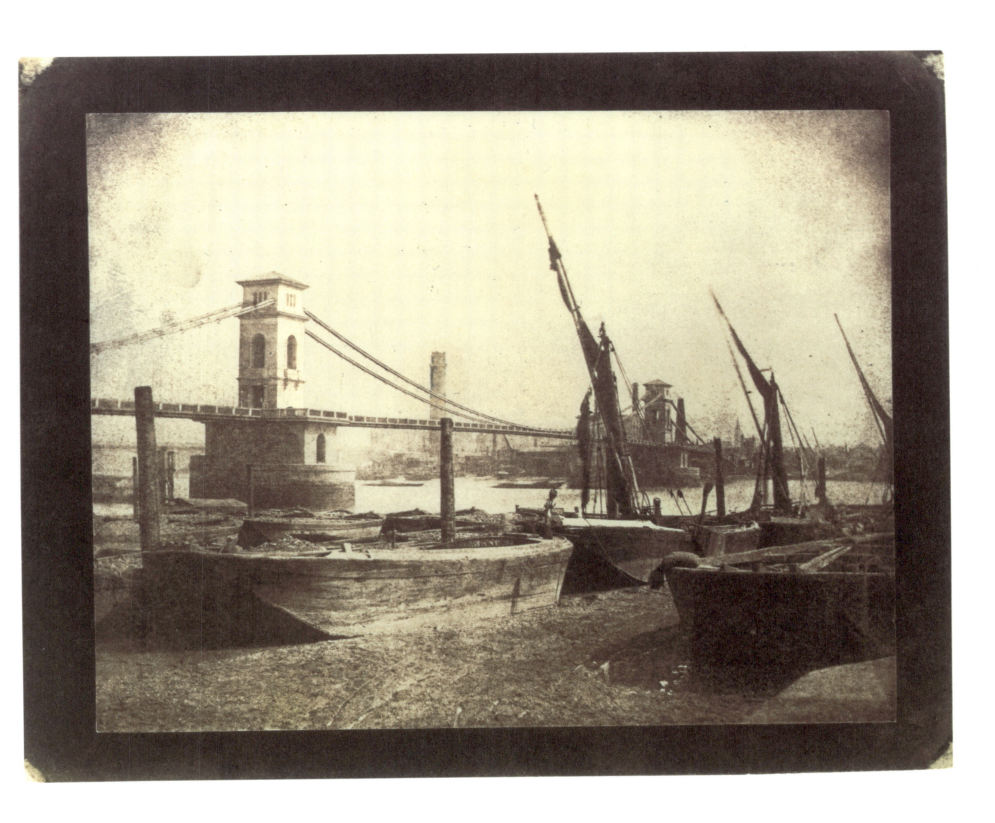

PLATE 93

Angel's-eye View of the Henry VII Chapel, Westminster Abbey

c. 1845. Salt print from a calotype negative,
16.9 x 20.2 cm image on 18.6 x 23.1 cm paper
Lacock Abbey Collection, The Fox Talbot Museum, Lacock (LA304)
SCHAAF 760

Completed in 1519, the Henry VII Chapel, or Lady Chapel, is one of the most deliciously and completely ornate structures in all of Europe. Comprised of sixteen Gothic towers, it is the resting place of numerous royalty, including Mary, Queen of Scots. Talbot's razor-sharp vision has represented its complexity well. About two years before this photograph was taken, he had climbed one of the twin towers of Orleans Cathedral (see pl. 66) to record a similar view. At that time, working well away from home, his negative paper was somewhat more coarse, preserving a sense of ornateness even while losing fine detail. With the context of the backdrop of the City of Orleans, that photograph has a much more gentle feel than the present one. Light is an essential element of this strikingly modern photograph of Westminster. Strongly directed from the side, it brings out in sharp relief the intricate chiseling. Glaring off the leaded glass windows (whose diamond structure must recall Talbot's photograph of Lacock's oriel window, pl. 1), there is a sense of liveliness and of space to this image. But unlike the invitation to the city of Orleans evoked in his earlier view, this is space that we cannot penetrate.

Talbot faced the south side of the chapel—counting in from the end near Parliament, this is the third Gothic tower. This small tower at Westminster lacked the adjacent twin that had facilitated his view at Orleans, and one is tempted at first to think that Talbot must have carried his camera up some of the scaffolding regularly erected over the years to repair the masonry. But scaffolding at this remove would have been of little use to the stonemason. Instead, Talbot climbed into one of the upper floors of a house on "College Street, on the south,—where a modern street builder would say the Abbey was smothered with buildings;—buildings the said builder would be eager to raze to the ground."[1] It is difficult today to imagine that the abbey was into recent times completely surrounded by more pedestrian buildings, but of course cathedrals and churches were the epicenter of medieval cities.[2] Only in recent years has their importance as inspirational architecture crowded out their functions in daily life, clearing away vistas for better views,

but losing the natural concentration that had originally evolved.

At one time, Talbot planned to include this image in his *Pencil of Nature*—in his projected list for part 5, to be issued at the end of 1845, he included "Balustrade W.r Abbey."[3] Instead, for reasons unknown, he turned to a photograph made by Nicolaas Henneman (it is the only photograph in *The Pencil of Nature* known to have been made by someone other than Talbot). Perhaps he was trying to support his former servant, who had just closed his establishment at Reading in favor of a location on Regent Street in London, but whatever reason he chose Henneman's over this photograph cannot be supported on visual grounds. We don't know just what view of Westminster Lady Elisabeth Feilding held in her hands as she wrote to her son in early 1845, but it could not have been the Henneman one that was eventually published: "The 'Westminster Abbey' meets with boundless praise & is said to be far more beautiful than those published. Indeed I wish you had mounted it in number 2.d" of *The Pencil of Nature*.[4] In the end, in the plate that was published—a somewhat awkward view of the front of Westminster Abbey—little sense of the intricacy of the stone is apparent. Talbot emphasized this in his text: "The stately edifices of the British Metropolis too frequently assume from the influence of our smoky atmosphere such a swarthy hue as wholly to obliterate the natural appearance of the stone of which they are constructed. This sooty covering destroys all harmony of colour, and leaves only the grandeur of form and proportions. This picture of Westminster Abbey is an instance of it; the façade of the building being strongly and somewhat capriciously darkened by the atmospheric influence."[5] With the controversial recent cleaning of the abbey, that "sooty covering" has been removed, revealing a richly sculpted and strangely white abbey not at all unlike Talbot's closer view of the chapel.

This negative is still in fine condition, but surprisingly, only this print is known from it.[6] Prints are generally more numerous from Talbot's five other negatives recording the rich architectural details of the chapel.[7]

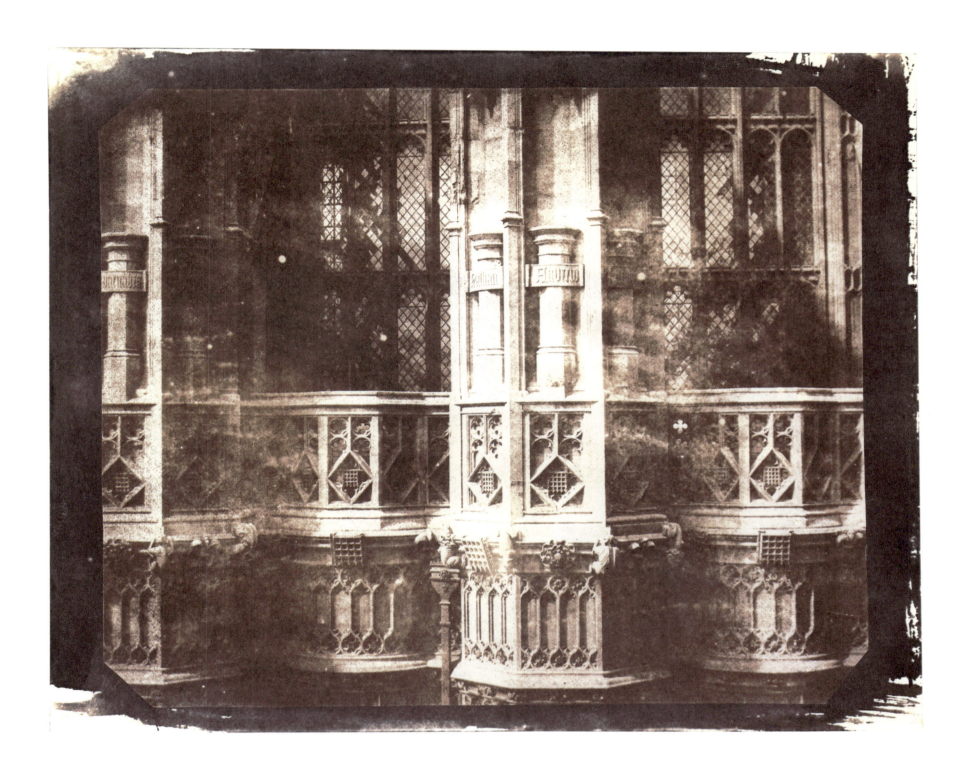

PLATE 94

The Royal Exchange, London

Spring 1845. Salt print from a calotype negative,
17.2 x 20.5 cm image on 18.8 x 22.4 cm paper.
Watermarked J Whatman Turkey Mill 1839
The National Museum of Photography, Film & Television, Bradford (1937-4422)
SCHAAF 1223

Although the people are hardly more than implied here, this Talbot photograph is full of life. Gaslighting filled the streets of London as early as 1807, and the row of the now-commonplace gas lamps marching down the side of the image immediately attracts the eye. The bustle of commerce was too much for Talbot's long exposure—perhaps two or three minutes on an overcast day like this—and only the ghosts of a cab and some pedestrians are recorded.

At the beginning of 1838, the second Royal Exchange was totally consumed by a rapidly spreading fire. It had replaced Sir Thomas Gresham's original Exchange, itself destroyed in the Great London Fire of 1666. The importance of this complex— "the Heart of the Empire"—demanded an immediate replacement. The trapezoidal site was challenging, but a cavalier attitude toward the hasty excavation of Roman ruins discovered underneath Wren's distinctive St. Michael's Crooked Lane Church made it adequate. Prince Albert laid the foundation stone early in 1842. At the time the nearly completed building was opened by Queen Victoria on 28 October 1844, Talbot was just returning from his sojourn to photograph the plates for his forthcoming *Sun Pictures in Scotland*. He must have taken this photograph not long after.

Talbot placed his camera above street level in one of the late Georgian houses then on the corner of Princes and Poultry Streets.[1] This is the west front of the Exchange. Richard Westmacott's tympanum on the pediment is carved with allegorical representations of commerce. Talbot's framing included the church of St. Michael's, Cornhill (seen in the distance to the right); built after the Great London Fire, it was one of Wren's most Gothic-style churches. It was a generous framing, appropriate to the sense of the scene. When the third Exchange was built, careful attention was given to how it would appear on approach. London, even then, had very few open vistas compared to most European cities. Over the years, the generous forecourt and prominent position of the equestrian statue of the duke of Wellington have suffered from the very commerce that the Exchange was meant to foster. Today, the Exchange drowns in canyons of towering modern buildings, devoid of the heavy symbolic meanings incorporated in this structure, and totally lacking in any sense of the progressive march of civilization. One would have to mount the dangerously curved top of a London Tube entrance to replicate Talbot's point of view.

The waxed negative survives, but this is the only known print from it.[2] Talbot is known to have taken three other negatives of the Exchange, all similar save for slight changes of camera position and differences in the street activity; none of them is positively dated.[3]

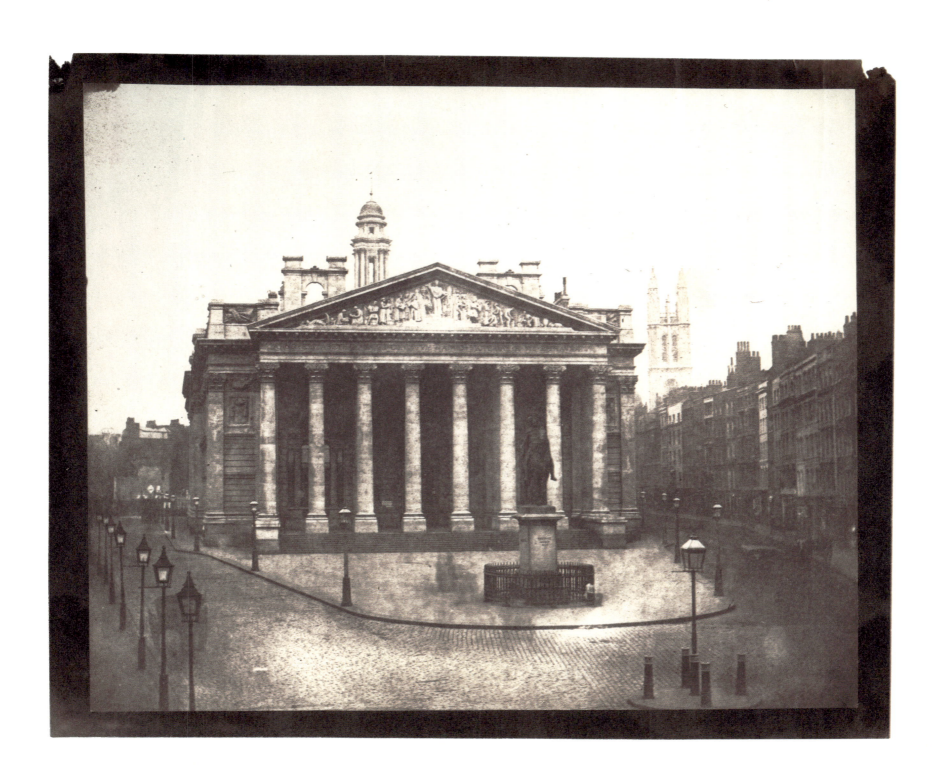

PLATE 95

"A Scene in York"—
York Minster from Lop Lane

28 July 1845. Salt print from a calotype negative,
16.1 x 20.3 cm image on 18.6 x 22.5 cm paper
The Manfred Heiting Collection
SCHAAF 19

In a confident composition, Talbot has placed the venerable Cathedral of York in its proper context of an urban setting. The dark buildings framing the scene tilt slightly inward, a consequence of vertical convergence from pointing the camera upward, but in this case one that adds a sense of movement to the frame. Henry Talbot had learned a great deal about composition by studying the output of his own camera. In the present image, he likely received additional advice. Talbot reported to his mother from York on 28 July 1845 that "M^{r.} Calvert Jones is just arrived to unite his photographic efforts with me."[1] The Reverend Calvert Richard Jones brought an artist's sense of composition to the effort and was rapidly becoming one of Talbot's most fervent supporters in photography on paper.

Constance Talbot wrote to her husband, delighted that "M^{r.} Calvert Jones is to be your travelling companion. I know he is a zealous admirer of your art & I hope he will be useful as an assistant—*but* how woefully dark the weather is for your operations & I cannot perceive any promise of changes."[2] The weather was always a problem for Talbot, and it was unlikely that he could have already forgotten his mother's stern warning of four days before: "I advise you not to indulge in your usual impatience, but stay in places (that are worth it) till the Sun *will* shine."[3] In this photograph, however, the lighting could not be better or more appropriate. The shadows are softened by a somewhat overcast day, but there is just enough direction left to the sunlight to clearly define the forms. The Minster rises majestically, given just enough distance from the mercantile world that surrounds it by a modest veil of atmospheric haze.

This is the west end of the Cathedral. Talbot placed his camera in an area that had been cleared in 1785 to "make a more commodious approach to the Minster."[4] It was then the corner of Blake Street and Lop Lane.[5] Ettridge's Hotel, on the right, would become a Register Office when this area was rebuilt in 1860, in a further attempt to clear lines of sight to the Minster.[6]

Talbot reported to Constance that Calvert Jones "got up extremely early this morning & took a long walk thro' the City, studying the points of view, before breakfast—We took 12 views of York today, most of them good—crowds of admiring spectators surrounded the Camera wherever we planted it."[7] The "crowds of admiring spectators" that we would so much like to see today are absent from Talbot's image. Those who did not stay out of the way were submerged in the long exposure time. Unfortunately, this proved to be the only day that the two men were able to photograph together—Calvert Jones received the news of the impending death of a relative and had to depart.

This is likely the "Street in York" that Nicolaas Henneman printed for Talbot in December 1845.[8] The waxed negative survives, along with numerous prints.[9]

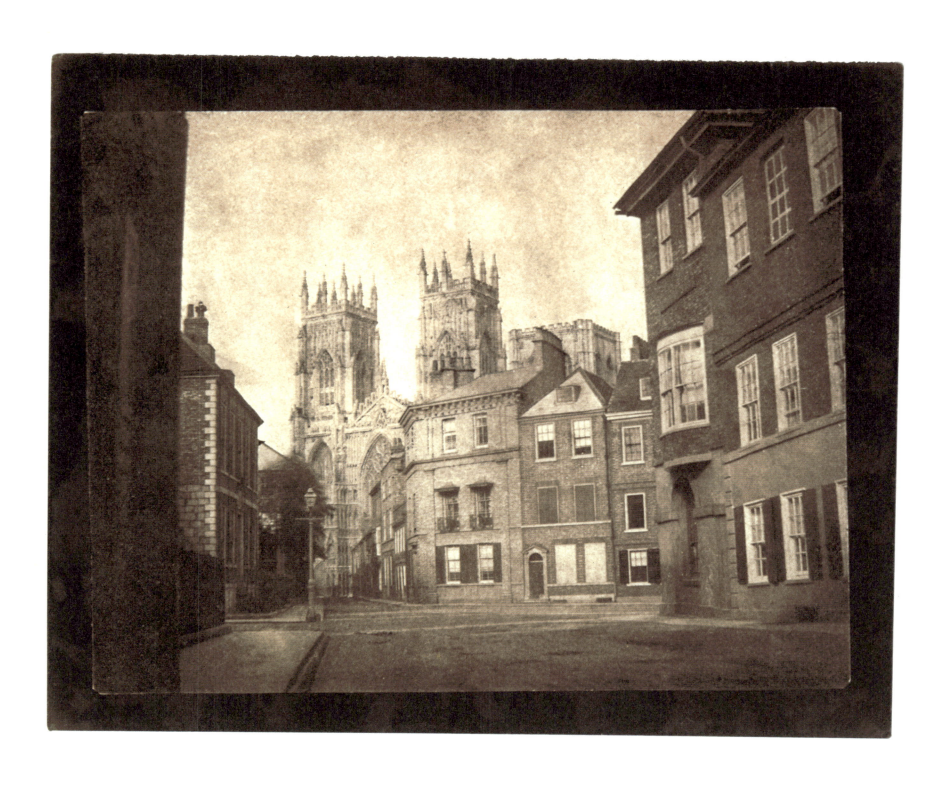

PLATE 96

Holy Trinity Church, Bishop's Road, Paddington, London

Late summer 1845? Salt print from a calotype negative,
19.2 x 17.4 cm image on 23.9 x 19.5 cm paper
Photographic History Collection, National Museum of American History,
Smithsonian Institution, Washington, D.C. (67.172.35)
SCHAAF 1196

Railways fascinated Talbot. He patented inventions for their locomotion and excitedly recorded in his diaries how quickly they conveyed him from one point to another. (True to his rural heritage, however, Talbot just as carefully fended off Isambard Kingdom Brunel's efforts to run a line through his Lacock estate!) In this photograph, Talbot marvels at one of the side effects of the Great Western Railway's new push into London. Stimulated by the opening of the railway terminus in 1838, the area north of Hyde Park became suddenly fashionable and a building boom ensued. The new residents had spiritual as well as temporal needs, and Holy Trinity was one of the new churches that sprang up in the area, hoping to meet these needs. Although loosely fifteenth century in style, it was hastily erected, starting in March 1845 and being consecrated by July 1846. Its lofty two-hundred-foot tower briefly dominated a landscape of intense construction, but its rapid design by Thomas Cundy prompted one journal to grouse that "it is externally a heap of misapplied ornament; battlements, finials, gargoyles guiltless of gutters, panellings &c &c. all carved in good stone, figure in tasteless confusion . . . such monsters are the inevitable birth of a transitional age like ours."[1]

Encouraged by the swift train journey into the terminus (now better known through Brunel's Paddington Station, built a decade later), Talbot became quite familiar with this new area of London. In June 1844, he hired rooms at 32 Sussex Gardens, only a few steps from the terminus.[2] Just off Talbot Square (no relation!), this is still an area of small hotels and rooming houses

today. During his first stay, Talbot photographed a bank of the buildings being constructed in Sussex Gardens, but this was too early to record the church.[3] In the summer of 1845, Lady Elisabeth Feilding noted that "H. went to live in Sussex gardens."[4] We don't know how long he stayed at that address, but it is likely that this photograph was taken then or the following year.

Talbot set up his camera to the northwest of the present Paddington Station, between Gloucester Terrace and Westbourne Terrace (just then being built on the right of Talbot's photograph). He was facing north. The monumental aspect of the church is enhanced by his very low camera angle, in this case a fortuitous opportunity occasioned by the local requirement to elevate the roadways and building sites. The grand townhouse with the half-round bay is typical of the area and appears on maps by 1846;[5] Orsett Terrace is on the horizon.

Alas, the exciting scene of building that Talbot recorded has recently given way to other sorts of progress. A faulty conversion in the nineteenth century, designed to accommodate the changing nature of parishioners, weakened the building's structure. The decayed spire of Holy Trinity was removed in 1972, and the balance of the church was demolished in 1986.[6]

The waxed negative and one other print have outlived the church.[7] Two other Talbot photographs of Holy Trinity are known, apparently taken at the same time. One is an oblique view of the front.[8] The other, seen obliquely of the rear, gives a good sense of the concentrated construction going on around the church at the time.[9]

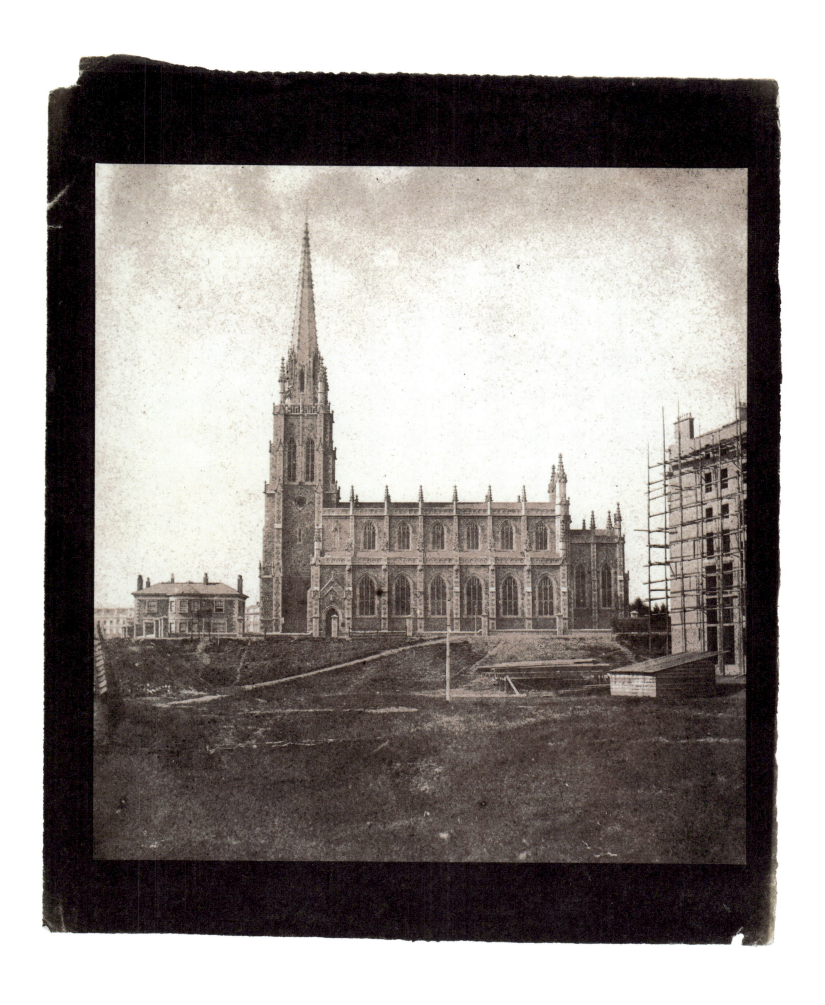

PLATE 97

"The Woodcutters—Nicole & Pullen
Sawing & Cleaving"

Summer 1845? Salt print from a calotype negative,
15.3 x 21.0 cm image on 18.8 x 22.5 cm paper
Photographic History Collection, National Museum of American History,
Smithsonian Institution, Washington, D.C. (67:172:12)
SCHAAF 1933

One recipient of this print applied a peculiarly appropriate title—*Labor omnia vincit*—labor overcomes all obstacles.[1] Henry Talbot had labored mightily in the years since his first inspiration on Lake Como—especially so after photography became known to the public in 1839. He had overcome many obstacles, not the least of which was his own lack of skills in draftsmanship. He could not have dreamed of sketching even the outline of this image a decade before. Now, with nature and science as his assistants, he could paint richly with light and silver. Nicolaas Henneman, once his servant, now his colleague, works busily at the left. Samuel Pullen, the groom at Lacock, just keeps his face from our view.[2] Both the poses and the Lady Elisabeth's title of "Nicole & Pullen" can be seen as symbolic, for she referred to Henneman alone by his first name.

Calvert R. Jones showed this image to Mr. Winsor (of the artists' supply firm of Winsor & Newton) and repeated to Talbot that "he was much pleased with the Laycock specimens, but thought the sawyers at the shed worth the whole together for the purpose to which he thinks they may be principally applied viz for the use of arts, and justly thought that nature was inexhaustible in such materials provided they were artistically chosen."[3]

Talbot had overcome many obstacles in addition to his problems with the pencil. He was caught off guard by a determined French rival and initially received very little credit for his own contributions. He could overcome these with labor, but one thing that he could not control through hard work was the travels of the mysterious entity called the shadow. In the case of this photograph, the cropping that Talbot eventually adopted was dictated by limitations of the space in which he was shooting. At least one print was made before the negative was trimmed to its present size. In this, it is revealed that the shadows of the surrounding trees completely dominated the right-hand foreground—traces of them can just be seen in the present print. A negative defect in the lower center further aggravated the problem. Their elimination much improved the composition. The waxed negative survives; there are numerous prints known, including at least one hand-colored print.[4]

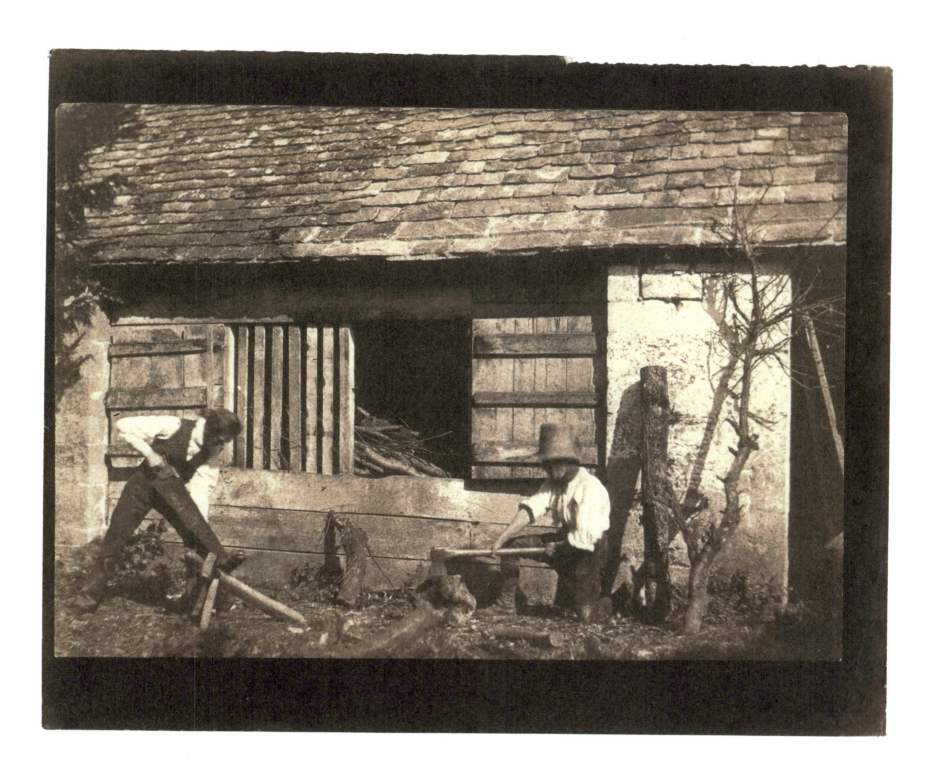

PLATE 98

The Victualling Office, Plymouth, from Mt. Edgcumbe

September 1845. Salt print from a calotype negative,
16.6 x 20.6 cm image on 18.6 x 22.5 cm paper
The Gilman Paper Company Collection, New York
SCHAAF 1931

Constance Talbot is one of the women in this charming photograph. The other two are both "Miss McDonald," but in the conforming dress of the 1840s it is impossible to tell which is which. The gentleman reaching with his telescope from the sylvan delights of Mt. Edgcumbe across to the bustle of Plymouth is probably the Reverend Calvert R. Jones.

Henry Talbot's sister Caroline had married the earl of Mt. Edgcumbe. Her marital home was an estate of considerable importance and great beauty, particularly known for its ancient and well-preserved grounds. But it was directly across the water from the bustling port of Plymouth and had always been a strategic target.[1] The admiral of the ill-fated Spanish Armada had fixed on the mansion to be his dwelling place. This view is of the "Blockhouse" and the guns are ones that were seized long before from a French frigate. One family member recalled that "no more charming spot on which to spend an hour on a summer's evening could be found."[2] Thirty years after Talbot's photograph, a much larger modern defensive fort was built on the site, destroying the view. However, in the 1840s the aesthetics of warfare still had some importance, and in March 1845, Caroline reported to her brother about plans for another emplacement farther around the peninsula: "They are actually going to build a Battery in Picklecombe with a Barrack to contain 60 men, who will occupy it without waiting for actual war." She and her husband held considerable sway in the area and were promised that in return for giving up their land to build the defensive position the authorities would "make it in any shape we please & as picturesque as we like; which must be our consolation."[3]

Of Henry Talbot's two sisters, Horatia, the younger one, was clearly his favorite. She collected his photographs into albums and helped him with his photographic publications. However, Caroline seems to have been the one who had the most effect on his photography. Horatia's attainments in music were matched by Caroline's facility with the pencil. As a young woman in 1828, Caroline was called on by the poet and family friend Thomas Moore to illustrate an edition of his *Legendary Ballads*.[4] Her contacts with artists were always available to Talbot. Later, as Lady Mt. Edgcumbe, she used her position in the royal household to show her brother's progress to the Queen.

At the beginning of September 1845, Caroline wrote again to her brother. Always encouraging him to take photographs, she pleaded that that she would "be delighted to have you here, & pray bring Mr. C. Jones too, & Nicole, & all the *apparatus*."[5] Lady Elisabeth Feilding had arrived in August to see the regatta at Plymouth,[6] and Horatia recorded in her diary that she had "sat in battery" at Mt. Edgcumbe.[7] At some point, Constance arrived there as well, and she is almost certainly the "Mrs. Talbot" in the title of one of the prints.[8] The identity of the "two Miss McDonalds" has yet to be established, but within three years one of them would be facing actual cannon fire in Sicily alongside Caroline and Horatia.[9] Calvert Jones often took a stance not unlike that of the man with the telescope. Constance was so impatient to see a print that she promptly reminded her husband that "I do long to see the Mount Edgcumbe views—particularly the battery scene."[10] Before the end of October 1845, Nicolaas Henneman supplied Talbot with prints of the "Victualling Office w/figures."[11] Demand for the print must have been high and immediate, for in December he supplied some additional "Batery at Mt Edge Cumbe (with figures)."[12]

The negative survives, but curiously only two other prints from it are known.[13] There was also a smaller negative taken at the same time; it is focused much more tightly on the group of people, not employing the visual framing of the tree on the left side.[14] An apparently more popular image of the larger size displays the battery devoid of human presence.[15] All three raised hopes for Nicolaas Henneman, and he had printed titles made up to attach to the mounts of copies offered for sale.[16]

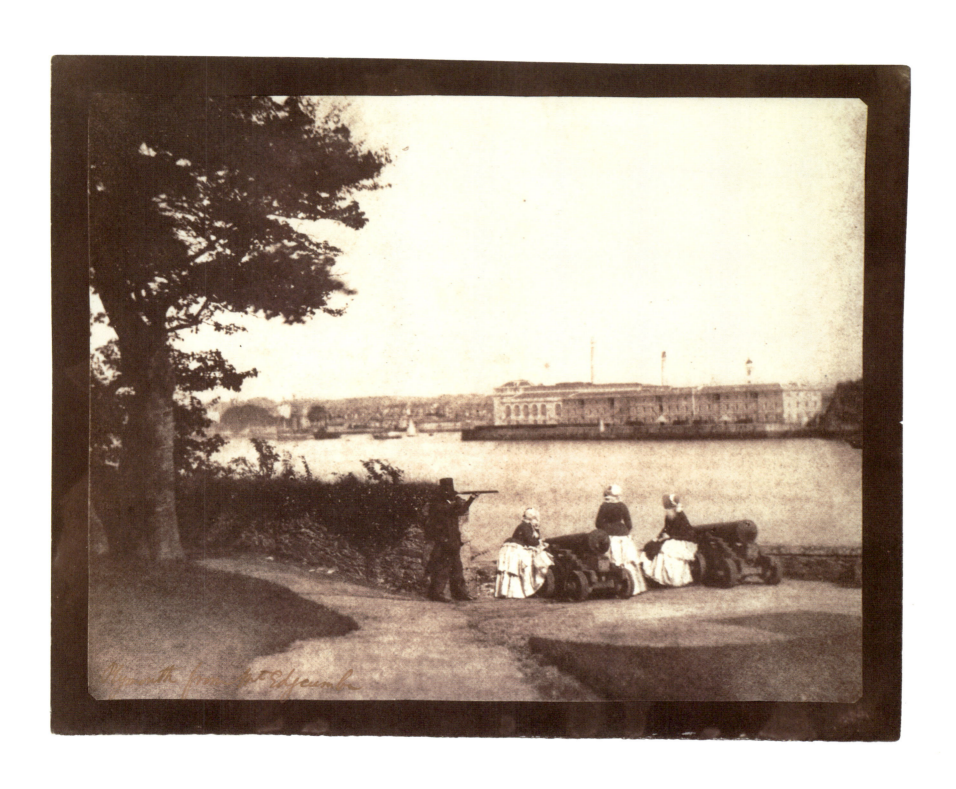

Plymouth from Mt Edgcumbe

PLATE 99

The Royal Pavilion, Brighton

Probably 11 February 1846. Salt print from a calotype negative,
16.7 x 20.8 cm image on 18.7 x 22.2 cm paper
Private collection, London
SCHAAF 150

Writing from Brighton in November 1840, Henry Talbot's sister Caroline told him that "when I am sitting in this warm sunny room . . . I fancy myself at Nice—I am sure the change of air will do you good . . . I . . . expect you to accept my invite—it will give you new ideas upon Photographs."[1] Constance urged him as well, saying that "I wish you *would* contrive time to visit Caroline at Brighton—you know you were wishing for some sea air a little while ago & even mentioned Brighton as the place which you thought would suit you."[2] Talbot evidently made the visit, for two weeks later Charles Wheatstone wished that he had "called upon me on your return from Brighton as I expected."[3] The negative for the present view of the pavilion is undated, and it is tempting to think that it could have been made in November 1840. Talbot's as yet unpublished calotype process was in its infancy, but in the right lighting it could have captured this rendition. As it was, however, Talbot apparently did not execute any successful negatives on this or any other of his early trips to Brighton.[4]

Certainly Brighton should have inspired Henry Talbot. Its Pavilion, an extravaganza of George IV, tells a visual story straight out of the pages of fiction. Under the left dome in Talbot's view is the music room; the salon is in the center, and the banqueting room is at the right. The grounds were extensively landscaped. The complex was started in 1787, building on the old Marine Pavilion, and was greatly enlarged by John Nash between 1815 and 1823. The young Queen Victoria visited it in October 1837, just four months after she acceded to the throne. During a visit there in 1842 she had her portrait taken in the daguerreotype process by William Constable. She was never

that pleased with the Pavilion, however, and her last visit was made in February 1845. In August 1846, half a year after the time Talbot likely took this image, the sale of the Pavilion was announced. The town of Brighton purchased it in 1850. The Pavilion changed very little during the 1840s when Talbot might have been photographing it. Another of Talbot's images, presumably taken at the same time as this one, shows a sentry box, the only reference to the royal presence. The weather vane poking out just behind the music room's dome is no longer shown in images from the 1850s and later.

The negative for the present image was made from an elevated point of view across from the Pavilion, from a semicircular window one storey above ground, still visible at 11 Pavilion Parade.[5] The only negatives of Brighton that Talbot dated are those he made of its St. Peter's Church; two are dated February 1846 and one is dated 3 February 1846.[6] In spite of the challenges of the weather, he must have been trying very hard to secure a good photograph, perhaps with the next part of *The Pencil of Nature* in mind. Responding to Talbot's request, Nicolaas Henneman brought some additional equipment to him on 9 February. On 11 February Henneman paid for the "hire of room in Pavillion Street."[7] All in all, this seems like the most reasonable dating of this entrancing image.

This print was in the Harold White Collection and is the only known print from this negative.[8] There are eleven other Talbot negatives of the Pavilion known; there are prints from some of them, but none of the prints or negatives carries a contemporaneous date.[9]

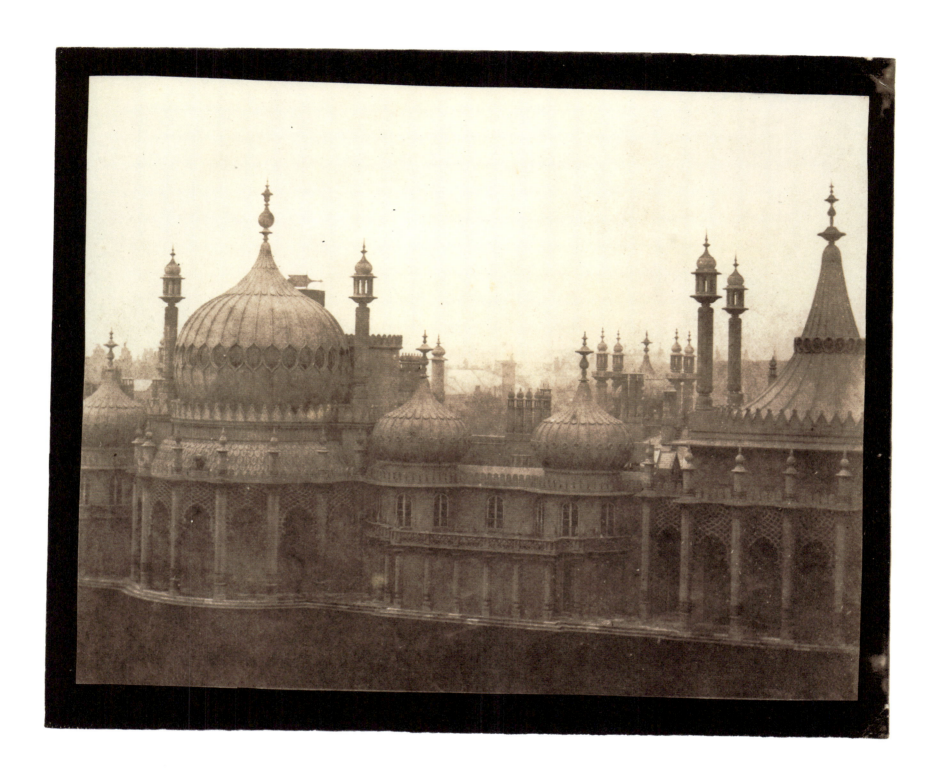

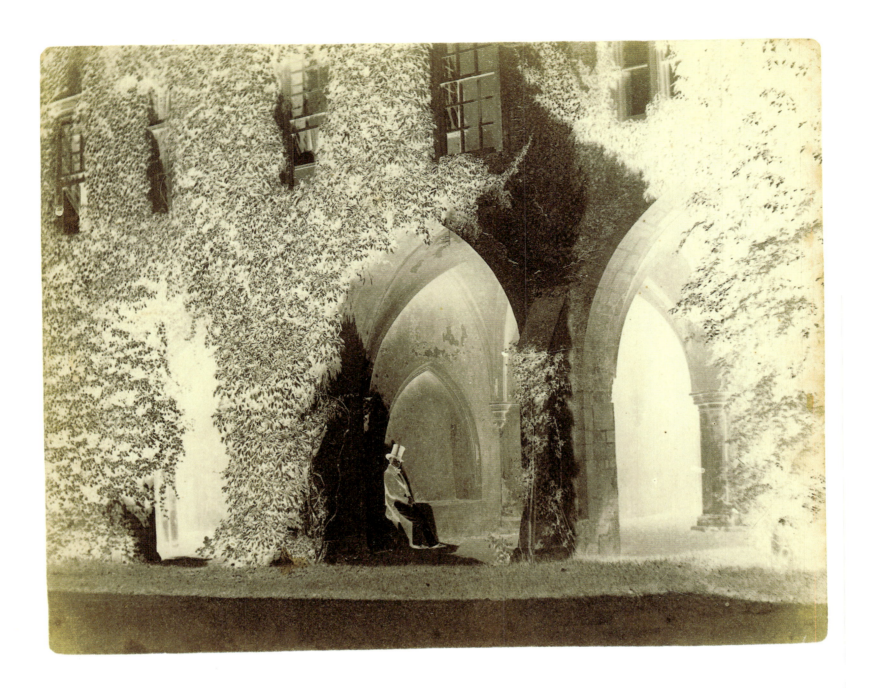

PLATE 100 A/B

*"The Ancient Vestry"—The Reverend Calvert R. Jones
in the Cloisters, Lacock Abbey*

Probably 9 September 1845. Calotype negative and salt print, 16.6 x 20.6 cm negative;
print on 19.8 x 25.5 cm paper. Negative: The Royal Photographic Society, Bath (RPS025164)
Print: The Metropolitan Museum of Art, New York. The Rubel Collection,
Promised Gift of William Rubel (L.1997.84.1)
SCHAAF 1913

Lacock Abbey is seen here at its finest. A warm sun, playing over the scene, rakes across the texture of the ivy and penetrates the windows. Natural shading on the left coaxes the eye back to the jauntily angled gentleman decked out in brilliant white trousers and black top hat. This photograph, about light and contrast and texture and surfaces, is timeless. Its subject proves to be a dual one of tradition and of transition, for it represents the symbolic pass-

ing of the torch from Henry Talbot to one of his chief disciples.

In July 1845, when Talbot went photographing with his friend, Constance was "*so* glad you have such an able assistant in Mr Jones—his activity is really surprising—& his example too excellent not to be followed."[1] In great anticipation, Lady Feilding recorded that "Mr & Mrs Calvert Jones came" to Lacock Abbey on 8 September. Nicolaas Henneman had already arrived from Read-

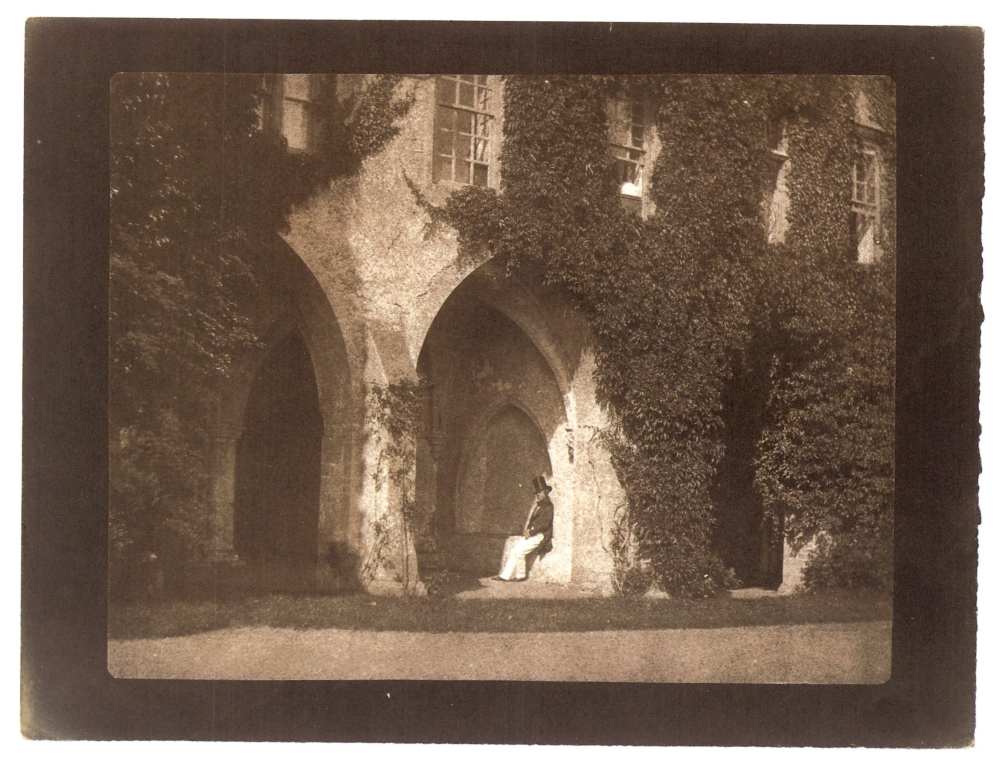

ing, and the following day she enthusiastically recorded that "Talbotypes taken all day; sat for mine, very hot."[2] As Talbot developed this extraordinary negative, Jones was probably watching; the sun-inspired sheet of paper grew in strength until the full beauty of the calotype process was realized. It yielded a splendid matrix. Henneman produced twenty prints of "Laycock Abbey — Arches with M.r Jones" before the end of October[3] and another twenty-seven "Vestry with M.r Jones" by mid-December.[4] Waxed for printing, the negative robustly withstood all this attention.[5] It is not surprising that such a fine negative of such an attractive subject would produce prints sought after by many collections.[6]

Talbot hoped to use this plate in an upcoming part of *The Pencil of Nature*. His draft text talked of the abbey church being "wholly destroyed at the Reformation. By the side of this door stood, and

still stands a stone receptacle for holy water . . . ye figure in ye plate is looking at this Holy water . . . to make a good figure in a photographic picture requires considerable steadiness of character but only for the fraction of a minute. This valuable quality together with many others too long to mention my friend possesses in an eminent degree."[7]

Taken within the supportive environment of the abbey that had so often been the subject of his photographs, this spectacular portrait of his dear friend was to be one of the last photographs ever created by Henry Talbot. Within months, his beloved and provocative mother died, removing one of the main influences that had kept him within the public eye. But he had proven his art, and Calvert Jones and others went on practicing his black magic, as they continue to do to this day.

Notes

PREFACE

1. The proceedings were published as *Les multiples inventions de la photographie* (Paris: Mission du Patrimoine Photographique, 1989).

MISCELLANEA PHOTOGENICA

1. John William Ward, later the first earl of Dudley, was an eccentric but highly intelligent man. An MP and a diplomat, he knew Virgil by heart and was a respected writer. His assessment of the young Talbot can be taken as a very serious one. The quotation is from the original letter, dated 27 November 1821, in the Devon Record Office. A transcription was published in *Letters of the Earl of Dudley to the Bishop of Llandaff* (London: John Murray, 1840), 291–98. Talbot's mother, Lady Elisabeth Feilding, was obviously proud of this. The year after the book was published, she wrote to her son after reminiscing with Lady Mildmay "over old times at Nice, & the accurate judgement Lord Dudley formed of you, tho' you were then a person not easily deterré [disinterred. i.e., brought out]. She likewise remarked that *you* are the only person he named in the Society at Nice—tho' there were many there at the time to like & who have been mortified at this omission" (Elisabeth Feilding to Henry Talbot, 11 December 1841, Fox Talbot Museum, Lacock, *Document 04489*).

2. This portrait is on paper watermarked 1810 and possibly was dated retrospectively and inaccurately (although certainly a long time ago). It seems more likely, however, that it could be a copy of a silhouette made a few years earlier. This portrait, one of two similar versions, came down through the descendants of Christopher Rice Mansell Talbot, Henry Talbot's Welsh cousin, and may have been made by any one of several family members adept at drawing. Life-size silhouettes like this were sometimes produced by casting a shadow of the person onto a sheet of translucent paper suspended in a frame and tracing the outline. Talbot himself referred to this in his first paper on photography, "Some Account of the Art of Photogenic Drawing, or the Process by Which Natural Objects May be Made to Delineate Themselves without the Aid of the Artist's Pencil," which was read before the Royal Society of London on 31 January 1839: "Another purpose for which I think my method will be found very convenient, is the making of outline portraits, or *silhouettes*. These are now often traced by hand from shadows projected by a candle. But the hand is liable to err from the true outline, and a very small deviation causes a notable diminution in the resemblance." The "solar flares" emanating from the young Talbot's head raise another possibility. This could have happened if excess ink had been applied to the paper while the image itself was upside down, causing some to run past the outline. The image projected by a lens in a camera obscura would have been inverted like this. Long before the invention of photography, such applications of optical devices were common in both parlors and in the work of artists. Such devices were common throughout Talbot's family and he must have retained some memory of them by the time he conceived of the art of photography. For an excellent survey of such influences see Martin Kemp, *The Science of Art: Optical Themes in Western Art from Brunelleschi to Seurat* (London: Yale University Press, 1990).

3. "A person unacquainted with the process, if told that nothing of all this was executed by the hand, must imagine that one has at one's call the Genius of Aladdin's Lamp. And, indeed, it may almost be said, that this is something of the same kind. It is a little bit of magic realized:— of natural magic. You make the powers of nature work for you, and no wonder that your work is well and quickly done" (Talbot, letter to the editor, William Jerdan, dated 30 January 1839; published in *The Literary Gazette*, no. 1150 [2 February 1839]: 74; *Document 03782*).

4. These were published in the *Annales de Mathématiques*, a respected journal edited in Nîmes. Talbot's numerous publications in many fields are summarized in Mike Weaver's very useful volume, *Henry Fox Talbot: Selected Texts and Bibliography* (Oxford: Clio Press, 1992).

5. Talbot, "Some Experiments on Coloured Flames," *Edinburgh Journal of Science* 5, no. 1 (March 1826): 77–81. Herschel had expressly encouraged Talbot to publish this: "I am very sure that an account of your interesting Exp^t on the glass films will be accepted to D^r Brewster and I shall be happy to transmit it to him according to your wish" (John Herschel to Henry Talbot, 12 January 1826, LA26-1, Fox Talbot Museum, Lacock, *Document 01354*).

6. The standard and most comprehensive biography is by H. J. P. Arnold: *William Henry Fox Talbot: Pioneer of Photography and Man of Science* (London: Hutchinson Benham, 1977). Arnold's biography presents an excellent and detailed picture of the range of Talbot's interests and is (as Arnold hoped for) an essential starting point for further inquiry. Arnold's strong grounding in mathematics and politics is apparent and he viewed Talbot's invention of photography as being only one component of a complex life. The published version of Arnold's text was cut by about a third, mostly in nonphotographic areas, but the author generously made the full typescript available to several institutions, including the Royal Photographic Society in Bath, England, and the Harry Ransom Humanities Research Center at The University of Texas at Austin. The other major biography is by Gail Buckland, the former curator of the Royal Photographic Society: *Fox Talbot and the Invention of Photography* (Boston: David R. Godine, 1980). Although much less concerned with detail than Arnold's text, Buckland's was the first serious assessment of the aesthetic qualities of Talbot's photographs. Profusely illustrated, it fell short in its monochrome renditions but provided numerous color illustrations that preserved the true spirit of Talbot's early photography. Each in its own way, both of these works have had a profound effect on the present author.

7. *Wrangler* is an academic term peculiar to Cambridge University's mathematics course, the *tripos*; it was conferred on those students who were placed in the honors category. An appointment as a *Scholar* was given based on merit and carried with it emoluments from the university's funds to defray the cost of study.

8. Elisabeth Feilding to Henry Talbot, 11 February 1821, LA21-6, Fox Talbot Museum, Lacock (*Document 00911*).

9. The phrase "Fox Talbot" is so harmonious and rolls off the tongue so easily that it is almost universally used for his name today. Many of his contemporaries who did not know him well did the same. However, this form of address was most certainly not warmly embraced by the subject himself! It was from one of the family names of his mother that Henry acquired the "Fox" so often associated with his surname. Perhaps out of deference to Lady Elisabeth, Henry signed some of his books and journal articles "H. Fox Talbot." In fact, Talbot was known to family and close friends nearly always as "Henry." He signed his letters "H. F. Talbot" or "Henry F. Talbot" far more often than "H. Fox Talbot." The "Fox" was only a middle name and Talbot's surname was never hyphenated, but it is not unusual to see it so treated in secondary literature. In fact, the occasional library card catalogue has Talbot filed under "F", a problem made even more serious by the ubiquitous computer sorting of today. Even this confusion in sorting is not a new problem—Henry wrote to his mother from Naples that "I observe you always direct to me Fox Talbot by way of discrimination, but it does rather the contrary. For, the letters are here distributed from different windows, according to the different letters of the Alphabet, and the other day I found no letter for me under T, and accordingly asked for letters for M^r Fox when they immediately produced one from you" (Henry Talbot to Elisabeth Feilding, 27 February 1823, Fox Talbot Museum, Lacock, *Document 01059*). Further evidence that Henry himself had little enthusiasm for the "Fox" is revealed in an 1839 letter to his mother on the birth of his only son: "You know we had fixed on the name Charles Henry, but if you wish it we can make it C.H.F.T. Constance says she is quite willing." Even the reluctant offer to incorporate the "F." here was not a reference to the family name of Fox, but rather an homage to his beloved late step-father, Admiral Feilding. A final clue to Talbot's own feelings on the subject is the fact that among the more than one hundred photographic prints and negatives that Talbot signed himself, there is not a single one—not a one—where he used the word "Fox" as part of the signature!

10. The correspondence between Henry Talbot and his uncle about this collecting is gathered in Christopher Lloyd's "Picture Hunting in Italy: Some Unpublished Letters (1824–1829)," *Italian Studies* 30 (1975): 42–68.

11. Tragically, he had suffered from lingering problems for many years and took his own life in 1850. See Larry J. Schaaf, "Portrait of the Artist, Rev. George Montgomerie," *Sun Pictures Catalogue Seven: William Henry Fox Talbot: Friends and Relations* (New York: Hans P. Kraus, Jr., 1999), pl. 22.

12. Moore later took a role in Talbot's seminal publication on photography. See Larry J. Schaaf, *Introductory Volume to the Anniversary Facsimile of H. Fox Talbot's "The Pencil of Nature"* (New York: Hans P. Kraus, Jr., 1989), 35–36.

13. There is still no adequate biography of Sir John Herschel. The only book (termed by its author as merely a "sketch") is Günther Buttmann's *The Shadow of the Telescope: A Biography of John Herschel*, translated by B. E. J. Pagel, introduction by David S. Evans (New York: Charles Scribner's Sons, 1970). Herschel's stint in South Africa is covered in *Herschel at the Cape: Diaries*

and Correspondence of Sir John Herschel, 1834–1838, edited by David S. Evans, Terence J. Deeming, Betty Hall Evans, and Stephen Goldfarb (Austin: The University of Texas Press, 1969). An examination of Herschel's contributions to the visual arts, with an overview of his life up to about 1830, is found in Larry J. Schaaf, *Tracings of Light: Sir John Herschel and the Camera Lucida* (San Francisco: The Friends of Photography, 1989). An important recent study of Herschel's drawings and his botany is by Brian Warner and John Rourke, *Flora Herscheliana: Sir John and Lady Herschel at the Cape, 1834–1838* (Houghton, South Africa: The Brenthurst Press, 1996). The relationship between Herschel and Talbot is explored in Larry J. Schaaf, *Out of the Shadows: Herschel, Talbot, and the Invention of Photography* (London: Yale University Press, 1992).

14. Like Herschel, Brewster deserves far more biographical treatment than he has been afforded thus far. A reminiscence by his daughter, Maria Margaret Gordon, is *The Home Life of Sir David Brewster* (Edinburgh: Edmonston and Douglas, 1869). Graham Smith has explored aspects of Brewster's contact with photography in *Disciples of Light: Photographs in the Brewster Album* (Malibu: The J. Paul Getty Museum, 1990). The most useful general reference work on this extraordinary man remains Alison Morrison-Low and J. R. R. Christie's *"Martyr of Science": Sir David Brewster 1781–1868* (Edinburgh: Royal Scottish Museum Studies, 1984).

15. The contributions of the Scottish partnership are best followed in the various publications by Sara Stevenson, starting with her *David Octavius Hill and Robert Adamson: Catalogue of Their Calotypes Taken between 1843 and 1847 in the Collection of the Scottish National Portrait Gallery* (Edinburgh: National Galleries of Scotland, 1981).

16. From Talbot's "Introductory Remarks" to *The Pencil of Nature* (London: Longman, Brown, Green, and Longmans, 1844).

17. The full technical history of this instrument is reviewed in John H. Hammond and Jill Austin, *The Camera Lucida in Art and Science* (Bristol: Adam Hilger, 1987). For more on the application of this instrument by artists, especially in the case of Sir John Herschel, see note 26 below.

18. From his "Introductory Remarks" in *The Pencil of Nature*.

19. Ibid.

20. Burns, "Let not woman e'er complain," in Robert Chalmers, revised by William Wallace, *The Life and Work of Robert Burns* (Edinburgh: W. and R. Chambers, 1896), 4:151.

21. Talbot, "Introductory Remarks."

22. Henry Talbot to John Herschel, 27 March 1833, HS17:270, The Royal Society, London (*Document 02670*).

23. Morse later introduced the daguerreotype to America. His account of his attempts to invent photography appeared in *The New York Observer*, 20 April 1839.

24. This passage was written on or around 28 February 1835. Talbot's notebook *M* is very miscellaneous in its contents and most of the entries lack a specific date. The flyleaf indicates when he started the notebook: "Lacock 4^th December 1834" (Fox Talbot Museum, Lacock).

25. Talbot, "Introductory Remarks."

26. Prompted by the impending visit of the prominent Scottish scientist Sir David Brewster, this meeting gave Charles Babbage the excuse to gather together a circle of friends and to show off the latest progress on his calculating machine. In Herschel's acceptance note to Babbage, he said that "3 days ago I fell on a most striking instance of the effect of violet light in producing a chemical compound of a singular nature—a *platinate of lime* which I mention to you that you may remind me to tell B. of it" (John Herschel to Charles Babbage, 23 June 1831, The Royal Society, London). Herschel's notebook sketches clearly show that he was using light to make simple patterns in test-tube solutions by masking areas with opaque paper. The experiment bears a striking similarity to the earlier and more familiar work with silver salts by Johann Heinrich Schulze. See Joseph Maria Eder (translated by Edward Epstean), *History of Photography* (New York: Columbia University Press, 1945), 60–63. On Sunday, 26 June 1831, the group met and Herschel recorded in his diary that he "Breakfasted at Babbage's—Brewster—Talbot—Drinkwater—Rob^t Brown." This informal gathering of friends might have been forgotten had it not been for another researcher's publication a year later of an experiment remarkably similar to what Herschel had demonstrated at Babbage's. Travelling in Hamburg, Herschel quickly dispatched a letter to the British Association for the Advancement of Science meeting in Oxford in 1832. Since this letter was primarily designed by Herschel to defend his claims to priority, he pointed out that the demonstration has "been shown by me to a great many individuals at various times in the interval; among whom I may mention . . . Sir D. Brewster, Mr. Babbage, Mr. Talbot, and others, in London, last summer" (Herschel, "On the Action of Light in Determining the Precipitation of Muriate of Platinum by Lime-water," *The London and Edinburgh Philosophical Magazine and Journal of Science* 1, no. 1 [July 1832]: 58–60). This episode is discussed in more detail in Larry J. Schaaf, "Herschel, Talbot, and Photography: Spring 1831 & Spring 1839," *History of Photography* 4, no. 3 (July 1980): 181–204.

27. As in any invention, the idea of photography had many claimants, some of them probably legitimate. The most important of these, and one who was undoubtedly legitimate, was Joseph Nicéphore Niépce. The two major examinations of his work are Paul Jay's *Niépce, Genèse d'une invention* (Chalon-sur-Saône: Société des Amis du Museé Nicéphore Niépce, 1988) and Jean-Louis Marignier's *Un savant, une époque: Nicéphore Niépce, 1765–1833, l'invention de la photographie* (Paris: Belin, 1999). A still-useful summary is in Helmut and Alison Gernsheim's *L. J. M. Daguerre: The History of the Diorama and the Daguerreotype* (London: Secker and Warburg, 1956). The idea of invention can be examined from many points of view. A classic examination of the forces that might have led to photography is Peter Galassi's *Before Photography: Painting and the Invention of Photography* (New York: The Museum of Modern Art, 1981). A recent and thought-

provoking work about the inventors is Geoffrey Batchen's *Burning With Desire: The Conception of Photography* (Cambridge: MIT Press, 1997). Most of the standard histories of photography outline efforts either claimed or attained by various individuals. A good balance of this conflicting information may be obtained by combining the material presented in Eder's *History of Photography* and in Helmut Gernsheim, in collaboration with Alison Gernsheim, *The History of Photography* (New York: McGraw-Hill, 1969). A brief survey of the claimants in Britain is in Larry J. Schaaf, "The First Fifty Years of British Photography: 1794–1844," *Technology and Art: The Birth and Early Years of Photography*, edited by Michael Pritchard (Bath: The Royal Photographic Society, 1990), 9–18.

28. In 1802, when Wedgwood was near death, his friend Humphry Davy published a brief account of his quest to invent photography. He had been able to make shadowgrams of leaves; some were produced on white paper, others on white leather, but they remained susceptible to the action of light and could be viewed only by candlelight. Wedgwood's process was published in "An Account of a method of copying Paintings upon Glass, and of making Profiles, by the agency of Light upon Nitrate of Silver. Invented by T. Wedgwood, Esq. With Observations by H. Davy," *Journals of the Royal Institution* 1, no. 9 (22 June 1802): 170–74. Though Thomas Wedgwood himself died in 1805, his idea did not die with him, and his process was republished in scientific journals and books many times in various languages prior to 1839. A representative list includes: *Annali di Chimica e Storia Naturale* 21 (1802): 212–18; *Annals of Philosophy* 3 (1802): 151; *Nicholson's Journal* 3 (November 1802): 165–70; *Bibliothèque Britannique* 22 (Geneva, January 1803): 93–98; *Bulletin des Sciences par la Société Philomatique* 3, no. 69 (1803): 167; *Annales de Chimie* 45 (1803): 256; *Annalen der Physik* 13 (1803): 113–19; Fredrick Accum, *A System of Theoretical and Practical Chemistry* (London, 1803), 1:122–24 and (Philadelphia, 1814), 1:159–61; John Imison, *Elements of Science and Art* (London, 1803), 2:606–9 and (new edition, 1822), 328–29; *Journal für die Chemie, Physik, und Mineralogie* 4 (1807); Benjamin Silliman, *Epitome of Experimental Chemistry* (Boston, 1810), 196; *Ackermann's Repository* 2 (October 1816): 203–4; Hewson Clarke and John Dougall, *The Cabinet of Arts, or General Instructor* (London: T. Kinnersley, 1817), 774–75; *Magazin for Naturvidenskaberne* (Christiania, Norway, 1824), 23–28; John Webster, *Manual of Chemistry* (Boston, 2nd ed., 1828), 432. It also appeared in various popular publications. In spite of this widespread publication, nobody other than Talbot is known to have solved the problem of permanence that had stymied Davy and Wedgwood.

29. Wedgwood, "An Account," 174.

30. This was Faraday's exclamation when he directed the audience to Talbot's first exhibition of photographs, at the Royal Institution on 25 January 1839. Quoted in Vernon Heath, *Recollections* (London: Cassell and Company, 1892), 49.

31. They were displayed in the customary library exhibit of scientific curiosities that was opened after the usual Friday evening lecture by Faraday.

32. "Some Account of the Art of Photogenic Drawing, or the Process by Which Natural Objects May Be Made to Delineate Themselves Without the Aid of the Artist's Pencil." An abstract of this was later published in the *Proceedings of the Royal Society* 4, no. 36 (1843): 120–21. The public probably found the first notices of it in the editorial summaries in the pages of the *Athenaeum* and the *Literary Gazette*. Talbot privately published the full text as a booklet. The exact date of publication of this is not known but it was probably printed quite promptly. Talbot compiled the list of recipients in his notebook: the dating in this is uneven, and the list follows an entry for 31 March 1839 but precedes one for 27 February! (Notebook, Lacock June 1838, Fox Talbot Museum, Lacock). The text of Talbot's booklet was reproduced in Beaumont Newhall, *Photography: Essay and Images, Illustrated Readings in the History of Photography* (New York: Museum of Modern Art, 1980), 23–30. Talbot's first paper outlined the possibilities of *photogenic drawing* but did not disclose the chemical processes involved. These were revealed in a paper read before the Royal Society on 21 February: "An Account of the Processes employed in Photogenic Drawing." An official notice was included in the *Abstracts of the Papers Printed in the Philosophical Transactions* 4 (1837 to 1843), 125–26, but a more immediate summary was published in the *Literary Gazette*, no. 1153 (25 February 1839): 123–24. The latter was also reproduced in Newhall, ibid., 30–31.

33. A solitary and unexplained comment in Talbot's notebook simply says "Patent Photogenic Drawing"; the entry is not dated (Diary, May 1834, The J. Paul Getty Museum).

34. Talbot's choice of a root word for the art was challenged almost immediately. On 2 February 1839, Charles Wheatstone wrote to Talbot expressing interest in his "photographic experiments" (LA39-5, Fox Talbot Museum, Lacock, *Document 03786*). Herschel wrote to Talbot on 10 February to inform him that "I left one or 2 Photographic specimens" for exhibit at the Royal Society (National Museum of Photography, Film & Television [1937-4831], *Document 03801*). The first appearance of the word "photography" in print was in an article by Herschel's correspondent, the German astronomer Johann Mädler, on 25 February. It was traced in the *Vössiche Zeitung* by Dr. Erich Stenger (*British Journal of Photography*, 23 September 1932, 578–79); however, it is unlikely that this notice in a small provincial newspaper had much effect. The word "photography" entered the public language when Herschel employed it on 14 March in his first presentation to the Royal Society on the subject: "Note on the Art of Photography." This text was published only in abstract in Herschel's day. For a transcription of the entire original paper as read, see Larry J. Schaaf, "Sir John Herschel's 1839 Royal Society Paper on Photography," *History of Photography* 3, no. 1 (January 1979): 47–60. Herschel's concern reflected a long-standing interest in precision in terminology. See his praise of "words and signs used in our reasonings that are full and true representatives of the things signified" and scorn of the "double or incomplete sense of words to which we must look for the origin of a very large por-

tion of the errors into which we fall" in his *Preliminary Discourse on the Study of Natural Philosophy* (London: Longman, Rees, Ormé, Brown, and Green, 1830), 20–21.

35. Talbot first announced this to the Royal Society on 21 March 1839, in "Notice Respecting a New Kind of Sensitive Paper." Brief notices of this meeting appeared in the press, but Talbot's communication was never published in full. The original manuscript is in the archives of the Royal Society, London. Talbot described his new paper thus: "The following method of preparing a sensitive paper appears to me to present some advantages. At any rate it is different from my former one, & I have therefore the honour of communicating it to the Society. Take good writing paper; & wash it over with nitrate of silver; then with bromide of potassium; & afterwards again with nitrate of silver, drying it at the fire between each operation. This paper is very sensitive to the light of the clouds, & even to the feeblest daylight. But it is insensible to radiant heat & therefore suffers no change from the warmth of the fire before which it is dried—It is of a pale yellow colour & the light changes it to blueish-green; olive-green, and finally almost black. From want of an acknowledged unit of measure it is difficult to define its *degree* of sensibility: but the following experiments made during the bad weather of last week will serve as an approximation. At 5 P.M. in very cloudy weather in London, this paper being placed in a Camera Obscura & directed towards a window; a picture of the window bars was obtained in six minutes. Shortly after sunset, being then still darker, the paper exposed near a window changed its colour sensibly in 20 or 30 seconds."

36. Talbot first used this provocative term in his research notebook *P* on 8 July 1839. See Larry J. Schaaf, *Records of the Dawn of Photography: Talbot's Notebooks P & Q* (Cambridge: Cambridge University Press, 1996).

37. This statement is not tied to a date but was likely written sometime in 1840 and was contained in Hunt's *A Popular Treatise on the Art of Photography, including Daguerréotype, and All the New Methods of Producing Pictures by the Chemical Action of Light* (Glasgow: Richard Griffin, 1841), 20.

38. Talbot's working practices evolved through this period, but all these early images were made with variations on photogenic drawing print-out negatives.

39. This was in his notebook *M*, in a passage dated around 28 February 1835 (Fox Talbot Museum, Lacock).

40. Henry Talbot to John Herschel, 2 July 1839, HS17:294, The Royal Society, London (*Document 03897*). The print referred to is likely the one of a Buckler Fern that came from Herschel's estate, signed and dated by Talbot; it is now in the collection of the Bibliothèque Nationale, Paris, E056[res]-03, *Schaaf 156*.

41. Talbot, text for plate XX. *Lace*, issued in part five of *The Pencil of Nature* in December 1845.

42. Henry Talbot to John Herschel, 27 April 1839, HS7:293, The Royal Society of London (*Document 03872*).

43. Talbot, "Some Account of the Art of Photogenic Drawing," 5, 12.

44. This was at the annual British Association for the Advancement of Science meeting, held in August that year in Birmingham. Talbot exhibited ninety-three negatives and prints there (not using these terms, of course). They were listed in a pamphlet: *A Brief Description of the Photogenic Drawings Exhibited at the Meeting of the British Association at Birmingham, in August, 1839, by H. Fox Talbot, Esq.*

45. This was his "Note on the Art of Photography, or the Application of the Chemical Rays of Light to the Purposes of Pictorial Representation." It was read before the Royal Society on 14 March 1839. Herschel later withdrew the paper from publication because he felt (wrongly, as it turned out) that he was on the verge of a breakthrough that would obsolete its information. An abstract (with a disastrous typographical error, substituting "hyposulphite" for "hyposulphuret of ammonia" on p. 132) was published in the *Proceedings of the Royal Society* 4, no. 37 (1839): 131–33. A transcription of Herschel's full original manuscript was published by Larry J. Schaaf in "Sir John Herschel's 1839 Royal Society Paper on Photography," *History of Photography* 3, no. 1 (January 1979): 47–60.

46. These were recorded on 16 and 19 April 1839. Herschel's unpublished and very detailed research notebooks are in the collection of the Science Museum Library in London.

47. Herschel, "On the Chemical Action of the Rays of the Solar Spectrum on Preparations of Silver and Other Substances, Both Metallic and Non-metallic, and on Some Photographic Processes," read before the Royal Society on 20 February 1840 and published in *Philosophical Transactions* 130, pt. 1 (1840): 3.

48. Talbot, "Some Account of the Art of Photogenic Drawing."

49. Herschel did not invent hypo and never claimed to. This class of substances was first identified (but no more) by François Chaussier, "Sur un nouveau genre de combinaison du soufre avec les alkalis," *Bulletin des Sciences par la Société Philomathique* 2, no. 9 (1799): 70–71. In a companion article, Louis Nicolas Vauquelin contributed a "Notice sur le Sel nommé Hydrosufure sulfuré de Soude," p. 71. Herschel was the first to thoroughly explore their properties, especially those that would contribute their usefulness to photography two decades later. See J. F. W. Herschel, "On the Hyposulphurous Acid and its Compounds" (communicated 8 January 1819), *The Edinburgh Philosophical Journal* 1, no. 1 (June 1819): 8–29; "Additional Facts relative to the Hyposulphurous Acid" (communicated 15 May 1819), 1, no. 2 (October 1819): 396–400; "Some Additional Facts relating to the Habitudes of the Hyposulphurous Acid, and Its Union with Metallic Oxides," (communicated November 1819), 2, no. 3 (January 1820): 154–56.

50. Letter dated 5 February 1841 and published in *The Literary Gazette*, no. 1256 (13 February 1841): 108 (*Document 04191*).

51. This appears in his research notebook *P*. The original of this notebook (and of his subse-

quent notebook *Q*) is in the National Museum of Photography, Film & Television. Facsimile reproductions of the pages of these notebooks, along with expanded transcriptions and annotations of them are in Schaaf, *Records of the Dawn of Photography: Talbot's Notebooks P & Q*.

52. Talbot's description of his new process (but not the working details) was published in two letters to *The Literary Gazette*, each under the title of "Calotype (Photogenic) Drawing"; the first was written on 5 February and published in no. 1256, 13 February 1841, p. 108 (*Document 04191*); the second was written on 19 February and published in no. 1258, 27 February 1841, pp. 139–40 (*Document 04195*). These were reprinted verbatim by Talbot in an undated pamphlet titled *Two Letters on Calotype Photogenic Drawing (Reprinted from The Literary Gazette)*. In the first letter, Talbot pointed out that "several photographic processes being now known, which are materially different from each other, I consider it to be absolutely necessary to distinguish them by different names, in the same way that we distinguish different styles of painting or engraving . . . the new kind of photographs, which are the subject of this letter, I propose to distinguish by the name of *Calotype*; a term which, I hope, when they become known, will not be found to have been misapplied."

53. καλοζ = Kalos = beautiful: David Brewster to Henry Talbot, 14 October 1841 (National Museum of Photography, Film & Television, 1937-4889, *Document 04342*).

54. On 8 February, Talbot enrolled a patent for *Certain Improvements in Photography*; it was awarded Patent No. 8842. As it was expensive to file patents, Talbot combined several things. This application covered the calotype process (not by name) and Talbot's direct positive process. Also tacked on were four rather impractical proposals: a "poor man's daguerreotype" forming images on copper; a lead-plated image on silver; extremely thin electro-deposited silver photographic plates; and a means of transferring an image from paper to metal. These last four, apparently thrown up as competition to the daguerreotype, were dropped in a disclaimer filed by Talbot on 8 March 1854, after the daguerreotype lost its commercial viability.

55. This was under the colorless title of "An Account of Some Recent Improvements in Photography," read at the 10 June 1841 meeting. The general public would have learned the details two days later from the summary of this: "Fine Arts. Calotype (Photogenic) Drawing," *The Literary Gazette*, no. 1273 (12 June 1841): 379. Only an abstract of the paper was published in the *Proceedings of the Royal Society* 4, no. 48 (1841): 312–16. Talbot published (likely almost immediately after the reading) a booklet with this text, under the title of *The Process of Calotype Photogenic Drawing*. Later, he published another booklet with the same text, under the title of *The Process of Talbotype (formerly called Calotype) Photogenic Drawing*. The only clue to dating this is the fact that the printer's credit changed slightly, from "J. L. Cox & Sons, 75, Great Queen Street" in the first version to "J. & H. Cox, Brothers, 74 & 75 Great Queen Street" in the second; the first time John and Henry Cox had this listing was in the post office directory for 1845. The text of the earlier of these is reprinted in Newhall, *Photography: Essay and Images*, 33–35.

56. Beaumont Newhall used this term as the title of his useful survey of the technological history of photography: *Latent Image: The Discovery of Photography* (New York: Doubleday, 1967).

57. Nobody seems to have anticipated that a process as sensitive to light as the calotype would be found, and thus none of the early workers tried their experiments in near darkness. Sir John Herschel immediately recognized that this had confused some of his earlier researches. In a letter to Sir John Lubbock, he confessed that "the action of the Gallic acid and its conjunction with Nitrate of Silver is indicated in my paper as a 'problematic exception' . . . the fact is that in my experiments the action was capricious and anomalous, the trial papers being laid by to dry were *sometimes found spontaneously darkened sometimes not*. It is evident *now* that this arose from their having been prepared without any precaution to exclude common daylight" (letter of 22 June 1841, Royal Society of London).

58. Technically, there are two broad classes of developers, although the final results are indistinguishable. Most modern materials use what is termed *chemical development*—the silver composing the final image comes from the photographic emulsion itself. Others, including Talbot's *calotype*, fall in a class termed *physical development*—the silver salts in the original material are used only as receptors of light—the metallic silver composing the final visible image actually comes from the developing solution.

59. One of the most practical of the early instructions on the calotype was George Smith Cundell's "On the Practice of the Calotype Process in Photography," *The London, Edinburgh and Dublin Philosophical Magazine and Journal of Science*, s. 3, v. 24, no. 160 (May 1844): 321–32.

60. Talbot, *The Process of Calotype Photogenic Drawing*, 3.

61. This observation was first made by Deborah Griggs Carter. See Larry J. Schaaf, "The Talbot Collection in the National Museum of American History," *History of Photography* 24, no. 1 (Spring 2000): 7.

62. He generally ignored the suggestion made to him by Sir David Brewster: "Mr Adamson & Mr Hill put up all their Calotypes by Cutting off the black border, and attaching them to Bristol Board. I have done this to several of yours, and find the effect much more agreeable than when the black border is retained. The effect is particularly good with dark pictures" (David Brewster to Henry Talbot, 28 November 1843, National Museum of Photography, Film & Television, 1937-4929, *Document 04898*).

63. This example is a negative of St. Cyriac's Church in Lacock, dated "Nov. 12/39" and inscribed "1h" to record the one hour's exposure. It is in the National Museum of Photography, Film & Television, 1937-1375, *Schaaf 2310*.

64. *Just Published, Part I, of The Pencil of Nature, by H. Fox Talbot, Esq.* Longman's announcement pamphlet, June 1844. One glaring exception to this, however, was his view of "The Boulevards of Paris" in *The Pencil of Nature* (pl. 64 in the present work). Sometime early in 1844, he

sent a memorandum to Nicolaas Henneman to "try to expunge spots wch have fallen on ye *original*" negative. In many published prints these spots have been retouched. In June 1844 Talbot paid his bookbinder, Alfred Tarrant, for "touching up 150 each of 3 plates" (invoice, 28 June 1844, LA44-28, Fox Talbot Museum, Lacock).

65. In LeGray's process, the wax was incorporated into the fibers of the paper before any photosensitive chemicals were applied. In this case, the wax took both an active physical and a chemical role in the materials. See the discussion in Larry J. Schaaf, *Sun Pictures Catalogue Six: Dr. Thomas Keith and John Forbes White* (New York: Hans P. Kraus, Jr., 1993), 10–11.

66. This view is of the side of Lacock Abbey, in the Royal Photographic Society, RPS025120, *Schaaf 2307*.

67. Photographers who have had darkroom experience in developing wider roll films are particularly familiar with another form of this problem; it is all too easy to create permanent little crescents in handling the film.

68. An excellent study of the factors affecting the fixation of Talbot's negatives is Mike Ware's *Mechanisms of Image Deterioration in Early Photographs: The Sensitivity to Light of W. H. F. Talbot's Halide-Fixed Images, 1834–1844* (London: Science Museum, 1994).

69. The general trend today, of course, is toward digital rendering of images, but it is to be hoped that darkroom practices will exist well into the future!

70. One (totally faded!), inscribed by Talbot "copy on Ctype paper," is in the collection of the Smithsonian Institution's National Museum of American History, 1995.0206.230, *Schaaf 4246*.

71. This effect is less pronounced within the limited tonal range of paper negatives. It was far more dramatic in the later albumen paper and wet collodion negatives.

72. Thomas Moore, "This World is All a Fleeting Show," *The Poetical Works of Thomas Moore, Including His Melodies, Ballads, etc.* (Philadelphia: Crissy & Markley, 1848), 361.

73. Many such variables could be introduced. Thomas Malone recalled that some of the prints for *The Pencil of Nature* "only received about half an hour's washing. After fixing each print was put into a pan with two gallons of water, and about 25 prints would be washed in that water. After remaining about ten minutes in the first pan, the print was removed into another similar pan, and in ten minutes more to a third; each print in succession, until the whole 25 were completed. So that six gallons of water washed the 25 prints of the size 9 x 7. That some portion of hyposulphite of soda remained in them there could be no doubt, as they toned darker when a hot iron was passed over them" *Photographic News* 5, no. 131 (8 March 1861): 115.

74. In some modern literature, this operation has been given the name of *Talbot's Reading Establishment*. It was definitely Henneman's business and Talbot had little more to do with it than being its major customer and in providing financial backing. He sometimes provided advice to Henneman but rarely visited there. A more detailed explanation of Henneman's working methods, and of some of the trials that he faced in this pioneering operation, is in Larry J. Schaaf's *Introductory Volume to the Anniversary Facsimile of H. Fox Talbot's "The Pencil of Nature."*

75. There is no adequate study on the effects of commercialization of photography in Britain. A good sense of the dimensions of this transition can be gained from Elizabeth Anne McCauley's excellent study, *Industrial Madness: Commercial Photography in Paris, 1848–1871* (New Haven: Yale University Press, 1994).

76. Various manuscript lists survive that outline the nature of the loans. One in the Fox Talbot Museum, Lacock, is headed "List of 50 large negatives lent May 20th 1848 by H. F. Talbot Esq$^{r.}$ to N. Henneman—& T.A. Malone." This list is in Malone's handwriting, and this may indicate that he and Henneman made the selection; the negatives on this particular list were primarily ones that Talbot had purchased from Calvert Jones and others. Another list, in the National Museum of Photography, Film & Television, is in Talbot's hand and is headed "Neg$^{ves.}$ lent to Henn$^{n.}$ Dec 10/52." Most of the fifteen negatives on this list are readily identifiable as Talbot's own photographs, although some are by Henneman, Jones, and one by a photographer Talbot no longer remembered. Another type of list, not dated and in an unidentified hand, is represented by a "List of Negatives" in the Fox Talbot Museum, Lacock. The fourteen negatives on this list include some well known ones such as the "Hungerford Bridge" and "The Open Door." These have been given numbers, presumably by Henneman, and these numbers can be correlated with inscriptions on the surviving negatives. When they were applied is not known. So far, no master list of this negative cataloguing structure has been found.

77. Some surviving examples of these commercial prints have printseller's labels attached. The pricing might have varied with the printseller, the market (London versus Reading), and even the time period (the same image might have fetched a different price in 1844 than it would have in 1854). No adequate records of the pricing system survive, although there are some manuscripts suggestive of the situation. One example is in Talbot's hand and is dated 11 December 1845. Talbot—perhaps with the assistance of Lady Elisabeth, Henneman, or others—assigned prints to four classes. The highest, at five shillings, included some readily identifiable images such as "Woodcutters" (pl. 97 in this book) and "Vestry" (pl. 100). Most of *The Pencil of Nature* and *Sun Pictures in Scotland* plates were priced at three and sixpence on this list. The "4th class" was priced at only one shilling sixpence (LA45-160, Fox Talbot Museum, Lacock).

78. There are a number of factors that confound attempts to isolate when or where an individual print was made. Because of market factors, it can be assumed that there was a diminishing demand for Talbot's images throughout the 1850s, as the rapid growth of the field of photography made more modern prints available from a wider range of sources. It can be pretty safely assumed that most prints from Talbot's negatives were made within the 1840s. Those

with a definite provenance are likely to be the only ones that can be end-dated with any certainty. Some prints from Talbot's negatives would have been made in the 1850s by Henneman's operation, although positively identifying these with the present levels of knowledge is impossible. A batch of prints might include some made early on at Lacock, some made later at Reading, and some made still later at London. These might all have been made on the same watermark paper and using the same basic printing techniques. They would have been mounted up as demand required, with no attention paid to the history of each particular print. Some of these made their way into circulation and some were returned to Lacock Abbey. Some classes of prints might prove more susceptible than others to further physical investigation. Some "Talbot" prints are made on a paper that is noticeably heavier in weight than the majority of known Talbot prints; it is a wove paper, lacking in watermarks. A good proportion of the prints in this class have a stark white band along one edge, indicating a style of printing that differed from the usual, and this might be used to establish when this group was printed. Another class of prints was made from Talbot's negatives after small paper tabs had been adhered to the negatives. Usually attached as a pair along one edge, these tabs would have been fastened to the glass in the printing frame. This kept the negative in one position while the progress of the print was inspected. This approach does not seem to have been used either at Lacock or early in Henneman's operation. The presence of the paper tabs can be seen on prints whose borders are intact. These prints obviously were made later than prints from the same negative where the tabs are absent.

79. The use of factory-made materials by more recent photographers makes it much more possible to trace the components of the print. Talbot's prints were made of ordinary materials that could be found around any household. Trace elements of chemicals and elements in the prints (unless they are the produce of modern industry) are meaningless since the quality of the materials Talbot used was beyond his control. Complicating this is the fact that many of Talbot's negatives survive in printable condition and stocks of vintage writing paper can still be found. Fortunately, there was absolutely no commercial incentive to forge Talbot's prints until quite recent times, after tools were set in place to establish the provenance of particular items. That provenance is still the best assurance of when a particular photograph was made.

80. Davy, "A Discourse Introductory to a Course of Lectures on Chemistry" (delivered 21 January 1802), *The Collected Works of Sir Humphry Davy; Early Miscellaneous Papers from 1799 to 1805*, vol. 2, edited by John Davy (London: Smith, Elder and Co., 1839), 320. Davy said this at just about the time that he published the pioneering efforts of Thomas Wedgwood.

81. The complicated reasons for this are examined in Larry J. Schaaf's *Introductory Volume to the Anniversary Facsimile of H. Fox Talbot's "The Pencil of Nature."*

82. *Edinburgh Evening Courant*, no. 23801, 2 April 1863, 5.

83. Talbot died during the course of writing this, and his son, Charles Henry Talbot, completed it the best he could. It was published as an appendix to John Thomson's translation of Gaston Tissandier's *History and Handbook of Photography*, 2d and rev. ed. (London: Sampson Low, Marston, Searle and Rivington, 1878). There is still no adequate investigation of Talbot's work in this area. A brief context for photoglyphic engraving is given in Larry J. Schaaf, "A Wonderful Illustration of Modern Necromancy: Significant Talbot Experimental Prints in the J. Paul Getty Museum," *Photography, Discovery and Invention* (Malibu, Cal.: The J. Paul Getty Museum, 1990), 31–46.

84. Daguerre never published anything, and there are no known archives bearing on his research. The usual explanation for this stems from 8 March 1839, when Daguerre called on the American painter, Samuel F. B. Morse, then in Paris to promote his invention of the telegraph. Morse wrote to his brother the next day that exactly when Daguerre was visiting him "the great building of the Diorama, with his own house, all his beautiful works, his valuable notes and papers, the labor of years of experiment, were, unknown to him, at the moment becoming the prey of the flames. His secret indeed is still safe with him, but the steps of his progress in the discovery and his valuable researches in science are lost to the scientific world" (*New York Observer*, 20 April 1839). The Diorama (a special type of theater) had burned, but Daguerre's house was little damaged, and besides his neighbors had removed its contents to safety. The scientist François Arago claimed to have seen Daguerre's research notebook ten days later, but it is difficult to imagine why such a valuable historical object was never quoted from at the time—and it has never been seen since. It is only through vaguely worded retrospective accounts after the public announcement of photography that Daguerre's story is known at all. While it seems unlikely that we will ever know Daguerre in the same way we can understand Talbot, the science underlying the daguerreotype process is now beginning to be understood. An excellent modern study is by M. Susan Barger and William B. White, *The Daguerreotype: Nineteenth-Century Technology and Modern Science* (Washington, D.C.: Smithsonian Institution Press, 1991). A good survey of the aesthetic potential of Daguerre's process is Bates Lowry and Isabel Barrett Lowry, *The Silver Canvas: Daguerreotype Masterpieces from the J. Paul Getty Museum Collection* (Los Angeles: The J. Paul Getty Museum, 1998).

85. A listing of many of them is provided in Appendix III of H. J. P. Arnold's *William Henry Fox Talbot*, 362–63.

86. Most of these are on deposit at the Fox Talbot Museum, Lacock.

87. The published ones cover the crucial period 1839–43; see Larry J. Schaaf, *Records of the Dawn of Photography: Talbot's Notebooks P & Q*. Volunteers at the Fox Talbot Museum have been transcribing others, and it is hoped that these will be available in some published form in the near future.

88. A few of these are at the Fox Talbot Museum, Lacock, and distributed through other col-

lections, but the largest group was donated to the Science Museum and is now in the National Museum of Photography, Film & Television. The material is not yet catalogued (a daunting task, but certainly a rewarding one).

89. Henry Talbot to Charles Feilding, appended to a letter written to Elisabeth Feilding, 27 May 1808 (LA8-5, Fox Talbot Museum, Lacock, *Document 00492*).

90. These are presently being transcribed into an electronically searchable form under a program sponsored by the University of Glasgow and the British Academy. Directed by Larry J. Schaaf, *The Correspondence of William Henry Fox Talbot* project has as its goal making the total corpus of these freely available to all researchers. The *Document Numbers* referred to throughout the notes in this volume are derived from the indexing for this project. An interim tool is Larry J. Schaaf's *The Correspondence of William Henry Fox Talbot: A Draft Calendar* (Glasgow: Glasgow University Library Studies, 1995). Brief synopses of some of the scientifically important letters are contained in Larry J. Schaaf, *Selected Correspondence of William Henry Fox Talbot, 1823–1874* (London: Science Museum, 1994).

91. In some collections, however, particularly in the past, such pieces were often confused with other early photographs. Out of understandable ignorance of all the other photographers who were producing work during the 1840s and 1850s, curators sometimes lumped together under Talbot's name anything of early date. As knowledge of photographic history has grown, many of these have been properly identified.

92. An uncompleted series of investigations was by the late Arthur Gill: "Nicholas Henneman, 1813–1893," *History of Photography* 4, no. 4 (October 1980): 313–22 [there is a typographical error here, for Henneman actually died in 1898] and "Nicholas Henneman P.S.," *History of Photography* 5, no. 1 (January 1981): 84–86. A broader look at Henneman's activities at Reading is in Larry J. Schaaf's *Introductory Volume to the Anniversary Facsimile of H. Fox Talbot's "The Pencil of Nature."*

93. One of the most intriguing of these was formerly thought to be Thomas Damont Eaton, a Norfolk photographer and musician; see Larry J. Schaaf, *Sun Pictures Catalogue Four: The Harold White Collection of Historical Photographs from the Circle of Talbot* (New York: Hans P. Kraus, Jr., 1987), pls. 17 and 18. This attribution has since been disproved, but no identity has been established to take his place. The work is very distinctive in style and in execution. More than eighty negatives by him or her are known in Talbot's collections; hundreds of prints have been made from these.

94. The records on this are unclear and it is likely that the matter was handled informally. It is hoped that the voluminous financial records that were retained at Lacock Abbey, and are now on deposit at the Fox Talbot Museum and the Trowbridge Records Office, may eventually yield a more detailed history of this transaction. By 1852, Henneman had transferred at least some of his work to Kensal Green, about four miles from his expensive Regent Street location. By 1856 he was attempting to sell his property at Kensal Green, but he maintained some presence at Regent Street until about 1858. He disappeared from the post office directory that year and had intentions of moving to Lisbon. By early 1859, Talbot was trying to find employment for him in England.

95. Some sense of this remarkable woman can be gained from her book, *My Life and Lacock Abbey* (London: George Allen and Unwin, 1956).

96. The circumstances of this donation are summarized in Larry J. Schaaf, "The Fox Talbot Collection," *Science Museum Review* (1991): 26–29. The recent efforts at cataloguing this collection are summarized in Roger Taylor and Larry J. Schaaf, "The Talbot Collection at Bradford," in Mike Weaver's *Henry Fox Talbot: Selected Texts and Bibliography* (Oxford: Clio Press, 1992), 57–58.

97. With Miss Talbot's encouragement, White started out to write a biography of Talbot, and his organizational work at the abbey was of critical value in preserving the material at a time when there was little public interest in such matters. His mixture of scholarly and collecting activity should be considered in the context of the time. It is summarized in Larry J. Schaaf, *Sun Pictures Catalogue Three: The Harold White Collection of Works by William Henry Fox Talbot* (New York: Hans P. Kraus, Jr., 1987). A compilation of White's unpublished manuscript is reproduced therein.

98. Caroline Ostroff, a dealer in Silver Spring, Maryland, arranged "An offering from the Personal Collection of W. H. F. Talbot." Offered in sets of three to fifteen prints, it was "made possible by a desire by Talbot's heirs, to make examples of his work available to the greatest number of viewers throughout the world" and was limited to public institutions. Twenty-four such sets were sold by March 1967. She also sold a similar "Offering of Photomechanical Prints by W. H. F. Talbot."

99. This story is told in more detail in Larry J. Schaaf, "The Talbot Collection in the National Museum of American History," *History of Photography* 24, no. 1 (Spring 2000): 7–15.

INTRODUCTION TO THE PLATES

1. John Ruskin, "The Lamp of Memory," *The Seven Lamps of Architecture* (London: J. M. Dent, 1906), 190.

2. The organizational structure of the *Catalogue* is based on the concept of families of images. Paralleling similar catalogues in the worlds of music and of manuscripts, each original image has been assigned a unique but arbitrary number—the *Schaaf number*. Thus, each negative has its own number, and any prints made from that negative are indexed by that master number. In the cases where a print survives but the negative is unknown, the print receives a master number. The records in the *Catalogue* are kept at the *item level*—in addition to the Schaaf number,

every print and every negative has its own distinct and unique record as well. Any institutional or collection numbers are preserved in the records, but the central Schaaf number insures that negatives and prints can be positively identified and matched up in collections worldwide. Rarely does the numbering system of one collection correlate with the practices of any others, and in many collections, particularly private ones, no distinct numbers are available at all. The organizational effect of the *Catalogue* has already provided a good deal of new information, for often only one particular print may be titled, the negative can supply a date, and another print may show the negative in a previously untrimmed state, sometimes with additional information. The *Catalogue* links together records not only from Talbot's photographs, but also those from his published works, his research notes, and his correspondence. This has provided additional titling and in some cases subject identifications. For example, by tracking Talbot's movements through the addresses in his correspondence, one can use the date of a photograph to determine where it was taken. Within the *Catalogue*, photographs created by Talbot himself predominate, as they should. However, there are a number of historical reasons for the *Catalogue* to encompass the immediate "Circle of Talbot." A natural reason is that Talbot worked within a social structure at Lacock Abbey that involved numerous people. In many cases we will never know whether a particular sheet of paper was prepared by Talbot himself, or by a servant working under his direction, or by a member of his family while he was away. Constance Talbot did not play an active role in the photographic productions but she did help from time to time. Lady Elisabeth directed the servants in making photograms of plants and suggested ideas for camera images she would like to see. But of all the people around him, Talbot relied most on his trusted servant, Nicolaas Henneman. The two men grew into a relationship more like a partnership, and Henneman's helping hand should be suspected in much of what Talbot photographed. They photographed side by side in many cases. Some photographers came to Lacock Abbey to learn the art from the inventor and some of what they produced stayed there. One of the earliest was Henry Collen, the miniature painter who attempted to establish calotype portraiture in London. Another was John Frederick Goddard, a scientist and an important daguerreotypist who grew interested in the calotype (see pls. 52 and 53). As photography began to grow as an art, others joined the ranks, most importantly, the Rev. Calvert Richard Jones. It is a fairly simple matter to separate out some of his work, particularly that taken in remote places such as Malta, but when he and Talbot photographed together in locations such as York it would be expected that their negatives might be much more difficult to attribute. The structure of the *Catalogue* permits the addition of works by other photographers who might have come under Talbot's influence, such as the Rev. George Bridges. The core *Catalogue*, however, has been restricted to photographs that Talbot created himself, to those in which he might have been an observer during the creation of the work, and to those photographs where he purchased negatives or otherwise had a direct role in handling them. Although the numbers will change as more material is catalogued, the project is sufficiently far along to give a good indication of what might be expected. More than three thousand distinct Talbot images have been identified. Negatives have been located for the majority of these and nearly five thousand prints are known. More than a thousand unique images beyond this have been attributed to Henneman and Jones. The detail of the identification in this book would not have been possible without the structure of the *Catalogue Raisonné*. Subsets of this work are on deposit in several public collections and it is hoped that a full publication of the *Catalogue Raisonné* will become possible before long.

3. This project is being undertaken at the University of Glasgow, under the direction of Larry J. Schaaf. With the welcome cooperation of Talbot's descendants, the approximately ten thousand known letters worldwide are being transcribed and annotated and will be made freely available in electronic form. It is hoped that there will be selective print publications of these as well. For progress on this project, see its website at *http://www.foxtalbot.arts.gla.ac.uk.* In addition to university support, major funding for this project has come from the Arts and Humanities Research Board, the British Academy, and the National Endowment for the Humanities.

PLATE 1

1. For more about White's relationship with Talbot studies, see Larry J. Schaaf, *Sun Pictures Catalogue Three: The Harold White Collection of Works by William Henry Fox Talbot* (New York: Hans P. Kraus, Jr., 1987).

2. The best-known example was mounted in a formal manner for presentation. A better sense of the more typical rough and pioneering character of these early images of the oriel window can be seen in an example formerly belonging to Harold White and now part of the Bensusan collection in South Africa. It is illustrated in Larry J. Schaaf, "Invention and Discovery: First Images," in Ann Thomas, *Beauty of Another Order: Photography in Science* (New Haven: Yale University Press, 1997), pl. 16.

3. It is illustrated in Larry J. Schaaf, *Out of the Shadows: Herschel, Talbot, and the Invention of Photography* (London: Yale University Press, 1992), pl. 45.

PLATE 2

1. Henry Talbot to William Jackson Hooker, 26 March 1839, EL13.141, Royal Botanic Garden, Kew (*Document 03845*).

2. This addendum was never published in full. A summary was published in the *Proceedings of the Royal Society* 4, no. 37 (21 March 1839): 134. The above passage is quoted from the original manuscript, AP23.31, The Royal Society of London.

3. When it was included in a group of prints that Talbot sent Bertoloni in June 1839, the print was probably freshly made, but the *cliché verre* negative may well have been created during Talbot's early experiments in 1834. The ground of the Bertoloni copy is faint but still reveals accidental markings of the glass plate identical to those shown in this print, and the two prints were most likely produced during the same period. It is in the Bertoloni album in the Metropolitan Museum of Art, New York (36.37-6). For more on the relationship between Talbot and Bertoloni, see Graham Smith, "Talbot and Botany: The Bertoloni Album," *History of Photography* 17, no. 1 (Spring 1993): 33–48; and Malcolm Daniel, "L'Album Bertoloni," in *Fotografia & Fotografi a Bologna 1839–1900* (Bologna: Grafis Edizioni, 1992), 73–78.

4. This particular print is salt-fixed and is likely on paper watermarked Whatman 1827 (it is difficult to tell whether the watermark is in the print's paper or in the paper sheet on which the print is mounted); it is very pale, making it difficult to determine if the image fills the entire 17.7 x 10.4 cm area of the paper. Now in the Alexander Novak Collection, it was originally sold as one of the items from the Babbage album scattered in the Sotheby's Belgravia sale on 1 July 1977, *Photographic Images and Related Material*. A copy was recently identified in the Tokyo Fuji Art Museum (FT-005); previously in the Stephen White Collection, it was listed only as an "etching" of a boat and windmill. Its paper carries a partial watermark of "tman Mill 8", likely indicating that it was printed on 1838 Whatman Turkey Mill paper.

PLATE 3

1. This is from Talbot's first paper on photography, read to the Royal Society on 31 January 1839. He published the full text as *Some Account of the Art of Photogenic Drawing, or the Process by Which Natural Objects May be Made to Delineate Themselves, Without the Aid of the Artist's Pencil* (London: R. and J. E. Taylor, 1839), 11.

2. Examples of Talbot's "mouse trap" cameras can be seen in H. J. P. Arnold, *William Henry Fox Talbot: Pioneering Photographer and Man of Science* (London: Hutchinson Benham, 1977), pl. 18.

3. H. F. Talbot, "Introductory Remarks," in *The Pencil of Nature* (London: Longman, Brown, Green, and Longmans, 1844).

4. Constance Talbot to Henry Talbot, 7 September 1835, LA35-26, Fox Talbot Museum, Lacock (*Document 03132*).

5. Mousetraps of this period did not use the spring-loaded wire loop so familiar today. They were little boxes with a trapdoor that could cover the hole once the mouse ventured in.

6. A simple example is a view of some of Thomas Moore's sheet music, "When Last We Parted," on a music stand; shot obliquely, the negative has been trimmed to a trapezoidal shape (National Museum of Photography, Film & Television [1937-1235, *Schaaf 687*]). In two other cases, Talbot trimmed his negatives much more elaborately in order to follow the shape of pieces of lace (National Museum of Photography, Film & Television [1937-1518, *Schaaf 1074*; 1937-1390, *Schaaf 1084*]).

PLATE 4

1. Adapted from Talbot's text for plate XIX, "The Tower of Lacock Abbey," in *The Pencil of Nature* (London: Longman, Brown, Green, and Longmans), part 5, December 1845.

2. This is from Talbot's first paper on photography, read to the Royal Society on 31 January 1839. He published the full text as *Some Account of the Art of Photogenic Drawing, or the Process by Which Natural Objects May be Made to Delineate Themselves, Without the Aid of the Artist's Pencil* (London: R. and J. E. Taylor, 1839), 10–11.

3. H. F. Talbot, "Introductory Remarks," in *The Pencil of Nature* (London: Longman, Brown, Green, and Longmans, 1844).

4. In some of Talbot's earliest cameras, a hole was bored in the *front* of the camera and plugged with a cork. Talbot would remove the cork in order to look into the camera to frame up his image and focus it. He could also take advantage of the fact that his photogenic drawing negative material was a "print-out" process. The image became visible as the paper was exposed—without needing further development—and he could pull the cork out briefly from time to time during the long exposure to see how things were coming along. An example of this type of camera is illustrated in H. J. P. Arnold, *William Henry Fox Talbot: Pioneer of Photography and Man of Science* (London: Hutchinson Benham, 1977), pl. 19.

PLATE 5

1. In his *Legendary Tales, in Verse and Prose* (London: James Ridgway, 1830), 116.

2. Henry Talbot to John Herschel, 9 March 1833, HS17:269, The Royal Society of London (*Document 02632*).

3. Wedgwood's process was published by his friend Humphry Davy in "An Account of a Method of Copying Paintings upon Glass, and of Making Profiles, by the Agency of Light upon Nitrate of Silver. Invented by T. Wedgwood, Esq., with Observations by H. Davy," *Journals of the Royal Institution* 1, no. 9 (22 June 1802): 170–74. Davy makes no mention of this work in his *Syllabus* of the regular lectures, and the structure of these makes it an unlikely fit. More likely he incorporated Wedgwood's work into his evening course on the "Chemistry of the Arts"; the introductory lecture of this series was given on 9 February 1802 and may have been the impetus for the formal publication. Wedgwood's story is a complex one and has yet to be fully explored; for some sources on this, see Larry J. Schaaf, *Out of the Shadows: Herschel, Talbot, and the Invention of Photography* (London: Yale University Press, 1992), 25–27 and passim. Samuel Highley, in proposing a national photographic library and museum in 1885, argued that "many specimens very illustrative will presently be swept away as rubbish." As an example, he claimed that

"only last night I was looking at specimens of some of Wedgwood's experiments with chloride of silver" (Highley, "Needed, A Photographic Library and Museum," *The Photographic News* 29, no. 1415 [16 October 1885]: 668–69). These fragile images remained visible nearly a century after they were produced!

4. Although Wedgwood's case was special, there were many precedents for this. Some idea of the range can be gleaned from Larry J. Schaaf, "The First Fifty Years of British Photography, 1794–1844," in Michael Pritchard, ed. *Technology and Art: The Birth and Early Years of Photography* (Bath: The Royal Photographic Society, 1990), 9–18.

5. One of the best discussions of this and related topics is in Mike Ware, *Mechanisms of Image Deterioration in Early Photographs: The Sensitivity to Light of W. H. F. Talbot's Halide-fixed Images 1834–1844* (London: Science Museum, 1994).

6. It is in the National Museum of Photography, Film & Television (1937-362, *Schaaf 2243*) and is illustrated in Schaaf, *Out of the Shadows*, pl. 24.

PLATE 6

1. Henry Talbot to Constance Talbot, 1 December 1838, LA(H)38-14, Fox Talbot Museum, Lacock (*Document 03760*).

2. This is the only occasion (public or private) where Talbot made such a claim, yet it would be unlike him to have actually fabricated such a story; see Henry Talbot, "Photogenic Drawing," letter to the editor, dated 30 January 1839; published in *The Literary Gazette*, no. 1150 (2 February 1839): 72–74 (*Document 03782*).

3. Henry Talbot to William Jackson Hooker, 26 March 1839, EL13.141, Royal Botanic Garden, Kew (*Document 03845*).

4. This is in Talbot's Memoranda notebook, which was started at Lacock in June 1838 but mostly represents miscellaneous entries for 1839 and later (Fox Talbot Museum, Lacock). Other possibilities for "ab" are considered in the discussion of plate 6, "Buckler Fern (version II)," in Larry J. Schaaf, *Sun Pictures Catalogue Seven: Photogenic Drawings by William Henry Fox Talbot* (New York: Hans P. Kraus, Jr., 1995).

PLATE 7

1. The others are all in the collection of the National Museum of Photography, Film & Television. In addition to the oriel window (see frontispiece), they include an inside view of the stained-glass windows in the great hall of Lacock Abbey (1937-1406, *Schaaf 1119*) and an inside view of the rose window in the same room (1937-1411, *Schaaf 1735*); a copy of a piece of cloth (1937-1429, *Schaaf 321*); a copy of a print of St. Mark's Square in Venice (1937-1430, *Schaaf 426*); and a copy of a print of a joker with a cat (1937-1408, *Schaaf 450*).

2. Talbot selected examples of his photogenic drawing process meant to demonstrate "the wide range of its applicability. Among them were pictures of flowers and leaves; a pattern of lace; figures taken from painted glass; a view of Venice copied from an engraving; some images formed by the Solar Microscope, viz. a slice of wood very highly magnified, exhibiting the pores of two kinds, one set much smaller than the other, and more numerous. Another Microscopic sketch, exhibiting the reticulations on the wing of an insect. Finally: various pictures, representing the architecture of my house in the country; all these made with the Camera Obscura in the summer of 1835" (letter to the editor, dated 30 January 1839; published in *The Literary Gazette*, no. 1150 [2 February 1839]: 73–74 [*Document 03782*]).

3. Vernon Heath, *Recollections* (London: Cassell & Company, 1892), 49.

4. This quote is taken from Talbot's original manuscript of "An Account of the Processes Employed in Photogenic Drawing," read before the Royal Society on 21 February 1839 and preserved in their archives. An abstract of this paper was published almost immediately in the *Athenaeum*, no. 591 (23 February 1839): 156.

5. Henry Talbot, letter to the editor, dated 30 January 1839; published in *The Literary Gazette*, no. 1150 (2 February 1839): 74 (*Document 03782*).

PLATE 8

1. Henry Talbot to John Herschel, 21 March 1839. HS17:289, The Royal Society of London (*Document 03843*).

2. This relationship is explored more fully in Larry J. Schaaf, *Out of the Shadows: Herschel, Talbot, and the Invention of Photography* (London: Yale University Press, 1992).

3. It was drawn on 12 February 1834 and beautifully colored by Margaret, his wife and collaborator. It is illustrated as plate 54 in Brian Warner and John Rourke, *Flora Herscheliana: Sir John and Lady Herschel at the Cape, 1834–1838* (Houghton, South Africa: The Brenthurst Press, 1996).

4. Henry Talbot to John Herschel, 9 March 1833, HS17:269, The Royal Society of London (*Document 02632*).

5. Caroline Mt. Edgcumbe to Henry Talbot, 8 April 1840, LA40-36, Fox Talbot Museum, Lacock (*Document 04067*).

6. Constance Talbot to Henry Talbot, 14 June 1841, LA41-38, Fox Talbot Museum, Lacock (*Document 04281*).

7. It is in the J. Paul Getty Museum, Los Angeles (85.XM.150.13, *Schaaf 2290*).

8. The similarity of these plant specimens was first noted by Tony Simcock, based on the illustration in Larry J. Schaaf, "'A Wonderful Illustration of Modern Necromancy': Significant Talbot Experimental Prints in the J. Paul Getty Museum," in *Photography: Discovery and Invention* (Malibu: The J. Paul Getty Museum, 1990), 32, fig. 2.

9. Henry Talbot to John Herschel, 21 March 1839. The packet in which Talbot sent the nega-

tive to Herschel is preserved in the Museum of the History of Science, Oxford; it is inscribed in pencil in his hand "not fixed." The letter is in the Royal Society of London, HS17:289 (*Document 03843*).

10. John Herschel to Henry Talbot, 27 March 1839, 1937-4842, National Museum of Photography, Film & Television (*Document 03846*).

PLATE 9

1. The south gallery incorporated some of the remains of the convent, leading to this somewhat unconventional architectural reference (Lady Elisabeth Feilding to Henry Talbot, 23 April 1839, LA39-34, Fox Talbot Museum, Lacock [*Document 03866*]).

2. Talbot dated quite a few of his items simply "1839," and many of them are impossible to date with more precision. No 1839 camera negatives dated April (or earlier) are known. Curiously, the other two Talbot photographs with the earliest dates in 1839 (also April!) are in the Russian Academy of Science; both are prints, and the negatives have not been located. One is a view looking up toward the summit of Sharington's Tower (visually similar to pl. 4) that has an image area of 15.8 x 16 cm. It is inscribed in ink on the verso "Lacock Abbey H. F. Talbot photogr. April 1839" and unusually records a partial watermark from the negative "key Mill" (*Schaaf 3690*). The other is an interior view of the windows in the front hall of Lacock Abbey; the image area of this is difficult to determine as the paper is trimmed and only a trace of one border can be seen; the paper is irregular and measures 18.2 x 17.8 cm (*Schaaf 4237*).

3. Henry Talbot to John Herschel, 27 April 1839, HS17:293, The Royal Society of London (*Document 03872*). The invoking of Rembrandt's name was actually first made in reference to Daguerre's plates, in a letter dated 16 January 1839 from a correspondent in Paris, published in the *Athenaeum*, no. 587 (26 January 1839): 69.

4. "In the Photogenic or Sciagraphic process, if the paper is transparent, the first drawing may serve as an object, to produce a second drawing, in which the lights and shadows would be reversed" Talbot, notebook *M*, around 28 February 1835, Fox Talbot Museum, Lacock).

5. Dr. Joseph Christianovich Hamel (or Gamell, 1788–1862). While German born, Hamel was a corresponding member of the Russian Academy of Sciences and from 1829 was appointed a regular member of staff in the department of "chemistry and technology applied to art and craft." Highly respected and well-liked, Hamel became a sort of roving scientific ambassador, gathering information on science and new technology. In April 1839, leaving on his regular foreign service, he was asked by the botanists K. M. Ber and F. Brandt to find out about Talbot's invention, which they hoped to use for depicting natural history objects. For additional information on Talbot in Russia, see Elena Barkhatova, "The First Photographs in Russia," in David Elliott, ed., *Photography in Russia, 1840–1940* (London: Thames and Hudson, 1992), 24–30.

6. Elisabeth Feilding to Henry Talbot, 30 April 1839, LA40-21, Fox Talbot Museum, Lacock (*Document 03873*).

7. One is mounted in one of Talbot's notebooks and inscribed in ink on verso "H.F. Talbot Photogr. April 1839 Middle Windows South Gallery Lacock Abbey"; it is printed on paper watermarked J. Whatman Turkey Mill 1838 (Fox Talbot Museum, Lacock [LA2067]). A badly trimmed and pale copy is in the National Museum of American History, Smithsonian Institution (1995.0206.339). Its image area exceeded the present trimmed size of the paper, which measures 18.9 x 14.7 cm; it carries no inscriptions and is on paper watermarked J. Whatman Turkey Mill. While the image area of the other three examples is consistent, the fourth known print establishes that the negative was cut down during its lifetime, possibly due to edge damage or edge fading. This print has an image area of 19.6 x 12.7 cm and is inscribed in ink on verso "Middle Window South Gallery Lacock Abbey H.F. Talbot photogr. April 1839" (The Royal Photographic Society [RPS025103]).

PLATE 10

1. Talbot felt that the word Bryonia was a northern word, bine, corrupted into bryne or bryon, hence a vine; see his *English Etymologies* (London: John Murray, 1847), 361.

2. See Larry J. Schaaf, *Sun Gardens: Victorian Photograms by Anna Atkins* (New York: Aperture, 1985).

3. Although his works are widely reproduced, the best context can be seen in Karl Blossfeldt's original *Art Forms in Nature: Examples from the Plant World, Photographed Direct from Nature* (London: A. Zwemmer, 1929).

4. Henry Talbot to Constance Talbot, 13 June 1841, LA41-37, Fox Talbot Museum, Lacock (*Document 04278*).

5. This is from Talbot's first paper on photography, read to the Royal Society on 31 January 1839. He published the full text as *Some Account of the Art of Photogenic Drawing, or the Process by Which Natural Objects May be Made to Delineate Themselves, Without the Aid of the Artist's Pencil* (London: R. and J. E. Taylor, 1839), 5.

6. Henry Talbot to William Jackson Hooker, 26 March 1839, EL13.141, Royal Botanic Garden, Kew (*Document 03845*).

PLATE 11

1. Talbot, *A Brief Description of the Photogenic Drawings Exhibited at the Meeting of the British Association, at Birmingham, in August, 1839, by H. F. Talbot, Esq.* This double-sided broadside lists ninety-three negatives and positives exhibited by Talbot; copies are in the Gernsheim Collection, the Harry Ransom Humanities Research Center, The University of Texas at Austin; the National Museum of Photography, Film & Television; and the Fox Talbot Museum, Lacock.

This listing was transcribed in Mike Weaver's *Henry Fox Talbot: Selected Texts and Bibliography* (Oxford: Clio Press, 1992), 57–58.

2. John M. Wilson, *The Rural Cyclopedia, or a General Dictionary of Agriculture, and of the Arts, Sciences, Instruments, and Practice, Necessary to the Farmer, Stockfarmer, Gardener, Forester, Landsteward, Farrier, &c.*, vol. 2 (Edinburgh: A. Fullerton and Co., 1849), 288.

3. Elisabeth Feilding to Henry Talbot, 5 December 1841, Fox Talbot Museum, Lacock (*Document 04384*).

PLATE 12

1. This is recorded in Talbot's Memoranda notebook, which was started at Lacock in June 1838 but mostly represents miscellaneous entries for 1839 and later (Fox Talbot Museum, Lacock).

2. In fact, the first dated letter between them relayed information about a living specimen of a very rare orchid; see Henry Talbot to John Lindley, 3 January 1836, no. 843, Royal Botanic Garden, Kew (*Document 01346*).

3. Larry J. Schaaf, *Sun Gardens: Victorian Photographs by Anna Atkins* (New York: Aperture, 1985).

PLATE 13

1. For more on the relationship between Talbot and Bertoloni, see Graham Smith, "Talbot and Botany, the Bertoloni Album," *History of Photography* 17, no. 1 (Spring 1993): 33–48; and Malcolm Daniel, "L'Album Bertoloni," in *Fotografia & Fotografi a Bologna 1839–1900* (Bologna: Grafis Edizioni, 1992), 73–78.

2. Henry Talbot to Antonio Bertoloni, June 1839; bound in the Bertoloni album, The Metropolitan Museum of Art, New York (*Document 03887*). This group of eight photographs was dispatched by Talbot on 14 June 1839 (Memoranda notebook, Lacock June 1838, Fox Talbot Museum, Lacock).

3. E. M. Goldschmidt & Company, *Catalogue One Hundred* (London: 1953).

PLATE 14

1. This and the broader context of Talbot's research notes are reproduced in facsimile and in transcription in Larry J. Schaaf, *Records of the Dawn of Photography: Talbot's Notebooks P & Q* (Cambridge: Cambridge University Press, 1996). Two negatives in the J. Paul Getty Museum exhibit different versions of the dark red and green balance Talbot described and might represent the "overdone" state. One is an image of the leaves and stem of the buttercup (84.XP.927.6, *Schaaf 1179*) and the other an image of hornbeam (85.XM.150.12, *Schaaf 3419*).

2. This is in Talbot's Memoranda notebook, which was started at Lacock in June 1838 but mostly represents miscellaneous entries for 1839 and later (Fox Talbot Museum, Lacock). Other possibilities for "ab" are considered in the discussion of the "Buckler Fern (version II)," in Larry J. Schaaf, *Sun Pictures Catalogue Seven: Photogenic Drawings by William Henry Fox Talbot* (New York: Hans P. Kraus, Jr., 1995), pl. 6.

3. The gift to "Estcourt" is recorded in Talbot's Memoranda notebook that was started at Lacock in June 1838 (see previous note). Although there are no letters directly linked to this item, his former classmate J. G. Bucknall Estcourt had remained a steady correspondent. It is also possible that the recipient was Walter Estcourt, of the Royal Navy, who is cited without explanation in another of Talbot's Memoranda notebooks, this one started at London in May 1840 and carrying entries through April 1844 (Fox Talbot Museum, Lacock).

PLATE 15

1. This is from Talbot's first paper on photography, read to the Royal Society on 31 January 1839. He published the full text as *Some Account of the Art of Photogenic Drawing, or the Process by Which Natural Objects May be Made to Delineate Themselves, Without the Aid of the Artist's Pencil* (London: R. and J. E. Taylor, 1839), 5.

2. This was plate XX, simply titled "Lace," published in fascicle 5 in December 1845.

3. Henry Talbot to William Jackson Hooker, 23 January 1839, EL13.140, Royal Botanic Garden, Kew (*Document 03772*).

4. William Jackson Hooker to Henry Talbot, 20 March 1839, Fox Talbot Museum, Lacock (*Document 03842*). Four decades later, the Scottish photohistorian, William Lang, Jr., reported to the Glasgow Photographic Association that he had "been informed that in an early number of the *Glasgow Mechanic's Magazine* there is to be found one of these Talbotypes, also issued in supplemental form, but this I have never seen" (Lang, "Photography and Book Illustration," *The British Journal of Photography* 34, no. 1408 [29 April 1887]: 263). Could this supplement have been the outcome of Hooker displaying Talbot's example? It appears that the *Glasgow Mechanic's Magazine* was not published during this period. However, a possible explanation is suggested by another journal's recording of the title as the *Glasgow Merchants Magazine*, likely a more ephemeral publication—if it existed at all ("Silver Prints and Book Illustration," *The Philadelphia Photographer*, no. 299 [4 June 1887]: 324).

5. No contemporaneous salt prints are known; there is a reproduction of a modern print made from this negative in Hubertus von Amelunxen, *Die Aufgehobene Zeit: Die Erfindung der Photographie durch William Henry Fox Talbot* (Berlin: Verlag Dirk Nishen, 1988), 74.

PLATE 16

1. No such print has been located in the dispersed Herschel collections. It most likely was Talbot's view of *Patroclus* in the window, made on 23 November 1839. This negative (National Museum

of Photography, Film & Television 1937-1514, *Schaaf 2317*) is illustrated in Larry J. Schaaf, *Out of the Shadows: Herschel, Talbot, and the Invention of Photography* (London: Yale University Press, 1992), pl. 51.

2. Henry Talbot to Sir John Herschel, 7 December 1839, HS17:299, The Royal Society of London (*Document 03987*).

3. Henry Talbot, manuscript list of negatives taken 12 November 1839 to 25 October 1840, Fox Talbot Museum, Lacock. The initial negatives are not listed in chronological order, apparently as the list was amended early on.

4. In the Fox Talbot Museum, Lacock.

5. The print was extracted at some point in the past and is now kept in Special Collections (B36/2); the album is preserved in the University Archives (v. Dc17/14). Lady Jane Montgomerie was the only daughter of Hugh Montgomerie, the 12th earl of Eglinton. In 1828, she married Edward-Archibald Hamilton, so this print was evidently a later addition, perhaps by herself, perhaps by another person, to her childhood album.

PLATE 17

1. H. F. Talbot, "Introductory Remarks," in *The Pencil of Nature* (London: Longman, Brown, Green, and Longmans, 1844).

2. Henry Talbot, letter to the editor, dated 5 February 1841; published in *The Literary Gazette*, no. 1256 (13 February 1841): 108 (*Document 04191*).

3. It is in very faded condition and was made after the lower left corner of the negative had been trimmed. Formerly in the collection of André Jammes, it is now in the Harrison Horblit Collection, the Houghton Library, Harvard University (TypPr805.T820.III).

PLATE 18

1. Henry Talbot, manuscript list of negatives taken 12 November 1839 to 25 October 1840, Fox Talbot Museum, Lacock. The 13 February negative, almost totally faded, is in the collection of the Fox Talbot Museum, Lacock (*Schaaf 2240*). The only print known from it is the one that Talbot sent to Sir John Herschel. Formerly in the collection of André Jammes, it is now in the Bibliothèque Nationale, Paris (E056[res]-07).

2. In the Fox Talbot Museum, Lacock.

3. Talbot first wrote to Raoul Rochette, the Académie's secretary, early in 1840, expressing concern that the Académie's bulletin had confused Bayard's process with his; see Talbot to Rochette, 27 January 1840, National Museum of American History, Smithsonian Institution (67-77; *Document 04006*). On 25 March 1840, Talbot recorded having sent thirty views to Rochette, including nineteen "camera drawings" and eleven "not"—one was this image, "Abbey clock tower (large)." A number of these original gifts are still in the collection of the Académie. The presentation is recorded in Talbot's Memoranda notebook, Lacock June 1838 (mostly miscellaneous entries for 1839), Fox Talbot Museum, Lacock.

PLATE 19

1. The later negative is now in the collection of the National Museum of American History, Smithsonian Institution (1995.0206.022, *Schaaf 2362*). Talbot sent a print from it to his friend Sir John Herschel; now very pale, it is in the Harry Ransom Humanities Research Center, The University of Texas at Austin (974:002:001).

2. The letter from John Ivory Talbot is quoted from Lilian Dickins and Mary Stanton, eds., *An Eighteenth-Century Correspondence, Being the Letters . . . to Sanderson Miller, Esq., of Radway* (London: John Murray, 1910), 308.

3. Matilda Talbot, *My Life and Lacock Abbey* (London: George Allen and Unwin, 1956), 92.

4. Henry Talbot, manuscript list of negatives taken 12 November 1839 to 25 October 1840, Fox Talbot Museum, Lacock.

5. The negative is in the Fox Talbot Museum, Lacock.

PLATE 20

1. The dated negative for the later image is in the National Museum of Photography, Film & Television (1937-1399, *Schaaf 2561*). The title comes from the print of this that he gave to Herschel, inscribed on verso "A ruined wall, H. F. Talbot 1841"; it is now in the Bibliothèque Nationale, Paris, E056[res]-19. Another print is illustrated in Larry J. Schaaf, *Out of the Shadows: Herschel, Talbot, and the Invention of Photography* (London: Yale University Press, 1992), pl. 69.

2. Henry Talbot to Sir John Herschel, 30 April 1840, HS17:301, The Royal Society of London (*Document 04070*).

3. Sir John Herschel to Henry Talbot, 3 May 1840, National Museum of Photography, Film & Television (1937-4859; *Document 04071*).

4. Henry Talbot, manuscript list of negatives taken 12 November 1839 to 25 October 1840, Fox Talbot Museum, Lacock.

5. National Museum of American History, Smithsonian Institution (1995.0206.023).

6. Fox Talbot Museum, Lacock (LA2242), in Talbot's album No. 7 (which he termed "bad").

PLATE 21

1. Because of conservation constraints, it was impossible to photograph the periphery of this print. All of the essential image area and some of the border area are retained in this reproduction.

2. H. F. Talbot, *The Pencil of Nature* (London: Longman, Brown, Green, and Longmans), part 1, pl. III, June 1844.

3. Caroline Mt. Edgcumbe to Henry Talbot, 8 April 1840, LA40-36, Fox Talbot Museum, Lacock (*Document 04067*).

4. Memoranda notebook, Lacock June 1838, Fox Talbot Museum, Lacock.

5. Constance Talbot to Henry Talbot, 10 September 1840, LA40-69, Fox Talbot Museum, Lacock (*Document 04138*).

6. Henry Talbot, manuscript list of negatives taken 12 November 1839 to 25 October 1840, Fox Talbot Museum, Lacock.

7. The negative is in the Fox Talbot Museum, Lacock; the museum also holds one print from it (LA2184) in Talbot's album No. 6 (all of the known dates in this album are 1840). Another print is in the National Museum of Photography, Film & Television in an album mostly titled in the hand of Lady Elisabeth Feilding (1937-2536/1). A nearly totally faded one is in the National Museum of American History, Smithsonian Institution (1995.0206.355). Two are in the Académie des Beaux Arts, Paris, and were sent by Talbot to their secretary, Raoul Rochette, on 25 March 1840. Talbot first wrote to Rochette early in 1840, expressing concern that the Académie's bulletin had confused Bayard's process with his. See Talbot to Rochette, 27 January 1840; National Museum of American History, Smithsonian Institution (67-77; *Document 04006*). He recorded having sent thirty views to Rochette, including nineteen "camera drawings" and eleven "not"—two were this image. This is recorded in Talbot's Memoranda notebook, which was started at Lacock in June 1838 but mostly represents miscellaneous entries for 1839 and later (Fox Talbot Museum, Lacock). A number of these original gifts are still in the collection of the Académie.

PLATE 22

1. Henry Talbot, manuscript list of negatives taken 12 November 1839 to 25 October 1840, Fox Talbot Museum, Lacock.

2. Nicolaas Henneman, manuscript "Coppies Send to Mr. Talbot Decr. 13/1845," LA45-164, Fox Talbot Museum, Lacock.

3. This was one of sixteen negatives listed in Henry Talbot's manuscript "Negves. lent to Hennn. Dec 10/52" (National Museum of Photography, Film & Television).

4. The negative is in the National Museum of American History, Smithsonian Institution (1995.0206.021). Sir John Herschel's print, formerly in the collection of André Jammes, is now in the Bibliothèque Nationale, Paris (E056[res]-05). There is another print in the same album in the Fox Talbot Museum, Lacock (LA2263); although all these are very pale and difficult to read, the edges warn that there is just a possibility that the two prints in this album came from extremely close variant negatives.

PLATE 23

1. The entry in this very miscellaneous notebook is not dated, but it is opposite one for February 1839; in any case, it would have been from the first half of that year (Talbot, Memoranda notebook, Lacock June 1838, Fox Talbot Museum, Lacock).

2. Henry Talbot to John Herschel, 21 March 1839, HS17:289, The Royal Society of London (*Document 03843*). The best known early application of this was done by Talbot's scientific colleague, Anna Atkins, in her *British Algae: Cyanotype Impressions* (1843), which used photography to reproduce both plates and her hand-lettered text. See Larry J. Schaaf, *Sun Gardens: Victorian Photograms by Anna Atkins* (New York: Aperture, 1985).

3. Although Talbot's notebook entry is not specifically dated, it falls between 28 February and 23 March 1840; *Notebook P* is held by the National Museum of Photography, Film & Television. See Larry J. Schaaf, *Records of the Dawn of Photography: Talbot's Notebooks P & Q* (Cambridge: Cambridge University Press, 1996), P169.

4. Originally published anonymously with sixteen stanzas, Byron reluctantly wrote three more at the request of his publisher (simply in order to expand the size of the publication beyond that which would attract the stamp tax). Shortly after this, the author's identity was revealed and the popular poem was included in an anthology. But Byron never favored the added stanzas, and they remained unpublished until after his death.

5. Thomas Moore, *The Works of Lord Byron; with His Letters and Journals, and His Life* (London: John Murray, 1832).

6. Thomas Moore to Henry Talbot, 6 August 1844, LA44-46, Fox Talbot Museum, Lacock (*Document 05028*).

7. Thomas Moore to Henry Talbot, 9 August 1844, LA44-48, Fox Talbot Museum, Lacock (*Document 05033*).

8. Talbot had originally planned fifty plates for *The Pencil of Nature* (only twenty-four were eventually published). His overall plan for the work, including the contribution Moore was to make, is outlined in "What Might Have Been," in Larry J. Schaaf's *Introductory Volume to the Anniversary Facsimile of H. Fox Talbot's "The Pencil of Nature"* (New York: Hans P. Kraus, Jr., 1989), 35–38.

9. Byron's original manuscript (ByL456 in the *Index of English Literary Manuscripts*) is now in the Harry Ransom Humanities Research Center, The University of Texas at Austin. It was included in the library of the Texas collector Miriam Lutcher Stark, but nothing else is known of its travels between the time Talbot held it and when it came to share the home of the Gernsheim Collection.

10. Henry Talbot to John Lubbock, 4 April 1840, LUB38T27, The Royal Society of London (*Document 04066*).

11. This is in the National Museum of American History, Smithsonian Institution

(1995.0206.003, *Schaaf 605*). A print from this was given by Talbot to Dr. Brabant before 30 June 1840 and is now in the collection of Göttingen University (M26869/Tech II. 7565-2). Two other negatives are in the Fox Talbot Museum, Lacock: LA3185 (*Schaaf 606*) and LA3184 (*Schaaf 967*), which was the source for a print in the National Museum of Photography, Film & Television (1937-1504).

PLATE 24

1. This is from Talbot's first paper on photography, read to the Royal Society on 31 January 1839. He published the full text as *Some Account of the Art of Photogenic Drawing, or the Process by Which Natural Objects May be Made to Delineate Themselves, Without the Aid of the Artist's Pencil* (London: R. and J. E. Taylor, 1839), 11.

2. H. F. Talbot, *The Pencil of Nature* (London: Longman, Brown, Green, and Longmans), part 1, June 1844.

3. It is listed in Henry Talbot's manuscript list of negatives taken 12 November 1839 to 25 October 1840, Fox Talbot Museum, Lacock.

4. National Museum of American History, Smithsonian Institution (1995.0206.059).

5. No. 6 in the Fox Talbot Museum, Lacock, inventory.

6. One example of the Maltese vase is in Calvert R. Jones's personal album; see Larry J. Schaaf, *Sun Pictures Catalogue Five: The Reverend Calvert R. Jones* (New York: Hans P. Kraus, Jr., 1990), pl. 9.

PLATE 25

1. John Herschel to Henry Talbot, 19 June 1840, National Museum of Photography, Film & Television (1937-4861, *Document 04098*).

2. This subsequent image is so rigid in its structure that it invoked in Mike Weaver an association with the gravedigger's tools! See his "Diogenes with a Camera," in *Henry Fox Talbot: Selected Texts and Bibliography* (Oxford: Clio Press, 1992), 21–22. The dated and waxed negative for this later view is in the National Museum of Photography, Film & Television (1937-1401, *Schaaf 2714*); no salt print of this is known to exist, but Weaver illustrates a modern print of it in fig. 20.

3. Henry Talbot, manuscript list of negatives taken 12 November 1839 to 25 October 1840, Fox Talbot Museum, Lacock.

4. Herschel's print was formerly in the collection of André Jammes and is now in the Bibliothèque Nationale, Paris (E056[res]-14). Bertoloni's print is in his album in the Metropolitan Museum of Art, New York (36.37-38). Brewster's print is in his album, formerly in the collection of Bruno Bischofberger, and now in the J. Paul Getty Museum (84.XZ.0574-104). It is illustrated in Graham Smith, *Disciples of Light: Photographs in the Brewster Album* (Malibu: The J. Paul Getty Museum, 1990), 144, pl. 104. Talbot kept one print in one of his own albums, now in the Fox Talbot Museum, Lacock (album No. 6, LA2176). Another print is in the National Museum of American History, Smithsonian Institution (1995.0206.590).

PLATE 26

1. A fine account of the early history of the society, including the social context in which it operated, is given in Roger Taylor, "The Graphic Society and Photography, 1839, Priority and Precedence," *History of Photography* 23, no. 1 (Spring 1999): 59–67. It is to be hoped that Mr. Taylor will extend his studies of photography and the Graphic Society into the 1840s.

2. *The Art-Journal* 11 (1 June 1849): 199.

3. Regulations of the Society.

4. Henry Talbot to Charles Babbage, 30 January 1840, add37191f229, British Library (*Document 04050*). Henry Talbot to Constance Talbot, 2 February 1840, LA(H)40-1, Fox Talbot Museum, Lacock (*Document 04015*).

5. "Graphic Society," *The Literary Gazette*, no. 1204 (15 February 1840): 108.

6. "Fine Arts, Graphic Society," *The Literary Gazette*, no. 1217 (16 May 1840): 315–16.

7. Although the whole height of the negative, and indeed some border, is retained in the other print, it is brutally trimmed in width to only 11 cm, completely cutting off the basket. Perhaps this was done to this particular print to fit the album: Talbot's album No. 3 is a small-format one, primarily composed of examples from 1840 and which appears to have been compiled by early 1841 (National Museum of Photography, Film & Television [1937-365/22]).

8. Henry Talbot, manuscript list of negatives taken 12 November 1839 to 25 October 1840, Fox Talbot Museum, Lacock.

PLATE 27

1. This is from Talbot's first paper on photography, read to the Royal Society on 31 January 1839. He published the full text as *Some Account of the Art of Photogenic Drawing, or the Process by Which Natural Objects May be Made to Delineate Themselves, Without the Aid of the Artist's Pencil* (London: R. and J. E. Taylor, 1839), 8–9.

2. Henry Talbot to Samuel Highley, Jr., 10 May 1853; published in the *Journal of the Society of Arts* (13 May 1853): 292 (*Document 06774*).

3. Illustrated in Ann Thomas's *Beauty of Another Order: Photography in Science* (London: Yale University Press, 1997), pl. 20.

4. National Museum of American History, Smithsonian Institution (1995.0206.091). It is cited in Henry Talbot's manuscript list of negatives taken 12 November 1839 to 25 October 1840, Fox Talbot Museum, Lacock.

5. Fox Talbot Museum, Lacock (LA2274).

PLATE 28

1. Henry Talbot, manuscript list of negatives taken 12 November 1839 to 25 October 1840, Fox Talbot Museum, Lacock. This negative is in the Royal Photographic Society (RPS025123, *Schaaf 2383*); Herschel's copy of a print from it is in the Bibliothèque Nationale, Paris (E056[res]-13).

2. That negative is in the Royal Photographic Society (RPS025161, *Schaaf 74*).

3. Talbot, Memorandum notebook (1840–44), Fox Talbot Museum, Lacock.

4. It is in the National Museum of Photography, Film & Television, 1937-3564.

5. Harrison Horblit Collection, Houghton Library, Harvard University (TypPr805.T820.021).

PLATE 29

1. This is from Talbot's first paper on photography, read to the Royal Society on 31 January 1839. He published the full text as *Some Account of the Art of Photogenic Drawing, or the Process by Which Natural Objects May be Made to Delineate Themselves, Without the Aid of the Artist's Pencil* (London: R. and J. E. Taylor, 1839), 6–7.

2. The excitement of Talbot's experiments surrounding this period can be seen in Talbot's own hand in Larry J. Schaaf, *Records of the Dawn of Photography: Talbot's Notebooks P & Q* (Cambridge: Cambridge University Press, 1996).

3. Talbot, manuscript list of negatives taken 12 November 1839 to 25 October 1840, Fox Talbot Museum, Lacock.

4. The letter from John Ivory Talbot is quoted from Lilian Dickins and Mary Stanton, eds., *An Eighteenth-Century Correspondence, Being the Letters . . . to Sanderson Miller, Esq., of Radway* (London: John Murray, 1910), 303–4.

5. Ibid., 308–9. A slightly different story was recalled by Miss Matilda Talbot, who related that the Great Hall was "decorated in an unusual fashion by terra-cotta figures, each standing in a separate niche of freestone, under a carved stone canopy. They were modeled by an Austrian artist, one Victor Alexander Sederbach, who was living in Lincoln's Inn Fields and whose work was very fashionable. He is said to have brought special clay with him, built a furnace in the grounds, and made and baked the figures on the spot. They are highly individual, and it is a great pity we do not know whom they are intended to represent" (Matilda Talbot, *My Life and Lacock Abbey* [London: George Allen and Unwin, 1956], 186). Even the great architectural historian Nikolaus Pevsner could only say that "on these brackets and in these niches stands the extraordinary statuary of *Victor Alexander Sederbach*, a pleasant, modest man and a cheap sculptor. Beyond that we know absolutely nothing about him. His Christian names sound North-East German, his surname South German or Austrian, and the statues in Austrian abbeys are indeed perhaps the nearest comparison to these wild, violent, and unrefined mid-c18 pieces. They are made of terracotta, and it has been suggested that Sederbach was perhaps a *Hafner*, i.e, stove-maker, and not a sculptor. Not even the programme which Sederbach followed is recorded" (Nikolaus Pevsner, revised by Bridget Cherry, *The Buildings of England: Wiltshire* [London: Penguin Books, 1975], 288–89).

6. Mike Weaver, "Diogenes with a Camera," in his *Henry Fox Talbot: Selected Texts and Bibliography* (Oxford: Clio Press, 1992); the Diogenes image is sensitively discussed on pages 1–6.

7. One is illustrated as being from the Fox Talbot Museum, Lacock. This must be a typographical error, for no print has been traced there, and the defects and edge trimming of the book copy precisely match the present print where it normally rests, with its corners hidden underneath slits in an album page (it was temporarily extracted for the present reproduction). It is figure 1 in Weaver, *Henry Fox Talbot: Selected Texts and Bibliography*.

8. National Museum of American History, Smithsonian Institution (1995.0206.093).

9. This later negative is in the Fox Talbot Museum, Lacock (*Schaaf 2490*); it is illustrated in Michael Gray's essay, "Zunächst verborgen, erscheine ich schließlich doch," in Hubertus von Amelunxen, *Die Aufgehobene Zeit: Die Erfindung der Photographie durch William Henry Fox Talbot* (Berlin: Verlag Dirk Nishen, 1988), 154. Prints from it are in National Museum of Photography, Film & Television (1937-1577) and in the Biblioteca Estense di Modena; this was from the collection of Giovan Battista Amici and is illustrated in Italo Zannier, *Henry Fox Talbot: La Raccolta della Biblioteca Estense di Modena* (Modena: Editphoto, 1978). The one in the Brewster album, formerly in the collection of Bruno Bischofberger and now in the J. Paul Getty Museum (84.XZ.0574.047), is illustrated in Graham Smith, *Disciples of Light: Photographs in the Brewster Album* (Malibu: The J. Paul Getty Museum, 1990), 36, fig. 13. Talbot kept a print in his own album (album No. 6, LA2208), and Amelina Petit kept one in her album (LA2221); both are now in the Fox Talbot Museum, Lacock.

PLATE 30

1. Today all three have been rid of them. The earlier removal can be seen in two views of the north courtyard. The first, taken 12 August 1842 (*Schaaf 2604*), shows the central chimney capped; the second (*Schaaf 2824*), undated but almost certainly done in 1844 or 1845, reveals a bare top. Both are illustrated in Larry J. Schaaf, *Sun Pictures Catalogue Three: The Harold White Collection of Photographs by William Henry Fox Talbot* (New York: Hans P. Kraus, Jr., 1987), pls. 27, 28.

2. One is not sure the architectural writer Joseph Gwilt would have been pleased with this. He observed that "in the external appearance of the chimney shafts, so as to group them with the building to which they belong . . . they become . . . as they always should do, parts of the building, inseparably connected with it, and their removal would detract from the majesty of the structure with which they are connected" (Gwilt, *An Encyclopædia of Architecture* [London: Longman, Brown, Green, and Longmans, 1842], 762).

3. Lady Elisabeth Feilding to Henry Talbot, 11 October 1831, LA31-54, Fox Talbot Museum, Lacock (*Document 02242*).

4. Carter, who died in 1766, was chiefly known for his carved marble chimneypieces, including those at Bowood. Talbot's 1840 photograph of the sphinx/chimney shaft mélange is illustrated in Mike Weaver, *Henry Fox Talbot: Selected Texts and Bibliography* (Oxford: Clio Press, 1992), fig. 5.

5. Henry Talbot, manuscript list of negatives taken 12 November 1839 to 25 October 1840, Fox Talbot Museum, Lacock.

6. Fox Talbot Museum, Lacock (LA2061).

PLATE 31

1. Henry Talbot to Sir John Herschel, 1 September 1840, HS17:303, The Royal Society of London (*Document 04133*).

2. Henry Talbot, manuscript list of negatives taken 12 November 1839 to 25 October 1840, Fox Talbot Museum, Lacock.

3. National Museum of American History, Smithsonian Institution (1995.0206.153).

4. Fox Talbot Museum, Lacock (LA2062).

PLATE 32

1. This is according to Talbot's manuscript negative list in the Fox Talbot Museum, Lacock. The negatives for two of these survive (in very weak condition) in the National Museum of American History, Smithsonian Institution. The first portrait was taken "without sun" in a five-minute exposure on 6 October (negative 1995.0206.088, *Schaaf 2493*); there are no known prints of it. The second, taken on 8 October, stretched the limits further; it was taken in five minutes without sun but in the evening (negative 1995.0206.108, *Schaaf 2497*); a print from this is illustrated in Larry J. Schaaf, *Sun Pictures Catalogue Nine, William Henry Fox Talbot: Friends and Relations* (New York: Hans P. Kraus, Jr., 1999), pl. 2. The first two, like the present plate, were essentially head and shoulder portraits. The third, taken on 9 October, deviated from this pattern by recording Constance standing in the garden in a three-minute exposure; the negative for this has not been traced. A very weak print from it, showing Constance standing in front of a rustic bench, is in an early album in a private collection in England. Its image area is 13.1 x 9.9 cm (*Schaaf 3842*).

2. Henry Talbot, letter to the editor, dated 5 February 1841; published in *The Literary Gazette*, no. 1256 (13 February 1841): 108 (*Document 04191*).

3. In turn, John Herschel had been influenced by the pioneering researches of his father, William. Sir John Herschel's research notes are voluminous and have yet to be studied in depth. An example of two pages of his notebook that dealt specifically with the effects of different colors of light, including examples of photosensitive paper attached, is illustrated as pl. 32 in Larry J. Schaaf, *Out of the Shadows: Herschel, Talbot, and the Invention of Photography* (London: Yale University Press, 1992).

4. Constance Talbot to Henry Talbot, 15 May 1840, Fox Talbot Museum, Lacock (*Document 04074*).

5. From Talbot's research notebook *P*; see Larry J. Schaaf, *Records of the Dawn of Photography: Talbot's Notebooks P & Q* (Cambridge: Cambridge University Press, 1996).

6. If it had been folded to fit into a frame or carrier, the central area would certainly exhibit a different density.

7. Henry Talbot, manuscript list of negatives taken 12 November 1839 to 25 October 1840, Fox Talbot Museum, Lacock.

8. National Museum of American History, Smithsonian Institution (1995.0206.047).

PLATE 33

1. Henry Talbot to Sir John Herschel, 18 March 1841, HS17:305, The Royal Society of London (*Document 04218*).

2. A small aperture would have had to have been used with the lens, increasing the depth of field and overall sense of sharpness but extending the time of exposure.

3. William L. Bathurst to Henry Talbot, 30 January 1840, Fox Talbot Museum, Lacock (*Document 04007*).

4. G. Fletcher and H. Fletcher to Henry Talbot, 19 February 1840, Fox Talbot Museum, Lacock (*Document 07355*).

5. Elisabeth Feilding to Henry Talbot, 22 February 1840, Fox Talbot Museum, Lacock (*Document 04039*).

6. Henry Talbot, manuscript list of negatives taken 12 November 1839 to 25 October 1840, Fox Talbot Museum, Lacock.

7. It is illustrated in Larry J. Schaaf, *Sun Pictures Catalogue Three: The Harold White Collection of Photographs by William Henry Fox Talbot* (New York: Hans P. Kraus, Jr., 1987), pl. 17.

8. Prints are known in the Agfa Foto Historama, Cologne (FH2793); the J. Paul Getty Museum (from the Arnold Crane Collection, 84.XM.1002.015); the Harry Ransom Humanities Research Center, The University of Texas at Austin (964:054:006); two are in the Fox Talbot Museum, Lacock (LA874 and one in Amelina Petit's album, LA2213); and two copies are in the National Museum of Photography, Film & Television, one in Talbot's album No. 4, thought to have been compiled by Lady Elisabeth Feilding (1937-366/105), and another in an album largely titled by Lady Elisabeth (1937-2536/23).

PLATE 34

1. Lady Elisabeth Feilding to Henry Talbot, 11 October 1831, LA31-54, Fox Talbot Museum, Lacock (*Document 02242*).

2. Although the formal terminology for this was long in the future (and Talbot may not have been fully aware of why he was doing what he was doing), this negative is an example of the approach that a modern photographer would take. There is a maxim among photographers of this sort of scene: *expose for the shadows, develop for the highlights*. The modern photographer allows sufficient exposure time to record the light in the deepest dark areas of the scene (although this exposure is now measured in seconds at most). Then, one limits the developing time to keep the bright areas of the scene (which will be dark in the negative) from getting too dense. This is an exceptional approach today, undertaken by only the most serious photographers. Talbot developed his calotype negatives under reduced light but not in the total blackness today's materials demand. He would have "developed by inspection," observing when the highlights had become sufficiently dense and stopping the process at that time. As a result, his negative could encompass the enormous range of brightness present in this scene.

3. Henry Talbot, manuscript list of negatives taken 12 November 1839 to 25 October 1840, Fox Talbot Museum, Lacock.

4. The negative is in the National Museum of Photography, Film & Television (1937-1514, *Schaaf 2317*); the only known print from it is an unfixed one that has darkened over the years (National Museum of American History, Smithsonian Institution [1995.0206.370]). This marvelous negative has been poorly served in modern book illustration. In one of my own earlier reproductions of the negative it was mistakenly reproduced in a brown tone, rather than the soft gray-lavender that it is: Larry J. Schaaf, *Out of the Shadows: Herschel, Talbot, and the Invention of Photography* (London: Yale University Press, 1992), pl. 51. A modern print from this negative (indicated as being in the Fox Talbot Museum, which has no vintage print) is plate 73 in Hubertus von Amelunxen, *Die Aufgehobene Zeit: Die Erfindung der Photographie durch William Henry Fox Talbot* (Berlin: Verlag Dirk Nishen, 1988).

5. Henry Talbot, manuscript list of negatives taken 12 November 1839 to 25 October 1840, Fox Talbot Museum, Lacock.

6. The negative for this is in the National Museum of American History, Smithsonian Institution (1995.0206.138, *Schaaf 1038*), and a print is in the Fox Talbot Museum, Lacock (LA2158).

7. National Museum of American History, Smithsonian Institution (1995.0206.121).

PLATE 35

1. Constance Talbot to Henry Talbot, 7 September 1835, LA35-26, Fox Talbot Museum, Lacock (*Document 03132*).

2. Formerly in the Rubel Collection, it is now in a private collection in North America; it was illustrated on the CD-ROM, image R158, included with Larry J. Schaaf, *Sun Pictures Catalogue Eight: The Rubel Collection* (New York: Hans P. Kraus, Jr., 1997).

3. The J. Paul Getty Museum (85.XM.150.47); Harrison Horblit Collection, the Houghton Library, Harvard University (TypPr805.T820.02); three other copies in private collections in North America. Four copies in the National Museum of Photography, Film & Television: one in Talbot's album No. 10, thought to have been compiled by Lady Elisabeth Feilding (1937-366/19); another in Talbot's album No. 4, also thought to have been compiled by Lady Elisabeth (1937-366/106); one in an album largely titled by Lady Elisabeth (1937-2536/3); and a loose print (1937-2620).

PLATE 36

1. Gail Buckland had an "intuition" that the hand was Talbot's and took this image and a portrait of Talbot to a palmist for a reading: "This is the hand of a man who could tune into the universe; who had psychic powers. Perhaps he did not recognize these powers, but he was extremely creative and this came from the same source. He could have been a scientist or an inventor" (Buckland, *Fox Talbot and the Invention of Photography* [Boston: David R. Godine, 1980], 193).

2. Mike Weaver, "Henry Fox Talbot: Conversation Pieces," in his *British Photography in the Nineteenth Century: The Fine Art Tradition* (Cambridge: Cambridge University Press, 1989), 16.

3. Henry Talbot, *English Etymologies* (London: John Murray, 1847), 64–65. The connections between Talbot's etymological pursuits and his photographs was first suggested by Gail Buckland but greatly expanded by Mike Weaver in "A Photographic Artist, W. H. F. Talbot," in his *The Photographic Art: Pictorial Traditions in Britain and America* (New York: Harper and Row, 1986), 10–15.

4. One copy is in Dr. John Adamson's album in the National Museums of Scotland, Edinburgh (NMS.T.1942.1.1/20/3); Brewster's copy is in his album in the J. Paul Getty Museum (84.XZ.0574.181; formerly in the collection of Bruno Bischofberger). Because of its faintness it remained unidentified and was cited but not illustrated in Graham Smith, *Disciples of Light: Photographs in the Brewster Album* (Malibu: The J. Paul Getty Museum, 1990), 125.

5. James Nasmyth and James Carpenter, *The Moon: Considered as a Planet, a World, and a Satellite* (London: John Murray, 1874), pl. 2. Reproduced in Lucien Goldschmidt and Weston J. Naef, *The Truthful Lens: A Survey of the Photographically Illustrated Book 1844–1914* (New York: The Grolier Club, 1980), pl. 73.

PLATE 37

1. First mentioned in a letter from Elisabeth Feilding to Henry Talbot on 12 January 1842, LA42-6, Fox Talbot Museum, Lacock (*Document 04423*).

2. The next two after this were both taken on 13 February 1843. In some essential ways, they were less successful than this one, for the framing is too loose, incorporating the entire doorway and a window to the right. Both of these negatives are dated; one is in the Royal Photographic Society (RPS025160, *Schaaf 2709*); the other is waxed and is in the National Museum of Photography, Film & Television (1937-1572, *Schaaf 2708*). The next known attempt was on 1 March 1843. The lighting is more boldly deployed in this one, but the overall effect still falls far short of the final version done a year later. The negative for this is in the National Museum of Photography, Film & Television (1937-1272, *Schaaf 2712*).

3. In the Fox Talbot Museum, Lacock.

4. One, formerly in the collection of André Jammes, is now in the National Gallery of Canada, Ottawa (P72:169:50). Two others are in albums thought to have been compiled by Lady Elisabeth Feilding and both now in the National Museum of Photography, Film & Television: one in Talbot's album No. 4 (1937-366/114) and another in his album No. 10 (1937-366/1). One other print is in a private collection in North America. Another is in an album compiled by Calvert R. Jones, which also includes works by the photographic pioneers Hippolyte Bayard and Antoine Claudet. See Larry J. Schaaf, *Sun Pictures Catalogue Five: The Reverend Calvert R. Jones* (New York: Hans P. Kraus, Jr., 1990).

PLATE 38

1. There is a substantial hook in the center of the ceiling to this day, indicating that a particularly heavy light fixture hung from here at some time in the past.

2. In a letter to the editor, dated 5 February 1841; published in *The Literary Gazette*, no. 1256 (13 February 1841): 108 (*Document 04191*).

3. Matilda Talbot, *My Life and Lacock Abbey* (London: George Allen and Unwin, 1956), 188.

PLATE 39

1. The negative for this was in the Arnold Crane Collection and is now in the J. Paul Getty Museum (85.XM.1002.7, *Schaaf 2367*). The negative is quite severely trimmed, with large chunks sliced out. Still, the scene must have impressed Talbot, for he sent an inscribed print of it to his friend Sir John Herschel; it is now in the Bibliothèque Nationale, Paris (E056[res]-11).

2. The undated negative is in the National Museum of Photography, Film & Television (1937-2068, *Schaaf 1161*). It is the source of prints in the Fox Talbot Museum, Lacock (LA289) and the George Eastman House (81:2850:01). The former is illustrated in H. J. P. Arnold, *William Henry Fox Talbot: Pioneer of Photography and Man of Science* (London: Hutchinson Benham, 1977), pl. 59; the latter in *Image* 7, no. 4 (1958): 95.

3. National Museum of Photography, Film & Television (1937-1449).

4. The first known print was made on paper watermarked J Whatman 1839, and the image area measures 16.7 x 21.6 cm. Although the print is faint, it shows that the bottom corners of the negative were clipped more severely than the top, and there are some blotches present in the lower area. Formerly in the collection of André Jammes, it is now in the National Gallery of Canada, Ottawa (P72:169:39). The National Museum of Photography, Film & Television has two other prints of this negative, one measuring 16.1 x 21.6 cm (1937-1549/1) and another measuring 13.9 x 21.1 cm (1937-1549/2). Another print measures 14.0 x 21.1 cm; it is in the Harrison Horblit Collection, Houghton Library, Harvard University (TypPr805.T820.027).

PLATE 40

1. The actual manipulatory details were not released until later: Henry Talbot to William Jerdan, letter to the editor, dated 19 February 1841; published in *The Literary Gazette*, no. 1258 (27 February 1841): 139–40 (*Document 04195*).

2. Henry Talbot to William Jerdan, letter to the editor, dated 5 February 1841; published in *The Literary Gazette*, no. 1256 (13 February 1841): 108 (*Document 04191*).

3. Henry Talbot to Sir John Herschel, 17 March 1841, HS17:304, The Royal Society of London (*Document 04214*). The actual print of Henneman that Talbot sent was donated to the Science Museum and is now in the National Museum of Photography, Film & Television (1943-33/5).

4. *Comptes Rendus* 12, no. 11 (15 March 1841): 492.

5. Translated from the French. Jean-Baptiste Biot to Henry Talbot, 16 March 1841, National Museum of Photography, Film & Television (1937-4872, *Document 04212*).

6. It is in the National Museum of American History, Smithsonian Institution, Washington, D.C. (1995.0206.009). There is now a neatly punched hole in the negative, approximately 3 cm from the top and 3.8 cm from the right edge, that corresponds to a light spot in some of the prints. A hole, of course, would allow the full amount of light through and would produce dark spots in that area of the print. It seems that a sample of a dark spot in the negative must have been extracted at some point for testing.

7. There are numerous contemporaneous references to this image, but the only association copy that is known to have survived is Sir John Herschel's copy; it was donated by Herschel's son to the Science Museum and is now in the National Museum of Photography, Film & Television (1943-33/5); the latter also has two loose prints of this (1937-2631/1–2), one of which is marked in French, possibly by Antoine Claudet, and includes the word "verte"—this might mean green, referring to the foliage, but can also mean unripe or blooming or undecayed or vigorous. Three other prints of this in the National Museum of Photography, Film & Television are in albums. One is in Talbot's album No. 10, thought to have been compiled by Lady Elisabeth Feilding (1937-366/2), and another is in a large-format album of calotypes (1937-2534/1). A final copy is in another

album, largely titled in Lady Elisabeth's hand (1937-2536/15); although soft in tone and not as visually complex an object as the present print, it is perhaps the most pleasing to the eye overall.

PLATE 41

1. The previous day, Lady Elisabeth had accompanied him to nearby Bowood for a similar purpose (Elisabeth Feilding, diary, 1841, Lacock Abbey Deposit, Wiltshire Record Office, Trowbridge).

2. A lively review of the vicissitudes of Corsham Court can be found in Nikolaus Pevsner, revised by Bridget Cherry, *The Buildings of England: Wiltshire* (London: Penguin Books, 1975), 192–94.

3. This is from Talbot's first paper on photography, read to the Royal Society on 31 January 1839. He published the full text as *Some Account of the Art of Photogenic Drawing, or the Process by Which Natural Objects May be Made to Delineate Themselves, Without the Aid of the Artist's Pencil* (London: R. and J. E. Taylor, 1839), 11.

4. Henry Talbot, letter to the editor, dated 5 February 1841; published *The Literary Gazette*, no. 1256 (13 February 1841): 108 (*Document 04191*).

5. Matilda Talbot, *My Life and Lacock Abbey* (London: George Allen and Unwin, 1956), 135.

6. The dated negative is in the J. Paul Getty Museum (85.XM.0150.034). The Campbell side of the present line, the Methuen-Campbells, is directly descended from Talbot's cousin Christopher Rice Mansell Talbot.

PLATE 42

1. Now the site of the Shell-Mex building.

2. Elisabeth Feilding, diary, 1841, Lacock Abbey Deposit, Wiltshire Record Office, Trowbridge.

3. Henry Talbot to Constance Talbot, 15 June 1841, LA41-39, Fox Talbot Museum, Lacock (*Document 04282*).

4. "Never did sun more beautifully steep / In his first splendour, valley, rock, or hill; / Ne'er saw I, never felt a calm so deep! / The river glideth at his own sweet will: / Dear God! the very houses seem asleep; / And all that mighty heart is lying still!" (William Wordsworth, "Composed Upon Westminster Bridge, September 3, 1802." Quoted from E. de Selincourt and Helen Darbishire, eds., *The Poetical Works of William Wordsworth*, 2d ed. [Oxford: Clarendon Press, 1954], 38).

5. William Thomas Horner Fox Strangways to Henry Talbot, 2 November 1841, LA41-64, Fox Talbot Museum, Lacock (*Document 04353*).

6. This print is in Talbot's album No. 10, thought to have been compiled by Lady Elisabeth Feilding. Phillipps's copy is in the Harrison Horblit Collection, the Houghton Library, Harvard University (TypPr805.T820.138); it is fairly strong, but with some blotches, and is inscribed in ink on the verso "River Thames." For a discussion of Talbot's connection with Phillipps over this image, see Larry J. Schaaf, "'Splendid Calotypes': Henry Talbot, Amelia Guppy, Sir Thomas Phillipps, and Photographs on Paper," in *Six Exposures: Essays in Celebration of the Opening of the Harrison D. Horblit Collection of Early Photography* (Harvard: The Houghton Library, 1999), 29. One is in the Fox Talbot Museum, Lacock (LA2138), in Talbot's album No. 9 (which he described as "bad"), and another, formerly in the collection of André Jammes, is now in a private collection in North America.

7. The next day he asked Constance to tell Nicolaas Henneman "to come up to Town by an early train on Friday morning. He had better bring with him 2 dozen sheets of iodized paper which Porter has been preparing" (postscript, dated 16 June, to the letter from Henry Talbot to Constance Talbot of 15 June 1841, LA41-39, Fox Talbot Museum, Lacock [*Document 04282*]). Charles Porter was a servant frequently called on to prepare photographic materials; see plate 53 below.

8. One shows the old Waterloo Bridge and the Shot Tower; this undated negative was formerly in the collection of Harold White and is illustrated in Larry J. Schaaf, *Sun Pictures Catalogue Three: The Harold White Collection of Works by William Henry Fox Talbot* (New York: Hans P. Kraus, Jr., 1987), pl. 49 (*Schaaf 1384*); the only known print of this is in Talbot's album No. 8 (which he termed "bad") in the Fox Talbot Museum, Lacock (LA2081). A similar image includes more foreground area and shows the Shot Tower more centered; the negative, dated "June 1841" is in the National Museum of American History, Smithsonian Institution (1995.0206.018, *Schaaf 2599*); the only known print from this is also in Talbot's album No. 8 in the Fox Talbot Museum, Lacock (LA2082). A completely faded negative, dated "June/41" is also in the National Museum of American History, Smithsonian Institution (1995.0206.002, *Schaaf 2600*); it is the source of a print in Talbot's album No. 10, thought to have been compiled by Lady Elisabeth Feilding (1937-366/43). Another negative showing the Shot Tower is in the same museum (1995.0206.096, *Schaaf 2601*); another of its negatives is too faint to read reliably but is dated "June/41" and appears to be consistent with the previous (1995.0206.195, *Schaaf 2602*).

PLATE 43

1. Caroline Mt. Edgcumbe to Henry Talbot, 7 September 1844, LA44-57, Fox Talbot Museum, Lacock (*Document 05057*).

2. Invoice, 16 September 1845, Fox Talbot Museum, Lacock.

3. Nicolaas Henneman to Henry Talbot, 31 October 1845, LA45-143, Fox Talbot Museum, Lacock (*Document 05428*). Mansion, an assistant to Antoine Claudet, was possibly the Leon Mansion who wrote the popular book *Letters upon the Art of Miniature Painting* (London: R. Ackermann, 1824); it was almost certainly the Leon Mansion who wrote *Guida dei fotografi per l'appli-*

cazione dei colori in polvere e della vernice-smalto di Mansion. Coll'aggiunta del processo di Sutton per l'intonazione delle prove positive, e del modo di adoperare il liquideo di diamond a pulire i vetri (Milan: G. Redaelli, 1865).

4. Nicolaas Henneman, manuscript "Coppies Send to M^r. Talbot De^cr. 13/1845," LA45-164, Fox Talbot Museum, Lacock.

5. "199. An aged Red Cedar Tree in the grounds of Mt. Edgecumbe [*sic*]."

6. National Museum of Photography, Film & Television (1937-2054).

7. National Museum of Photography, Film & Television (1937-2055/1). This is one of four loose prints under this number; 1937-2055/3 is the strongest in tone. Another fine print is in the Manfred Heiting Collection, illustrated as plate 9 in *At the Still Point: Photographs from the Manfred Heiting Collection*, vol. 1, *1840–1916* (Amsterdam: Cinumba, 1995). The copy in the Fox Talbot Museum, Lacock, is LA201. Another print is in a private collection in Ireland. The print in the National Gallery of Canada, Ottawa (P75:008:08), is in the Bath Photographic Society album. This album, hand-selected from prints in the abbey's archives by Talbot's son, Charles Henry Talbot, was presented to the Bath Photographic Society on 27 February 1889. It was sold by the society at Sotheby's in 1975.

8. This measures 9.9 x 8.0 cm and is a slightly more distant view of the tree, with much tighter cropping on the sides. A copy of this was in Thereza Mary Dillwyn Llewelyn's personal album, illustrated in Larry J. Schaaf, *Sun Pictures Catalogue Two: Lleweyln, Maskelyne, Talbot—A Family Circle* (New York: Hans P. Kraus, Jr., 1986), 44. This negative is in the National Museum of Photography, Film & Television (1937-2028, *Schaaf 248*); the museum has seven prints: 1937-2029/1–7. Other prints are: one in the Fox Talbot Museum, Lacock (LA202); one in Henri-Victor Regnault's album in the Société Française de Photographie (R83); and one in Alexander Ritchie's album in the Museum of Modern Art, New York (75.64-14).

PLATE 44

1. From Welsh mythology, as interpreted in Robert Graves, *The White Goddess: A Historical Grammar of the Poetic Myth*, amended and enlarged ed. (New York: Farrar, Straus, and Giroux, 1966), 33.

2. "At Innwood, between Lacock and Beanacre, there is a very singular *Oak Tree*. At about five feet from the ground, the trunk is divided into four stems, which rise perpendicularly and do not overhang the base of the parent stock, in consequence they look like so many trees growing from the same root. This tree is called the 'Four Sisters,' an appellation which has occasioned a mistake in some maps of the county, where we find the site of this tree marked as if it were a park, or seat, and named the *Fair Sister*, though there is no such place in the county" (John Britton, *The Beauties of Wiltshire*, vol. 3 [London: printed for the author, 1825], 245–46). This tree was still standing throughout Talbot's lifetime. On 26 May 1874, his cousin Louisa Charlotte Frampton asked him to measure its girth for her (Fox Talbot Museum, Lacock [*Document 02859*]). It is believed that this is the tree Talbot depicted in an undated image; the negative for this has not been located, but a print is in the Fox Talbot Museum, Lacock (LA224, *Schaaf 4239*).

3. Diary, 1841, Lacock Abbey Deposit, Wiltshire Record Office, Trowbridge.

4. Talbot, Memoranda, 1840–44, Fox Talbot Museum, Lacock.

5. In the National Museum of Photography, Film & Television (1937-2058). For a well-reproduced example of the present cropping, see page 91 in Hubertus von Amelunxen, *Die Aufgehobene Zeit: Die Erfindung der Photographie durch William Henry Fox Talbot* (Berlin: Verlag Dirk Nishen, 1988); unfortunately, there is a typographical error in the measurements here.

6. One, in an album in a private collection in Ireland, was labeled by Talbot's sister Horatia "Oak Tree in the Park at Carclew—Cornwall." Another, formerly belonging to the Rev. Calvert R. Jones, and now in the Thomas Walther Collection, is labeled in Talbot's hand "Oak Tree Carclew Park Cornwall." Two copies are in private collections in North America, one in an 1846 copy of the *Art-Union*. The Fox Talbot Museum, Lacock, has an excellent varnished copy (LA223). In addition to the present print, the National Museum of Photography, Film & Television has two other loose prints (1937-2059/1–2); the museum has an additional copy in Talbot's album No. 10, thought to have been assembled by Lady Elisabeth Feilding (1937-366/37).

7. "31. Remarkable Oak Tree in Carclew Park, Cornwall. *The seat of Sir C. Lemon, Bart., M.P.*"

PLATE 45

1. Charles Lemon to Henry Talbot, 18 September 1841, LA39-56, Fox Talbot Museum, Lacock (*Document 03935*).

2. Letter of 29 August 1841, quoted in Thomas Carlyle's *The Life of John Sterling* (London: Chapman and Hall, 1851), 276–77.

3. *The Works of D. Jonathan Swift, Containing Travels into Several Remote Nations of the World, by Lemuel Gulliver* (Edinburgh: G. Hamilton and J. Balfour, 1752), vol. 3, ch. 5, p. 170.

4. The negative is in the National Museum of Photography, Film & Television (1937-1380); the museum also holds the print from the early state of the negative, in Talbot's album No. 10, one thought to have been assembled by Lady Elisabeth Feilding (1937-366/36); in addition to this and the present print, the museum has two other copies of this image, one a loose print (1937-2623) and one in a calotype album, largely titled by Lady Elisabeth (1937-2536/13). The Fox Talbot Museum, Lacock, has one print (LA548). Two copies, one from the collection of André Jammes and one from the collection of Harold White, are in private collections in North America.

PLATE 46

1. Entry for 8 February 1840. See Larry J. Schaaf, *Records of the Dawn of Photography: Talbot's Notebooks P & Q* (Cambridge: Cambridge University Press, 1996), P167.

2. The widely reproduced ones most commonly associated with Talbot, depicting Antoine Claudet as one of the opponents, were almost certainly made in Claudet's studio and very likely had nothing to do with Talbot at all. See the discussion in Larry J. Schaaf, *Sun Pictures Catalogue Eight: The Rubel Collection* (New York: Hans P. Kraus, Jr., 1997), 18.

3. The collection of the National Museum of Photography, Film & Television includes several negatives: 1937-3862 (*Schaaf 975*)—the one for the present image; 1937-4400 (*Schaaf 970*); 1937-4406 (*Schaaf 971*); and 1937-4408 (*Schaaf 961*); one image survives only as a print in an album, 1937-366/57 (*Schaaf 1486*). The National Museum of American History, Smithsonian Institution has three negatives: 1995.0206.063, dated September 1841 (*Schaaf 2613*); 1995.0206.079 (*Schaaf 2018*); and 1995.0206.082, showing Goddard and dated 7 April 1842 (*Schaaf 2639*). In addition, there are two partial negatives in the National Museum of Photography, Film & Television that were once one; both are dated July 1842. One almost certainly depicts Sir David Brewster (1937-4402, *Schaaf 2667*); the other an unidentified woman (1937-1397, *Schaaf 2669*). It is difficult to imagine why Talbot cut this negative into two, but on 15 August 1842, Brewster complained to Talbot that "I fear the Chess party has failed from your mutilating it" (1937-4905, National Museum of Photography, Film & Television [*Document 04573*]).

4. This is in the National Museum of American History, Smithsonian Institution (1995.0206.063, *Schaaf 2613*). The date, in the upper left-hand corner of the verso, was partially cut off when that corner was clipped. Two prints are known from this negative, both in the Fox Talbot Museum, Lacock, and both are in Talbot's album No. 8, which he labeled as "bad" (LA2077 and LA2104).

5. In a private collection in Ireland. By the time this print was made, the top right-hand corner of the negative had been triply clipped and the bottom right corner had been trimmed.

6. In the National Museum of Photography, Film & Television (1937-3862).

PLATE 47

1. Caroline Mt. Edgcumbe to Henry Talbot, 5 August 1841, LA41-49, Fox Talbot Museum, Lacock (*Document 04318*).

2. Mary Talbot to Henry Talbot, 13 September 1841, LA41-55, Fox Talbot Museum, Lacock (*Document 04329*).

3. William Thomas Horner Fox Strangways to Henry Talbot, 2 November 1841, LA41-64, Fox Talbot Museum, Lacock (*Document 04353*).

4. Excluding simple arrangements of pots on a table, and others in which Talbot involved live people, the first positively dated examples of this genre were two negatives taken on 2 May 1840: one in the Royal Photographic Society (RPS025119, *Schaaf 2409*) and one in the National Museum of American History, Smithsonian Institution (1995.0206.021, *Schaaf 2358*). On 27 May 1840, Talbot took another negative, now in the Fox Talbot Museum, Lacock (the museum's print from it is LA2178, *Schaaf 2430*). On 3 September 1841, two negatives were taken: one now in the National Museum of American History, Smithsonian Institution (1995.0206.025, *Schaaf 2614*) and one that survives only as a print in the Fox Talbot Museum, Lacock (LA2109, *Schaaf 3849*); these were followed closely by two on 6 September, both now in the National Museum of Photography, Film & Television (1937-2516, *Schaaf 2616*; and 1937-1428, *Schaaf 2617*). The final dated one exists only as a print given to Amici, dated 22 April 1842, in the Biblioteca Estense di Modena (*Schaaf 4240*). Undated negatives are in the J. Paul Getty Museum (84.XM.1002.040, *Schaaf 141*); the Royal Photographic Society (RPS025153, *Schaaf 142*); and four in the National Museum of Photography, Film & Television (1937-1495, *Schaaf 1907*; 1937-2517, *Schaaf 1903*; 1937-2519, *Schaaf 1904*; and 1937-2520, *Schaaf 1905*).

5. The Royal Photographic Society (RPS025282, *Schaaf 2826*).

6. Eliza Meteyard's theories were first published in *The Life of Josiah Wedgwood, from His Private Correspondence and Family Papers* (London: Hurst & Blackett, 1865); they were amplified in *A Group of Englishmen* (London: Longmans, Green, and Co., 1871). R. B. Litchfield did his best to debunk these in his chapter "A Mythical Account of T. Wedgwood's Photographic Work," in his *Tom Wedgwood, The First Photographer* (London: Duckworth and Co., 1903), 241–45. Finally, Arthur Gill published one of his always-useful summaries of the situation in "The Supposed Early Photographs," *The Photographic Journal* 103 (October 1963): 286–93.

7. Henry Talbot to Dr. Hugh Welch Diamond, as secretary of the Photographic Society, 10 November 1863; printed in *The Photographic Journal* 9, no. 141 (15 January 1864): 430 (*Document 06559*).

8. Henry Talbot to Dr. Hugh Welch Diamond, as secretary of the Photographic Society, 25 November 1863; printed in ibid. (*Document 06593*).

9. None of the prints from the various negatives so far actually carries the label, but it appears on uncut letterpress sheets that Henneman had printed up: "61. A Breakfast Service."

10. The negative is in the National Museum of Photography, Film & Television (1937-2517), which also has one loose print (1937-2518). There is also a waxed print, once in the collection of Herbert Lambert, in a private collection in North America. The Fox Talbot Museum, Lacock, does not have a contemporary print, but a modern print in their collection, made from the National Museum of Photography, Film & Television negative, is shown in Robert Lassam, *Fox Talbot, Photographer* (Tisbury, Wiltshire: Compton Press, 1979), 53.

PLATE 48

1. Book IV, lines 460–68, *The Poetical Works of John Milton*, 2d ed., vol. 4 (London: J. Johnson, 1809), 119.

2. It can be seen in relation to his other casts in Larry J. Schaaf, *Out of the Shadows: Herschel, Talbot, and the Invention of Photography* (London: Yale University Press, 1992), pl. 74.

3. A negative dated "April 24. 1840" in Talbot's hand is in the National Museum of American History, Smithsonian Institution (1995.0206.060, *Schaaf 2394*); prints from it are in the Howard Stein Collection (formerly in the André Jammes Collection) and an interesting one that was printed in reverse, likely by Henneman, in Talbot's album No. 7 in the Fox Talbot Museum, Lacock (LA2282); this was reversed back to the correct orientation by an overly conscientious printer for the plate in Robert Lassam, *Fox Talbot, Photographer* (Tisbury, Wiltshire: Compton Press, 1979), 73. The first mention of a negative of *Eve* is four days later, on 28 April 1840, in Talbot's manuscript list of negatives taken 12 November 1839 to 25 October 1840, Fox Talbot Museum, Lacock (*Schaaf 2405*), but there are no known prints from it. The last positively dated negative was made on 9 August 1843 and is in the Royal Photographic Society (RPS025152, *Schaaf 2746*). Although there are no known prints of it, this is likely explained by the fact that its inscription indicates that it was part of an experimental series: "µ π. No 2ᵈ· wash." Although this experiment is beyond the date range of Talbot's notebook Q, its roots can be seen on pages Q77 and Q103 in Larry J. Schaaf, *Records of the Dawn of Photography: Talbot's Notebooks P & Q* (Cambridge: Cambridge University Press, 1996).

4. "222. Eve at the Fountain."

5. The negative is in the National Museum of Photography, Film & Television (1937-2821). Both prints are in the Royal Photographic Society (RPS025178 and RPS025179).

PLATE 49

1. William Thomas Horner Fox Strangways to Henry Talbot, 22 February 1840, Fox Talbot Museum, Lacock (*Document 04038*).

2. Visually similar high-contrast images, employing different botanical subjects, are found throughout Talbot's work, although they are rarely so dramatic as the present one. In some cases, the lighter areas of the negatives have faded (these parts are generally the most delicate and most vulnerable), leaving behind white paper and still-dense dark areas and giving a false sense of the original contrast. Examples include three in one of Talbot's albums in the Fox Talbot Museum, Lacock: LA2052 (*Schaaf 861*); LA2053 (*Schaaf 1185*); and LA2054 (*Schaaf 857*). The same umbellifer fern used to make LA2052 was employed to make a negative in the J. Paul Getty Museum (84.XM.1002.57, *Schaaf 1887*). The National Museum of Photography, Film & Television has two similar items in Talbot's album No. 15: a negative 1937-2533/41 (*Schaaf 1705*) and a negative 1937-2533/42 (*Schaaf 1183*) with matching print 1937-2533/43; all of these are watermarked 1842.

3. It was sent by Talbot to Professor Martius on 10 June 1842 and was made on paper watermarked J Whatman Turkey Mill 1839. In Talbot's letter sending this group of material, he explained that most of the items were made by his new method of calotype, but that some were made by the method he discovered in 1834 (photogenic drawing); the letter (*Document 04530*), along with eleven surviving Talbot examples, was recently discovered in the archives of the Bavarian Academy of Science, Munich, by Ulrich Pohlmann. The negative is illustrated in his *Alois Löcherer: Photographien 1845–1855* (Munich: Fotomuseum im Münchner Stadtmuseum, 1998), pl. 2 (*Schaaf 4212*).

PLATE 50

1. This is recorded in Talbot's Memoranda notebook, started in London in May 1840 and carrying entries through April 1844 (Fox Talbot Museum, Lacock).

2. Sir John Herschel to Henry Talbot, 16 March 1841, National Museum of Photography, Film & Television (1937-4873, *Document 04213*).

3. Henry Talbot to Sir John Herschel, 18 March 1841, HS17:305, The Royal Society of London (*Document 04218*).

4. Henry Talbot to William Thomas Horner Fox Strangways, 11 December 1834, LA(H)34-15, Fox Talbot Museum, Lacock (*Document 03016*).

5. Letter (in French), N. P. Lerebours to Henry Talbot, 26 October 1846, Fox Talbot Museum, Lacock (*Document 05760*).

6. It is in the National Museum of Photography, Film & Television (1937-2049). There is a trace of a paper tab pasted to the negative; these were used in pairs to paste the negative to the glass of the printing frame, in order to keep the negative in one place. The printing was done on Talbot's original photogenic drawing paper, a print-out paper, and the printer would periodically open the frame partially to see how the density of the print was coming along. It was important for the negative and print to stay in registration in case they had to be returned to the sun for more exposure. While the meaning of these in the context of the Talbot archives is not fully understood, they appear mostly on negatives that were done in the late 1840s (often by Henneman or Calvert Jones) or ones that were known to have been printed from later in Henneman's operation (i.e., into the early 1850s). The image of these tabs shows clearly in the prints and would normally have been trimmed off. None of the known prints of the present image appears to have been made after the tab was attached.

7. Charles Isaacs Collection (871004). A mounted copy, carrying a "Patent Talbotype" label and priced for commercial sale by Henneman is in the Harrison Horblit Collection, the Houghton Library, Harvard University (TypPr805.T820.110). The National Museum of Pho-

tography, Film & Television has thirteen loose prints (1937-2050/1–12 and 1937-389/2). The Fox Talbot Museum, Lacock, has a loose print (LA214) and one mounted in an album of mostly later calotypes (LA2034). One print was a gift presented in 1937 by Miss Matilda Talbot to Auckland Institute (C26453). The Gilman Paper Company Collection copy was illustrated in Maria Morris Hambourg, et al., *The Waking Dream: Photography's First Century* (New York: The Metropolitan Museum of Art, 1993), pl. 10. Another fine print is in the Manfred Heiting Collection, illustrated as plate 10 in *At the Still Point, Photographs from the Manfred Heiting Collection*, vol. 1, *1840–1916* (Amsterdam: Cinumba, 1995).

PLATE 51

1. On 28 February 1842, Constance wrote to her husband to report that "our Nurse, Eliza Frayland, pleases me very much.—She is a clean, good-natured, & healthy-looking person—And as far as I can judge in one day, is very civil, quiet & respectful in her manner with nothing vulgar or awkward—only a little shy, which is natural.—Our little dear has not been backward in enjoying her since she came last evening—He has had a few uncomfortable hours today, which Mrs Havergal says is always the case with the first change of food" (Fox Talbot Museum, Lacock, *Document 01047*).

2. William Thomas Horner Fox Strangways to Henry Talbot, 2 July 1841, Fox Talbot Museum, Lacock (*Document 04295*).

3. In the National Museum of Photography, Film & Television (1937-2493). The other print is in a sketchbook of Constance Talbot's and is in a private collection in England.

PLATE 52

1. Essentially, by using bromine as well as iodine to fume the plates.

2. Jabez Hughes, "The Discoverer of the Use of Bromine in Photography: A Few Facts and an Appeal," *British Journal of Photography* 10, no. 204 (15 December 1863): 487–88. The English Goddard is often confused with the American of the same surname, Dr. Paul Beck Goddard, whom Marcus Root later put forward as the inventor of bromine-accelerated daguerreotypes. These claims were disproven more than seventy years ago but the confusion persists in some historical accounts. See "The Two Goddards and the Improvement of the Daguerreotype," *British Journal of Photography* 79, no. 3742 (29 January 1932): 58. Additional information on Goddard is in Arthur T. Gill's typically thorough "J. F. Goddard and the Daguerreotype Process," *Photographic Journal* 106, no. 11 (November–December 1966): 370–76, 389–95.

3. In August 1841. The literature on Collen's portraiture is inadequate; some indication of his early efforts is outlined in Larry J. Schaaf, "Henry Collen and the Treaty of Nanking," *History of Photography* 6, no. 4 (October 1982): 353–66, and "Addenda to Henry Collen and the Treaty of Nanking," *History of Photography* 7, no. 2 (April–June 1983): 163–65.

4. Richard Beard to Henry Talbot, 2 April 1842, Fox Talbot Museum, Lacock (LA(B)42-12, *Document 04478*).

5. Diary, 1842, Lacock Abbey Deposit, Wiltshire Record Office, Trowbridge.

6. Organized by the eccentric scientist David Boswell Reid, the *Exhibition of Arts, Manufactures, and Practical Science* opened at the Assembly Rooms in Edinburgh in December 1839. A special room was dedicated to Goddard's polariscope, and regular demonstrations allowed public audiences to view the seemingly magical effects of polarized light. Talbot's childhood friend Sir Walter Calverly Trevelyan was one of the committee members, and he placed on exhibition twenty of Talbot's photogenic drawings. Some of these were recently acquired from the Trevelyan family by the National Museum of Photography, Film & Television. See Larry J. Schaaf, "Henry Talbot's First Exhibition in Scotland," *Studies in Photography 1998* (Edinburgh: The Scottish Society for the History of Photography, 1998), 25–28.

7. "In memory of John Frederick Goddard, Esq., late of Brook Green, Hammersmith; born on 8th December, 1797, and died on 28th December, 1866. He was distinguished for his discoveries in science. In 1838 he received from the Society of Arts a silver medal for his apparatus for experiments on polarised light, and in 1840 he discovered the use of bromine in photography, the value of which is well known to the photographic world, and this valuable discovery was published in the *Literary Gazette* of December in the same year. He was one of the earliest lecturers on the oxyhydrogen microscope, and was lecturer at the Adelaide Gallery and Royal Polytechnic Institution on optics and kindred subjects, and the greater part of his life was spent in scientific pursuits. He died much respected, and was a steadfast follower of the Catholic faith, R.I.P." Transcribed in *British Journal of Photography* 14, no. 370 (7 June 1867): 273.

8. One is illustrated in John Ward, *Printed Light: The Scientific Art of William Henry Fox Talbot and David Octavius Hill with Robert Adamson* (Edinburgh: Scottish National Portrait Gallery, 1986), pl. 72. The waxed negative for this is in the National Museum of Photography, Film & Television (1937-3874, *Schaaf 1920*), which also has a print from it (1937-3875). Another negative is in the same museum (1937-3864, *Schaaf 973*), which also has two loose prints of it (1937-3863/1–2) and one mounted in a small album of people posing in front of backdrops, thought to have been produced by Nicolaas Henneman and Thomas Augustine Malone (1937-2532/20).

9. One of the best prints is the one Talbot sent to his friend Dr. Carl Fredrich von Martius; it is illustrated in Ulrich Pohlmann, *Alois Löcherer: Photographien 1845–1855* (Munich: Fotomuseum im Münchner Stadtmuseum, 1998), pl. 4. The National Museum of Photography, Film & Television has two copies of this, one in an album largely titled by Lady Elisabeth Feilding (1937-2536/04), and one in a large-format album of calotype views (1937-2534/11). The Fox Talbot Museum, Lacock, also has two copies, one in Talbot's album No. 9 (LA2152) and one that is heavily retouched and outlined, much in the manner of some of the prints done by Talbot's

licensee, the miniature painter Henry Collen (LA860). Sir John Herschel's copy is a strangely unexplained one; with two sets of photographic borders, it might have been made from a now-unknown copy negative—it was initialed and dated 1842 in ink by Talbot. Once in the collection of André Jammes, it is now in the Bibliothèque Nationale, Paris (E056[res]-02).

PLATE 53

1. The full inscription was "from the life, in one minute ¼, H.F. Talbot 1842." Herschel's print was donated to the Science Museum by his son; it is now in the National Museum of Photography, Film & Television (1943-33/1).

2. Sir John Herschel to Henry Talbot, 21 April 1842 (1937-4900, National Museum of Photography, Film & Television, *Document 04490*). In this same batch Talbot sent Herschel a copy of *The Handshake*; it is in the collection of the Bibliothèque Nationale, Paris (E056-2).

3. Robert Hunt to Henry Talbot, 22 April 1842, LA42-23, Fox Talbot Museum, Lacock (*Document 04493*).

4. One is an experimental negative of Lady Feilding, dated 9 April 1842, and illustrated in Larry J. Schaaf, *Sun Pictures Catalogue Three: The Harold White Collection of Works by William Henry Fox Talbot* (New York: Hans P. Kraus, Jr., 1987), pl. 18.

5. Diary, 9 April 1842, Lacock Abbey Deposit, Wiltshire Record Office, Trowbridge.

6. Obviously inspired during this visit by the potential of photography on paper, Goddard quickly wrote to Talbot that although he had "not yet had an opportunity of making any experiments in the Calotype I am having a room at the Western Establishment fitted up for the purpose and the necessary apparatus &c made and in a few days hope to be doing something with it" John Frederick Goddard to Henry Talbot, 14 April 1842, LA42-22, Fox Talbot Museum, Lacock, *Document 04486*). No operation called the "Western Establishment" has yet been traced for London in this period; perhaps Goddard was referring to the rooms of the Western Literary Institution, in Leicester Square. Unfortunately for this developing relationship, Richard Beard and Henry Talbot were unable to agree to terms for the license, and Beard soon dropped the idea. However, this did not signal the end of Talbot's relationship with his fellow scientist. Talbot offered Goddard a license for the calotype exclusively for the county of Hampshire, with the first year free from 1 December 1842 (this arrangement is recorded in a memorandum in Talbot's hand, outlining the terms at a rate of 25% of the income, in a private collection in North America). There is presently no evidence that this was put into effect, but the contact obviously continued. In March 1846, Henneman billed Talbot for nine pounds for "expenses during Mr. Goddard's stay." This is during the period when Talbot was preparing to take over Henneman's operation and he was seeking someone to manage the business end of the affairs. Was Goddard a candidate?

7. Henry Talbot to John Frederick Goddard, 1 July 1854, BR f91 B60 n. 40, Manchester Central Library (*Document 07017*).

8. "Settlement of the Goddard Fund," *British Journal of Photography* 15, no. 448 (4 December 1868): 576. Goddard's epitaph and occasional contemporary accounts stress that he continued his interest in science. In 1863, Jabez Hughes made an impassioned and persuasive plea for a Goddard Relief Fund to recognize the inventor's contributions to the art of photography. See Jabez Hughes, "The Discoverer of the Use of Bromine in Photography: A Few Facts and an Appeal," *British Journal of Photography* 10, no. 204 (15 December 1863): 487–88. The Goddard Relief Fund persisted through the end of his life and wound up with a surplus after his death. Dr. Hugh Diamond, George Shadbolt, George W. Simpson, and T. R. Williams served with Hughes on the committee, and its appeals met with an enthusiastic response from grateful daguerreotypists who still remembered the impact of his contribution. In this sympathetic climate, claims were made by well-intentioned supporters that Goddard was the first to apply bromine to photography. Henry Talbot was prompted into a rare response, pointing out his own introduction of bromine into photogenic drawing in March 1839, a fact that was rapidly communicated to the Académie des Sciences in Paris. See Henry Talbot, letter to the editor of 31 March 1864, "The First Use of Bromine in Photography," *British Journal of Photography* 11, no. 212 (15 April 1864): 127–28 (*Document 07030*). Even by the 1890s the *British Journal of Photography* found it necessary to comment forcefully on this subject, stating in no uncertain terms that "the evidence . . . leaves no room for doubt that Mr. Fox Talbot was the first to apply bromine to photography." "Who first suggested the use of bromine in photography?," *British Journal of Photography* 38, no. 1633 (21 August 1891): 529–30. Equally, there is no doubt that John Frederick Goddard was the first to apply this critical element to the practice of the daguerreotype.

9. In the National Museum of Photography, Film & Television (1937-1513).

10. Another print from this state was owned by Sir John Herschel and donated to the Science Museum by his son; it is now in the National Museum of Photography, Film & Television (1943-33/1); the museum also has one in an album, largely titled by Lady Elisabeth Feilding (1937-2536/24). A varnished print from this state is in an album once owned by Talbot's sister Horatia and now in a private collection in Ireland. An intermediate state, with the two bottom corners neatly trimmed, can be seen in Larry J. Schaaf, *Sun Pictures Catalogue Nine: William Henry Fox Talbot, Friends and Relations* (New York: Hans P. Kraus, Jr., 1999), pl. 14 (three different prints of this image are illustrated in this catalogue). Later prints, with one bottom corner of the negative clipped doubly, are in Talbot's album No. 9, in the Fox Talbot Museum, Lacock (LA2148), and in a large-format album of calotypes in the National Museum of Photography, Film & Television (1937-2534/10). Three prints are known in private collections in North America.

PLATE 54

1. The negative (*Schaaf 2656*) is reproduced in Larry J. Schaaf, *Sun Pictures Catalogue Three: The Harold White Collection of Works by William Henry Fox Talbot* (New York: Hans P. Kraus, Jr., 1987), pl. 36.

2. Introduced by their common friend Sir David Brewster, Talbot and Hill and Adamson respected each others' contributions and maintained a friendly, if sporadic, awareness of each others' work. The contributions of the Scottish partnership are best followed in the various publications by Sara Stevenson, starting with her *David Octavius Hill and Robert Adamson: Catalogue of Their Calotypes Taken between 1843 and 1847 in the Collection of the Scottish National Portrait Gallery* (Edinburgh: National Galleries of Scotland, 1981).

3. In this view, a prominent candle provides a conceit for the strangely artificial nature of the light in the scene. The negative for this is in the National Museum of Photography, Film & Television (1937-1426, *Schaaf 2627*), which also holds a print from it in Talbot's album No. 10, thought to have been compiled by Lady Elisabeth Feilding (1937-366/23). Another print is in Talbot's album No. 9 in the Fox Talbot Museum, Lacock (LA2137). A privately held print is illustrated in Larry J. Schaaf, *Sun Pictures Catalogue Nine: William Henry Fox Talbot, Friends and Relations* (New York: Hans P. Kraus, Jr., 1999), pl. 8.

4. But this has so often been confused that it led to Talbot's biographer devoting a section of a journal article to the question: H. J. P. Arnold, "A Question of Identity: Who Were 'Pullen' and 'Porter'," in "Talbot and the 'Great Britain'," *British Journal of Photography* 134 (28 August 1987): 986–89. Samuel Pullen was the groom at Lacock and was far too old to have been the subject of this portrait. Pullen originally worked for Talbot's stepfather, Admiral Charles Feilding, but in 1828 the responsibility for his wages was transferred to Talbot. He eventually married a younger servant at Lacock, and the Talbot family much regretted his retirement in the early 1860s. Pullen appears in a number of Talbot's photographs, perhaps most spectacularly in *The Footman* (pl. 33). The form of Pullen's body, but frustratingly not his face, can be seen in *The Woodcutters* (pl. 97).

5. It is possible that he was Charles Fleetwood Porter, who graduated from Caius College, Cambridge, in 1853. Talbot had approached his father (also Charles Porter) in 1832 hoping that he would take over the curacy of Lacock; however, the vicarage proved to be unsuitable. Possibly the son came to Lacock for a period; the age would have been about right and his attendance at Cambridge would explain his absence in 1851. In 1863, Talbot once again tried to lure the elder Porter to Lacock. He was unwilling to move that late in life but suggested that Talbot come listen to a sermon by his son in the nearby parish. In the end, another curate was chosen for Lacock.

6. Constance Talbot to Henry Talbot, 7 July 1841, LA41-46, Fox Talbot Museum, Lacock (*Document 04301*).

7. This print is in a large format Talbot album. The negative is in the National Museum of American History, Smithsonian Institution (1995.0206.066); the other print is in the National Museum of Photography, Film & Television, in an album largely titled by Lady Elisabeth Feilding (1937-2536/10).

PLATE 55

1. Canova's original marble, dating from 1805–8, referred to the Venus Victrix in the Judgment of Paris. The aristocratic Paolina Borghese struck a neoclassical pose, nude to the waist, in the style of a goddess of antiquity—a daring move for a person of nobility, but one that Lady Elisabeth would have been unlikely to imitate. Recently restored, it is on display in the Borghese Gallery in Rome.

2. Text for "Articles of Glass," part 1, June 1844.

3. Elisabeth Feilding to Henry Talbot, 11 February 1821, LA21-6, Fox Talbot Museum, Lacock (*Document 00911*).

4. One is in the Brewster Codex in the J. Paul Getty Museum (84.XZ.0574.061); it is illustrated in Graham Smith, *Disciples of Light: Photographs in the Brewster Album* (Malibu: The J. Paul Getty Museum, 1990), 136, pl. 61. The other two are in the National Museum of Photography, Film & Television, one a loose print (1937-2461) and one in Talbot's album No. 4, one of a pair of albums thought to have been compiled by Lady Elisabeth Feilding (1937-366/124).

5. The dated and waxed negative for this image (*Schaaf 2659*) measures 10.4 x 16.1 cm and is in a private collection. Two prints from it are known, one in Talbot's album No. 9 in the Fox Talbot Museum, Lacock (LA2131), and one in the National Museum of Photography, Film & Television (1937-2462).

PLATE 56

1. In the National Museum of Photography, Film & Television (1937-2230). The copy in the Fox Talbot Museum, Lacock, is LA210, and the National Museum of Photography, Film & Television has eight prints (1937-2231/1–8); one is titled "Hydrangea" in ink on recto and verso and has a Nicolaas Henneman price on the verso. There is a print in the Richard Menschel Collection, and another fine print is in the Manfred Heiting Collection; it is illustrated as plate 12 in *At the Still Point: Photographs from the Manfred Heiting Collection*, vol. 1, *1840–1916* (Amsterdam: Cinumba, 1995).

2. One, measuring 8.4 x 10.0 cm, has the bush filling the frame more tightly. It is in the National Museum of Photography, Film & Television (1937-2025, *Schaaf 15*), which has fifteen prints from it (1937-2026/1–15); two of them are very good. The Royal Photographic Society also has a varnished and mounted copy, priced for sale by Nicolaas Henneman. This version is illustrated in Gail Buckland, *Fox Talbot and the Invention of Photography* (Boston: David R.

Godine, 1980), 172. The National Museum of Photography, Film & Television also has a waxed negative measuring 7.8 x 9.4 cm (1937-2232, *Schaaf 166*) and twenty-four prints made from it (1937-2233/1–24).

3. "163–165. A Bush of *Hydrangea* in flower."

PLATE 57

1. See Charles Edgcumbe, "Mount Edgcumbe," *Pall Mall Magazine* 12 (May 1897): 12.

2. Robert Graves, *The White Goddess: A Historical Grammar of the Poetic Myth*, amended and enlarged ed. (New York: Farrar, Straus, and Giroux, 1966), 38.

3. It was plate twenty-three of twenty-four. Many of the photographs were by Calvert Jones, some by George Bridges, some by Talbot, one possibly by Nevil Story-Maskelyne, and one by Antoine Claudet. As far is known, only one copy of this interesting work was made up, although the setting of the letterpress and the preparation of the mounts should have encouraged more than one sample. The title page lists Henneman as the publisher and a publication date of 1847. The only known copy is in the National Museum of Photography, Film & Television (1937-2530/1–24).

4. The negative is in the National Museum of Photography, Film & Television (1937-2042), which also has seven loose prints (1937-2043/1–7) and one mounted in Henneman's *Talbotypes or Sun Pictures* (1937-2530/23). Prints are in Fox Talbot Museum, Lacock (LA212), and mounted in an album largely titled in Talbot's hand (LA2031). There is a print in the Toledo Art Museum (87.182), the Richard Menschel Collection, and one in a private collection in North America.

PLATE 58

1. Henry Talbot to Sir John Herschel, 28 February 1840, HS17:300, The Royal Society of London (*Document 04046*).

2. This variety is explored in Susan L. Taylor, "Fox Talbot as an Artist: The 'Patroclus' Series," *Bulletin, The University of Michigan Museums of Art and Archaeology* 8 (1986–88): 38–55.

3. Just when Talbot acquired the bust of Patroclus is not known. His mother had plaster busts for many years before photography; on 12 April 1840, she recorded in her diary that "Henry broke the bust of Clytie, which I have had for 43 years!" (Fox Talbot Museum, Lacock). Talbot recorded having visited 41 Albany Street, Regents Park, London to see "plaster casts" in early March 1839 but did not mention what, if anything, he purchased (Memoranda notebook, Lacock June 1838, Fox Talbot Museum, Lacock).

4. The earliest positively dated negative was in the André Jammes Collection and is now in the National Gallery of Canada, Ottawa (P72:169:30, *Schaaf 2318*); two prints are known from this, both in Talbot's album No. 7 in the Fox Talbot Museum, Lacock (LA2251 and LA2255). The negative for plate XVII of the *The Pencil of Nature* has not been traced; the image is *Schaaf 3664*. To this range of dates one must add an anomalous experiment involving *Patroclus* and dated September 1845. This is a matching set of two experimental negatives. They are in a hand-made envelope, inscribed in pencil "2 Patroclus facsimiles to be superposed Sept/45." They are waxed and the inscription was obviously written on the envelope while they were inside as the writing has transferred to the wax. This group is in the National Museum of Photography, Film & Television (1937-1540/1–3, *Schaaf 2808*).

5. It is BM1860. For a more complete history of Townley's collection, see B. F. Cook, *The Townley Marbles* (London: The British Museum, 1985).

6. See Giulio Jacopi, *The Grotto of Tiberius and the National Archaeological Museum, Sperlonga* (Rome: Istituto Poligrafico dello Stato, 1967). A scholarly study is by Gösta Säflund, *The Polyphemus and Scylla Groups at Sperlonga* (Stockholm: Almquist and Wiksell, 1972). The latest research is summarized in Nicoletta Cassieri, *La grotta di Tiberio e il Museo Archeologico Nazionale, Sperlonga* (Rome: Libreria dello Stato, 2000).

7. One is in the Humboldt album, Agfa Foto Historama, Cologne (FH2778); one in the Maitland Codex at the J. Paul Getty Museum (85.XZ.0262.036); Fox Talbot Museum, Lacock (LA794); a gift from Miss Matilda Talbot is in the National Museums of Scotland, Edinburgh (1937.92.5); Lady Elisabeth Feilding sent a copy to the duke of Devonshire on 2 February 1846, and it is still in the collection at Chatsworth (864-21). Nine are in National Museum of Photography, Film & Television: one in Talbot's album No. 15 (1937-2533/27); one from the Kodak Museum (1990-5151); and seven other loose prints (1937-2695/1–7). For other prints of this that are included in copies of *The Pencil of Nature*, see Larry J. Schaaf, "Henry Fox Talbot's *The Pencil of Nature*: A Revised Census of Original Copies," *History of Photography* 17, no. 4 (Winter 1993): 388–96.

8. Account book of John Gale Sen. & Jr., Lacock, 2198/2, Wiltshire Record Office, Trowbridge.

9. The other negative referred to in this text, "Part of Queen's College, Oxford" (pl. 72), was only damaged. Talbot observed that "a very great number of copies can be obtained in succession, so long as great care is taken of the original picture. But being only on paper, it is exposed to various accidents; and should it be casually torn or defaced, of course no more copies can be made. A mischance of this kind having occurred to two plates in our earliest number after many copies had been taken from them, it became necessary to replace them by others; and accordingly the Camera was once more directed to the original objects themselves, and new photographic pictures obtained from them, as a source of supply for future copies. But the circumstances of light and shade and time of day, &c. not altogether corresponding to what they were on a former occasion, a slightly different but not a worse result attended the experiment" (text for pl. XXIV, "A Fruit Piece," part 6, April 1846).

PLATE 59

1. George Butler to Henry Talbot, 25 March 1841, LA41-22, Fox Talbot Museum, Lacock (*Document 04226*).

2. Henry Talbot to John Herschel, 18 March 1841, HS17:305, The Royal Society of London (*Document 04218*).

3. Captain Rooke to Henry Talbot, 13 November 1834, LA34-44, Fox Talbot Museum, Lacock (*Document 03005*).

4. Elisabeth Feilding to Henry Talbot, 14 November 1838, Fox Talbot Museum, Lacock (*Document 03752*).

5. Elisabeth Feilding to Henry Talbot, 29 August 1842, Fox Talbot Museum, Lacock (*Document 04598*).

6. In the Fox Talbot Museum, Lacock (LA3065); its print is LA226. There are fourteen prints in the National Museum of Photography, Film & Television (1937-2045/1–14); of these, eleven were made when the stub was still on the negative and three were not. Another print (without the stub) is in the National Gallery of Art, Washington, D.C. (1995.36.117). One in the J. Paul Getty Museum (84.XM.0893.001) is illustrated as plate 4 in Larry J. Schaaf, *Sun Pictures Catalogue One: Early British Photographs on Paper* (New York: Hans P. Kraus, Jr., 1983).

PLATE 60

1. William Wordsworth, "Oxford, May 30, 1820." Quoted from E. de Selincourt and Helen Darbishire, eds., *The Poetical Works of William Wordsworth*, 2d ed. (Oxford: Clarendon Press, 1954), 39.

2. *Knight's Excursion Companion: Excursions from London, 1851* (London: Charles Knight, 1851), 6.

3. James Dallway, *Observations on English Architecture, Military, Ecclesiastical, and Civil, Compared with Similar Buildings on the Continent; Including a Critical Itinerary of Oxford and Cambridge . . .* (London, 1806), 165–66.

4. "Travellers from the British Rail station, having glided by a good view of the City's skyline seen over the green foreground of the gas works site, may later be excused for thinking that they have alighted at the wrong destination as they gaze at the squalor of the station area" (Anthony F. Kersting and John Ashdown, *The Buildings of Oxford* [London: B. T. Batsford Ltd., 1980]: 16).

5. Henry Talbot to Amelina Petit, started on 14 July 1842 and added to on 28 and 30 July. LA(AM)42-1, Fox Talbot Museum, Lacock (*Document 04546*).

6. A good example of this is in his *Pencil of Nature*, plate XVIII, *Gate of Christchurch* (*Schaaf 913*).

7. In the National Museum of Photography, Film & Television (1937-1777); they also hold eight prints from this (1937-1778/1–8). The Royal Photographic Society has a loose print (RPS025258) as well as a print (RPS025037) in their interesting album "Talbotypes Taken in 1843." The J. Paul Getty Museum's copy was formerly in the Samuel Wagstaff, Jr. Collection (84.XZ.0478.005). The Fox Talbot Museum, Lacock, has a loose print (LA113) as well as one in an album compiled in the mid to late 1840s (LA2014). This image remains a favorite of private collectors, and there are copies in the Rubel Collection, in the Judith Hochberg and Michael Mattis Collection, the Jay McDonald Collection, the Howard Stein Collection, a private collection, and the Vernon Collection. The Vernon copy is illustrated in Penelope Salinger, ed., *An Eclectic Focus: Photographs from the Vernon Collection* (Santa Barbara: Santa Barbara Museum of Art, 1999), pl. 28.

PLATE 61

1. James Dallway, *Observations on English Architecture, Military, Ecclesiastical, and Civil, Compared with Similar Buildings on the Continent; Including a Critical Itinerary of Oxford and Cambridge . . .* (London, 1806), 166.

2. H. F. Talbot, *The Pencil of Nature* (London: Longman, Brown, Green, and Longmans), part 3, May 1845.

3. *Athenaeum*, no. 920 (14 June 1845): 592–93.

4. *The Literary Gazette*, no. 1481 (7 June 1845): 365.

5. For prints of this that are included in copies of *The Pencil of Nature*, see Larry J. Schaaf, "Henry Fox Talbot's *The Pencil of Nature*: A Revised Census of Original Copies," *History of Photography* 17, no. 4 (Winter 1993): 388–96. The negative is in the National Museum of Photography, Film & Television (1937-1252); they have five loose prints from it (1937-1253/1–5). Other prints (not in copies of *The Pencil of Nature*) include one in the Canadian Centre for Architecture (PH1995.48); one in an 1846 copy of the *Art-Union*, formerly in the collection of Bruno Bischofberger and now in the J. Paul Getty Museum (84.XB.0280.004); a varnished one, titled in ink on the verso of the mount "The Cupola of Queens College Oxford," in the Harrison Horblit Collection, the Houghton Library, Harvard University (TypPr805.T820.113); Fox Talbot Museum, Lacock (LA13); the National Museums of Scotland, Edinburgh (1937.92.13); and one in the Edinburgh Calotype Club album in the Edinburgh Central Library (album no. 117). There are three copies in private collections in North America. The Royal Photographic Society has three loose prints (RPS025230, RPS025231 and RPS025247, the latter from an ancient loan from Robert C. Murray). Lady Elisabeth Feilding sent a copy to the duke of Devonshire on 2 February 1846, and it is still in the collection at Chatsworth (864-19). There is also a copy in the Bath Photographic Society album at the National Gallery of Canada, Ottawa (P75:008:39); this album, hand-selected from prints in the abbey's archives by Talbot's son, Charles Henry Talbot, was presented to the Bath Photographic Society on 27 February 1889. It was sold by the society at Sotheby's in 1975.

PLATE 62

1. From the manuscript in the Fox Talbot Museum, Lacock. Talbot originally wrote "when we visited this interesting building" but then crossed the last word out and changed it to "interesting spot," showing that his thoughts of making an architectural record had evolved into a more complex reaction to the special nature of the place at that particular point in time. He also reconsidered his title and added "(smaller type)", indicating that for unexplained reasons he planned to use one of the smaller variant negatives that he took on this occasion.

2. Calvert Jones to Henry Talbot, 6 October 1845, LA45-134, Fox Talbot Museum, Lacock (*Document 05404*).

3. The window was fully restored in 1996, and the doorway is now primarily opened for weddings, which are popular in the chapel. The stonework above the five statues has also been restored.

4. Augustus Pugin, *Specimens of Gothic Architecture, Consisting of Doors, Windows, Pinnacles &c; with the Measurements, Selected from Ancient Buildings at Oxford &c.; Drawn and Etched on Sixty Plates* (London: J. Taylor, 1825), pl. 10, *The Old Gateway, Magdalen College*.

5. H. F. Talbot, text for plate XVIII, *Gate of Christchurch*, in *The Pencil of Nature* (London: Longman, Brown, Green, and Longmans), part 4, June 1845.

6. Henry Talbot, manuscript list, "Copy of ~~last invoice~~ Mr Talbot's list of Negatives left with N.H. ~~Jan. 2~~ Feb'y 1845," National Museum of Photography, Film & Television, Bradford.

7. Six of the new ones were listed as being available in the undated manuscript list of *The Pencil of Nature* plates on hand during this period (LAM-57, Fox Talbot Museum, Lacock).

8. The negative is in the National Museum of Photography, Film & Television (1937-1725), which also holds twelve prints (1937-1726/1–12). Prints are also known in the LaSalle National Bank Collection, Chicago (68.35.5); the Charles Isaacs Collection (901007); the Richard Menschel Collection; Harrison Horblit Collection, the Houghton Library, Harvard University (TypPr805.T820.163); the Michael Wilson Collection (98:5864); the Cleveland Museum of Art (91.39); and National Gallery of Art, Washington, D.C. (1997.28.1). Three copies are in the Royal Photographic Society (RPS025254, RPS025255 and RPS02503, the latter in their album "Talbotypes Taken in 1843." In 1914, Charles Henry Talbot gave a copy of this image to the Smithsonian (now their National Museum of American History, no. 1924). The copy in the Fox Talbot Museum, Lacock (LA129), is well reproduced on page 122 of Hubertus von Amelunxen's *Die Aufgehobene Zeit: Die Erfindung der Photographie durch William Henry Fox Talbot* (Berlin: Verlag Dirk Nishen, 1988); unfortunately, there is a typographical error here that erroneously labels the subject as a portal at Christchurch, Oxford.

9. They are both in the National Museum of Photography, Film & Television and both are waxed. One measures 7.3 x 6.0 cm (1937-1706, *Schaaf 45*) and is the original of a lively print, formerly in the Joel Snyder Collection, now in the Art Institute, Chicago (1972.335/13). There is also a copy of it in the Gernsheim Collection, the Harry Ransom Humanities Research Center, The University of Texas at Austin (964:054:024). Another print, formerly owned by Talbot's sister Horatia, is now in a private collection in Ireland, and two copies are in the National Museum of Photography, Film & Television (1937-1707/1–2). The other negative measures 9.9 x 7.9 cm (1937-1708, *Schaaf 46*) and is the original of eleven prints in the National Museum of Photography, Film & Television (1937-1710/1–11), as well as one in a small album, comprising mostly views of Oxford (1937-2531/12). Lady Elisabeth Feilding sent a copy to the duke of Devonshire on 2 February 1846, and it is still in the collection at Chatsworth (864-29). A copy of this print is bound in an extra-illustrated copy of the *Pencil of Nature*, in the William Euing Collection, Glasgow University Library (Photo A18). Another copy is in the Bath Photographic Society album; this album, hand-selected from prints in the abbey's archives by Talbot's son, Charles Henry Talbot, was presented to the Bath Photographic Society on 27 February 1889. It was sold by the society at Sotheby's in 1975.

PLATE 63

1. Henry Talbot to Elisabeth Feilding, 1 May 1843, LA43-57, Fox Talbot Museum, Lacock (*Document 04824*).

2. Talbot's seminal publication is often misunderstood. It was originally planned to be an edition of fifty photographs, showing the whole range of potential of the new art, and was to have included portraits, copies of works of art, still lifes, and architecture and views from many regions. In the end, only half this number of plates was published. Of the twenty-four published plates, three show Lacock Abbey and fourteen were taken of objects there (although these could have been done anywhere). Four were included from Oxford, two from France, and one from London. Even of the imbalanced set published, one can hardly agree with the all too common statements like the one made about Talbot's trip to France: "Working under such circumstances didn't suit Talbot's temperament . . . he decided to base the book he had planned on views of his ancestral home, in Wiltshire, England. Thus did *The Pencil of Nature* come to be about life at Lacock Abbey" (Colin Westerbeck and Joel Meyerowitz, *Bystander: A History of Street Photography* [Boston: Little, Brown and Company, 1994], 67).

3. This is expanded from the shorthand form of Talbot's draft manuscript. Private collection, United States. The view of the Palais de Justice that Talbot planned to use (*Schaaf 1445*) is reproduced in Larry J. Schaaf, *Introductory Volume to the Anniversary Facsimile of H. Fox Talbot's "The Pencil of Nature"* (New York: Hans P. Kraus, Jr., 1989), fig. 37.

4. An *éclairci* is a bright spell or a break in the clouds; see Henry Talbot to Elisabeth Feilding, 22 May 1843, LA43-58, Fox Talbot Museum, Lacock (*Document 04825*).

5. The negative is in the National Museum of Photography, Film & Television, 1937-2344,

which also holds a loose print (1937-2345). The Fox Talbot Museum, Lacock, has a loose print (LA272) and one mounted in Talbot's album No. 9 (LA2167). Another print is in the Brewster Codex at the J. Paul Getty Museum (84.XZ.0574.171); it is illustrated in Graham Smith, *Disciples of Light: Photographs in the Brewster Album* (Malibu: The J. Paul Getty Museum, 1990), 157, pl. 171. There is also a print in an album formerly owned by Talbot's sister Horatia and now in a private collection in Ireland.

6. One in the National Maritime Museum, Greenwich, was a gift of Miss Matilda Talbot in 1934; it measures 8.5 x 15.6 cm (C3604, *Schaaf 1900*). The wrong illustration is assigned to it in Rollin Buckman, *The Photographic Work of Calvert Richard Jones* (London: Science Museum, 1990), HS52—this illustration possibly records another negative, unknown to the present author. Another negative is in the National Museum of Photography, Film & Television (1937-2433, *Schaaf 2087*); it measures 8.9 x 17.4 cm and is illustrated as Buckman HS51. A severely vertical one, measuring 15.0 x 9.0 cm, is quite irregular and was apparently never printed (National Museum of Photography, Film & Television, 1937-2337, *Schaaf 1898*). Another negative, formerly in the collection of André Jammes (*Schaaf 2721*), is now in a private collection in North America and is illustrated in André Jammes, *William H. Fox Talbot: Inventor of the Negative-Positive Process* (New York: Macmillan, 1973), 49

PLATE 64

1. Henry Talbot to Elisabeth Feilding, 22 May 1843, LA43-58, Fox Talbot Museum, Lacock (*Document 04825*).

2. Madame Costnoble's "Bains des Capucines, élégance et comfort," along with the eighteenth-century *hotels privés*, were demolished in 1862 to make way for the creation of the Place de l'Opéra.

3. H. F. Talbot, *The Pencil of Nature* (London: Longman, Brown, Green, and Longmans), part 1, June 1844.

4. *The Spectator* 17, no. 838 (20 July 1844): 685.

5. William Thompson to Henry Talbot, 4 March 1845, LA45-29, Fox Talbot Museum, Lacock (*Document 05203*).

6. *The Literary Gazette*, no. 1432 (29 June 1844): 410.

7. *The Art-Union* 6 (1 August 1844): 223.

8. Undated memorandum in Talbot's hand, Fox Talbot Museum, Lacock.

9. "Just Published, Part I, of The Pencil of Nature, by H. Fox Talbot, Esq.," Longman's announcement pamphlet, June 1844.

10. Invoice, Alfred Tarrant to Henry Talbot for part 1 of *The Pencil of Nature*, 28 June 1844, LA 44-28, Fox Talbot Museum, Lacock.

11. For prints of this that are included in copies of *The Pencil of Nature*, see Larry J. Schaaf, "Henry Fox Talbot's *The Pencil of Nature*: A Revised Census of Original Copies," *History of Photography* 17, no. 4 (Winter 1993): 388–96. The negative is in the National Museum of Photography, Film & Television (1937-2368), which holds four loose prints of it (1937-1292/1–4): a print in Talbot's album No. 15 (1937-2533/9), one in Lady Elisabeth Feilding's personal album, compiled in 1844 (1937-2535/05), and one formerly in the Kodak Museum, Harrow (1990-5164). Prints are known in the Alexander Humboldt album in Agfa Foto Historama, Cologne (FH2768); Art Institute, Chicago (formerly in the Joel Snyder Collection, 1972.342/20); Musée Carnavalet, Paris; the George Eastman House (81:2835:02); and the Royal Photographic Society (RPS025219). There is one, mounted in an 1846 copy of the *Art-Union*, formerly in the Samuel Wagstaff, Jr. Collection and now in the J. Paul Getty Museum (84.XM.0478.003); they also have an unusually dense copy of this print (also from Wagstaff, 84.XM.0478.008). Another overly dense copy is in the Fox Talbot Museum, Lacock (LA2). In 1936, Miss Matilda Talbot gave one to the National Museums of Scotland, Edinburgh. Lady Elisabeth Feilding sent a copy to the duke of Devonshire on 2 February 1846, and it is still in the collection at Chatsworth (864-17). There is also a copy in the National Gallery of Canada, Ottawa (P75:008:08), in the Bath Photographic Society album; this album, hand-selected from prints in the abbey's archives by Talbot's son, Charles Henry Talbot, was presented to the Bath Photographic Society on 27 February 1889. It was sold by the society at Sotheby's in 1975.

PLATE 65

1. Henry Talbot to Elisabeth Feilding, 14 August 1818, LA18-22, Fox Talbot Museum, Lacock (*Document 00813*).

2. Henry Talbot to Horatia Feilding, 14 June 1843, LA43-63, Fox Talbot Museum, Lacock (*Document 04831*).

3. Plate XII in part 2, published January 1845.

4. George Montgomerie (at Garboldisham, Norfolk) to Lady Feilding, 21 February 1845, LA 45-25, Fox Talbot Museum, Lacock.

5. William Thomas Horner Fox Strangways to Henry Talbot, 1 March 1844, LA44-13, Fox Talbot Museum, Lacock (*Document 04955*).

6. Henry Talbot, manuscript list, "Copy of ~~last invoice~~ Mr Talbot's list of Negatives left with N.H. ~~Jan. 2~~ Feb'y 1845," National Museum of Photography, Film & Television.

7. In National Museum of Photography, Film & Television (1937-2334); the museum also holds a copy in Talbot's album No. 15 (1937-2533/21). A print, formerly in the collection of André Jammes, is in the National Gallery of Canada, Ottawa (P72:169:46). There is a print in an album formerly belonging to Talbot's sister Horatia and now in a private collection in Ireland and another copy in a private collection in North America. The copy in the Fox Talbot

Museum, Lacock (LA274), is illustrated in Robert Lassam, *Fox Talbot, Photographer* (Tisbury, Wiltshire: Compton Press, 1979), 85, where it is erroneously described as being a view of Malines Cathedral in Belgium.

PLATE 66

1. William Thomas Horner Fox Strangways to Henry Talbot, 1 March 1844, LA44-13, Fox Talbot Museum, Lacock (*Document 04955*).

2. Robert Hunt to Henry Talbot, 30 March 1843, LA43-43, Fox Talbot Museum, Lacock (*Document 04787*).

3. In essence: "permission to draw is never given."

4. Henry Talbot to Elisabeth Feilding, 22 May 1843, LA43-58, Fox Talbot Museum, Lacock (*Document 04825*).

5. H. F. Talbot, text for plate XII, *The Bridge of Orleans*, in *The Pencil of Nature* (London: Longman, Brown, Green, and Longmans), part 2, January 1845.

6. Undated manuscript list, in the hand of Horatia Feilding, apparently written after part 1 was completed (24 June 1844) but before part 2 was issued in January 1845 (National Museum of Photography, Film & Television).

7. The negative is in the National Museum of Photography, Film & Television (1937-2306), which also holds seven loose prints (1937-2307/1–7) and one in Talbot's album No. 15 (1937-2533/24). Prints are known in the Alexander Humboldt album, Agfa Foto Historama, Cologne (FH2772); two copies in the Canadian Centre for Architecture (PH1986.019 and PH1986.508); one in the Art Institute, Chicago (1967.150); and one in the LaSalle National Bank Collection, Chicago (68.35.4). There is a copy in the Bayard Codex, formerly in the Arnold Crane Collection and now in the J. Paul Getty Museum (84.XO.0968.161); the Metropolitan Museum of Art, New York (1996.5); and the National Gallery of Art, Washington, D.C. (1998.136.1). The copy in the Fox Talbot Museum, Lacock, is varnished and on a mount (LA784). Prints of this are mounted in copies of the 1846 *Art-Union* in the Harrison Horblit Collection, the Houghton Library, Harvard University, and in the Gernsheim Collection, the Harry Ransom Humanities Research Center, The University of Texas at Austin (964:054:033). The copy in the George Eastman House (81:2850:02) is mounted and labeled and has a "Patent Talbotype" stamp and a price set by Nicolaas Henneman. This image is also a favorite of private collectors and is included in the Charles Isaacs Collection (H1009), the Jay McDonald Collection, the Richard Menschel Collection, and the Howard Stein Collection.

8. It is illustrated on the same page as the present image in Gail Buckland, *Fox Talbot and the Invention of Photography* (Boston: David R. Godine, 1980), 150. The negative for this is also in the National Museum of Photography, Film & Television (1937-2308, *Schaaf 2727*), which has prints from it in Talbot's album No. 15 (1937-2533/23) and in Lady Elisabeth Feilding's 1844 personal album (1937-2535/06). Prints are known in the Alexander Humboldt album, Agfa Foto Historama, Cologne (FH2773), and in the Fox Talbot Museum, Lacock (LA783). One, formerly in the Willats Collection, is in the National Gallery of Canada, Ottawa (P68:046:98). A mounted copy with a printed title label, formerly in the Janos Scholz Collection, is in the Snite Museum of Art, Notre Dame, Indiana (85.74.02). There is one in the Bayard Codex, formerly in the Arnold Crane Collection and now in the J. Paul Getty Museum (84.XO.0968.160). There is a copy on a Brooks Brothers mount, with a "Patent Talbotype" label, in the Harrison Horblit Collection, the Houghton Library, Harvard University (TypR805.T820.089); the George Eastman House also has a copy on a Brooks Brothers mount (81:2834:02)—it is illustrated in *Image* 7, no. 59 (March 1958): 69 (there dated, for unknown reasons, to 1842). There are two copies in private collections in North America.

PLATE 67

1. Sir Theodore Andréa Cook, *Twenty-five Great Houses of France* (London: Country Life, 1916), 246.

2. The drawing, still preserved in a private collection, measures 37 x 46 cm. A small reproduction of it is in Larry J. Schaaf, *Introductory Volume to the Anniversary Facsimile of H. Fox Talbot's "The Pencil of Nature"* (New York: Hans P. Kraus, Jr., 1989), fig. 35.

3. Expanded from Talbot's shorthand manuscript, private collection, United States.

4. William Thomas Horner Fox Strangways to Henry Talbot, 1 March 1844, LA44-13, Fox Talbot Museum, Lacock (*Document 04955*).

5. Elisabeth Feilding to Henry Talbot, 13 September 1844, LA44-60, Fox Talbot Museum, Lacock (*Document 05066*).

6. Undated manuscript list, in the hand of Horatia Feilding, apparently written after part 1 was completed (24 June 1844) but before part 2 was issued in January 1845 (National Museum of Photography, Film & Television).

7. The negative is in the National Museum of Photography, Film & Television (1937-2317), which also holds five loose prints (1937-2319/1–5), as well as one in Talbot's album No. 15 (1937-2533/25) and one, crudely removed from an album page, that was formerly in the Kodak Museum, Harrow (1990-5162). There is a print in the Bayard Codex, formerly in the Arnold Crane Collection and now in the J. Paul Getty Museum (84.XO.0968.069). The latter museum also holds one in the Brewster Codex, formerly in the Bruno Bischofberger Collection (84.XZ.0574.188); it is illustrated in Graham Smith, *Disciples of Light: Photographs in the Brewster Album* (Malibu: The J. Paul Getty Museum, 1990), 160, pl. 188. One is mounted in an 1846 copy of the *Art-Union* in the Harrison Horblit Collection, the Houghton Library, Harvard University. Fox Talbot Museum, Lacock, has a loose copy (LA662) and one mounted in an album com-

piled in the mid to late 1840s (LA2035)—the latter is titled "H.F.T. June 1843." The Royal Photographic Society has a copy (RPS025270). A copy that was formerly owned by Talbot's sister Horatia is now in a private collection in Ireland, and there is one in a private collection in North America. The print in the National Gallery of Canada, Ottawa, titled "Château de Chambord Taken in June 1843" (P75:008:14), is in the Bath Photographic Society album. This album, hand-selected from prints in the abbey's archives by Talbot's son, Charles Henry Talbot, was presented to the Bath Photographic Society on 27 February 1889. It was sold by the society at Sotheby's in 1975.

8. Both are in National Museum of Photography, Film & Television; neither is waxed and the pencil outlines around their edge indicate that it was unlikely either was ever printed (1937-2315, *Schaaf 1162* and 1937-2316, *Schaaf 1163*).

PLATE 68

1. Matilda Talbot, *My Life and Lacock Abbey* (London: George Allen and Unwin, 1956), 27.

2. This is adapted from the text Mr. Burnett-Brown created for a National Trust commemorative postcard.

3. All three negatives are waxed, but none of them is inscribed or dated. All three are in the National Museum of Photography, Film & Television; this one is 1937-2348, and four prints are held there under 1937-2439/1–4. A negative measuring 6.1 x 9.9 cm (1937-2440, *Schaaf 1612*) is the source of two prints (1937-2441/1–2). A negative measuring 6.7 x 9.5 cm (1937-2442, *Schaaf 1613*) is the source of three prints (1937-2443/1–3), as well as the one in Fox Talbot Museum, Lacock, mounted in a 25 February 1851 presentation album given by Henry Talbot to his young daughter Matilda; this image is illustrated in Gail Buckland, *Fox Talbot and the Invention of Photography* (Boston: David R. Godine, 1980), 167.

PLATE 69

1. Henry Collen to Henry Talbot, 12 May 1842, LA42-31, Fox Talbot Museum, Lacock (*Document 04503*).

2. Hariot Mundy to Henry Talbot, 26 February 1839, LA39-14, Fox Talbot Museum, Lacock (*Document 03818*).

3. Matilda Talbot, *My Life and Lacock Abbey* (London: George Allen and Unwin, 1956), 12–13, 35.

4. The negative is in the Fox Talbot Museum, Lacock, which also has one print (LA957). The National Museum of Photography, Film & Television has three prints (including the present one, 1937-3476/1–3). The negative is illustrated in Michael Gray's essay, "Zunächst verborgen, erscheine ich schließlich doch," in Hubertus von Amelunxen, *Die Aufgehobene Zeit: Die Erfindung der Photographie durch William Henry Fox Talbot* (Berlin: Verlag Dirk Nishen, 1988), 155, image at far left.

5. There are no known prints from the earlier negative (*Schaaf 2741*); it is reproduced in Larry J. Schaaf, *Sun Pictures Catalogue Three: The Harold White Collection of Works by William Henry Fox Talbot* (New York: Hans P. Kraus, Jr., 1987), pl. 32. The later negatives are in the National Museum of Photography, Film & Television (1937-3492, *Schaaf 2767* and 1937-3493, *Schaaf 2768*).

6. A negative of Ela Theresa is inscribed in Talbot's hand "Ela April/44" (National Museum of Photography, Film & Television 1937-3486, *Schaaf 2762*; a print from it is reproduced (but identified as Matilda!) in von Amelunxen, *Die Aufgehobene Zeit*, center image on p. 96. A negative of Rosamond Constance is similarly inscribed "Rosamond April/44"; it is in the National Museum of Photography, Film & Television (1937-3458, *Schaaf 2769*). It is reproduced (but identified as Matilda!) in John Ward, *Printed Light: The Scientific Art of William Henry Fox Talbot and David Octavius Hill with Robert Adamson* (Edinburgh: Scottish National Portrait Gallery, 1986), pl. 53.

PLATE 70

1. Plate XIV, in part 3, issued May 1845.

2. An excellent discussion of tableaux in this period is in Richard D. Altick, *The Shows of London* (London: Belknap Press of Harvard University Press, 1978), 342–49.

3. Horatia Feilding to Henry Talbot, 2 December 1830, LA30-56, Fox Talbot Museum, Lacock (*Document 02094*).

4. Although Longman used the spelling "Calcott", the proper spelling was "Callcott". See Thomas Longman to Henry Talbot, 24 May 1843, LA44-29, Fox Talbot Museum, Lacock (*Document 05001*).

5. John Callcott Horsley to Henry Talbot, 25 May 1843, Fox Talbot Museum, Lacock (*Document 04990*). Unfortunately, Horsley (1817–19 October 1903) does not mention anything about this in his autobiography. See John Callcott Horsley, R.A., *Recollections of a Royal Academician*, edited by Mrs. Edmund Helps (New York: E. P. Dutton and Company, 1903).

6. "Tableau Flamand" translates as a Flemish tableau; Henry Talbot to Elisabeth Feilding, 18 April 1845, LA45-39, Fox Talbot Museum, Lacock (*Document 05231*).

7. Constance Talbot to Henry Talbot, 31 August 1843, LA43-75, Fox Talbot Museum, Lacock (*Document 04872*).

8. In the National Museum of Photography, Film & Television (1937-2587).

9. This commemorated the centenary of Talbot's first successes in 1834, particularly the negative of the oriel window (frontispiece). A symposium with numerous speakers was held at Lacock on 23 June 1934 and a "Centenary Exhibition of Early Photographs and Photo-Engravings" was held on 27–29 July 1934. Photographs, arranged by subject matter, were displayed on various tables and pinned by their corners to temporary screens. These groupings were labeled

by category from "A" to "P" and these informal labels (having pale blue stripes and an ink capital letter) are sometimes found on prints and negatives yet today. The best visual record of these panels is the set of monochromatic prints from the estate of the late Dudley Johnston that was donated to the Royal Photographic Society—a copy of the present print clearly shows in the one of these that records screen D, "Portraits and Groups."

PLATE 71

1. William Wordsworth, "Oxford, May 30, 1820." Quoted from E. de Selincourt and Helen Darbishire, eds., *The Poetical Works of William Wordsworth*, 2d ed. (Oxford: Clarendon Press, 1954), 39.

2. Alex Chalmers, *A History of the Colleges, Halls, and Public Buildings, attached to the University of Oxford*, vol. 2 (Oxford: Collingwood and Company, 1810), 457–58.

3. William Thomas Horner Fox Strangways to Henry Talbot, 10 June 1839, Fox Talbot Museum, Lacock (*Document 03890*).

4. The smaller one is in the National Museum of Photography, Film & Television (1937-1849, *Schaaf 1437*), which also holds seven prints from it (1937-1758/1–7). The same museum also has a larger waxed negative which now measures 17.0 x 16.5 cm (1937-1926, *Schaaf 3659*) and a print (1937-1911); two prints are known from when this negative measured 18.3 cm wide, one in the Fox Talbot Museum, Lacock (LA131), and one in the Art Institute, Chicago (1967.151); this image is illustrated as lot 104 in the Sotheby's Belgravia catalogue, *Photographic Images and Related Material*, 1 July 1977. The most common print is a larger view (*Schaaf 3429*) for which no negative is known to have survived; its awkward cropping is revealed by the survival of one print made before the negative was trimmed down—it measures 17.9 x 22.4 cm and exhibits uneven edge coating and the shadow of an adjacent wing dominating the right third of the image (Fox Talbot Museum, Lacock, LA130). The other known prints were made after the negative was trimmed to 16.5 x 15.3 cm. The National Museum of Photography, Film & Television has nine copies of this version (1937-1759/1–9); the trimmed version in the Fox Talbot Museum is LA132; there is one in the National Museum of American History, Smithsonian Institution, donated by Charles Henry Talbot in 1914 (No. 1927); one in the Harrison Horblit Collection, the Houghton Library, Harvard University (TypPR805.T820.133); one is in the Bayard Codex (formerly in the Arnold Crane Collection) at the J. Paul Getty Museum (84.XO.0968.098); and one is in a private collection in North America. The one in the Royal Photographic Society (RPS02546) is in their album "Talbotypes Taken in 1843," and a copy of this print is bound in an extra-illustrated copy of *The Pencil of Nature*, in the William Euing Collection, Glasgow University Library (Photo A18).

5. In 1884, Symm & Company undertook renovation work on the Tower, where "almost the whole of its ornamentation, originally in stone, had been replaced in cement. Bath stone, which had been used for repairs some FORTY years before, was already beginning to decay" (Sir Edmund Craster, *History of the Bodleian Library, 1845–1945* [Oxford: Oxford University Press, 1952], 142). This would have centered the original work on the year 1844. While specific invoices have not been retained, the library's accounts, which were closed on 8 November each year, provide some indication. During the 1840s, the local firm of Hudson & Mathew did most of the library's building work. Payments were made to them almost every year, averaging less than one hundred pounds per annum. However, in the middle of that decade, their compensation rose to the range of three hundred to nearly five hundred pounds per annum, indicating more major work. Between this evidence, Craster's statement, and the visual testimony that indicates the work had not gone very far by the time of Talbot's photograph, it seems likely that he took these images during his trips later in 1843 or 1844.

6. See "An Extension of Vision" in Larry J. Schaaf, *Sun Pictures Catalogue Five: The Reverend Calvert R. Jones* (New York: Hans P. Kraus, Jr., 1990), 38–43.

7. There are two negatives of the base of the Radcliffe Observatory, Oxford, that cannot be explained in conventional visual terms—they almost certainly were the lower sections of two-part compositions, but the upper parts have yet to be located. Both negatives are dated in Talbot's hand 29 July 1842. One is in a private collection in North America (*Schaaf 2675*) and one is in the Art Institute, Chicago (1975.1046, *Schaaf 3668*). Perhaps the upper parts were failures or were damaged in Talbot's day, for a print from the latter negative is included without comment in Talbot's album No. 10 (National Museum of Photography, Film & Television 1937-366/60).

8. The two negatives and the only known prints from them are in the National Museum of Photography, Film & Television; the top half is 1937-1761 (prints are 1937-1762/1–7) and the bottom 1937-1760 (prints are 1937-1471/1–6).

9. Henry Talbot, manuscript list, "Copy of last invoice M^r. Talbot's list of Negatives left with N.H. Jan. 2 Feb^ry 1845," National Museum of Photography, Film & Television. This was most likely *Schaaf 3429*.

10. "180–182. The Schools at Oxford."

PLATE 72

1. "On Photogenic Drawing," *The Saturday Magazine* 14, no. 435 (13 April 1839): 139. Much of this quote was borrowed from Talbot's section on "The Art of Fixing a Shadow," part of his first paper on photography, read to the Royal Society on 31 January 1839. He published the full text as *Some Account of the Art of Photogenic Drawing, or the Process by Which Natural Objects May be Made to Delineate Themselves, Without the Aid of the Artist's Pencil* (London: R. and J. E. Taylor, 1839). The reference is to French naturalist Adelbert von Chamisso's *Peter Schlemihls wundersame Geschichte* (1814). It has been translated numerous times; an illustrated one is A. S. Rapoport's

The Marvellous History of The Shadowless Man (London: Holden & Hardingham, 1913).

2. *The Spectator* 17, no. 838 (20 July 1844): 685.

3. *The Literary Gazette*, no. 1432 (29 June 1844): 410.

4. *The Art-Union* 6 (1 August 1844): 223.

5. Talbot was entirely correct in worrying about the quality of the medieval Burford and Headington stone. Major refacings of this were attempted in 1864, 1909, and 1911. Modern refacing began in 1957 and by 1968 the High Street façade was repaired in Clipsham stone. Later repairs have been done with stone imported from France. See W. F. Oakeshott, ed., *Oxford Stone Restored: The Work of the Oxford Historic Buildings Fund, 1957–1974* (Oxford: Oxford University Press, 1975).

6. At least it did not suffer the total destruction that happened to another *Pencil* image, the *Bust of Patroclus* (pl. 58). In his text for plate XXIV, "The Fruit Piece," issued in April 1846, Talbot observed that "a very great number of copies can be obtained in succession, so long as great care is taken of the original picture. But being only on paper, it is exposed to various accidents; and should it be casually torn or defaced, of course no more copies can be made. A mischance of this kind having occurred to two plates in our earliest number after many copies had been taken from them, it became necessary to replace them by others; and accordingly the Camera was once more directed to the original objects themselves, and new photographic pictures obtained from them, as a source of supply for future copies. But the circumstances of light and shade and time of day, &c. not altogether corresponding to what they were on a former occasion, a slightly different but not a worse result attended the experiment."

7. However, Talbot thought Henneman's prints of it "lowered on Linen paper" (i.e., over-printed and reduced in a strong fixing bath) to be "very good"; undated (early 1844) memorandum to Henneman, in Talbot's hand, Fox Talbot Museum, Lacock. For prints of this that are included in copies of *The Pencil of Nature*, see Larry J. Schaaf, "Henry Fox Talbot's *The Pencil of Nature*: A Revised Census of Original Copies," *History of Photography* 17, no. 4 (Winter 1993): 388–96. The negative is in the National Museum of Photography, Film & Television (1937-1284), which also holds three loose prints (1937-1296/1–3), as well as one in Lady Elisabeth Feilding's 1844 personal album (1937-2535/09), one in Talbot's album No. 15 (1937-2533/01), and one from the Kodak Museum, Harrow, Collection (1990-5173). A copy is in the Alexander Humboldt album in the Agfa Foto Historama, Cologne (FH2775); Lady Elisabeth Feilding sent a copy to the duke of Devonshire on 2 February 1846, and it is still in the collection at Chatsworth (864-16). One, mounted in an 1846 copy of the *Art-Union*, is in the Gernsheim Collection, the Harry Ransom Humanities Research Center, The University of Texas at Austin (964:054:034). The Fox Talbot Museum, Lacock, has a loose copy (LA48); one is in a private collection in North America; the Royal Photographic Society has a loose print (RPS025218) and one in their album "Talbotypes Taken in 1843" (RPS025031). The print in the National Gallery of Canada, Ottawa (P75:008:03), is in the Bath Photographic Society album. This album, hand-selected from prints in the abbey's archives by Talbot's son, Charles Henry Talbot, was presented to the Bath Photographic Society on 27 February 1889. It was sold by the society at Sotheby's in 1975.

8. The "new plate" of Queens College was printed between when part 4 of *The Pencil of Nature* was issued in June 1845 and when part 5 was ready in December 1845; six of the new ones were listed as being available in the undated manuscript list of *Pencil* plates on hand during this period (LAM-57, Fox Talbot Museum, Lacock). Prints from the replacement are found in a few later copies of *The Pencil of Nature*. It was employed as plate I in Beaumont Newhall's facsimile of *The Pencil of Nature* (New York: DaCapo Press, 1969). Newhall did not have access to original prints at the time and instead employed copy prints from the collection of Harold White. The dating for this variant was first suggested by Graham Smith in a book review in the *Print Collector's Newsletter* 20, no. 4 (September/October 1989): 148; he based this on the records of the Royal Commission's *Inventory of the Historical Monuments in the City of Oxford* (London: His Majesty's Stationery Office, 1939), 143. The negative is in the National Museum of Photography, Film & Television (1937-1293, *Schaaf 1462*), which also holds fifteen loose prints (1937-1288/1–15). Other copies are in the Fox Talbot Museum, Lacock (LA1); one copy is in the University of Michigan Art Gallery; two are in private collections in North America; and one was donated by Miss Matilda Talbot to the National Museums of Scotland, Edinburgh, in 1936. The Royal Photographic Society has a loose print (RPS025245) and one in their album "Talbotypes Taken in 1843" (RPS025032). One, extracted from an 1846 copy of the *Art-Union*, preserving its text, is in the Harrison Horblit Collection, the Houghton Library, Harvard University (TypPr805.T820.127). In 1914, Charles Henry Talbot donated one to the National Museum of American History, Smithsonian Institution, Washington, D.C. (No. 1926).

PLATE 73

1. Plate XXI, part 5, December 1845.

2. *Knight's Excursion Companion: Excursions from London, 1851.* (London: Charles Knight, 1851), 22–23.

3. Henry Talbot to Elisabeth Feilding, 6 September 1843, LA43-76, Fox Talbot Museum, Lacock (*Document 04875*).

4. Constance Talbot to Henry Talbot, 7 September 1843, Fox Talbot Museum, Lacock (*Document 04876*).

5. Talbot notebook, Memoranda, London, May 1840–April 1844, p. 78 (Fox Talbot Museum, Lacock).

6. Elisabeth Feilding to Henry Talbot, 27 October 1845, Fox Talbot Museum, Lacock (*Document 05423*).

7. William Thomas Horner Fox Strangways to Henry Talbot, 1 March 1844, LA 44-13, Fox Talbot Museum, Lacock (*Document 04955*).

8. "Bishops Monument" is entered under 7 September 1843 in the Nicholls account book, which covers the period of 3 December 1841 through 2 January 1844 (Fox Talbot Museum, Lacock).

9. The Humboldt album is in the Agfa Foto Historama, Cologne (FH2776)—the waxed negative for this particular image is in the National Museum of Photography, Film & Television (1937-1784, *Schaaf 1311*).

10. For prints of this that are included in copies of *The Pencil of Nature*, see Larry J. Schaaf, "Henry Fox Talbot's *The Pencil of Nature*: A Revised Census of Original Copies," *History of Photography* 17, no. 4 (Winter 1993): 388–96. The negative is in the National Museum of Photography, Film & Television (1937-1275), which also holds one loose print (1937-1912). Other loose prints are in the Fox Talbot Museum, Lacock (LA21); one in a private collection in North America; one loose print in the Royal Photographic Society (RPS025239); and one extracted, with its text, from an 1846 copy of the *Art-Union*, in the Harrison Horblit Collection, the Houghton Library, Harvard University (TypPr805.T820.126). In 1914, Charles Henry Talbot donated one to the National Museum of American History, Smithsonian Institution, Washington, D.C. (No. 1928). The print in the National Gallery of Canada, Ottawa (P75:008:04), is in the Bath Photographic Society album. This album, hand-selected from prints in the abbey's archives by Talbot's son, Charles Henry Talbot, was presented to the Bath Photographic Society on 27 February 1889. It was sold by the society at Sotheby's in 1975.

11. Henry Talbot, manuscript list, "Copy of ~~last invoice~~ M^r. Talbot's list of Negatives left with N.H. ~~Jan. 2~~ Feb^ry. 1845," National Museum of Photography, Film & Television.

12. "121. The Martyr's Monument, Oxford. Statue of Bishop Latimer."

13. The negative is National Museum of Photography, Film & Television (1937-1787, *Schaaf 1325*); a hand-colored print is in the Fox Talbot Museum, Lacock (LA994A).

14. The negative is National Museum of Photography, Film & Television (1937-1781, *Schaaf 1326*); a hand-colored print is in the Fox Talbot Museum, Lacock (LA994B). A modern print from this negative is illustrated in Larry J. Schaaf, *Introductory Volume to the Anniversary Facsimile of H. Fox Talbot's "The Pencil of Nature"* (New York: Hans P. Kraus, Jr., 1989), fig. 28.

PLATE 74

1. Anthony Hamber, Introduction, in *"A Higher Branch of the Art," Photographing the Fine Arts in England, 1839–1880* (Amsterdam: Gordon and Breach, 1996). A related publication is Anthony Hamber and Ken Jacobson, *Étude d'après nature: 19th-Century Photographs in Relation to Art* (Petches Bridge, England: Ken and Jenny Jacobson, 1996).

2. His caption on the album page was "Copy of Painting—Neapolitan Conveyance—at Lacock Abbey." This album, hand-selected from prints in the abbey's archives by Talbot's son, Charles Henry Talbot, was presented to the Bath Photographic Society on 27 February 1889. It was sold by the society at Sotheby's in 1975. It is now in the National Gallery of Canada, Ottawa (this print is P75:008:28).

3. In a private collection, North America.

4. Nicolaas Henneman, undated manuscript list of copies supplied, the receipt of which is acknowledged in Talbot's manuscript notation on 23 January 1844 (Fox Talbot Museum, Lacock).

5. The first manuscript list is in Talbot's hand, LAM-49, Fox Talbot Museum, Lacock. The second, also undated manuscript list, in the hand of Horatia Feilding, was apparently written after part 1 was completed (24 June 1844) but before part 2 was issued in January 1845 (National Museum of Photography, Film & Television).

6. The negative is in the National Museum of Photography, Film & Television (1937-3200), which also has thirteen prints from it (1937-3201/1–13). In addition to the print at the National Gallery of Canada, Ottawa, and the one in a private collection, prints are known at the Art Institute, Chicago (1972.377/1); the LaSalle National Bank Collection, Chicago (73.35.8); and at the Fox Talbot Museum, Lacock.

7. This waxed negative is in the National Museum of Photography, Film & Television and measures 16.5 x 19.4 cm (1937-3202, *Schaaf 631*); no prints of it are known.

PLATE 75

1. The original is titled "Veduta dell' antico Ponte situato fuori di Porta Romana nella Città di Cora, costruito da Cora nei tempi di Claudio," "l'Altezza totale è di circa 110 palmi; d'après nature." In Luigi Rossini, *Le Antichità Romane* (Rome: Scudellari, 1829).

2. H. F. Talbot, text for plate XI, "Copy of a Lithographic Print," in *The Pencil of Nature* (London: Longman, Brown, Green, and Longmans), part 2, January 1845.

3. Talbot, *A Brief Description of the Photogenic Drawings Exhibited at the Meeting of the British Association, at Birmingham, in August, 1839, by H. F. Talbot, Esq*. This double-sided broadside lists ninety-three negatives and positives exhibited by Talbot; copies are in the Gernsheim Collection, the Harry Ransom Humanities Research Center, The University of Texas at Austin; the National Museum of Photography, Film & Television; and the Fox Talbot Museum, Lacock. This listing was transcribed in Mike Weaver's *Henry Fox Talbot: Selected Texts and Bibliography* (Oxford: Clio Press), 57–58.

4. See Larry J. Schaaf, "Herschel, Talbot, and Photography: Spring 1831 and Spring 1839," *History of Photography* 4, no. 3 (July 1980): 199.

5. Longman advertisement, "Illustrated Works and Books on Science and Art," in *The Art-Union* 7 (March 1845): 62. This point is emphasized in Susan Lambert's *The Image Multiplied* (London: Trefoil Publications, 1987), 47–48

6. *Athenaeum*, no. 904 (22 February 1845): 202.

7. *The Literary Gazette*, no. 1463 (1 February 1845): 73.

8. Elisabeth Feilding to Henry Talbot, 6 January 1845, LA45-4, Fox Talbot Museum, Lacock (*Document 05150*).

9. Nicolaas Henneman, undated manuscript list of copies supplied, the receipt of which is acknowledged in Talbot's manuscript notation on 23 January 1844 (Fox Talbot Museum, Lacock).

10. "49. & 50. Copy of an Italian Engraving, much diminished in size."

11. The negative is in the Fox Talbot Museum, Lacock (LA3207), which also holds a print in an album of calotypes mostly dating from 1843-1846 (LA2043). Known prints are in the Gernsheim Collection, the Harry Ransom Humanities Research Center, The University of Texas at Austin (964:054:021); and the National Museum of Photography, Film & Television (1937-373/3) and twenty-two copies (1937-333/1–22). The copy in the George Eastman House (81:280:08) was a gift of Miss Matilda Talbot. Miss Talbot also gave one in 1936 to the National Museums of Scotland, Edinburgh (1937.91.2).

12. This is also in the Fox Talbot Museum, Lacock (LA3198, *Schaaf 639*); no prints of it are known to exist.

PLATE 76

1. His uncle's list was enclosed in a letter filled with suggestions on how to photograph some architecture near where Talbot was visiting. William wrote from the Foreign Office, where he worked, but he was about to depart for Frankfurt and was planning to take along an assortment of Talbot's new photographs to display and distribute to people he met in his travels. William's ten divisions were Sculpture, Architecture, Landscape, Insects, Plants, Facsimiles, Lace, Cotton, Prints, and Microscopia. He thought that "two or three of these styles might be brought into one drawing & if well combined would make a better specimen of the art" (William Thomas Horner Fox Strangways to Henry Talbot, 7 March 1840. LA40-32, Fox Talbot Museum, Lacock, *Document 04056*). Perhaps his suggestion to combine different elements in display photographs is what prompted Henry Talbot to attempt this. There are a number of Talbot's contact negatives where the visual basis for the combination of subjects is not immediately obvious. An example of a mixture of lace and botanical specimens is illustrated as plate 6 in Larry J. Schaaf, *Sun Pictures Catalogue Three: The Harold White Collection of Works by William Henry Fox Talbot* (New York: Hans P. Kraus, Jr., 1987).

2. Henry Talbot, letter to the editor, dated 30 January 1839; published in *The Literary Gazette*, no. 1150 (2 February 1839): 73–74.

3. This is recorded in Talbot's Memoranda notebook, which was started at Lacock in June 1838 but mostly represents miscellaneous entries for 1839 and later (Fox Talbot Museum, Lacock).

4. It was proposed for part 3. The list was written after part 2 was finalized (29 January 1845) but before part 3 was issued on 14 May 1845 (LAM-49, Fox Talbot Museum, Lacock).

5. A similar treatment of four diatoms (*Schaaf 1482*) is illustrated in Gail Buckland, *Fox Talbot and the Invention of Photography* (Boston: David R. Godine, 1980), 29, lower right.

6. Calvert Jones to Henry Talbot, 23 February 1843, LA43-25, Fox Talbot Museum, Lacock (*Document 04736*).

7. See Larry J. Schaaf, *Sun Pictures Catalogue Five: The Reverend Calvert R. Jones* (New York: Hans P. Kraus, Jr., 1990),

8. This album has yet to be fully catalogued and researched. An excellent survey of its potential is by Nancy Keeler, "Souvenirs of the Invention of Photography on Paper: Bayard, Talbot, and the Triumph of Negative-Positive Photography," in *Photography, Discovery and Invention* (Malibu: The J. Paul Getty Museum, 1990), 47–62.

9. All of these negatives are in the National Museum of Photography, Film & Television—the one employed for this print is 1937-4146. Two of these negatives group four specimens together: 1937-373/4, *Schaaf 1482* (illustrated in John Ward, *Printed Light: the Scientific Art of William Henry Fox Talbot and David Octavius Hill with Robert Adamson* [Edinburgh: Scottish National Portrait Gallery, 1986], fig. 8) and 1937-4140, *Schaaf 1483*, and one shows two specimens (1937-4136, *Schaaf 1491*). The others have a single specimen, as in the present example. They are 1937-4143, *Schaaf 1486*; 1937-4154, *Schaaf 1488*; 1937-4155, *Schaaf 1489*; 1937-4142, *Schaaf 1490*; and 1937-4149, *Schaaf 1492*—the last illustrated in Ward, *Printed Light*, fig. 8. An example of a print combining the negative for this image printed on the same sheet with another is plate 23 in Larry J. Schaaf, *Out of the Shadows: Herschel, Talbot, and the Invention of Photography* (London: Yale University Press, 1992)—the print is in the National Museum of Photography, Film & Television (1937-4151), and the second negative used to make it is there as well (1937-4142, *Schaaf 1490*).

PLATE 77

1. As quoted in the entry for honeysuckle in Geoffrey Grigson, *The Englishman's Flora* (London: J. M. Dent and Sons, 1955), 356.

2. For example, see her letter from Malvern of 23 June 1812, while he was studying with Dr. Butler at Harrow (Lacock Abbey Deposit, Wiltshire Record Office, Trowbridge, *Document 00573*).

3. Clear evidence of their skill and scientific attainment is attractively presented in Brian Warner and John Rourke, *Flora Herscheliana: Sir John and Lady Herschel at the Cape, 1834–1838*

(Houghton, South Africa: Brenthurst Press, 1996). This limited-edition publication may be difficult for some to find; some sense of this body of work can be obtained from the single example reproduced in Ann Thomas, *Beauty of Another Order: Photography in Science* (London: Yale University Press, 1997), pl. 14.

4. This was for the translation by her father, John George Children, of Lamarck's *Genera of Shells*. See Larry J. Schaaf, *Sun Gardens: Victorian Photograms by Anna Atkins* (New York: Aperture, 1985), fig. 2.

5. See Larry J. Schaaf, "Niépce Abroad: Britain in 1827 and 1839—Russia in 1839 and 1994," in *Nicéphore Niépce, une nouvelle image* (Chalon-sur-Saône: Museé Nicéphore Niépce, 1998), 100–112.

6. Quoted in Ann Thomas, "The Search for Pattern," in her *Beauty of Another Order*, 92. Ms. Thomas's entire chapter (pp. 76–119) is a model of clarity in outlining the importance, and cautioning about some limitations, of photography to illustration in various fields of science.

7. The negative for the field of grass measures 7.6 x 9.6 cm and is in the National Museum of Photography, Film & Television (1937-2053, *Schaaf 933*), which also has two prints from it (1937-2052/1–2). This is reproduced the same size above the reduced *Honeysuckle* on page 168 of Gail Buckland, *Fox Talbot and the Invention of Photography* (Boston: David R. Godine, 1980).

8. The negative is in the National Museum of Photography, Film & Television (1937-2236).

PLATE 78

1. The title is in her hand on the album page in Talbot's album No. 15, which he listed as "partial fill" (National Museum of Photography, Film & Television, 1937-2533/50).

2. This is clearly seen in a Talbot image of his plaster casts: in order to accommodate the highest ones on the top shelf, he allowed the camera framing to include the courtyard of Lacock Abbey in the background. This image (*Schaaf 1246*) is illustrated in Larry J. Schaaf, *Out of the Shadows: Herschel, Talbot, and the Invention of Photography* (London: Yale University Press, 1992), pl. 74.

3. Illustrated in Ann Thomas, *Beauty of Another Order: Photography in Science* (London: Yale University Press, 1997), pl. 48.

4. Of the positively dated items in this album, two are from 1842 and fourteen from 1843. The watermarks on the prints are predominantly 1842, consistent with an 1843 printing.

5. Nicolaas Henneman, undated manuscript list of copies supplied, the receipt of which is acknowledged in Talbot's manuscript notation on 23 January 1844 (Fox Talbot Museum, Lacock).

6. The negative is in the National Museum of Photography, Film & Television (1937-4310). The present print is one of six loose prints held by them (1937-4317/1–6); in addition, the museum has two more prints in albums, one in Talbot's album No. 15 (which he listed as "partial fill", 1937-2533/50) and another in an album largely titled by Lady Elisabeth Feilding (1937-2536/33). An unusual print—varnished but not trimmed and mounted—is in a private collection in North America; another print, formerly in the Gilman Paper Company Collection, is in a private collection in North America. Another print, formerly owned by Talbot's sister Horatia is in a private collection in Ireland. The copy in the Fox Talbot Museum, Lacock (LA282) is on a mount carrying the label of Brooks Brothers; it is priced and has a "Patent Talbotype" label. There is also a copy in the Brewster Codex, formerly in the Bruno Bischofberger Collection, in the J. Paul Getty Museum (84.XZ.0574.061); it is illustrated in Graham Smith, *Disciples of Light: Photographs in the Brewster Album* (Malibu: The J. Paul Getty Museum, 1990), 149, pl. 131.

PLATE 79

1. *The Daily Telegraph*, 27 September 1877, 5.

2. Henry Talbot, manuscript list of negatives taken 12 November 1839 to 25 October 1840 (Fox Talbot Museum, Lacock).

3. One might be the 10 October one, although no date appears on it. The waxed negative is really a fragment, measuring 6.7 x 14.4 cm, and shows two shelves of books falling down. No print is known of the negative (National Museum of Photography, Film & Television 1937-4328, *Schaaf 103*), but a modern print is illustrated in Gail Buckland, *Fox Talbot and the Invention of Photography* (Boston: David R. Godine, 1980), 34. The earliest positively dated image is an extreme closeup of the spines; the dated negative measures 10.3 x 12.9 cm and is in the National Museum of American History, Smithsonian Institution (1995.0206.137, *Schaaf 2531*); prints are in the Fox Talbot Museum, Lacock (LA2214) and three in the National Museum of Photography, Film & Television (1937-1580; in Talbot's album No. 4, 1937-366/110; and in Talbot's album No. 10, 1937-366/56). Another waxed negative measures 8.7 x 7.5 cm and depicts books on three shelves; it is in the National Museum of American History, Smithsonian Institution (1995.0206.442, *Schaaf 3963*); a print from this is in National Museum of Photography, Film & Television in Talbot's album No. 3 (1937-365/25). The most popular rendering of this theme shows books on four shelves, tumbled in disarray. The negative measuring 14.6 x 18.0 cm is waxed and is in the Fox Talbot Museum, Lacock (LA3247, *Schaaf 104*); prints are in the Brewster Codex (formerly in the Bruno Bischofberger Collection), the J. Paul Getty Museum (84.XZ.0574.186); two in the Harrison Horblit Collection, the Houghton Library, Harvard University (TypPr805.T820.014 and TypPr805.T820.106); one is also in a private collection in North America. Another print of this image is in the National Museum of Photography, Film & Television (1937-1580) and is illustrated in Larry J. Schaaf, *Out of the Shadows: Herschel, Talbot, and the Invention of Photography* (London: Yale University Press, 1992), pl. 102.

4. It appeared in part 2, issued 29 January 1845.

5. André Jammes, "A Scene in a Library," *Photographie*, no. 1 (Spring 1983): 50.

6. It is likely she was looking at the version with four shelves of tumbled books (*Schaaf 104*). Elisabeth Feilding to Henry Talbot, 12 January 1845, LA45-6, Fox Talbot Museum, Lacock (*Document 05156*).

7. William Thompson to Henry Talbot, 4 March 1845, LA45-29, Fox Talbot Museum, Lacock (*Document 05203*).

8. "110. Scene in a Library."

9. For prints of this that are included in copies of *The Pencil of Nature*, see Larry J. Schaaf, "Henry Fox Talbot's *The Pencil of Nature*: A Revised Census of Original Copies," *History of Photography* 17, no. 4 (Winter 1993): 388–96. The negative is in the National Museum of Photography, Film & Television (1937-1301); in addition to the former Kodak Museum print, they have four loose prints (1937-1302/1–4) and one in an album largely titled by Lady Elisabeth Feilding (1937-2536/41). There is a print in the Alexander Humboldt album in Agfa Foto Historama, Cologne (FH2786); one in an 1846 copy of the *Art-Union*, in the Gernsheim Collection, the Harry Ransom Humanities Research Center, The University of Texas at Austin; in the Fox Talbot Museum, Lacock (LA8); RPS (RPS025226); and one in a private collection in North America. The print in National Gallery of Canada, Ottawa (P75:008:30), is in the Bath Photographic Society album. This album, hand-selected from prints in the abbey's archives by Talbot's son, Charles Henry Talbot, was presented to the Bath Photographic Society on 27 February 1889. It was sold by the society at Sotheby's in 1975.

10. Although it appears identical, it is just possible that this was made from a now unknown close variant negative. It was removed at some time in the past from an unknown album page; the paper is watermarked J Whatman 1839. Formerly in the Kodak Museum at Harrow, it is now in National Museum of Photography, Film & Television (1990-5171).

PLATE 80

1. "Fine Arts, Graphic Society," *The Literary Gazette*, no. 1217 (16 May 1840): 315–16.

2. *Athenaeum*, no. 904 (22 February 1845): 202.

3. *The Spectator* 17, no. 838 (20 July 1844): 685.

4. *The Literary Gazette*, no. 1432 (29 June 1844): 410.

5. *The Art-Union* 6 (1 August 1844): 223.

6. Henry Talbot, manuscript draft, National Museum of Photography, Film & Television.

7. For prints of this that are included in copies of *The Pencil of Nature*, see Larry J. Schaaf, "Henry Fox Talbot's *The Pencil of Nature*: A Revised Census of Original Copies," *History of Photography* 17, no. 4 (Winter 1993): 388–96. The negative is in the National Museum of Photography, Film & Television (1937-1304), which also holds twelve loose prints from it (1937-130/1–12). Other loose prints are in the Art Institute of Chicago, formerly in the Joel Snyder Collection (1972.344/22); the Toledo Art Museum (89.32); the Michael Wilson Collection (95:5337); the Cleveland Museum of Art (1992.121); the Fox Talbot Museum, Lacock (LA4); the Royal Photographic Society (RPS025221); and the Metropolitan Museum of Art, New York (1998.1047). Charles Henry Talbot donated one to the National Museum of American History, Smithsonian Institution, in 1914 (No. 1921) and an additional copy was acquired from the family in 1967 (67.172.5). Miss Matilda Talbot donated a copy to National Museums of Scotland, Edinburgh, in 1936 (1937.94.4). A copy mounted in an 1846 volume of the *Art-Union* is in the Harrison Horblit Collection, the Houghton Library, Harvard University (No. 4), which also has a loose copy (TypPr805.T820.104). The J. Paul Getty Museum has three copies mounted in 1846 volumes of the *Art-Union*; two were formerly in the Bruno Bischofberger Collection (84.XB.0280.001 and 84.XB.0280.002) and one was formerly in the collection of Samuel Wagstaff, Jr. (84.XB.0952.002); the same museum also has a loose print with a stellar vintage palmprint in the center of the image, formerly in the collection of Arnold Crane (84.XM1002.059). Lady Elisabeth Feilding sent a copy to the duke of Devonshire on 2 February 1846, and it is still in the collection at Chatsworth (864-23). The print in the National Gallery of Canada, Ottawa (P75:008:21), is in the Bath Photographic Society album. This album, hand-selected from prints in the abbey's archives by Talbot's son, Charles Henry Talbot, was presented to the Bath Photographic Society on 27 February 1889. It was sold by the society at Sotheby's in 1975. A fine print is in the Manfred Heiting Collection—illustrated as plate 8 in *At the Still Point, Photographs from the Manfred Heiting Collection*, vol. 1, *1840–1916* (Amsterdam: Cinumba, 1995).

8. The closest variant is waxed and measures 13.4 x 15.4 cm; it is in the National Museum of Photography, Film & Television (1937-1303, *Schaaf 70*). The more severely trimmed negative is also waxed and now measures 10.4 x 17.6 cm; it is in the Royal Photographic Society (RPS025174, *Schaaf 72*).

PLATE 81

1. *The Times*, 27 April 1844, 6.

2. *Punch* 14 (1848): 110.

3. It took five hundred police to disperse the disorderly crowd. Although the palisades around Nelson's Column were torn down, there were no serious injuries. On the same day, riots that did claim lives took place in Glasgow, Edinburgh, Liverpool, and elsewhere in Britain. See Joseph Ivory, *The Annals of Our Time* (London: MacMillan and Co., 1869), 133–34. Talbot's sister Horatia was in Italy, trapped by the revolution there; he wrote to her about the "great riots in Glasgow, tumultuous lampbreaking in London—open rebellion preached at Dublin" (Henry Talbot to Horatia Feilding, 8 March 1848, LA48-16, Fox Talbot Museum, Lacock [*Document*

06117]). A month later, a true Chartist rally held in Kennington Common was recorded by the daguerreotype. See Gail Buckland, *First Photographs: People, Places, and Phenomena as Captured for the First Time by the Camera* (New York: Macmillan Publishing Co., 1980), 22.

4. Manuscript list in Talbot's hand, LAM-49, Fox Talbot Museum, Lacock.

5. "53. The Nelson Column in Trafalgar Square, when building."

6. One is in the Canadian Centre for Architecture (PH1982.775); the Art Institute, Chicago (1967.149); the LaSalle National Bank Collection, Chicago (68.35.6); the Charles Isaacs Collection; two in the Michael Wilson Collection (93:4886 and 97:5647, formerly in the Rubel Collection); the Museum of Modern Art, New York; one, formerly in the collection of Samuel Wagstaff, Jr., is now in the J. Paul Getty Museum (84.XM.0478.109); the Fox Talbot Museum, Lacock (LA209); two copies (one in an album) that belonged to Talbot's sister Horatia are in a private collection in Ireland. The National Museum of Photography, Film & Television has nineteen prints (1937-3943/1–19) plus one that was formerly in the Kodak Museum, Harrow (1990-5177). Another fine print is in the Manfred Heiting Collection—illustrated as plate 14 in *At the Still Point, Photographs from the Manfred Heiting Collection*, vol. 1, *1840–1916* (Amsterdam: Cinumba, 1995).

7. It is illustrated in Gavin Stamp, *The Changing Metropolis: Earliest Photographs of London, 1839–1879* (London: Viking, 1984), pl. 63, where he assigns a date of 1845. The negative is in the National Museum of Photography, Film & Television (1937-3923, *Schaaf 1225*). No prints are known from the later negative.

PLATE 82

1. H. F. Talbot, *The Pencil of Nature* (London: Longman, Brown, Green, and Longmans), part 2, January 1845.

2. *The Art-Union* 7 (1 March 1845): 84. None of the seventeenth-century Dutch artist Philips Wouvermans's known works are in this style, but the comparison with Dutch painting is quite appropriate. *The Open Door* is used as an example in Carl Chiarenza's "Notes on Aesthetic Relationships between Seventeenth-Century Dutch Painting and Nineteenth-Century Photography," in *One Hundred Years of Photographic History: Essays in Honor of Beaumont Newhall*, ed. Van Deren Coke (Albuquerque: University of New Mexico Press, 1975), 23–26. From Chiarenza's comments, one can only assume that he did not have access to a fine Talbot print.

3. *The Literary Gazette*, no. 1463 (1 February 1845): 73.

4. It was plate ten of twenty-four. Many of the photographs were by Calvert Jones, some by George Bridges, some by Talbot, one possibly by Nevil Story-Maskelyne, and one by Antoine Claudet. As far is known, only one copy of this interesting work was made up, although the setting of the letterpress and the preparation of the mounts should have encouraged more than one sample. The title page lists Henneman as the publisher and a publication date of 1847. The only known copy is in National Museum of Photography, Film & Television (1937-2530/1–24).

5. "106. The Open Door."

6. No. 162. "The Open Door" was one of several *Pencil of Nature* plates that Talbot placed in this exhibition. See the *Catalogue of an Exhibition of Recent Specimens of Photography Exhibited at the . . . Society of Arts . . . in December 1852* (London: Printed by Charles Whittingham for the Society, 1852).

7. For prints included in copies of *The Pencil of Nature*, see Larry J. Schaaf, "Henry Fox Talbot's *The Pencil of Nature*: A Revised Census of Original Copies," *History of Photography* 17, no. 4 (Winter 1993): 388–96. The negative is in the National Museum of Photography, Film & Television (1937-1247), which also holds seven loose prints (1937-1249/1–7) as well as one in Nicolaas Henneman's 1847 *Talbotypes or Sun Pictures*, where this is titled "The Broom" (1937-2530/10). There are loose copies in a private collection; one in the Bayard Codex, formerly in the Arnold Crane Collection and now in the J. Paul Getty Museum (84.XO.0968.167); the copy in the Fox Talbot Museum, Lacock, shares the number LA6 with the variant version; one in the Robert Drapkin Collection; one in the National Museum of American History, Smithsonian Institution (67.172.48); one in an album compiled by the Cowper family, descendants of the eighteenth-century poet, in the Art Institute of Chicago (1960.815[b]); and two copies are in a private collection in North America. The copy in the Gilman Paper Company Collection (from the Harold White Collection) is illustrated in Maria Morris Hambourg, et al., *The Waking Dream: Photography's First Century* (New York: The Metropolitan Museum of Art, 1993), pl. 12. An unusually presented copy is mounted on a gilded brass border card and titled "Stableyard in Talbotype"—it is in the Gernsheim Collection, the Harry Ransom Humanities Research Center, The University of Texas at Austin (94:054:019); the latter also has a loose print (964:054:020). The copy in the Royal Photographic Society is in their album "Talbotypes Taken in 1843" and is titled "The Broom—a Stable Scene from Nature" (RPS025001); the society has two additional loose copies (RPS025223 and RPS025224).

8. Fox Talbot Museum, Lacock. This undated manuscript lists fourteen images, mostly with higher numbers (up to 355) and most of which can be correlated with inscriptions on existing negatives.

9. It is *Schaaf 2821* and is illustrated in Robert Lassam, *Fox Talbot, Photographer* (Tisbury, Wiltshire: Compton Press, 1979), pl. 52. The only copy of the variant so far identified in a fascicle of *The Pencil of Nature* (but it is not known if it is original) is in the Royal Photographic Society, in a part 2 formerly owned by J. Traill Taylor (RPS025366). The National Museum of Photography, Film & Television has six copies of this version (1937-1271/1–6). Fox Talbot Museum, Lacock copy shares the LA6 number with the published version. Sir John Herschel had a print of the variant; it is now in the collection of the Bibliothèque Nationale, Paris (E056[res]-04).

There is a copy in a private collection in North America. Charles Henry Talbot gave one to Smithsonian Institution's National Museum of American History, in 1941 (No. 1914). Miss Matilda Talbot gave two copies to the National Museums of Scotland, Edinburgh, in 1936 (1937-92.6 and unnumbered). The print in the National Gallery of Canada, Ottawa (P75:008:33), is in the Bath Photographic Society album. This album, hand-selected from prints in the abbey's archives by Talbot's son, Charles Henry Talbot, was presented to the Bath Photographic Society on 27 February 1889. It was sold by the society at Sotheby's in 1975.

PLATE 83

1. Plate X, part 2, issued 29 January 1845.

2. H. F. Talbot, *The Pencil of Nature* (London: Longman, Brown, Green, and Longmans), part 2, January 1845.

3. *Athenaeum*, no. 904 (22 February 1845): 202.

4. *The Art-Union* 7 (1 March 1845): 84.

5. *The Literary Gazette*, no. 1463 (1 February 1845): 73.

6. Invoice, Fox Talbot Museum, Lacock.

7. Nicolaas Henneman, manuscript "Coppies Send to Mr. Talbot Decr. 13/1845," LA45-164, Fox Talbot Museum, Lacock.

8. "108. The Haystack."

9. For prints included in copies of *The Pencil of Nature*, see Larry J. Schaaf, "Henry Fox Talbot's *The Pencil of Nature*: A Revised Census of Original Copies," *History of Photography* 17, no. 4 (Winter 1993): 388–96. The dated negative is in the National Museum of Photography, Film & Television (1937-1248), which also holds eight loose prints (1937-1251/1–8). Loose copies are known in the Art Institute, Chicago (1972.347); the Fox Talbot Museum, Lacock (LA10); and there is one one in a private collection in North America. One copy in the Royal Photographic Society (RPS025002) is in their album "Talbotypes Taken in 1843"; the society also has two loose copies (RPS025227 and RPS025228). Miss Matilda Talbot donated one to the National Museum of American History, Smithsonian Institution, in 1928 (3864.02.5) and in 1936 gave one to the National Museums of Scotland, Edinburgh (1937.92.10). The print in the National Gallery of Canada, Ottawa (P75:008:31), is in the Bath Photographic Society album. This album, hand-selected from prints in the abbey's archives by Talbot's son, Charles Henry Talbot, was presented to the Bath Photographic Society on 27 February 1889. It was sold by the society at Sotheby's in 1975.

PLATE 84

1. Wiltshire was an area that suffered much destruction at the hands of frustrated workers in the period when the economy was shifting from an agrarian base to a manufacturing one. Talbot guided the village of Lacock through this tumultuous period with very few problems.

2. Text for plate XIV, in part 3, issued May 1845.

3. This project is splendidly reconstructed in Sara Stevenson, *Hill and Adamson's The Fishermen and Women of the Firth of Forth* (Edinburgh: Scottish National Portrait Gallery, 1991).

4. Plate XIV, in part 3, issued May 1845.

5. Discussion following Mr. Rothwell's talk, "On the Apparently Incorrect Perspective of Photographic Pictures . . . ," *The Photographic Journal* 7, no. 103 (15 November 1860): 33. Henry Collen had probably been persuaded on this point of perspective by their mutual friend Sir John Herschel. Herschel stressed to Talbot that "in looking at photographic pictures from Nature . . . they are hardly one in fifty perspective representations *on a vertical plane*. In consequence perpendicular lines all condense upwards or downwards which is a great pity. . . . When a high station can be chosen this is not the case & this is a reason for chusing a station half way up to the height of the principal object to be represented" (John Herschel to Henry Talbot, 23 October 1847, 1937-4960, National Museum of Photography, Film & Television, *Document 06024*). Talbot promised to "always endeavour if I can to do what you recommend, place the instrument on a level with the central part of the object, or the first or second story of the building. It is however a pity that artists should object to the convergence of vertical parallel lines, since it is founded in nature and only violates the *conventional* rules of Art" (Henry Talbot to John Herschel, 26 October 1847, HS17:319, The Royal Society of London, *Document 06031*).

6. *Athenaeum*, no. 920 (14 June 1845): 592–93.

7. *The Art-Union* 7 (1 September 1845): 296.

8. "114. The Ladder."

9. For prints included in copies of *The Pencil of Nature*, see Larry J. Schaaf, "Henry Fox Talbot's *The Pencil of Nature*: A Revised Census of Original Copies," *History of Photography* 17, no. 4 (Winter 1993): 388–96. The negative is in the National Museum of Photography, Film & Television (1937-1294), which also has seven additional loose prints besides this one (1937-1295/1–8)—1937-1295/2 is printed with the negative accidentally flipped!—and an additional print formerly in the Kodak Museum, Harrow (1990-5174). Lady Elisabeth Feilding sent a copy to the duke of Devonshire on 2 February 1846, and it is still in the collection at Chatsworth (864-18). Miss Matilda Talbot donated one to the National Museums of Scotland, Edinburgh, in 1936. There is a copy in the Edinburgh Calotype Club album in the Edinburgh Central Library (no. 116). The Fox Talbot Museum, Lacock, has a loose print (LA14) and one mounted in a album (LA2033). The Royal Photographic Society has two loose copies, one varnished (RPS025233) and one not (RPS025232). Private collections in North America hold another varnished copy; a print formerly in the André Jammes Collection; and one mounted in an 1846 copy of the *Art-Union*. The print in the National Gallery of Canada, Ottawa (P75:008:34), is in the Bath Photographic Soci-

ety album. This album, hand-selected from prints in the abbey's archives by Talbot's son, Charles Henry Talbot, was presented to the Bath Photographic Society on 27 February 1889. It was sold by the society at Sotheby's in 1975.

PLATE 85

1. Although he reaches a very different conclusion about Lady Elisabeth's role, the most complete summary of this publication is Graham Smith's "William Henry Fox Talbot's Views of Loch Katrine," *Bulletin, Museums of Art and Archaeology, The University of Michigan* 7 (1984–85): 49–77.

2. Nicholls account book, 3 December 1841–2 January 1844 (Fox Talbot Museum, Lacock).

3. Constance Talbot to Henry Talbot, 17 October 1844, Fox Talbot Museum, Lacock (*Document 05105*).

4. Cranston had started a temperance rooming house near this location in 1836. His first temperance hotel lasted from 1843 to 1854 and then began to change. In 1884 it received its current splendid exterior and is now the Old Waverley Hotel.

5. His story, and a good outline of the genesis of the monument, is told in Thomas Bonnar, *Biographical Sketch of George Meikle Kemp, Architect of the Scott Monument, Edinburgh* (Edinburgh: William Blackwood and Sons, 1892).

6. With the full support of Talbot (who had patent rights in England on the calotype), Hill and Adamson set out to photograph the members of the British Association for the Advancement of Science. See Katherine Michaelson, "The First Photographic Record of a Scientific Conference," in Van Deren Coke, ed., *One Hundred Years of Photographic History: Essays in Honor of Beaumont Newhall* (Albuquerque: University of New Mexico Press, 1975), 110–15.

7. Good examples of their photographs during construction and after completion are in David Bruce, *Sun Pictures: The Hill-Adamson Calotypes* (Greenwich, Conn.: New York Graphic Society, 1973), 42, 65. Others are in Colin Ford and Roy Strong, *An Early Victorian Album: The Photographic Masterpieces (1843–1847) of David Octavius Hill and Robert Adamson* (New York: Alfred A. Knopf, 1976), 246, 247, 251, 252.

8. "123. Walter Scott's Monument, Edinburgh: *As it appeared when approaching completion in October, 1844.*"

9. In the National Museum of Photography, Film & Television (1937-1324), which also holds four prints (1937-1325/1–4). Other prints are: one from the Robert Lebeck Collection in Agfa Foto Historama, Cologne (05055599); one in the Royal Photographic Society (RPS025217); one in the Cleveland Museum of Art (1987.23); one in the Judith Hochberg and Michael Mattis Collection; one formerly owned by Talbot's sister Horatia, now in a private collection in Ireland; and one in a private collection in North America. The Fox Talbot Museum, Lacock, has a loose copy (LA26), one in an album (LA2007), and an extraordinary varnished copy, with the clouds greatly enhanced, mounted in a passe-partout mount.

10. All are in the National Museum of Photography, Film & Television. One measures 21.1 x 16.5 cm (1937-1322, *Schaaf 1690*), and a virtually identical one has a slight coating skip near the bottom—it measures 21.0 x 15.9 cm (1937-1323, *Schaaf 1691*); a muddy and unsharp negative, measuring 22.5 x 17.5, has several pencil markings, possibly indicating that it was done by Henneman or another person (1937-1321, *Schaaf 1692*); a similar muddy one with markings measures 22.0 x 17.7 cm (1937-1319, *Schaaf 1693*); a final negative has similar markings but is more successful (1937-1320, *Schaaf 1694*).

PLATE 86

1. See Thomas Joshua Cooper's haunting *Between Dark and Light* (Edinburgh: Graeme Murray, 1985). Even Talbot's print color would not have been too far off from Cooper's later work.

2. This version has very little sky area and only a hint of the base of Doune Castle. It is illustrated in Larry J. Schaaf, *Sun Pictures Catalogue One: Early British Photographs on Paper* (New York: Hans P. Kraus, Jr., 1983), pl. 19. The negative for this is in the National Museum of Photography, Film & Television (1937-1366, *Schaaf 2781*); one loose print from it, mounted in the Edinburgh Calotype Club album, is titled "Allan Water," in the Edinburgh Central Library.

3. But this section had a footnote that gave the present hours for the steamboat leaving the east end of the loch, so the service must have started. See *Black's Picturesque Tourist of Scotland*, 3d ed. (Edinburgh: Adam and Charles Black, 1844), 194.

4. Nicholls account book, which covers the period of 3 December 1841 through 2 January 1844 (Fox Talbot Museum, Lacock).

5. Constance Talbot to Henry Talbot, 26 October 1844, Fox Talbot Museum, Lacock (*Document 05110*).

6. "141. A Mountain Stream which runs at the foot of the Castle of Doune, Scotland." Another label refers to an image that has not yet been reliably identified: "225. A Mountain Torrent which flows at the foot of the Castle of Doune, in Scotland." This may be a view persistently (but vaguely) identified as a bridge in Scotland. The negative for it is in the National Museum of Photography, Film & Television (1937-4059, *Schaaf 754*), which also has eleven prints (1937-4060/1–11). Other prints are in the Jay McDonald Collection; a private collection, North America; the Rubel Collection; the Fox Talbot Museum, Lacock (LA576); and one given in 1934 by Miss Matilda Talbot to the National Museums of Scotland, Edinburgh (T.187.91.3).

7. Henry Talbot, manuscript list, "Copy of ~~last invoice~~ Mr Talbot's list of Negatives left with N.H. ~~Jan. 2~~ Febry 1845," National Museum of Photography, Film & Television. The negative is in the National Museum of Photography, Film & Television (1937-1352), which also holds four prints (1937-1353/1–4). Other prints are in the Harrison Horblit Collection, the Houghton Library, Harvard University (TypPr805.T820.072); and one is in a private collection in North

America. Charles Henry Talbot donated a copy in 1914 to the National Museum of American History, Smithsonian Institution (No. 1934). The Fox Talbot Museum, Lacock, has a plain copy (LA854) and one hand-colored and inscribed "Walker" in pencil on the verso (LA1033).

8. National Museum of Photography, Film & Television 1937-1353/4.

PLATE 87

1. Plate 11.

2. Fox Talbot Museum, Lacock. This undated manuscript lists fourteen images, mostly with higher numbers (up to 355) and most of which can be correlated with inscriptions on existing negatives. Also listed is no. 322, "Loch Katrine (Man & Boat) in the Highlands."

3. Constance Talbot to Henry Talbot, 25 October 1844, LA44-78, Fox Talbot Museum, Lacock (*Document 05109*).

4. But this section had a footnote that gave the present hours for the steamboat leaving the east end of the loch, so the service must have started. See *Black's Picturesque Tourist of Scotland*, 3d ed. (Edinburgh: Adam and Charles Black, 1844), 194.

5. This was plate 10 in the publication. The negative is in the National Museum of Photography, Film & Television (1937-1326, *Schaaf 2791*), and a fine print is illustrated in Larry J. Schaaf, *Sun Pictures Catalogue Nine, William Henry Fox Talbot: Friends and Relations* (New York: Hans P. Kraus, Jr., 1999), pl. 32.

6. *Black's Picturesque Tourist of Scotland*, 12th ed. (Edinburgh: Adam and Charles Black, 1856), 166.

7. See, for example, George Biddell Airy, *On the Topography of the "Lady of the Lake"* (London: John Murray, 1873).

8. A good summary of this effort is in the Glasgow Corporation's *Notes on the Water Supply of Glasgow, Prepared on the Occasion of the Celebration of the Jubilee of the Loch Katrine Water-Works, 14th October 1909* (Glasgow, 1909).

9. See George Washington Wilson, *Photographs of English and Scottish Scenery: Trossachs and Loch Katrine, 12 Views* (London: Marlon, 1868).

10. It is in the National Museum of Photography, Film & Television (1937-1329), which also holds four prints (1937-1338/1–4). Other loose prints, not mounted in copies of *Sun Pictures in Scotland*, are in the Harrison Horblit Collection, the Houghton Library, Harvard University (TypPr805.T820.038); the Howard Stein Collection; the Judith Hochberg and Michael Mattis Collection; the Museum of Modern Art, New York (231.89); the Fox Talbot Museum, Lacock (LA35); and one in a private collection in North America. Charles Henry Talbot donated one in 1914 to the National Museum of American History, Smithsonian Institution (No. 1936).

11. The negative is in the National Museum of Photography, Film & Television (1937-1357, *Schaaf 2790*).

12. It measures 18.0 x 22.3 cm and is in National Museum of Photography, Film & Television (1937-1328, *Schaaf 1191*).

PLATE 88

1. George Smith, in James Morton, *The Monastic Annals of Teviotdale: or, the History and Antiquities of the Abbeys of Jedburgh, Kelso, Melros, and Dryburgh* (Edinburgh: W.H. Lizars, 1832), 322.

2. Plate 13.

3. Morton, *Monastic Annals*, 289–90.

4. Ibid., 289.

5. John G. Lockhart, *Memoirs of the Life of Sir Walter Scott, Bart.*, new ed. (Edinburgh: Robert Cadell, 1836), 754.

6. Nicholls account book, which covers the period of 3 December 1841 through 2 January 1844 (Fox Talbot Museum, Lacock).

7. Constance Talbot to Henry Talbot, 29 October 1844, LA44-79, Fox Talbot Museum, Lacock (*Document 05111*).

8. The manuscript register is still preserved at Abbotsford. Talbot was one of five gentlemen who visited that day, and he may have been traveling with one or more of them. James Donaldson of Edinburgh, William Wight of Jedburgh, and George Wight of Morpeth left us clear signatures. Another visitor from Edinburgh was a bit more excited, and his signature has yet to be decoded. Although the others do not appear in the list of subscribers to *Sun Pictures in Scotland*, perhaps this mystery visitor was a subscriber.

9. "The Tomb of Sir Walter Scott in Dryburgh Abbey: *View taken at the close of an autumnal evening.*"

10. The negative is in the National Museum of Photography, Film & Television (1937-1347), which also holds five prints from it (1937-1349/1–5). Other loose prints, not in copies of *Sun Pictures in Scotland*, are in the Bayard Codex, formerly in the Arnold Crane Collection and now in the J. Paul Getty Museum (84.XO.0968.120); two in the Harrison Horblit Collection, the Houghton Library, Harvard University (TypPr805.T820.041 and TypPr805.T820.108); the Fox Talbot Museum, Lacock, has both an unvarnished and a varnished copy (both under LA37), another under LA696, and one in an album (LA2006). Charles Henry Talbot donated a print in 1914 to the National Museum of American History, Smithsonian Institution (No. 1937).

11. These show as white spots in the prints. Two examples are in the National Museum of Photography, Film & Television, 1937-1349/1 and 1937-1349/3.

12. A virtually exact variant, measuring 17.5 x 16.8 cm, lacks the defect spots but is not quite as sharp overall; it is in the National Museum of Photography, Film & Television (1937-1346, *Schaaf 1928*).

PLATE 89

1. Quoted from Scott's autobiographical fragment in John G. Lockhart's *Memoirs of the Life of Sir Walter Scott, Bart.*, new ed. (Edinburgh: Robert Cadell, 1836), 1.

2. Lockhart, ibid., 19.

3. Harry F. Inglis, "The Roads and Bridges in the Early History of Scotland," *Proceedings of the Society of Antiquaries of Scotland* 11, 4th series (1913): 303.

4. Nicholls account book, which covers the period of 3 December 1841 through 2 January 1844 (Fox Talbot Museum, Lacock).

5. This very complex camera has not been located. but it is possible that parts of it are scattered amongst various archives. While bits of his cameras and supporting apparatus remain at Lacock, other parts have wound up in the Royal Photographic Society, the National Museums of Scotland, Edinburgh, the Smithsonian Institution's National Museum of American History, the Bensusan Museum in South Africa, and in private collections. This experimental approach may explain why there are very similar large and small plates reproduced in the *Sun Pictures in Scotland*—perhaps one set was done in the "traveller's camera." Talbot explained this machine in a detailed letter dated 23 November 1852 (*Document 06705*) to *The Literary Gazette*, no. 1871 (27 November 1852): 876.

6. "220–221. A Bridge in Scotland, 1844."

7. The negative is in the National Museum of Photography, Film & Television (1937-4061). There is one other known print from this negative, in an album once owned by Talbot's sister Horatia and now in a private collection in Ireland.

8. This negative, which measures 16.0 x 20.5 cm, has a dominant vintage palm print in the center which has discolored the area to an orange color—no prints are known from it and it was likely never printed. It is in the National Museum of Photography, Film & Television (1937-4064, *Schaaf 1153*).

PLATE 90

1. J. R. Wardale, *Clare College* (London: F. E. Robinson and Co., 1899), 62.

2. The negative is in the National Museum of Photography, Film & Television (1937-2300). The print made from the earlier state of the negative, when it measured 7.3 x 9.7 cm, is in the Fox Talbot Museum, Lacock (LA574).

PLATE 91

1. Henry Talbot to Elisabeth Feilding, 16 April 1826, LA26-20, Fox Talbot Museum, Lacock (*Document 01425*).

2. James Bass Mussinger, *St. John's College* (London: F. E. Robinson & Co., 1901), 276.

3. The negative is in the National Museum of Photography, Film & Television (1937-2254), which also holds eleven prints from it (1937-2255/1–11). Other prints are in the Canadian Centre for Architecture (PH1982.619); in the Bayard Codex, formerly in the Arnold Crane Collection and now in the J. Paul Getty Museum (84.XO.0968.122); the Gernsheim Collection, the Harry Ransom Humanities Research Center, The University of Texas at Austin (964:054:025); two in the Royal Photographic Society (RPS025251 and RPS025252); the Fox Talbot Museum, Lacock (LA144); the Judith Hochberg and Michael Mattis Collection; the Jay McDonald Collection; the Richard Menschel Collection; one in a private collection in North America; and one as a 1937 gift by Miss Matilda Talbot to Auckland Institute.

PLATE 92

1. "Horrible" in the assessment of the architectural historian Gavin Stamp (with whose opinion one must agree). In contrast to Talbot's image of the opening of the Bridge, Stamp illustrates an anonymous stereo photograph c. 1860 that shows its demise; see plate 132 in *The Changing Metropolis: Earliest Photographs of London, 1839–1879* (London: Viking, 1984).

2. The waxed negative for this, measuring 16.1 x 21.1 cm, is in the National Museum of Photography, Film & Television (1937-4032, *Schaaf 1204*), which has one print from it (1937-3886), mounted and priced for sale and carrying a "Patent Talbotype" stamp. The other known print, formerly in the Harold White Collection, is in the collection of the Gilman Paper Company. It has an ink inscription "T" on verso, indicating that Henneman wanted to preserve the authorship of the image as being Talbot himself. This print is illustrated in Larry J. Schaaf, *Sun Pictures Catalogue Three: The Harold White Collection of Works by William Henry Fox Talbot* (New York: Hans P. Kraus, Jr., 1987), pl. 50.

3. In the National Museum of Photography, Film & Television (1937-3948), which also holds they also hold sixteen prints (1937-3949/1–16) plus one formerly in the collection of the Kodak Museum, Harrow (1990-5157). Two prints are in the Canadian Centre for Architecture (PH1982.365 and PH1986.494); one is in the J. Paul Getty Museum (85.XM.0150.026); the Fox Talbot Museum, Lacock, has one (LA251). The Royal Photographic Society has three copies (RPS025260, RPS025261, RPS025262); one is in the National Museum of American History, Smithsonian Institution (67.172.16); in 1934 Miss Matilda Talbot gave one to the National Maritime Museum, Greenwich (No. 4402); one is in the Robert Hershkowitz Collection; and one, formerly in the André Jammes Collection, is in a private collection in North America.

PLATE 93

1. Felix Summerly, *A Handbook for the Architecture, Sculpture, Tombs, and Decorations of Westminster Abbey* (London: George Bell, 1842).

2. Some sense of this can be gleaned from David Cox's 1811 watercolor overlooking a mélange of buildings on the St. Margaret's side; illustrated in Celina Fox, ed., *London—World City: 1800–1840* (London: Yale University Press, 1992), 362, fig. 237. Even in the late 1850s buildings crowded the side of Westminster Abbey—see plate 7 in Gavin Stamp's *The Changing Metropolis: Earliest Photographs of London, 1839–1879* (London: Viking, 1984).

3. Manuscript list, in Talbot's hand, LAM-49, Fox Talbot Museum, Lacock.

4. No print meeting this description has been located in any of the albums normally associated with Lady Feilding (Elisabeth Feilding to Henry Talbot, 12 January 1845, LA45-6, Fox Talbot Museum, Lacock, *Document 05156*).

5. H. F. Talbot, text for plate XXII, *Westminster Abbey*, in *The Pencil of Nature* (London: Longman, Brown, Green, and Longmans), part 6, April 1846.

6. In the National Museum of Photography, Film & Television (1937-3957).

7. One with trimmed corners, measuring 15.3 x 21.3 cm, is in the Fox Talbot Museum, Lacock (*Schaaf 317*). A waxed negative, with trimmed corners and a small damage hole, measures 15.8 x 20.7 cm, in the National Museum of Photography, Film & Television (1937-3958, *Schaaf 999*). A variant view, likely taken from a similar camera position but with the camera pointing up, measures 15.2 x 21.1 cm; this negative, waxed and with the corners trimmed, is in the National Museum of Photography, Film & Television (1937-3959, *Schaaf 1414*). Prints from it are in a an album formerly belonging to Talbot's sister Horatia, now in a private collection in Ireland; in the Fox Talbot Museum, Lacock (LA305); and one in the album "Talbotypes Taken in 1843" in the Royal Photographic Society (RPS025027). This image is illustrated in Stamp, *The Changing Metropolis*, pl. 6. Two negatives of the upper part of the chapel are different in style and just possibly might have been made by Calvert R. Jones. One measures 16.7 x 11.0 cm and is in the National Museum of Photography, Film & Television (1937-3960, *Schaaf 1230*), which also holds a print (1937-3961). One print from this negative, in the Thomas Walther Collection, came from a sale of the Calvert R. Jones Collection. Another print from this is in the Brewster Codex, formerly in the Bruno Bischofberger Collection, in the J. Paul Getty Museum (84.XZ.0574.190); it is illustrated in Graham Smith, *Disciples of Light: Photographs in the Brewster Album* (Malibu: The J. Paul Getty Museum, 1990), 161, pl. 190. A close variant of the previous, with slightly different framing, is a 16.7 x 11.1 cm negative in the National Museum of Photography, Film & Television (1937-3962, *Schaaf 1231*); the latter holds two prints from it (1937-3963/1–2). The copy in the Fox Talbot Museum, Lacock, is LA303, and another print from it is in an 1846 copy of the *Art-Union*, in the Tokyo Metropolitan Museum of Photography (85011066).

PLATE 94

1. On the site of what is presently the massive NatWest building.

2. In the National Museum of Photography, Film & Television (1937-3936).

3. All are in the National Museum of Photography, Film & Television. One waxed one, measuring 9.7 x 7.4 cm, shows a single blurred cab in the foreground (1937-3916, *Schaaf 1220*); the museum has one print from this (1937-3917). Another, measuring 16.5 x 19.5 cm, shows a cab in the street at the right and an indistinct horse cart on the left (1937-3933, *Schaaf 1221*); there are no known prints from this. Another waxed negative, measuring 16.8 x 20.6 cm, has a sharp horse cart in the foreground and other blurred figures and carts (1937-3934, *Schaaf 1222*); a print from this negative, formerly in the Harold White Collection, is illustrated in Larry J. Schaaf, *Sun Pictures Catalogue Three: The Harold White Collection of Works by William Henry Fox Talbot* (New York: Hans P. Kraus, Jr., 1987), pl. 47; a modern print, made directly from the negative, is illustrated in Gail Buckland, *Fox Talbot and the Invention of Photography* (Boston: David R. Godine, 1980), 103.

PLATE 95

1. Henry Talbot to Elisabeth Feilding, 28 July 1845, LA45-108, Fox Talbot Museum, Lacock (*Document 05338*).

2. Constance Talbot to Henry Talbot, dated "Friday"—likely 25 July 1845—LA41-43, Fox Talbot Museum, Lacock (*Document 04290*).

3. Elisabeth Feilding to Henry Talbot, 24 July 1845, Fox Talbot Museum, Lacock (*Document 05335*).

4. G. E. Aylmer and Reginald Cant, eds., *A History of York Minster* (Oxford: Clarendon Press, 1977), 269.

5. Otherwise known as Little Blake Street. In some references, it is incorrectly listed as "Lob" Lane.

6. It is now Duncombe Place (earlier, Duncombe Street), named after Augustus Duncombe, the Dean of Westminster who pulled down tumbled houses in Little Blake Street to clear the cathedral area of the clutter of unsightly buildings.

7. Henry Talbot to Constance Talbot, 29 July 1845, LA45-110, Fox Talbot Museum, Lacock (*Document 05341*).

8. Nicolaas Henneman, manuscript "Coppies Send to Mr. Talbot Decr. 13/1845," LA45-164, Fox Talbot Museum, Lacock.

9. It is in the Fox Talbot Museum, Lacock (LA3204), which has a varnished print from it (LA485). Prints of this view are relatively widespread. The Art Institute, Chicago, has two (1967.146 and 1975.1059); also in the J. Paul Getty Museum (85.XM.0150.001); the Harrison Horblit Collection, the Houghton Library, Harvard University (TypPr805.T820.057); the Gernsheim Collection, the Harry Ransom Humanities Research Center, The University of Texas at Austin (964:054:023); the Cleveland Museum of Art (1984.163); the Michael Wilson Collection (84:1026); the Judith Hochberg and Michael Mattis Collection; fourteen in the National Museum of Photography, Film & Television (1937-1625/1–14); Canadian Centre for Architec-

ture (PH1978.218). The Royal Photographic Society has two copies (RPS025264 and RPS025265); the Iris and B. Gerald Cantor Center for Visual Arts, Stanford University, has one (1988.41); Tokyo Fuji Art Museum also has one (FT-025); and there are two copies (one from the André Jammes Collection) in private collections in North America. Charles Henry Talbot donated a copy in 1914 to the National Museum of American History, Smithsonian Institution (No. 1931), and another copy was acquired by purchase from the family in 1967 (67.172.33). The print in the National Gallery of Canada, Ottawa (P75:008:07), is in the Bath Photographic Society album. This album, hand-selected from prints in the abbey's archives by Talbot's son, Charles Henry Talbot, was presented to the Bath Photographic Society on 27 February 1889. It was sold by the society at Sotheby's in 1975. An unusual copy from the Prentice and Paul Sack Collection, formerly in the Harold White Collection, is now in the San Francisco Museum of Modern Art (95.416/ST1998.0467). This unique print has a totally bleached sky area and presents a very different visual appearance; it is illustrated in Larry J. Schaaf, *Sun Pictures Catalogue Three: The Harold White Collection of Works by William Henry Fox Talbot* (New York: Hans P. Kraus, Jr., 1987), pl. 44.

PLATE 96

1. Quoted in Basil F. L. Clarke, *Parish Churches of London* (London: B. T. Batsford, 1966), 115.
2. Talbot, travel diary, 1843–44, Fox Talbot Museum, Lacock.
3. This is illustrated in H. J. P. Arnold, *William Henry Fox Talbot: Pioneering Photographer and Man of Science* (London: Hutchinson Benham, 1977), pl. 44. The negative for this is in the National Museum of Photography, Film & Television (1937-3952, *Schaaf 1198*).The 1844 dating is confirmed by Henneman's printed title for this image: "15. A House Building in London, 1844." When Lady Elisabeth Feilding sent a copy of this image to the duke of Devonshire on 7 February 1846, she titled it "A House Building in Sussex Gardens" (manuscript note, National Museum of Photography, Film & Television). Talbot's sister Horatia labeled it "Unfinished House in Sussex Gardens—London" in one of her albums, now in a private collection in Ireland.
4. Diary, 7 June 1845, Lacock Abbey Deposit, Wiltshire Record Office, Trowbridge.
5. At this writing, a fine remaining example of this type is "Brunel House" at 140 Westbourne Terrace.
6. An arrangement was reached with community organizers to convert the ecclesiastical ground to housing for the poor; however, it is now a luxury flat development.
7. In the National Museum of Photography, Film & Television (1937-3946). The only other known print is in the Fox Talbot Museum, Lacock (LA710).
8. The waxed negative, measuring 21.4 x 17.7 cm, is in the Fox Talbot Museum, Lacock (LA3051, *Schaaf 1007*), along with a print (LA711).
9. The waxed negative, measuring 20.6 x 16.7 cm, is in the Fox Talbot Museum, Lacock (LA3050, *Schaaf 1008*), along with a print (LA712).

PLATE 97

1. This print is in an album compiled by the Cowper family, descendants of the eighteenth-century poet; in the Art Institute, Chicago (1960.815[a]).
2. Pullen has often been confused with Charles Porter, so much so that Talbot's biographer was prompted to devote a section of a journal article to the question: H. J. P. Arnold, "A Question of Identity: Who Were 'Pullen' and 'Porter'," in "Talbot and the 'Great Britain'," *British Journal of Photography* (28 August 1987): 986–89. Samuel Pullen was a groom at Lacock, originally having worked for Talbot's stepfather, Admiral Charles Feilding. In 1828, the responsibility for his wages was transferred to Talbot. He eventually married a younger servant at Lacock and the Talbot family much regretted his retirement in the early 1860s. Pullen appears in a number of Talbot's photographs, perhaps most spectacularly in *The Footman* (pl. 33).
3. Calvert Jones to Henry Talbot, 6 October 1845, LA45-134, Fox Talbot Museum, Lacock (*Document 05404*).
4. The negative is in the Royal Photographic Society (RPS025159), which also has two prints (RPS025206 and a varnished one, RPS025277). The sole known print made before the negative was trimmed down from a 17.1 x 21.2 cm size, but with its four corners trimmed, is in the National Museum of Photography, Film & Television (1937-2573/4—it is one of five copies of this print under this number). Prints are in the George Eastman House (81:2844:01); Société Française de Photographie (formerly in the André Jammes Collection, 412-13). One, formerly in the Harold White Collection, is in Tokyo Fuji Art Museum (FT-007); the Cleveland Museum of Art (1987.24). Three are in the J. Paul Getty Museum (85.XM.105.5, and two from the Arnold Crane Collection, 84.XM.1002.018 and 84.XM.1002.51). Two copies are in the Harrison Horblit Collection, the Houghton Library, Harvard University (TypPr805.T820.103 and TypPr805.T820.134). One is in the Bath Photographic Society Album in the National Gallery of Canada, Ottawa (P75:008:32); this album, hand-selected from prints in the abbey's archives by Talbot's son, Charles Henry Talbot, was presented to the Bath Photographic Society on 27 February 1889. It was sold by the society at Sotheby's in 1975. Unusually, a copy of this print is bound in an extra-illustrated copy of *The Pencil of Nature*, in the William Euing Collection, Glasgow University Library (Photo A18). The print titled *Labor omnia vincit*, is in the Cowper family album, Art Institute, Chicago (1960.815[a]). Lady Elisabeth Feilding sent a copy to the duke of Devonshire on 2 February 1846, and it is still in the collection at Chatsworth (864-9). The copy in the Fox Talbot Museum, Lacock (LA559), is on a mount with a "Patent Talbotype" stamp and was priced for sale by Henneman; the museum also has a hand-colored print, colored

by Mr. Mansion, an assistant to Antoine Claudet, on a mount with a "Patent Talbotype" label and priced for sale by Nicolaas Henneman (LA1040). This is possibly the Leon Mansion who wrote the popular book *Letters Upon the Art of Miniature Painting* (London: R. Ackermann, 1824); it was almost certainly the Leon Mansion who wrote *Guida dei fotografi per l'applicazione dei colori in polvere e della vernice-smalto di Mansion. Coll'aggiunta del processo di Sutton per l'intonazione delle prove positive, e del modo di adoperare il liquideo di diamond a pulire i vetri* (Milan: G. Redaelli, 1865).

PLATE 98

1. This accounts for the bombing of Mt. Edgcumbe house during World War II. The library took a direct hit, probably destroying most if not all of the photography and correspondence that Caroline had received from her brother.
2. Charles Edgcumbe, "Mount Edgcumbe," *Pall Mall Magazine* 12 (May 1897): 8.
3. Caroline Mt. Edgcumbe to Henry Talbot, 13 and 14 March 1845, LA45-31, Fox Talbot Museum, Lacock (*Document 05207*).
4. In his diary for 2 April 1828, Moore recorded: "Have induced Caroline Fielding [*sic*] to undertake some designs for a volume of Legends I am about to publish with Power. Those she has already done promise very well." Quoted from Lord John Russell, *Memoirs, Journal, and Correspondence of Thomas Moore*, vol. 5 (London: Longman, Brown, Green, and Longmans, 1854). Moore's dedication in the published work is "To the Miss Feildings this volume is inscribed by their faithful friend & servant. Thomas Moore." He credits "To another fair amateur I am indebted for the Drawings which illustrate the Legends; and it is but right to add, they are the young artist's first attempts at original design. T.M." Each of the nine engravings is signed "C.A.F. del." See Thomas Moore, *Legendary Ballads, Arranged with Symphonies and Accompaniments by Henry R. Bishop* (London: J. Power, 1828). One of the ballads is "The Magic Mirror." It is a less elaborate variation of the story told in Henry Talbot's subsequent *Legendary Tales, in Verse and Prose, Collected by H. Fox Talbot* (London: James Ridgway, 1830). Writing from Florence on 1 July 1822, Horatia gleefully reported to their mother that "Caroline now draws landscapes *from nature*" (LA22-39, Fox Talbot Museum, Lacock).
5. Caroline Mt. Edgcumbe to Henry Talbot, 7 September 1845, LA45-124, Fox Talbot Museum, Lacock (*Document 05385*).
6. Elisabeth Feilding, diary, 21 August 1845, Lacock Abbey Deposit, Wiltshire Record Office, Trowbridge.
7. Horatia Feilding, diary, 24 August 1845, Lacock Abbey Deposit, Wiltshire Record Office, Trowbridge.
8. A letter from Ela Talbot to Henry Talbot reveals this: 21 September 1845, LA45-130, Fox Talbot Museum, Lacock (*Document 05397*).
9. This was on 4 February 1848. See the account in Earl of Mount-Edgcumbe, *Extracts from a Journal Kept During the Commencement of the Revolution at Palermo, in the Year 1848*, 2d ed. (London: James Ridgway, 1850), 30.
10. Constance Talbot to Henry Talbot, 12 October 1845, LA45-136, Fox Talbot Museum, Lacock (*Document 05409*).
11. Manuscript list of copies, 27 October 1845, LA45-139, Fox Talbot Museum, Lacock.
12. Nicolaas Henneman, manuscript "Coppies Send to Mr. Talbot Decr. 13/1845," LA45-164, Fox Talbot Museum, Lacock.
13. The negative is in the National Museum of Photography, Film & Television (1937-1679). Other prints are in the Fox Talbot Museum, Lacock (LA488B) and in the National Museum of American History, Smithsonian Institution (67.172.54).
14. The negative for this, measuring 8.1 x 9.7 cm, is in the National Maritime Museum, Greenwich (B2779). Prints are in the Edinburgh Calotype Club album in the Edinburgh Central Library (No. 107); the Fox Talbot Museum, Lacock (LA488A); eight in National Museum of Photography, Film & Television (1937-1680/1–8); and a varnished print, formerly in the Janos Scholz Collection, in the Snite Museum of Art, Notre Dame, Indiana.
15. The negative for this, measuring 16.6 x 20.0 cm, is in the National Maritime Museum, Greenwich (B2780N, *Schaaf 2088*), which also has a print (B2780P). Other prints from it are in an 1846 copy of the *Art-Union* in the Gernsheim Collection, the Harry Ransom Humanities Research Center, The University of Texas at Austin (964:0342:001); the National Gallery of Canada, Ottawa (P94:002); the National Museum of Photography, Film & Television (1937-1681); and one is in a private collection in North America. The Fox Talbot Museum, Lacock, has both a plain salt print (LA489) and a hand-colored one, signed by "Walker" on the verso (LA1019).
16. "160-162. The Victualling Office, Plymouth, seen from Mount Edgecumbe [*sic*]."

PLATE 99

1. Caroline Mt. Edgcumbe to Henry Talbot, 3 November 1840, Fox Talbot Museum, Lacock (*Document 04159*).
2. Constance Talbot to Henry Talbot, 10 November 1840, LA40-83, Fox Talbot Museum, Lacock (*Document 04165*).
3. Charles Wheatstone to Henry Talbot, 15 December 1840, LA40-89, Fox Talbot Museum, Lacock (*Document 04170*).
4. Brighton was a favorite destination for Talbot's family, and they visited there often. Sometimes Talbot himself went along, as he did with his mother in October 1841 (Elisabeth Feilding, diary, 19 October 1841, Fox Talbot Museum, Lacock). No photographs can be definitely linked to this or immediately subsequent trips.

5. In the 1845 *Brighton Directory* this property is listed as being occupied by Mrs. Elizabeth Jackson.

6. These are a waxed paper negative, 11.2 x 8.9 cm, in the Fox Talbot Museum, Lacock (*Schaaf 3785*) and two in the National Museum of Photography, Film & Television, a 17.6 x 22.0 cm negative (1937-4373, *Schaaf 2811*) and another measuring 18.0 x 21.8 cm (1937-4374, *Schaaf 2812*). The Fox Talbot Museum, Lacock, also has an undated waxed paper negative, 11.2 x 9.0 cm (*Schaaf 3786*).

7. Invoice, period of 3 January–18 May 1846 (National Museum of Photography, Film & Television).

8. The negative for this print is in the National Museum of Photography, Film & Television (1937-1622).

9. Large negatives, of a size similar to this, include a waxed one in the National Museum of Photography, Film & Television (1937-1620, *Schaaf 148*)—there is a print of this in a private collection in England. The National Museum of Photography, Film & Television also has a large waxed negative (1937-1621, *Schaaf 149*) and two others (1937-1623, *Schaaf 151* and 1937-1624, *Schaaf 152*). Smaller negatives include one in the National Museum of Photography, Film & Television, 8.4 x 10.2 cm (1937-1616, *Schaaf 145*), which is a close variant of a negative, in a private collection in England, that measures 9.1 x 11.1 cm (*Schaaf 4229*). Other small negatives are in National Museum of Photography, Film & Television: 1937-1618 (*Schaaf 146*, with a print, 1937-1617) and 1937-1619 (*Schaaf 147*), which was the source of a print in an 1851 album owned by the young Matilda Talbot, now in the Fox Talbot Museum, Lacock. The latter also has three small negatives: *Schaaf 3787*, *Schaaf 3788*, and *Schaaf 3789*.

PLATE 100 A/B

1. This was to York and was highly successful (see pl. 95). Constance Talbot to Henry Talbot, 31 July 1845, Fox Talbot Museum, Lacock (*Document 05345*).

2. Elisabeth Feilding, diary, 1845. Lacock Abbey Collection, Wiltshire Record Office, Trowbridge.

3. Perhaps Ann and Calvert Jones were able to see a print when they returned on 11 October for dinner. See Constance Talbot to Henry Talbot, 12 October 1845, LA45-136, Fox Talbot Museum, Lacock. Henneman's prints were recorded in his manuscript "List of copies sent to H. F. Talbot Esq Oct. 27–1845" (LA45-139, Fox Talbot Museum, Lacock).

4. Nicolaas Henneman, manuscript "Coppies Send to M^r. Talbot De^cr. 13/1845" (LA45-164, Fox Talbot Museum, Lacock).

5. It carries the number "184", which matches an undated manuscript negative list of fourteen images, mostly with higher numbers (up to 355) and most of which can be correlated with inscriptions on existing negatives (Fox Talbot Museum, Lacock).

6. Prints are known in the Canadian Centre for Architecture (PH1981.536); the Art Institute of Chicago (1967.155); LaSalle National Bank Collection, Chicago (68.35.2); one, formerly in the Arnold Crane Collection, is in the J. Paul Getty Museum (84.XM.1002.016); the Harrison Horblit Collection, the Houghton Library, Harvard University (TypPr805.T820.082); the Gernsheim Collection, the Harry Ransom Humanities Research Center, The University of Texas at Austin (964:054:022); the Fox Talbot Museum, Lacock, has a loose print (LA295) and one in an album (LA2009); the Michael Wilson Collection (90:4051); National Gallery of Canada, Ottawa (P67:003); eighteen in the National Museum of Photography, Film & Television (1937-376/1, 1937-2584/1–16), and one from the collection of the Kodak Museum, Harrow (1990-5152); the Cleveland Museum of Art (1987.177). The Royal Photographic Society has two (RPS025197 and RPS025207); and two are in private collections in North America. Lady Elisabeth Feilding sent a copy to the duke of Devonshire on 2 February 1846, and it is still in the collection at Chatsworth (864-8). In 1928, Miss Matilda Talbot donated one to the National Museum of American History, Smithsonian Institution (3864.c), which has a second copy (67.172.03). In 1936, Miss Talbot gave one to the National Museums of Scotland, Edinburgh (NMS.T.1937.91.4). In 1938, she gave one to the Museum of Modern Art, New York, for Beaumont Newhall's pioneering exhibition (371.38); the museum has a second copy (450.88). An interesting faded copy, sliced in half diagonally, with one side intensified by Harold White in 1945, is illustrated in Larry J. Schaaf, *Sun Pictures Catalogue Three: The Harold White Collection of Works by William Henry Fox Talbot* (New York: Hans P. Kraus, Jr., 1987), pl. 20.

7. The full text for this, expanded from Talbot's shorthand manuscript, is "the Abbey Church, which once ranged along the South side of ye Abbey, but was wholly destroyed at the Reformation. By the side of this door stood, and still stands a stone receptacle for holy water. The priest as he passed through a doorway, could dip his hand into this holy water, and passing on, entered the Church at its East End, immediately behind the High Altar. Ye figure in ye plate is looking at this Holy water vase which will point out its position to ye reader. To make a good figure in a photographic picture requires considerable steadiness of character but only for the fraction of a minute. This valuable quality together with many others too long to mention my friend possesses in an eminent degree" (private collection, United States).

A Brief Annotated Bibliography

Amelunxen, Hubertus von. *Die Aufgehobene Zeit; Die Erfindung der Photographie durch William Henry Fox Talbot*. With an afterword by Michael Gray. Berlin: Verlag Dirk Nishen, 1988.

This is the best single source of high-quality reproductions of Talbot's images. Unfortunately, the text is available only in German; the English translation, *Time Reprieved/Time Retrieved*, has yet to be published. The plates are impressive, although they are given a uniformity in reproduction lacking in the originals, and no distinction is drawn between reproductions made from vintage prints and those made from modern copies. The afterword, by Michael Gray (the present curator of the Fox Talbot Museum), usefully outlines Talbot's techniques and includes a number of highly important full-color reproductions of Talbot's early images.

Arnold, H. J. P. *William Henry Fox Talbot: Pioneer of Photography and Man of Science*. London: Hutchinson Benham, Ltd., 1977.

The standard biography of Talbot, this work outlines the full range of his activities and interests. It is extensively documented and endnoted; the family trees and bibliography form useful appendixes. The illustrations, while numerous, are regrettably small and secondary to the text. Arnold's extensive research was cut by about a third for publication (with the cuts mostly in non-photographic areas). The full unpublished text may be consulted in typescript at the Humanities Research Center of The University of Texas at Austin and at The Royal Photographic Society in Bath, England.

Buckland, Gail. *Fox Talbot and the Invention of Photography*. Boston: David R. Godine, 1980.

Buckland, the former curator of the Royal Photographic Society collection, gives a lively and sensitive account of Talbot's activities, concentrating on photography. Whereas the text is less extensive and less documented than Arnold's, Buckland's selection of Talbot's imagery is superb. Indeed, a goodly number of the plates in the present book were first publicly seen in Buckland's biography. The quality of the monochromatic reproductions is uneven but the full-color reproductions give a very good sense of the originals.

Jammes, André. *William Henry Fox Talbot: Inventor of the Negative-Positive Process*. New York: Macmillan Publishing Co., 1973.

Jammes, a noted Parisian bookseller, became the most active and the most sophisticated early collector of Talbot's images. In spite of a poor translation of the text and mediocre reproduction quality of the images, this book gives a good insight into Jammes's strong vision. A major portion of his collection, including several of the photographs in this volume, became one of the essential elements of the J. Paul Getty Museum collection of Talbot's images.

Lassam, Robert. *Fox Talbot, Photographer*. Tisbury, Wiltshire: Compton Press, 1979.

In 1977, Lassam, a former Kodak employee, became the first curator of the Fox Talbot Museum at Lacock. Although some of the images are drawn from elsewhere, this volume concentrates on photographs that are on deposit at that museum.

Schaaf, Larry J. *The Correspondence of William Henry Fox Talbot: A Draft Calendar*. Glasgow: Glasgow University Library Studies, 1995.

Approximately ten thousand letters to and from Talbot are listed in this preliminary calendar. Details are included of the correspondents, the dates, the addresses, the collection in which the letter is held, and the item's number within that collection. A rudimentary index indicates the years for which some letters from each correspondent exist.

Schaaf, Larry J. *Introductory Volume to the Anniversary Facsimile of H. Fox Talbot's "The Pencil of Nature."* New York: Hans P. Kraus, Jr., Inc., 1989.

Talbot's seminal photographically illustrated book announced a new era in the way that illustrations were to be distributed to the public; the six original fascicles of this work are faithfully reproduced in this facsimile. The *Introductory Volume* outlines the struggles Talbot faced when moving from his base of invention in Lacock to the production of commercial quantities of photographic prints for sale.

Schaaf, Larry J. *Out of the Shadows: Herschel, Talbot and the Invention of Photography*. London: Yale University Press, 1992.

This work examines the invention of photography from the contemporaneous points of view of Talbot and his scientific friend Sir John Herschel. The progress of invention was governed not only by scientific and technical advances, but also by more mundane factors such as the weather, the inventor's state of health, and the misunderstandings common in human endeavors. This book contains numerous full-color illustrations of very early Talbot and Herschel photographs.

Schaaf, Larry J. *Records of the Dawn of Photography: Talbot's Notebooks P & Q*. Cambridge: Cambridge University Press, 1996.

Talbot maintained various series of research notebooks. These two, covering his researches from 1839–43, are the ones most important to understanding his invention of photography. Each notebook page is reproduced in facsimile, opposite an expanded transcription of Talbot's text. There are extensive notes and a synoptic index, which facilitates understanding the archaic chemical terms of Talbot's day with modern terminology.

Schaaf, Larry J. *Selected Correspondence of William Henry Fox Talbot, 1823–1874*. London: Science Museum, 1994.

In 1934, Matilda Talbot donated the larger portion of Talbot's archives to the Science Museum, including several hundred of the most important letters that Talbot had received from scientists such as Sir John Herschel and Sir David Brewster. This volume contains a brief synopsis of each letter in this collection (which is now housed at the National Museum of Photography, Film & Television in Bradford).

Talbot, Matilda. *My Life and Lacock Abbey*. London: George Allen and Unwin, Ltd., 1956.

Talbot's Scottish-born granddaughter changed her surname to Talbot when she inherited Lacock Abbey after the death of Talbot's son Charles. More than anyone else, Matilda Talbot was responsible for preserving Talbot's archives and his photographic legacy and for inspiring scholars to study his work. Her title is accurately descriptive, and there is very little in this volume directly about Henry Talbot. However, her book gives a good sense of the environment in which the inventor of photography worked.

Thomas, D. B. *The First Negatives: An Account of the Discovery and Early Use of the Negative-Positive Process*. London: Science Museum, 1964.

Dr. Thomas, then Curator of Photographs at the Science Museum, was the first modern scholar to intensively study and publish on Talbot's work. He was also responsible for making Talbot's archive more accessible to other scholars, thus promoting publication of books such as Gail Buckland's.

Ward, John, and Sara Stevenson. *The Scientific Art of William Henry Fox Talbot and David Octavius Hill with Robert Adamson*. Edinburgh: Scottish National Portrait Gallery, 1986.

John Ward succeeded Dr. Thomas as curator of photography at the Science Museum and continued in that post until the collection was transferred to the National Museum of Photography, Film & Television in Bradford. This book, which includes a few excellent color illustrations, documents what will probably be the largest exhibition of Talbot's work that will ever be shown at one time.

Ware, Mike. *Mechanisms of Image Deterioration in Early Photographs: The Sensitivity to Light of W. H. F. Talbot's Halide-Fixed Images, 1834–1844*. London: Science Museum, 1994.

Dr. Ware has made a unique contribution to understanding why some of Talbot's early photographs have survived and why some have not. The first part of this slender volume is the most clearly written summary of Talbot's technical procedures; it should be understandable to any interested reader. The second part presents some of the highly technical resources Ware consulted to arrive at his conclusions.

Weaver, Mike. *Henry Fox Talbot: Selected Texts and Bibliography*. Oxford: Clio Press, Ltd., 1992.

Professor Weaver has gathered together a variety of texts by and about Talbot. The bibliography section is extensive and lists many of Talbot's lesser-known publications, such as those in the area of Assyriology.

Index and Glossary

Sabines
Apple Tree } May 1
3 busts on the grass }

Walk in Melon ground . May 2

trunk of larch
Chintz Chair } May 3
Abbey from Woodyard }

Church, near view
Urn, to C's garden } May 4
Coachhouse & carriage }

Abbey S. front
do. small camera
E. side Courtyard from window } May 22
E. & N. side do. from corner
Vase & the Medusa's head
table with 3 china & 1 glass cup }

table with 2 candles & teapot — May 27.

Alcove
Seaweed } microscope } May 28
Slice H. Chesnut }

window seat — May 29
 do. May 30

Tower from urn
Hall steps } May 31
N. front Abbey in Woodyard }

Stone gallery
Honeysuckle shed
Trellis, to C's garden } June 1
group of trees, from the
 American walnut }

Abbey N. End, from orchard
Stone figure on gable of dormitory } June 21
 with telescope
Bas relief, aged head
Bas relief — crucifix — June 23
Tower from urn
Middle window of Terrace } July 15
2 windows of do.
Venus }